Art For Dummies®

P9-DNW-950

Is a Work of Art Any Good?

How can you tell if a work of art is any good? That's simple (and see Chapter 1 for details!).

- Does it express successfully what it's intending to express?
- Does it amaze you in a different way each time you look at it?
- Does it grow in stature?
- Does it continually mature?
- Does its visual impact of mysterious, pure power increase every day?
- Is it unforgettable?

The Greatest Works of Western Civilization

These are the ones that changed my life; I look upon them as friends, works I continually revisit because no matter how many times I gaze at them, I find something new and inspirational. (See Chapter 20 for the full details on each of these works.)

- King Tut's Golden Mask
- The Sculptures of the Parthenon
- The Scythian Gold Pectoral
- Nicholas of Verdun's Enameled Altar
- Giotto's Arena Chapel
- The Ghent Altarpiece by van Eyck
- Leonardo's Mona Lisa
- Michelangelo's David
- The Isenheim Altarpiece by Grünewald
- El Greco's *Burial of Count Orgaz*
- Velázquez's *Las Meninas*
- Rembrandt's *Return of the Prodigal Son*
- Goya's *The Third of May, 1808*
- Renoir's *Luncheon of the Boating Party*
- Picasso's *Les Demoiselles d'Avignon*

Visiting a Museum the Way the Pros Do

For those of you who are not professional curators or directors, visit any museum the ways the pros do. See Chapter 3 for more details.

Get a postcard: Postcards are cheaper and are a whole lot easier to lug around than three-pound guide books. When you lose your way, simply flash a postcard at a guard and get directions quickly.

Make a wish list: If you go in a small group, write down the three items you'd like to steal — that is, the three best works in the entire collection. It's amusing to compare notes.

Look at what you don't like: Go to the galleries containing materials you just know you don't like. Also find out what section of the museum is the least visited and take a look. Wonderful finds may come out of that.

Become a member of the museum: Become a member of the museum even for a day's visit: for freebies, discounts at the gift shops, and for the warm feeling you'll get when you know you've become a lifelong supporter of a place that honors beauty, artistic excellence, and the truth.

Listen to some music: Bring along a portable CD or tape player and listen to classical music.

...For Dummies®: Bestselling Book Series for Beginners

Ten Last Words on Art

- Art is for enjoyment, fun, the lifting of your spirits.
- Reading about art is okay, but looking at it is the only way to appreciate it.
- Look at ten works of art each day and your life will change for the better.
- Art and politics never mix.
- Art is not utilitarian.
- Forget about art as an investment. Maybe in 50 years the prices of your works will be higher than when you bought them; probably not, but so what?
- Collect living artists. That way you'll never buy a fake. You'll also gain great satisfaction in knowing you're supporting a cause not usually known for its economic well-being.
- Every work of art, except for those finished yesterday, has changed from its original appearance.
- A reproduction is always a pale reflection of the original.
- Be sure to watch what kind of art your children are creating. One — or more — could have that super touch. (See Chapter 23 for all the details!)

Artists Worth Watching

Who alive today is going to gain the heights of universal art history? Who will stand side by side with the giants? Here's my short list of those living artists who are the prime. (Check out Chapter 22 for more information.)

- Mark di Suvero
- Gary Simmons
- Helen Frankenthaler
- Andrew Wyeth
- Frank Stella
- Anselm Kiefer
- Wayne Thiebaud
- Robert Rauschenberg
- Jenny Saville
- Dale Chihuly

The IDG Books Worldwide logo is a registered trademark under exclusive license to IDG Books Worldwide, Inc., from International Data Group, Inc. The ...For Dummies logo is a trademark, and For Dummies and ...For Dummies are registered trademarks of IDG Books Worldwide, Inc. All other trademarks are the property of their respective owners.

...For Dummies®: Bestselling Book Series for Beginners

Praise for Art For Dummies

"As an art history student at Columbia University in the early 60s, I often went to the Metropolitan Museum to be alone among the masterpieces. That solitude ended when Tom Hoving became director. Suddenly the place was hopping; art was no longer just for the elite. Tom stripped away the veil of intimidation of a museum, and with this book, he has now done the same for everyone who ever considered learning about and collecting art.
—Gerald G. Stiebel, Rosenberg & Stiebel Gallery

"Thomas Hoving's no-holds-barred approach to connoisseurship is refreshing. Passionately exploring the greatest challenge of our time — to define art and defend its merits — the charismatic scholar elucidates the mystery of art's faculty to excite the heart and lift the mind based upon the simple principle of looking with one's eyes, not one's ears, in a word . . . saturation. A must-read for aspiring collectors and an essential companion for would-be art aficionados.
— Edmund P. Pillsbury, Ph.D., Les Peintures (Gironde), France

"Tom has always been an inspiration for me, and *Art For Dummies* proves why! He has done a great job to de-bunk the mysteries and myths of the art world. It has been long in coming, much-needed, and clearly and accurately written. Congratulations, Tom."
— Peter L. Schaffer, A La Vieille Russie, New York

"No one could be better suited than Tom Hoving to guide both the novice and the experienced collector through the sometimes treacherous highways and byways of the art world. This former director of The Metropolitan Museum of Art has a marvelous eye for quality, instinctive good taste, and an unsparing contempt for what is mediocre and bogus. In his witty writing style, Hoving shows us that when all is said and done, art remains the truest and most durable pleasure that money can buy."
— Guy Wildenstein, President & CEO, Wildenstein & Co Inc.

"Do you love art but feel intimidated by it? Would you like to know more? Then this book is for you. It is clearly written, easy to understand, and full of smart tips on how to see art. It begins with a simple question: "What do you see?" Hoving, the talented former director of the Metropolitan Museum of Art, invites you into his mind and shares how he looks at art, giving techniques that help you see. One tip for the museum-goer is to buy postcards in the shop where the best of the collection is displayed, then use them to guide you in finding the best to look at. Afterwards they become a record of what you've seen and are easier to reference than catalogs."
— Anne Hawley, Director, Isabella Stewart Gardner Museum, Boston

by Thomas Hoving
Foreword by Andrew Wyeth

IDG Books Worldwide, Inc.
An International Data Group Company

Foster City, CA ◆ Chicago, IL ◆ Indianapolis, IN ◆ New York, NY

Art For Dummies®

Published by
IDG Books Worldwide, Inc.
An International Data Group Company
919 E. Hillsdale Blvd.
Suite 400
Foster City, CA 94404
www.idgbooks.com (IDG Books Worldwide Web site)
www.dummies.com (Dummies Press Web site)

Library of Congress Catalog Card No.: 99-65838

ISBN: 0-7645-5104-3

Printed in the United States of America

10 9 8 7 6 5 4 3 2 1

1B/TR/QY/ZZ/IN

Distributed in the United States by IDG Books Worldwide, Inc.

Distributed by CDG Books Canada Inc. for Canada; by Transworld Publishers Limited in the United Kingdom; by IDG Norge Books for Norway; by IDG Sweden Books for Sweden; by IDG Books Australia Publishing Corporation Pty. Ltd. for Australia and New Zealand; by TransQuest Publishers Pte Ltd. for Singapore, Malaysia, Thailand, Indonesia, and Hong Kong; by Gotop Information Inc. for Taiwan; by ICG Muse, Inc. for Japan; by Intersoft for South Africa; by Eyrolles for France; by International Thomson Publishing for Germany, Austria and Switzerland; by Distribuidora Cuspide for Argentina; by LR International for Brazil; by Galileo Libros for Chile; by Ediciones ZETA S.C.R. Ltda. for Peru; by WS Computer Publishing Corporation, Inc., for the Philippines; by Contemporanea de Ediciones for Venezuela; by Express Computer Distributors for the Caribbean and West Indies; by Micronesia Media Distributor, Inc. for Micronesia; by Chips Computadoras S.A. de C.V. for Mexico; by Editorial Norma de Panama S.A. for Panama; by American Bookshops for Finland.

For general information on IDG Books Worldwide's books in the U.S., please call our Consumer Customer Service department at 800-762-2974. For reseller information, including discounts and premium sales, please call our Reseller Customer Service department at 800-434-3422.

For information on where to purchase IDG Books Worldwide's books outside the U.S., please contact our International Sales department at 317-596-5530 or fax 317-596-5692.

For consumer information on foreign language translations, please contact our Customer Service department at 1-800-434-3422, fax 317-596-5692, or e-mail rights@idgbooks.com.

For information on licensing foreign or domestic rights, please phone +1-650-655-3109.

For sales inquiries and special prices for bulk quantities, please contact our Sales department at 650-655-3200 or write to the address above.

For information on using IDG Books Worldwide's books in the classroom or for ordering examination copies, please contact our Educational Sales department at 800-434-2086 or fax 317-596-5499.

For press review copies, author interviews, or other publicity information, please contact our Public Relations department at 650-655-3000 or fax 650-655-3299.

For authorization to photocopy items for corporate, personal, or educational use, please contact Copyright Clearance Center, 222 Rosewood Drive, Danvers, MA 01923, or fax 978-750-4470.

About the Author

Thomas Hoving (New York, New York) was the director of the Metropolitan Museum of Art in New York for ten years (1967-77). During his tenure, he renovated more than 50 galleries and doubled the size of the museum from 7 to 14 acres, constructing five wings and the facade with its monumental stairs. He acquired for the Metropolitan 25,000 works of art in all fields. He also brought the so-called "Blockbuster" exhibition to America, personally designing the Tutankhamun Show, which is still the all-time museum box-office attraction. These blockbusters made art more accessible to the general public, for Hoving is most proud of his role as the popularizer of the fine arts.

Hoving has written 12 non-fiction and fiction books since 1979, including two national best-sellers, *The Untold Story, King Tutankhamun,* and *Making the Mummies Dance,* an unvarnished account of his tenure as director of The Met. He was also the entertainment editor on ABC's 20/20 from 1980 until 1986 and was editor-in-chief of *Connoisseur* magazine from 1981 to 1990. Hoving writes a monthy column, "My Eye," for the Internet Art magazine published in the Web site, www.ArtNet.com. His latest book to be released in the Fall for Abrams Press is on the Native American painter and sculptor Dan Namingha.

ABOUT IDG BOOKS WORLDWIDE

Welcome to the world of IDG Books Worldwide.

IDG Books Worldwide, Inc., is a subsidiary of International Data Group, the world's largest publisher of computer-related information and the leading global provider of information services on information technology. IDG was founded more than 30 years ago by Patrick J. McGovern and now employs more than 9,000 people worldwide. IDG publishes more than 290 computer publications in over 75 countries. More than 90 million people read one or more IDG publications each month.

Launched in 1990, IDG Books Worldwide is today the #1 publisher of best-selling computer books in the United States. We are proud to have received eight awards from the Computer Press Association in recognition of editorial excellence and three from Computer Currents' First Annual Readers' Choice Awards. Our best-selling *...For Dummies®* series has more than 50 million copies in print with translations in 31 languages. IDG Books Worldwide, through a joint venture with IDG's Hi-Tech Beijing, became the first U.S. publisher to publish a computer book in the People's Republic of China. In record time, IDG Books Worldwide has become the first choice for millions of readers around the world who want to learn how to better manage their businesses.

Our mission is simple: Every one of our books is designed to bring extra value and skill-building instructions to the reader. Our books are written by experts who understand and care about our readers. The knowledge base of our editorial staff comes from years of experience in publishing, education, and journalism — experience we use to produce books to carry us into the new millennium. In short, we care about books, so we attract the best people. We devote special attention to details such as audience, interior design, use of icons, and illustrations. And because we use an efficient process of authoring, editing, and desktop publishing our books electronically, we can spend more time ensuring superior content and less time on the technicalities of making books.

You can count on our commitment to deliver high-quality books at competitive prices on topics you want to read about. At IDG Books Worldwide, we continue in the IDG tradition of delivering quality for more than 30 years. You'll find no better book on a subject than one from IDG Books Worldwide.

John Kilcullen
Chairman and CEO
IDG Books Worldwide, Inc.

Steven Berkowitz
President and Publisher
IDG Books Worldwide, Inc.

VIII WINNER

Eighth Annual Computer Press Awards ≥1992

IX WINNER

Ninth Annual Computer Press Awards ≥1993

WINNER

X WINNER

Tenth Annual Computer Press Awards ≥1994

XI WINNER

Eleventh Annual Computer Press Awards ≥1995

Dedication and Acknowledgments

To all living artists and appreciators of every aspect of fine art who please us, puzzle us, and sometimes annoy us, but always give balance to our lives and energize us.

Cover art: *The Thinker* (c.1880, cast c. 1904) by Auguste Rodin, French 1840-1917 Fine Arts Museums of San Francisco, gift of Alma De Bretteville Spreckels

Publisher's Acknowledgments

We're proud of this book; please register your comments through our IDG Books Worldwide Online Registration Form located at http://my2cents.dummies.com.

Some of the people who helped bring this book to market include the following:

Acquisitions, Editorial, and Media Development

Project Editor: Bill Helling

Acquisitions Editor: Tammerly Booth

Copy Editor: Stacey Mickelbart

General Reviewer: Sarah Davis

Editorial Coordinator: Maureen Kelly

Editorial Assistant: Alison Walthall

Acquisitions Coordinator: Karen S. Young

Production

Project Coordinator: Tom Missler, Cindy L. Phipps

Layout and Graphics: Amy Adrian, Brian Drumm, Angela F. Hunckler, Barry Offringa, Jill Piscitelli, Douglas L. Rollison, Brent Savage, Janet Seib, Jacque Schneider, Kathie Schutte, Michael A. Sullivan, Brian Torwelle, Maggie Ubertini, Mary Jo Weis

Proofreaders: Chris Collins, Nancy Price, Marianne Santy

Indexer: Tech Indexing

Special Help

Diana R. Conover, Corey M. Dalton, Tim Gallan, Donna Love, Heather Prince, Anita C. Snyder, Linda S. Stark, Nívea C. Strickland, Billie A. Williams

General and Administrative

IDG Books Worldwide, Inc.: John Kilcullen, CEO; Steven Berkowitz, President and Publisher

IDG Books Technology Publishing Group: Richard Swadley, Senior Vice President and Publisher; Walter Bruce III, Vice President and Associate Publisher; Steven Sayre, Associate Publisher; Joseph Wikert, Associate Publisher; Mary Bednarek, Branded Product Development Director; Mary Corder, Editorial Director

IDG Books Consumer Publishing Group: Roland Elgey, Senior Vice President and Publisher; Kathleen A. Welton, Vice President and Publisher; Kevin Thornton, Acquisitions Manager; Kristin A. Cocks, Editorial Director

IDG Books Internet Publishing Group: Brenda McLaughlin, Senior Vice President and Publisher; Diane Graves Steele, Vice President and Associate Publisher; Sofia Marchant, Online Marketing Manager

IDG Books Production for Dummies Press: Michael R. Britton, Vice President of Production; Debbie Stailey, Associate Director of Production; Cindy L. Phipps, Manager of Project Coordination, Production Proofreading, and Indexing; Tony Augsburger, Manager of Prepress, Reprints, and Systems; Laura Carpenter, Production Control Manager; Shelley Lea, Supervisor of Graphics and Design; Debbie J. Gates, Production Systems Specialist; Robert Springer, Supervisor of Proofreading; Kathie Schutte, Production Supervisor

Dummies Packaging and Book Design: Patty Page, Manager, Promotions Marketing

◆

The publisher would like to give special thanks to Patrick J. McGovern, without whom this book would not have been possible.

◆

Contents at a Glance

Cartoons at a Glance

By Rich Tennant

page 21

page 221

page 203

page 7

page 251

page 263

Fax: 978-546-7747 • *E-mail:* the5wave@tiac.net

Table of Contents

Foreword

I first met the author in the early 1970s when, as director of the Metropolitan Museum of Art, he was curating an exhibition of my works. Right away I figured he must be the sharpest eye in the art business. He arrived at Chadds Ford to look at hundreds of my works and immediately honed in on what I myself considered my best works, but hadn't told many people. When Tom Hoving started interviewing me for the exhibition catalogue, he did something that stunned me. He asked questions about materials — pen, pencil, tempera, watercolor, and drybrush — and their qualities and how they affected me creatively. It wasn't what the usual art historian would have gotten into. That showed me he was sensitive to the act of creativity.

He followed by asking questions about my works of Maine and Brandywine, specifically the things I'd done at Christina Olson's and Karl Kuerner's (neighbors and frequent models), which were not so much questions than the guidance an excellent teacher might offer to reveal things about my art to me. He's always gotten me to see things in my paintings that I only suspected were there. Once, when I changed my way of depicting light — and it was a fundamental change — he was the only one to recognize it the moment it happened.

Over the years, Tom Hoving has interviewed me many times and is, in fact, the only person I feel comfortable talking to about my art. In our sessions, we always get into the art of the past, and he continually amazes me by the breadth of his knowledge — which ranges from the time before Greece and Rome through the medieval period and the northern Renaissance (we both have the highest regard for Albrecht Dürer, who you can read more about in this very book), to the latest contemporary trends. He's the best I've come across when it comes to spotting quality, too. What I admire about his approach to art is that he's not hung up on a particular period or style. He doesn't favor, say, the abstract over realism. He respects all styles as legitimate artistic expressions. And he knows something that I believe deeply: The so-called common man instinctively knows what's worthy in art and what to like and just needs a little coaxing to express it and be confident with it.

I know of no art historian other than Tom Hoving who could write about art from the beginning to today, choose the best museums in the world, select their top pieces, and give us the inside word on collecting. He's been everywhere, seen everything, and knows what quality in art is all about.

— Andrew Wyeth

Introduction

*I*f I asked you to tell me what cultural activity you'd like to become more involved with, I'm confident you'd say the fine arts — old master paintings, legendary cultures, and antiquities. I know this to be true because I ask the question frequently and get the same reply. A surprising majority of folks want to feel comfortable with high art and would enjoy dashing into art museums in America and the world, being able to point out the masterpieces and savoring them. But they're a bit scared, they tell me. The art world seems a bit precious and uppity, something for the very rich.

The image of the art world is frightening to most people, and for good reasons.

Museums can be forbidding structures. Some look like something built for a Roman emperor. Others are modernistic, in-your-face buildings surrounded by weird sculptures that make no sense. After you enter the museum, no one seems to want to help — and the galleries go on for miles without places to sit, carpets to soothe the aching feet, or toilets. The walls are loaded with what seems like a million works of art with explanatory labels as long and comprehensible as logarithm tables. If you let it be known above a whisper that you like something, you are warned by one of the guards. If you ask that guard where to go to find whatever, you get a disdainful glance.

Art experts seem to be snobbish, impeccably dressed sorts who speak with at least a trace of an English accent. Their attitude is that art is for the highly educated and socially acceptable, not the common man. When asked for an opinion about some work of art, they either don't bother to answer because you're one of the masses, or if they do, what they tell you sounds like a cross between the contents of a Dead Sea scroll, medieval manuscript, and a Hollywood contract.

The art market seems terrifying. It's international, completely unregulated, and based on the cold-eyed dictum of *caveat emptor* — let the buyer beware. Fakes and reworked pieces are the rule. Dealers delight in scamming the unwary. Auction houses are minefields in which bids are inflated, and if you sneeze, you become the owner of a million-dollar item that you never wanted and can't get out of buying.

Art collectors are the snobbiest folks on earth and pride themselves on looking down their noses at newcomers.

Critics write in jargon that is little understood even by other critics. They invariably either ignore or try to destroy the true genius of the day whose talent will be discovered only after the artist has died — in abject poverty.

Those are some of the images that you may have of the art world, and, believe me, they are faulty.

Sure, the world of the fine arts has its share of snobs. Yes, museums can be confusing and exhausting. Art language can be incomprehensible — having written a lot of it, I ought to know. A few dealers are super con artists. Collectors can be distant and secretive. But these are the exceptions.

- ✔ Museums have spent decades becoming among the most hospitable and educational (and inexpensive) institutions in the land. Sure, they have a long way to go, especially in communicating with you, but they go out of their way to be helpful to the general public. Great exhibitions have become an American way of life.

- ✔ The art market — although a risky place, as any market is — is populated by individuals, especially younger dealers, who ceaselessly help fledgling collectors, often allowing them to buy on time without interest and always taking back a work that has displeased the client.

- ✔ Auction houses have cleaned up their act in the past several years and are playing it mostly straight-arrow.

- ✔ Once you get to know the art expert and show enthusiasm in his or her field, most of them don't let you out of their sight. An old-time collector appreciates nothing more than teaching a newcomer the joys of the game.

- ✔ Even critics are trying hard to write plain English these days. They tell us a painter reached creative maturity instead of telling us he or she has achieved "a harmony, an equilibrium, a wholeness in the Jungian sense that enabled the artist to express universal truths in his breakthrough works, fusing the conscious with the unconscious, the finite and the infinite, the equivocal and the unequivocal, the sensuous and the spiritual."

This book is dedicated to shattering these and other faulty conceptions about the art world and seeks to direct the art-lover-to-be to the truth and the facts.

About This Book

If you think only folks who have spent 40 years studying art and reading thousands of books in eight languages can become appreciators of fine art, think again. The secret to becoming a *connoisseur,* someone who recognizes artistic quality in all its subtle variations, is simple. You look and look more and look again. That's what the best of the pros do. The secret is being saturated in art. Almost anyone can become an art expert with the right amount of saturation. And only by saturation of the original art itself, not through books, or gazing at photographs, or attending slide lectures or taking copious notes at seminars. You will gain expertise and authority (and confidence) simply by soaking up physically all the art your eyes can digest.

Another secret is that art appreciation is subjective. And it doesn't matter where you start — green frogs or paintings on black velvet of puppy dogs or pirate ships. Saturation, on its own, soon weeds out the trite and the tired and leads you to ever-higher levels of appreciation.

This book tells you how to start becoming saturated, informs you about the essential styles and forms and materials of fine art, and tells you where to go for the best artistic experiences.

What should a fine work of art do for your soul? It sets your blood racing. It changes your life for the better every time you look at it.

How This Book Is Organized

If you want to become obsessed — in the right way — with the fine arts, set aside your anxieties, know exactly how to conquer the most confusing museum in a country whose language you don't know a single word of, and with confidence buy a work of art, you have to jump right in and begin looking. I start calming your anxieties by reassuring you that you can become an expert, then guide you through the basics of the entire 50 centuries of art, and finally I point out the most glorious places on earth where art lives forever.

This book tells you how to start becoming saturated, it informs you what are the essential historical styles and forms of fine art, and it tells you where to go for the best artistic experiences. Of course, every style in history isn't here, and many artists aren't mentioned that possibly should have been, but the great ones, in my opinion, are included. In the history of styles section (Part II), I have emphasized the Western world, which I know better than the Orient. I have also, on occasion, neglected to mention certain styles because I'm not that much in love with them — a prime example is the colonial art of South America. In the guides regarding which museums on earth to visit, I concentrate on the ones I personally have haunted.

Part I: Appreciating Art

I define art — past, present, and future — in the broadest possible way.

"Art is when anyone in the world takes any sort of material and fashions a deliberate statement with it." That's all-encompassing and should be, because any sensible definition must include popular art and crafts. I also identify the only true enemy of art and why. It may surprise you because it's *good taste*. The greatest art that has survived has no taste at all. And you don't need a sense of taste to appreciate fine art.

I also indicate that you can appreciate art without an advanced degree. And I point out that it may be the only sure way. I spell out what is the foolproof way to visit any art museum in the world, and reveal what professionals do — their method may surprise you also.

Part II: Art through the Ages

I show you that the secret to knowing the rudiments of art history is to know the styles. I tell you what a style is, which is simply the specific visual language an artist employs to render a certain subject matter and which is like your handwriting or your signature — but infinitely more complex, elaborate, and expressive. Styles can be exceedingly broad, yet so narrow that they can be detected in a tiny portion of a single work of art. I steer you through 50 centuries of artistic styles — from Paleolithic to contemporary, explaining those arcane "isms." I identify the most typical of each epoch and the best of the best works of art in a particular style. You don't have to become steeped in art history to become an art expert, but it's important to have a grasp of the basics. Then, if you carry out the process of saturation successfully, you can forget somewhat about art history. The most fortunate connoisseurs eventually gain a plateau where they can love a work purely for the power that surges from it, not caring all that much about who created it or when.

Part III: Beginning Your Own Collection

I let you in on how the professional examines a work of art — ten vital steps that anyone can follow. If you do, you can avoid pitfalls, seldom buying a fake or even plain bad art. I let you in on the proper way to approach art galleries and auction houses. I reveal the truth about "caveat emptor." I spell out how to get the proper appraisal. And how, if necessary, to get your money back.

Part IV: The Part of Tens

I isolate the greatest works of art ever made and why they are. You'll find when you start becoming a connoisseur that it's all but impossible to stick to a precise ten. I also select the ten most interesting artists who ever lived and why they are so captivating. Leonardo da Vinci is one of them, as is Michelangelo and a few you may never have heard of but will cherish from the moment you see one of their great works. I also present my list of the artists I think will last through another millenium. Finally, I let you in on how to tell if your child has artistic talent — for the future of art is always with the very young. And that is why it will live forever.

Part V: Appendixes

In this part, I show you how to speak artspeak, in case you're interested. In addition, I include a copy of a form I developed at the Metropolitan Museum of Art to help guide the purchase of art. Finally, I provide a list of artists mentioned in the book along with the dates of their lives so that you can put them into historical context (and also so I can avoid making you wade through a sea of parentheses in the text itself).

The Essential Guide to the World's Top Art Cities and Centers

In this special part (which stands out in its yellow color), I begin with the Americas and single out the top cities, identifying dozens of the prime pieces in each museum. Then it's on to cities in Europe and the rest of the world — paying heed to the works that you simply cannot miss. This part has its very own color insert so that you can get a good idea of some of these works I mention.

Icons Used in This Book

This icon points out things you should pay attention to. Take a tip from an expert.

Watch out! This icon helps you avoid making a *faux pas* in the art world — from confusing the work of Manet with that of Monet to buying those "newly discovered" companion pieces to the *Venus of Willendorf.*

If you pay attention to this icon, you'll soon find yourself understanding all those art terms such as *tenebrism* and *chiaroscuro* — terms that prevented you from applying for that job as director of the Metropolitan Museum of Art. Now nothing is holding you back!

This icon signals a story you may not need to know in order to understand art any better — but it surely will help you appreciate all that has gone on in the art world. In any case, these are great stories for any occasion.

Say you're planning to spend some days near a museum or other repository of art mentioned in *Art For Dummies.* Before you leave, you can consult this book and be sure not to miss a great opportunity. To help you prepare your wanderings, I use this icon for those marvelous pieces that are worth a long detour — whether it be to Baltimore or to Vienna.

I often add a personal insight or advice. I offer such material free of charge, of course, so take advantage of the opportunity to hear what I have to say!

When you see this icon next to a description of a work of art, you can safely assume that the work is in one of this book's color inserts — the next best thing to viewing the work in person!

Where to Go from Here

This depends on where you happen to be right now. If you're on a plane headed for London, turn to The Part of Tens and soak up a list of the greatest works in London's three top museums and galleries. If you and your child are just back from first-grade art class with a painting that pleases you more than just as a parent, turn to the end and find out what makes a work by a child an indicator of possible great talent. If you have never seriously looked at a work of art and feel a momentary panic about doing so, go right to the beginning and learn that the most accomplished curator the great Metropolitan Museum of Art ever had was trained as a stockbroker.

This book does not burden you with theories or speculations (or jargon) — it tells you how to start becoming saturated, it touches upon the essential styles and forms of the entire span of fine art, and, most of all, it tells you where to go and what to see for the best artistic experiences.

In addition, the titles of works of art can be confusing — and I don't mean only those black-on-black paintings titled Number 2 or such. Great masterpieces often are known and referred to by several titles given to them at different times throughout their histories. Subjects were interpreted differently, and owners changed over time. The titles I have chosen may not always match up exactly with those used by other books or the museums where the works reside, but they are as valid.

As you read *Art For Dummies,* you'll see small numerals positioned in some of the paragraphs. These numerals correspond to the Bibliography at the end of this book, which includes a listing of the materials that I used to fact-check the many dates and historical facts that are sprinkled throughout. If you're looking for more detailed or in-depth information than I provide here, I recommend that you start with these excellent resources as you expand your understanding and appreciation of art.

Part I:
Appreciating Art

The 5th Wave — By Rich Tennant

"Oh, it's okay if you're into neo-romanticist art. Personally, I prefer the soaring perspectives of David Hockney or the controlled frenzy of Gerhard Richter."

In this part . . .

1 define art in the broadest possible way, including popular art and crafts (no sensible definition could leave them out). I also identify the only true enemy of art and tell you what it is.

I indicate that you can appreciate art without an advanced degree — which may be the only sure way. I describe the foolproof way to visit any art museum in the world, and I tell you what professionals do when they visit a museum.

Chapter 1

What Is Art?

In This Chapter

▶ Defining art

▶ Recognizing different levels of art

▶ Realizing the constant in art

▶ Knowing good art

*T*he definition of art has changed almost every day since the first artist created the first work at least fifty thousand years ago. In fact, the definition of art has to shift whenever an innovator appears. Definitions range across the full spectrum of humanity and are infinite in number. A classic sour one is that dreamed up by the Roman poet Horace: "He who knows a thousand works of art, knows a thousand frauds." Pretty and polite is that served up by the great 17th century French painter Nicholas Poussin, "The purpose of art is delectation."

Smug and proper is a Victorian definition, "Art is something made with form and beauty." A well-known contemporary assessment is, "Art is," which, oddly, although slightly bewildering, is probably closer to the mark than anything.

Toward a Definition of Art

The bottom line is that art can be almost anything. What is considered to be good art and bad art has also changed over the eons. I find it significant that with each change of definition, something considered non-art or bad art by a previous generation is suddenly acceptable. Because I am a medievalist (when every kind of art was as good as another and art was always part of daily life), I define all art — past, present, and future — in the broadest possible way. My definition is, "Art happens when anyone in the world takes any kind of material and fashions it into a deliberate statement."

All-encompassing? You bet. You'll say, but this definition includes popular art and crafts. Yes, it does. And why not? Folk art and especially crafts are as legitimate as so-called "high art" (and in 50 years or so may be thought of as far more legitimate than the somewhat off-putting contemporary "high art"). From the birth of modern art in 1907 (*Les Demoiselles d'Avignon* by Picasso), art doesn't have to please as Poussin would have it or have beauty and form as the Victorians would insist. It can even be deliberately ugly and be profoundly satisfying. In fact, the only true enemy of art is taste. True art has no taste, good or bad. (Although it can be disgusting and tasteless.)

Think of it this way: does the explosive *Last Judgment* by Michelangelo in the Sistine Chapel have taste? (See Figure 1-1.) No. Or even the Sistine Chapel Ceiling itself? No, again. Is a penetrating late self-portrait by Rembrandt showing the artist as a bloated wreck in good taste? Of course not. Great works of art are beyond taste, fashion, and what's trendy.

Levels of art

Even if virtually anything can be art, there are levels of quality. I suppose a cute green clay frog or a sad circus clown painted on fuzzy black velvet can be a phenomenal work of art, but I doubt it. Yet, something created out of chopped up green-frog clay or the paint made by grinding up the tatters of paintings of oh-so-sad circus clowns can definitely be art and may even be great art, too.

The constant in art

The one constant thing about all art is that it is forever changing. There have been countless changes in the long history of art. The most significant have been brought about by the genius of a single artist. Some changes have come about through the invention of new media and new techniques — say, the birth of mosaic, manuscript illumination, oil paint, or perspective. Other changes have come about because a young artist threw aside all traditions and depicted his or her world in a fresh, different, and completely new way. Leonardo Da Vinci was one such revolutionary. So was Claude Monet. And Pablo Picasso, of course. (You can find all these artists described in this book.)

Each change was initially looked upon with suspicion and skepticism as to its artistic worth, but in time, each was accepted. And the same will be true of all the "nutty" subjects, styles, and media that will show up in the future.

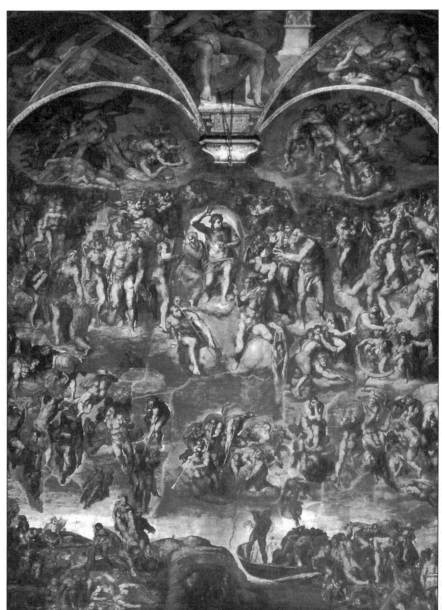

Figure 1-1:
Michel-
angelo's
*Last
Judgment.*

How to Recognize Good Art

How can you tell if a work of art is any good? That's simple.

- ✔ Does it express successfully what it's intending to express?
- ✔ Does it amaze you in a different way each time you look at it?
- ✔ Does it grow in stature?
- ✔ Does it continually mature?
- ✔ Does its visual impact of mysterious, pure power increase every day?
- ✔ Is it unforgettable?

If the answers are all Yes! then it's got a chance to be great. All great art will strongly affect the viewer in some way. Some great art is bothersome — for example, at times I find the paintings of the French Post-Impressionist Paul Cézanne (described in Chapter 14) puzzlingly awkward, even inept, but I cannot keep my eyes off them nonetheless.

To appreciate a work of art, is it okay to like what you like (and the heck with the art critics or experts)? Absolutely. Even ceramic green frogs? Yes. But to a point. For if you learn how to appreciate true art (explained immediately below), it is a given that you'll probably begin by loving a fairly primitive and unsophisticated kind of art, and you will soon elevate your sights and in time look to new heights.

As you climb the stairs of quality, you'll meet individual works that you'll need for the rest of your life, works that will thrill you, energize you, lift your soul, soothe you, make you smile, make you think about the fate of mankind and the universe, make you have to see them again and again for the good of your psyche, state of mind, and strength of heart.

Chapter 2

How to Appreciate Art Without an Advanced Degree

*T*here have been many gifted and sharp-eyed *curators* (keepers and protectors) in the 129-year history of New York's Metropolitan Museum of Art — hundreds of them, expert in fields as diverse as ancient Egypt, Arms and Armor, and Prints, Drawing, and Photographs. Line up the letters designating the advanced degrees held by the curators who worked at the Metropolitan over the years — those MAs, MFAs, and Ph.D.s — and they'd stretch from Maine to Oregon. Yet the single most accomplished curator in the history of the grand institution had no advanced degree and was self-taught in art history. He was for most of his life a stockbroker. His name was William Ivins, and he was responsible for establishing the all-encompassing Prints collection. He was perhaps the most legendary "eye" or connoisseur in the history of the Metropolitan.

The Key to Being a Connoisseur

What is an "eye"? Simply, someone who can instantly spot quality in art in all its subtle gradations. How did Bill Ivins become such a special "eye"? First, he had the urge to know about art, and second, he possessed an inborn talent for appreciating art, which he may not have recognized for some years. But he needed more than that. He recognized he'd never be able to appreciate art in the right way if he didn't get saturated.

The bottom line of connoisseurship and art appreciation is saturation — seeing it all. Ivins immersed himself in prints, tens of thousands of them of all kinds and levels of quality. Soon he was cataloging in his keen mind every unique quality — the strokes of genius and the glitches, too. If you examine every one of thousands of existing prints of Rembrandt van Rijn, those in great condition, the messed up ones, the genuine articles, the copies and fakes, in a shorter time than you think, you'll be able to recognize quality. Ivins did. Just by opening his eyes and looking.

Distinguishing the good from the bad

If you keenly examine every painting, sketch, or drawing by that grand Flemish master of the 17th century, Peter Paul Rubens — there are hundreds — you'll be able to distinguish yards away which one is real and which questionable. If you saturate yourself in absolutely everything Claude Monet ever painted, no matter if that painting is hanging in the Musée d'Orsay in Paris, in the Getty in Los Angeles, or in the bedroom of some wealthy private collector on Park Avenue, you'll become an expert in Monet. After a total immersion, you'll be able to spot a top piece — or a phony — a hundred feet away.

You don't have to start at such heights. If you saturate yourself starting with those ceramic green frogs or clowns on black velvet, you'll soon gravitate to something better and better, and before you know it, you'll be blissfully soaking up Rembrandt prints, or Monet paintings, or drawings by Peter Paul Rubens. Gravitating upwards is the normal process — it's all but automatic with the passage of time.

Examining the real thing

Book learning and attending countless lectures by the best art professors and scholars may help sharpen your eye. But they won't equal a gradual and complete saturation. After I had secured my Ph.D. in art history and archaeology and joined the staff of the Met (on the lowest rung of the curatorial ladder), I found to my dismay I had to work hard to get over my enslavement to art theories that came hand in hand with the doctorate. I had to start looking at works of art in the flesh. No more black-and-white photographs. Or the printed word.

Early on in my career, I had the good fortune to work with a young German super-curator who came to New York for a year on a special fellowship and was assigned to my department, Medieval Art. After hours, together we opened every glass case in the galleries. Over the months, I took in my hands thousands of works — manuscripts, sculptures, bejeweled reliquaries,

ivories, enamels, and silver and gold. Seeing these marvelous things very close to, from all angles, feeling their heft and weight, studying with a pocket magnifying glass and a spotlight the tiniest bumps and knocks of time, and figuring out the almost-secret way they were made was a revelation. In time, I devoured in the same way the works of virtually every department in the Met.

My German "teacher" guided me every step of the way and urged me to grill the works of art as though they were living human beings. Ask questions! Why is something this way, and something else that way? I remember him seizing a beautiful German Gothic medieval reliquary, a silver finger in the shape of an actual index finger set on three delicate feet, embellished with a splendid ring decorated with a huge emerald. Devour this! he urged. Peel it like an onion with your eyes! Interrogate it.

The piece had been given to the museum in the early 1930s by a wealthy industrialist who'd specialized in collecting medieval reliquaries. Finger reliquaries are the rarest of the rare — and ones embellished with emeralds were unique. This object was stunning and very costly, but it was not 13th century my "teacher" warned. It's a fraud. To find out, he demanded that I ask the reliquary some questions.

> ✔ **Why can't the emerald ring be removed?** That was a bad sign, for no genuine finger reliquary would ever be adorned, when it was made, with such a secular ornament. Rings were always added later in homage to the saint whose finger bone was preserved in the finger.

> ✔ **Why were there three small silver hallmarks on one of the feet?** The problem was that they were typical export marks only applied to gold, not silver, and during the 18th, not the 13th, century, in France, not Germany.

> ✔ **Why was the black material making up the inscription (which happened to be unreadable, by the way) actually made of common tar (my "teacher" had easily picked out a tiny hunk and actually tasted it)?** The material should be a hard jet-black enamel (called *niello*).

The problematical answers to the questions all summed up to the reliquary being a fake, made, no doubt, to trap the rich collector who had to pay dearly because, naturally, the emerald was real. In time, through saturation, I was able to conduct my own interrogations and find on my own whatever inconsistencies existed. I could never have learned how to do this by reading books or attending seminars. I became a connoisseur only by saturation, which allowed me to react at once to any work I spotted from then on. I could see at once how it stacked up in quality — good, better, or best. I could determine quickly if I should buy it or pass on it.

Keeping your eye in tune

It doesn't matter how you go about gorging yourself. To see originals is vital, but photographs can keep your eye constantly trained. One of the keenest great, late art dealers never went to sleep without poring through dozens of photographs of a wide variety of works. Keeping his eye in tune.

Saturation means not only examining all the originals of the artist or period. It also means a judicial reading of the scholarly literature and picking through specialist magazines. But the bottom line is looking, looking, and more looking. Looking will transform a totally untrained person with a keen mind and good vision (for it helps a lot to have great eyesight or polished glasses) into a superior art expert. And the beauty is that anyone can do it with a little obsession and a little time.

The bottom line is never pass up the opportunity to look hard at any work of art (even those frogs), and pass your fingers over its surface (if you're allowed), and ask a bunch of sharp questions. I never fail to do so, and I find that no matter what the art is, I invariably learn something revealing and profound.

Chapter 3

How to Visit a Museum the Way the Pros Do

*T*he best way to go is to be already a highly placed member of the curatorial staff of an American museum, especially one that happens to hand out large grants. Or be a museum director as I once was. Then you'll have no trouble getting around, even after hours!

Doing What the Pros Do

For those of you who are not professional curators or directors or don't have the good luck to be armed with the likes of Jackie Onassis (check out the sidebar, "It pays to go with a famous person — the likes of Jackie Onassis"), visit any museum you've never been to before the ways the pros do.

Get a postcard

Go first to the postcard shop. There's always one. Even in tiny, out-of-the-way museums in the outback of Turkey, there will be a postcard shop. And as you may expect, the pride of the museum's holdings will be sitting there ready for you to purchase. So in an instant, you can assess the strengths of the place without getting embroiled in what can be frustratingly uninformative conversations in Turkish or Korean or whatever. Virtually every museum in the world publishes a color postcard of the hottest material.

I buy what I want to see in the galleries — I always find several works that I had no idea were there. Postcards are cheaper and are a whole lot easier to lug around than three-pound guidebooks (which most museums don't have anyway and if they do are in Azerbajianian or something). I proceed to the entrance, flash the card of the painting I want to see, and the guard motions me to it. I never get lost, or feel trapped, or silly. When I lose my way, I simply flash another postcard at a guard deep in the bowels of the museum and get further directions quickly. I also obtain solid information, for invariably the description of the work is crisper on postcards than the labels or catalogs and is in English to boot.

Make a "wish list"

The pros do several other tricks that I'd recommend. If they go in pairs or a small group and tour the galleries alone, they write down the three items they'd steal — that is, the three best works in the entire collection. Almost always they select the same ones as their colleagues. It's amusing to compare notes. This happens virtually the same with people who aren't postgraduately trained, too.

Look at what you don't like

Another trick is to deliberately go to the galleries containing materials you just know you don't like. For me it's 18th-century porcelains, especially Sèvres. Know what? I usually find something that surprises me by its elegance and power, something often that's as good as anything the museum puts in their top 10 pieces. I also will ask the information desk what section of the museum is the least visited and take a look, for wonderful finds may come out of that, too.

Become a member of the museum

I have also become a member of the museum, even for a day's visit. Most European museums have a common membership for a number of museums in the same city — the government owns them all — and the benefits come right away. I have, on occasion, even asked the hotel concierge to call the curator of a department I want to see seeking an appointment and have always been pleasantly surprised at how hospitably I'm received (and in these cases, I didn't identify myself as a former director). I also haunt the information desks and courtesy booths in whatever museum has one.

I never hire a guide inside or outside the place, especially in Egypt or the Middle East, unless, of course, I feel in the need of a few belly laughs. What I have heard over the years from expert guides is a constant fountain of joy to dispel momentary downers.

ART ANECDOTE

It pays to go with a famous person — the likes of Jackie Onassis

I recall fondly during my tenure as director of the Metropolitan those special entrées into storerooms that few outsiders had ever been allowed in. Once the soviets threw the visitors out when I arrived — nothing could change their minds. It's also handy to go with a famous professional.

In the Hermitage, one was never taken to storerooms. Once I had total run of the most secret one. The reason was that I had a secret weapon — in Jaqueline Kennedy Onassis, who was editing the catalogue of the Russian costume show at the Met. Jackie kept badgering the soviet cultural nabobs to send just one item from the clothing of Czar Nicholas and his Czarina Alexandra. They refused. The explanation we got was that the killings of the Czar, his wife, and the children was Lenin's only sin, and to send a dress or a military costume would remind the world of that sin. Jackie shot back that she'd feel better if we could have for the show the marvelous winter sledding cape of Princess Elizabeth. Sorry, it had vanished. She insisted it was still around — she knew. No, it's disappeared. Jackie turned on the right pout. My Russian colleagues cringed, and I knew they had to do something big in exchange for the turn-downs.

A few days later in the Hermitage, we were taken by the Costumes curator and the Communist Party representative of the museum to "someplace where no one has been very often." When we got to a massive door in the middle of a gallery, he said to Jackie and me, "For security reasons, we beg you to close your eyes and we shall lead you."

We did. After a trip down a small flight of stairs and through another door, we were halted in a place, told to open our eyes, and there we were in Stygian blackness. Suddenly, an array of spotlights was illuminated, and there was a steel sled of wondrous Baroque design — as large as a Volkswagen Beetle — upholstered in beautiful green velvet with a luxurious green cape in silks and satins edged in ermine laying over its front seat.

It was Princess Elizabeth's sled. She had the habit of flooding the halls of the Hermitage during the winter and opening the windows so she could skate and sled. Our Russian colleagues told us that they had "found" the missing cape as well as the sled and assured us that we could have both for the costume show — and that they were far better than anything Nicholas or Alexandra ever owned.

I never listen to the recorded guide machines unless they are the ones designed to give you a mini-lecture within a short distance of the work of art you choose or those set up so that you can go where you want rather than being forced through the galleries the way the tape or CD demands.

Listen to some music

What many professionals do when they are solo is to bring along a portable CD or tape player and listen to classical music. From years of experience, here are a few of my choices.

Sound and light at Giza

To be very, very specific now, I find that the long, boring, but visually exciting sound and light at the Pyramid at Giza (forget the sound, for this is the one that starts off pompously with, "Man fears time; time fears the Pyramids") is energized by Richard Strauss' opera *Aegyptische Helena*, or *Helen of Troy in Egypt* (from any handy portable CD or tape player). For the sound and light at Karnak, I always go on Arabic night when the full mystery of the gigantic temple complex is enhanced by a marvelous voice intoning in this entrancing language, not a word of which I understand, but that's what makes it better.

✓ For the Golden Age of the 17th century, Ludwig von Beethoven — anything except the opera *Fidelio,* which gets in the way.

✓ For the 18th century, Mozart, naturally.

✓ For Impressionism, Saint-Saens.

✓ When poking through Italian Renaissance delights, I try Puccini and Verdi.

✓ Telemann is super for the academic artists of the 19th century.

✓ Albinoni is invigorating for classical art of all kinds.

✓ Bach, Chant, and anything by the genius Hildegard of Bingen (c. 1100) is perfect for medieval art.

Dress code

Be practical. In general, walking shoes are the best. Abroad, be sure that shorts as well as short sleeves are acceptable. At the entrance to St. Peter's in the Vatican, for example, "dress-code" watchers turn away people wearing shorts. Of course, at any Islamic site, be sure to wear discreet, respectful clothing.

A final plea

In conclusion, a plea and an exhortation: the best way to see any museum in the United States is to become a member of the institution first or a member of the American Association of Museums, for freebies, discounts at the gift shops, and for the warm feeling you'll get when you know you've become a lifelong supporter of a place that honors beauty, artistic excellence, and the truth.

Part II:
Art through the Ages

In this part . . .

1 show you that the secret to knowing the rudiments of art history is to know the *styles*. I guide you through 50 centuries of artistic styles (from Paleolithic to contemporary), explaining those "isms," and I identify the most typical of each period and its best works of art.

Remember that this book tells you how to start becoming saturated and informs you about the essential historical styles and forms of fine art. Of course, you won't be able to find every style in history here, and I don't mention some artists who possibly should have been. However, I believe that I include the great ones. In this part I emphasize the Western world (which I know better than the rest).

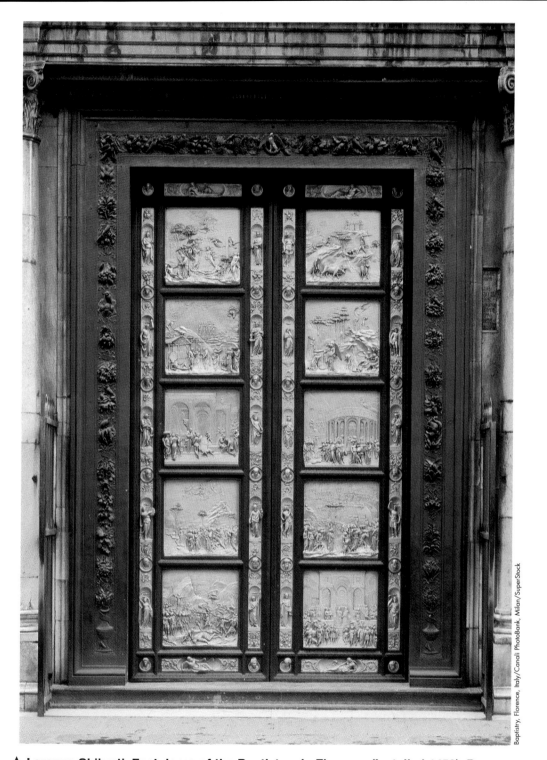

▲ **Lorenzo Ghiberti, East doors of the Baptistery in Florence (Installed 1452). Bronze gilded, 15 ft. high (4.57 m).** These grandiose bronze and gilded doors were created between 1425 and 1452. Their ten rectangular panels, flanked by small figures and diminutive heads, depict scenes from the Old Testament and look almost like easel paintings rather than sculpture because the relief, although high, is exceedingly delicate. Breathtakingly skillful, they demonstrate an unparalleled mastery of the human figure and perspective, and they pulsate with deep religious fervor. Michelangelo, rightly, christened them the "Gates of Paradise."

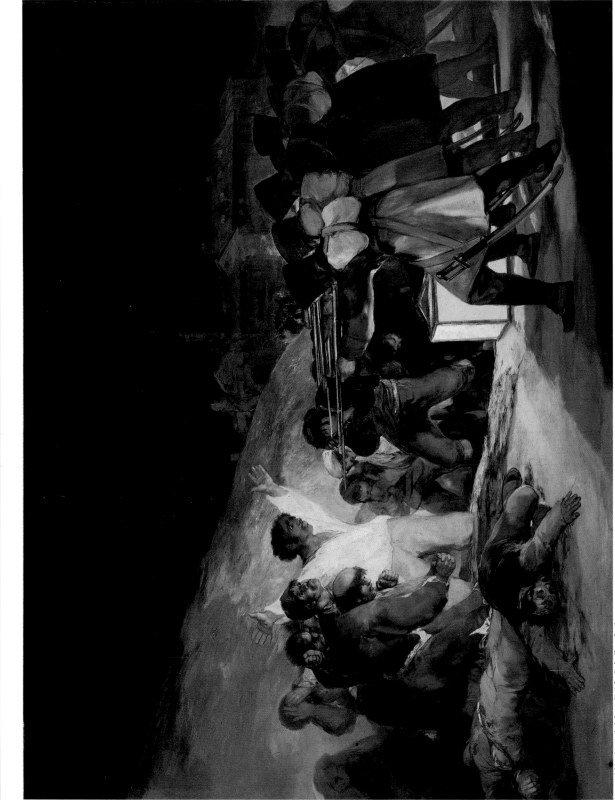

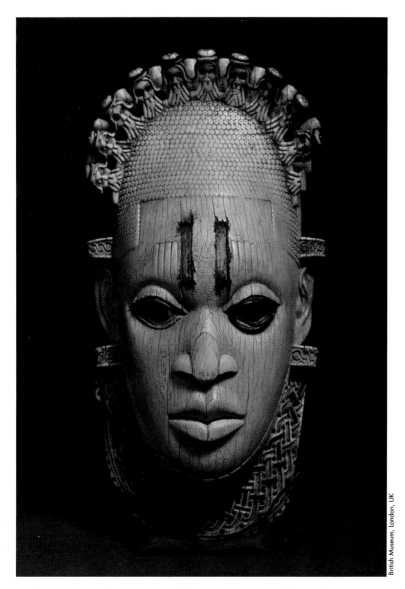

▲ **Benin Mask, Bibi tribe (17th century). Ivory, 9 in. high (23 cm). British Museum, London.** Potent and soft, awesome and subtle, this ivory mask was worn on the ceremonial belt of a great chief of the Bibi tribe in ancient Benin (today's Nigeria). Created by an unknown artist, it's one of the most imposing representations of royal power, intelligence, and authority ever fashioned. The linked "skull" figures crowning the head and curving below the face are abstracted Portuguese mercenaries on hire to the chief.

◄ **Francisco Goya, *The Third of May, 1808* (1814). Oil on canvas, 8 ft. 9 in. x 13 ft. 3 in. (2.67 x 4.06 m). Prado, Madrid.** No artist in history handled the sweet and the cruel as equally well as Goya. This huge, powerful, and frightening work commemorates the horrible slaughter at the end of the peoples' uprising in Madrid in 1808 when Napoleon's troops massacred hundreds. The futile gesture of the peasant in the highlighted center with his arms stretched out to the sky is a reference to Christ on the cross. The deed will never be forgotten, however, for almost hidden in the background are scores of witnesses.

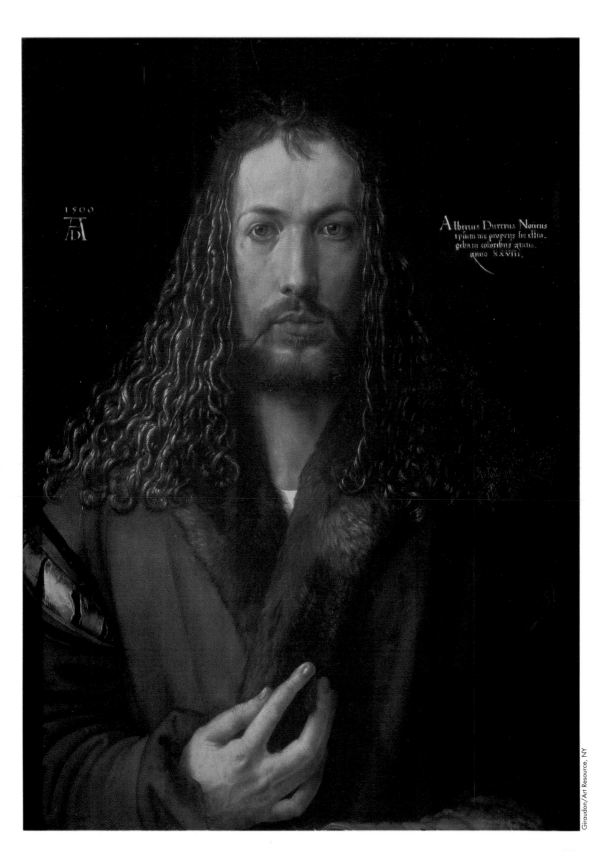

1500

Albertus Durerus Noricus
ipsum me proprijs sic effin
gebam coloribus ætatis
anno XXVIII.

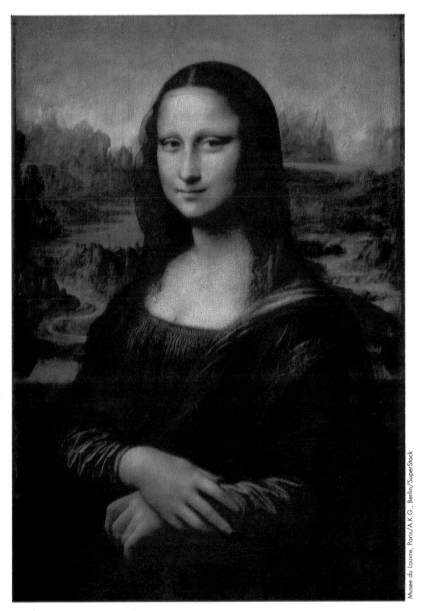

▲ **Leonardo Da Vinci,** *Mona Lisa* **(1503-1506). Oil on wood panel, 21 x 30½ in. (53 x 75 cm). Louvre, Paris.** There's a very good reason why so many people line up to see this portrait of an enigmatic and beautiful woman: It's a one-of-a-kind act of painterly genius – supple, vivid, and unforgettable. The portrait looks so fresh and even revolutionary in its directness and sense of contemporaneousness. Although some observers have fallen for her profound sense of mystery, I find the young lady compelling and totally, almost shockingly, alive.

◀ **Albrecht Dürer,** *Self-Portrait* **(1500). Oil on panel, 26¼ by 19¼ in. (67 x 49 cm). Alte Pinakothek, Munich.** This is, to me, the single most arrogant and gorgeous self-portrait ever made. The German northern Renaissance artist has shown himself as Christ and God. The stark frontality is like a Byzantine mosaic of Christ, and the crooked, open fingers of his right hand looks like a gesture of blessing. In the limpid eyes you can see the reflections of Dürer's studio as well as the cosmic beyond. You are left with the impression that although his genius may not have created the cosmos, he believes he controls it.

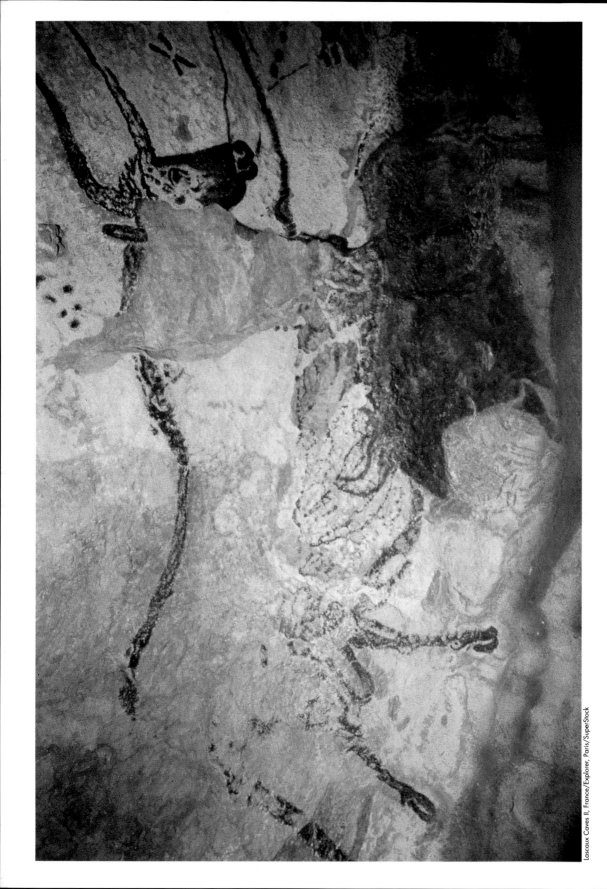

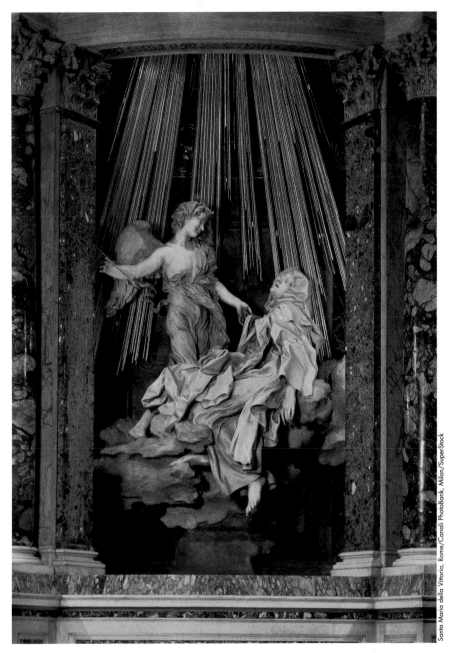

Santa Maria della Vittoria, Rome/Canali PhotoBank, Milan/SuperStock

▲ **Gianlorenzo Bernini.** *The Ecstasy of Saint Teresa* **(1645-52). Marble, life-size. The Cornaro Chapel, Church of Santa Maria della Vittoria, Rome.** This work by the most flamboyant sculptor of Italian Baroque art is a fabulous piece of religious theater that merges sculpture, painting, and architecture in entertaining and emotional ways. The Saint's eyes are closed, and a look of rapture shines upon her beautiful face. But this is a rapture that's far from the pleasures of the flesh. It's the ultimate ecstatic transport to a spiritual realm. Bernini served eight popes and was considered to be one of Europe's most gifted creative geniuses.

◀ **The Caves of Lascaux, France (19,000 B.C.). Paint on raw rock, 5 ft. long (1.5 m).** From the beginning of time there have always been two basic artistic styles – realism and abstraction. This large image of a bison, a superb example of early realism, was created in Paleolithic times (roughly 20,000 years ago). Why were over 2,000 bison and horses painted so deep underground? No one knows, but it may have been purely for the sheer excitement and beauty of it all. Art for art's sake.

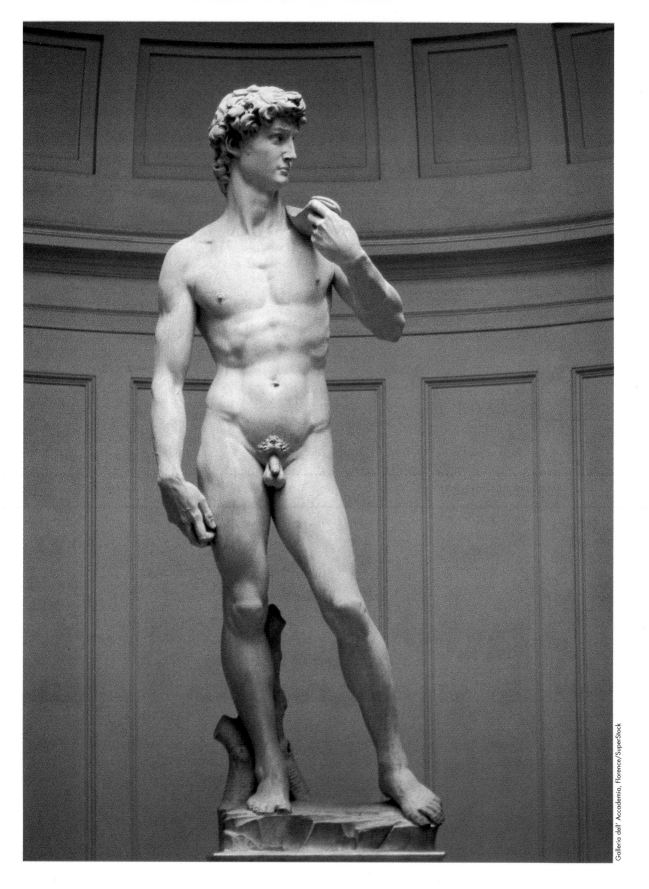

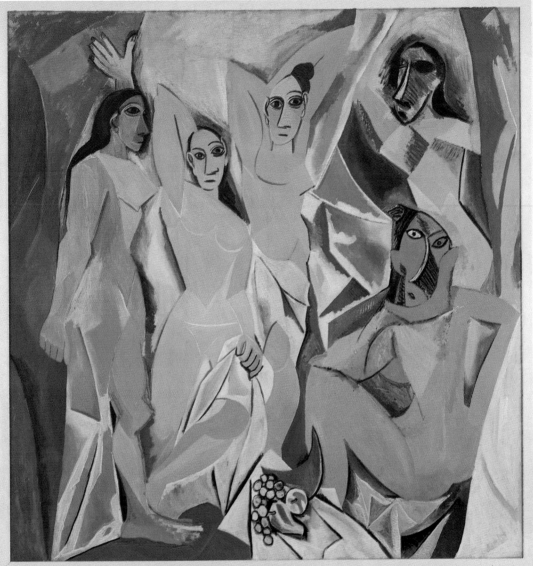

▲ **Pablo Picasso, *Les Demoiselles d'Avignon* (1907). Oil on canvas, 8 x 7½ ft. (2.4 x 2.3 m). The Museum of Modern Art, NYC.** In 1907, Pablo Picasso exploded into a fury of creativity that produced this nerve-shattering and unpleasant, yet beautiful image of humanity that changed the course of art forever. Three faces seem to be African masks. The bodies are flat planes of raw color. A more abstract depiction of humanity cannot be imagined. Face it, the work is not pretty. Picasso kept the radical canvas hidden for several years. When it was finally shown to his friends at a drunken party, his colleague, the painter Georges Braque, exclaimed, "After this, we'll all have to drink gasoline." From the creation of this chaotic, repellent, magnetic, and lyrical painting onward, art no longer had to be aesthetically right or nice to be a masterpiece.

◀ **Michelangelo, *David* (1504). Marble, 13½ ft. high (4.09 m). The Accademia, Florence.** The near fatal defect in this block of Carrara marble didn't faze Michelangelo in the least, for he slammed his chisel right into the marble and somehow avoided the flaw, which might have splintered the block into smithereens. This vivacious figure stands among the top two or three works of all western art. Carved in 1504 to portray Florence's legendary symbol, the statue caused riots when it was first displayed because the Florentines were so delighted. The work is both a triumph of anatomy and psychological awareness. This sculpture, which sums up the Renaissance ideal of both humankind and divinity, is bursting with what Michelangelo's contemporaries called terribilitá (raw dynamism).

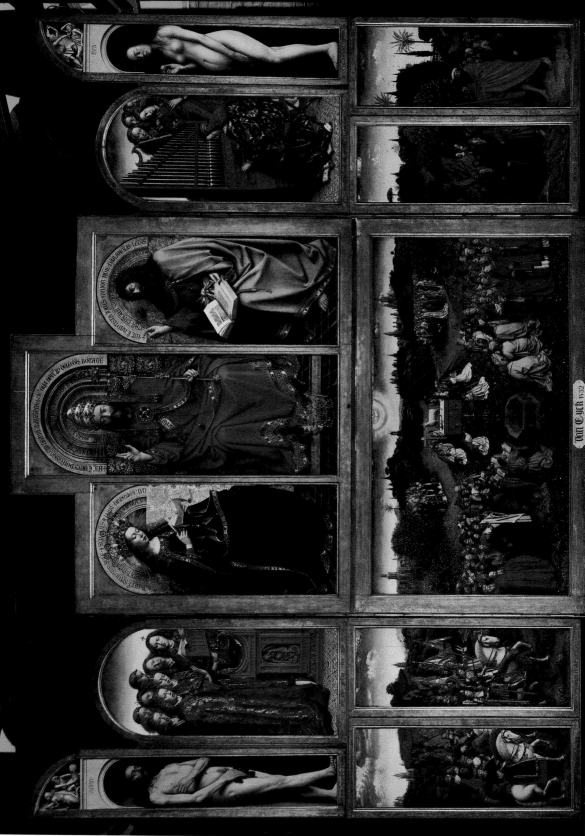

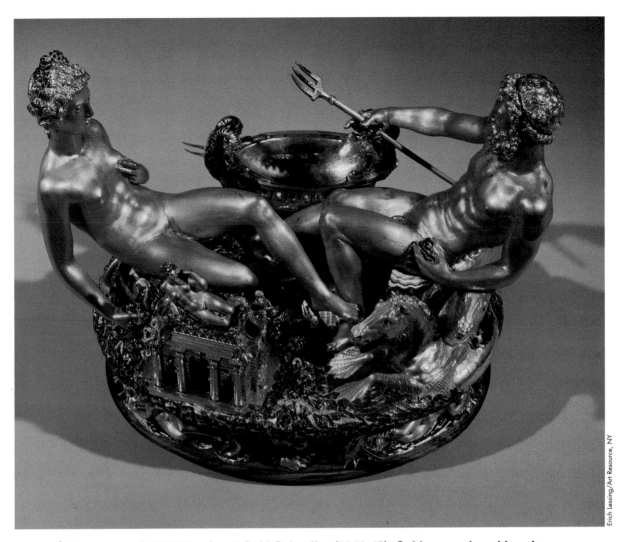

▲ **Benvenuto Cellini, The Great Gold Saltcellar (1540-43). Gold, enamel, and jewels; 10¼ by 13⅛ in. (26 x 33.33 cm). The Kunsthistorisches Museum, Vienna.** Cellini is perhaps the greatest goldsmith of all times. He fashioned this delightful, sensuous receptacle for salt and pepper for Francis I, King of France, in the form of Neptune admiring a very saucy Mother Earth. When he saw the wax model, Francis I exclaimed, "This is a hundred times more divine than I ever could have imagined. This man is a wonder!" When I first confronted this dream of a work, the King's praise struck me as being a bit faint.

◄ **Jan and Hubert van Eyck, The Ghent Altarpiece (1425-1432). Oil on panel, 11 ft. 5¾ in. x 15 ft. 1½ in. (3.5 x 4.6 m). Cathedral of Saint-Bavo, Ghent, Flanders.** This altar, made up of twenty diversely-shaped oil panels, is (to me) the single finest work ever created in all of western civilization. The painting is world famous for its monumental conception and for the consummate, almost microscopic care with which every detail has been rendered. No other work comes close in its intense portrayal of materials. Everything, from the hundreds of jewels and pearls in the huge bejeweled crown worn by God the Father to the hairs on the fleece of the Mystic Lamb, seems to have been painted with a single-hair brush. The colors of crimson, azure, soft emerald, gold, and silver look as if they had been distilled from melted down gems. The truly wondrous thing is that van Eyck's zeal for details did not diminish the overall grandeur or the powerful feelings of spirituality, devotion, and piety.

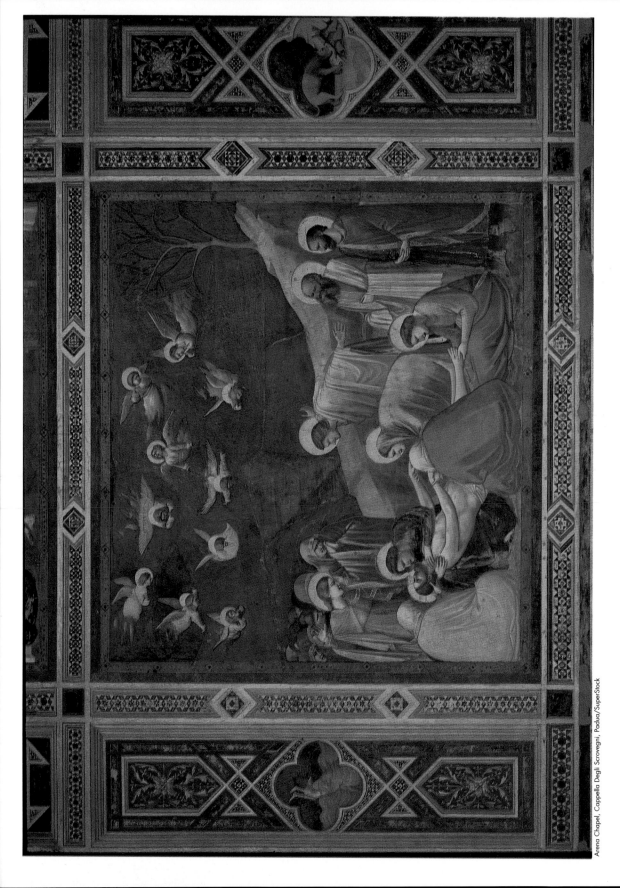

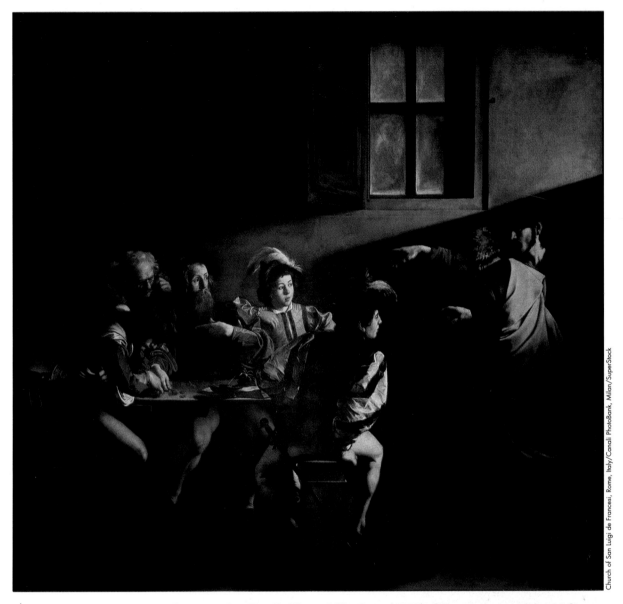

▲ **Michelangelo Merisi da Caravaggio,** *The Calling of Matthew* **(1599). Oil on canvas, 11 by 11 ft. (3.6 x 3.6 m). In the Contarelli chapel of the church in Rome of San Luigi dei Francesi.** This work is one of the banner moments of Italian Baroque art. The artist's signature features are the dramatic contrast of light and shadow, an intense realism, and a theatrical mood. Christ, shrouded in ink-black shadows but with a shining light emanating from his halo, has just entered a murky money-changers den and gestures languidly towards Matthew to come and join his crusade. The future saint is shocked, "Who me? Him?" he says, pointing partly to himself and the older man beside him. It is no mistake that Christ's gesture is similar to that which Michelangelo gave to God the Father in the Sistine ceiling when he brings Adam to life.

◄ **Giotto,** *The Lamentation* **(1305-06) Fresco. The Arena Chapel, Padua.** Giotto gave birth to modern painting in the early 14th century by moving away from the accepted stylized, and rather stiff, Byzantine style. For the first time since ancient Roman times, figures possess bulk, movement, and expression. The rest of Giotto's frescoes in the Chapel in Padua portray scenes from the lives of Joachim and Anna, the Virgin, and the life and passion of Christ as a continuous narrative with the Last Judgment as a climax. The emotional content of these paintings is such that the stories seem fresh, laden with tension and a sorrow so profound that tears come to the eyes of many viewers.

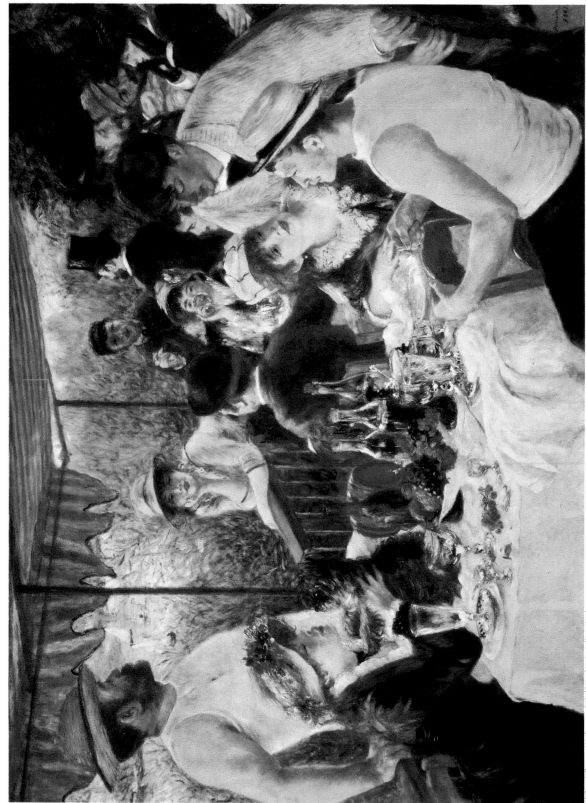

➤ **King Tut's Golden Mask (Ca. 1323 B.C.). Gold, lapis lazuli, and glass; 21¼ in. high (54.5 cm). The Cairo Museum.** I'll never forget how overwhelmed I was, as the organizer of the exhibition of some of Tut's works of art that came to the U.S. in 1976, when I lifted this golden mask off its perch. It weighed nearly twenty pounds. When I got it safely to the ground, I gave it a kiss. This captivating mummy mask is the most splendid goldsmith's work to have survived antiquity. It ranks in my book among the top portraits ever created. The 14-year-old is portrayed as a king, a god, and a vulnerable teenager.

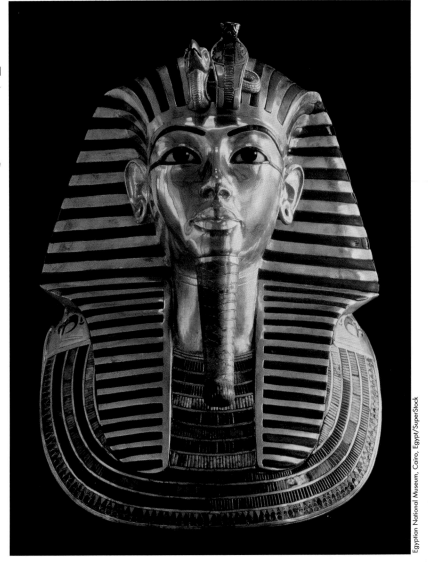

◄ **Pierre-Auguste Renoir, *Luncheon of the Boating Party* (1881). Oil on canvas, 51 x 68 in. (130 x 173 cm). The Phillips Gallery, Washington DC.** Of the many glories of Impressionism, this large, sunny, and ebullient work may be the tops. Renoir's captivating portrait of a congregation of his young and attractive friends at a restaurant outside of Paris seems larger than life. It bubbles with fun, celebration, and a heady late-summer heated sensuality – and sums up every happy moment of that fortunate age of placidity called the Belle Epoque, just before the dawn of the 20th century. Renoir, to many art historians, is a lesser member of the Impressionist group, but this work goes to show that even a lesser artist can create one extraordinarily exciting work.

➤ **The Sculptures from the Parthenon (5th Century B.C.). Marble, 3 ft. 7 in. high (1 m). British Museum, London.** These noble stones resonate with what is most noble and civilized in human nature. Not only are they carved with a perfection that has never been equaled, but they possess an astonishing sense of life and consciousness. In antiquity, these white stones were originally vividly painted – the hair was of varying colors, including bright red and the eyes sparkling blue. Seeing these sculptures is equal to any of the greatest artistic experiences. The bulk of the frieze and pediment sculptures are in the imposing Duveen Gallery of the British Museum, though a few sections of the frieze are on display in the Acropolis Museum in Athens.

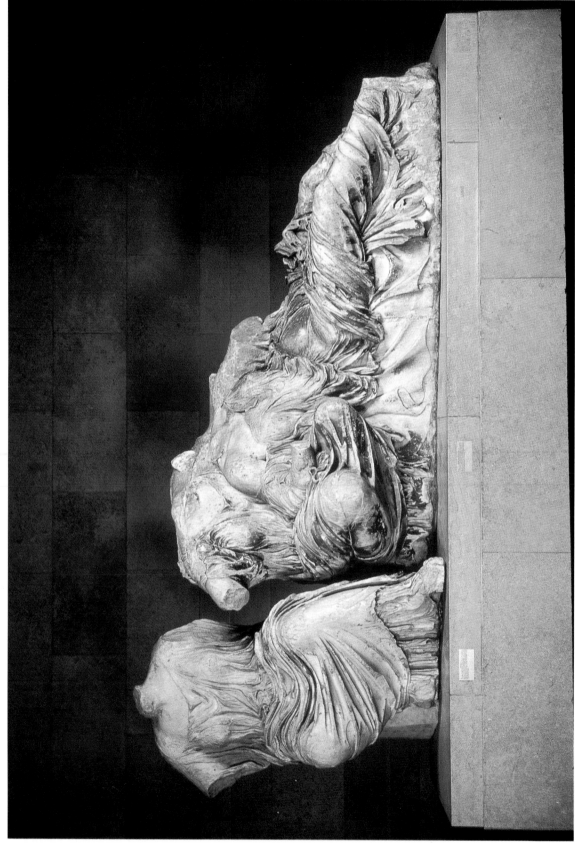

Chapter 4

Prehistoric Art (More Sophisticated Than You Would Believe)

• •

• •

*L*ong Before the Written Word, There was Art, and it was Fantastic. Art of a startlingly gorgeous and exceptionally capable kind representing animals, human beings, and intricate abstract patterns began in caves as far back as 33,000 years ago. This means that the two fundamental styles of all time — naturalism and the geometric or abstract — were invented just about the same time and right at the beginning of art.

Prehistoric Cave Art

The span of prehistoric art is vast — from 30,000 B.C. to the dawn of the Pyramid Age around 5000 B.C. and beyond to the time of Stonehenge, around 2000 B.C. The range is staggering — from sculptures in carved bone and stone, to jewelry made of beads, stone, ivory, and shells, to cave paintings. Cave art is, however, the most impressive.

What were the prehistoric artists striving for? No one knows. (But isn't that true of today's artists?) There is a host of theories.

✔ **Were the images made as a hunting aid — to help hunters trap or ambush their prey?** Maybe. But the creatures represented — horses and bison, even rhinoceroses, and giant felines — weren't the standard diet back then.

✔ **Were the animals deities or symbols that early mankind wanted to emulate?** Perhaps. But horses and bison aren't ideal predatory creatures.

✔ **Was it something to do with fertility — in the sense that the painted animals would reproduce regularly, thus providing the hunters with ample food?** Unlikely, since genders are seldom indicated.

✔ **Was it purely because gifted artists were moved by the majesty of these incredible animals — art for art's sake?** I like to think so.

Altamira

The first painted cave was discovered in Altamira, northern Spain, in 1879, while an amateur paleontologist was searching for prehistoric tools. At first, the authenticity of these spectacular paintings was rejected because the works were thought too good to be prehistoric, and it was not until the early 1900s that the art was accepted by prehistorians as genuine and dating to 18,000 B.C. The ceiling of the main hall is loaded with paintings of bisons, red deer, horses, and boar.[2]

Some of the animals, the deer especially, are large in size, over six feet long (1.8 m), and very lifelike, for the artists carefully recorded their physical features (see Figure 4-1). What makes the creatures so vivid is their energy and because they seem three-dimensional from the way they have been painted on carefully chosen undulating walls of the caves. Furs and manes of the different species are painted with great fidelity despite using only the colors ochre, red, and black. Because of the potential danger to the surfaces, the public is no longer allowed to enter Altamira.[2,3]

Lascaux

The "Sistine Ceiling" of Paleolithic art is to be found in the caves of Lascaux in France near Montignac. It was found on September 12, 1940, when four local boys and a dog, Robot, were climbing to the top of Lascaux Hill, which was their favorite place to explore. Robot fell into a hole in the ground, and the four boys determined to return early the next morning with a rope and lamps to find their special friend. As they dropped one by one into the unknown, how could they have thought that they would discover a site of prehistoric man.[4] (They did find Robot, too.) Until recently, the boys, grown up, served as guides at Lascaux.

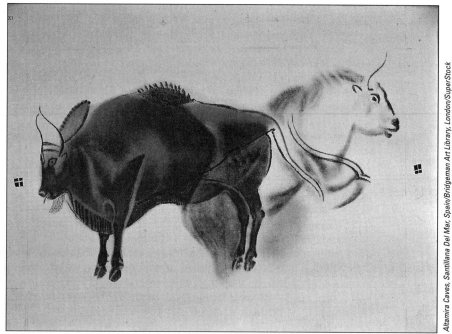

Altamira Caves, Santillana Del Mar, Spain/Bridgeman Art Library, London/SuperStock

Figure 4-1:
Cave art
from
Altamira.

Lascaux consists of a main cavern and many galleries — in fact, there are 110 caves. See the main color insert for a sample.

The 2,000 or more animal figures on the cave walls are mostly bulls, bison, and horses. There are signs of near-human representation, but man is not nearly as richly defined as the creatures. Lascaux would most likely have been a place where humans did not necessarily go to pray for a good hunt, but where the gifted artists would go to draw what they hoped would be a good hunt.[4]

The closing of Lascaux

In 1963, the caves of Lascaux were closed because of the dangers to their survival caused by the presence of tourists whose very breath set up a destructive moisture. The authorities have created a large replica, which isn't much but at least offers some idea of the immense scale of these paintings.

Chauvet

The most recent discovery, on December 18, 1994 — also in France — has proved that cave art is far, far older than anyone believed. At "Chauvet," named for one of the finders, Jean-Maire Chauvet, in the Ardèche Gorges of southeastern France, amateur speleologists discovered the world's oldest painted prehistoric cave, which has paintings that date to some 31,000 years ago. While exploring a cave, the explorers felt a blast of fresh air. They proceeded towards it and discovered a series of galleries and rooms. Under the stark light of their miner's lamps, they saw gigantic columns of white and orange calc-spar — the image of a small mammoth.[10]

In time, some 300 horses, rhinoceros, lions, buffalo, mammoth, alone or in packs, came to light after thousands of years of sleep. Eventually carbon-14 dating analyses showed that one buffalo and two rhinoceros were 31,000 years old, the oldest ever and by far the most dynamic. The rhinos are the dominant animal. There are lions, mammoths, bears, horses, bison, reindeer, ibex, stags, aurochs, a red panther, and an engraved owl. No full human images were found, only a variety of disjointed limbs, a composite half-man, half-bison, and positive and negative stenciled images of hands made by blowing paint onto hands placed up against the wall.[10]

The creatures are so naturalistic that they remind you of zoological illustrations, and highly polished anatomical details make it possible to guess the precise species of each animal. Bursting with vitality, these age-old animals fight and chase one another, appearing like the players in some contemporary nature television program.

Art Leaves the Caves

Sculpture, engraved bones, and primitive jewelry seem to have appeared around the same time — 30,000 – 25,000 B.C. One of the earliest known is astoundingly modern, the *Venus of Willendorf,* which dates to around 28,000–18,000 B.C. and was found in a Paleolithic site in that town in Austria. Images like these were first called "Venus" figures in the 1860s, and the term has subsequently been used to represent all ancient depictions of (usually corpulent) women.

The Willendorf (shown in Figure 4-2) is of such womanhood that this dazzling statuette may well stand for the universal portrayal of female power. Her face is hidden by a sort of stocking cap, which is probably a mask signifying high rank. She is marked by enormous breasts, a large pubic triangle, and large buttocks, which may symbolize early man's reverence for the life-giving powers of the human form. Originally, the figure was painted with red ochre,

the sacred color of blood. It is one of the finest works of art of any epoch, combining raw realism with the abstract strength that comes when divinity or magic is being portrayed.

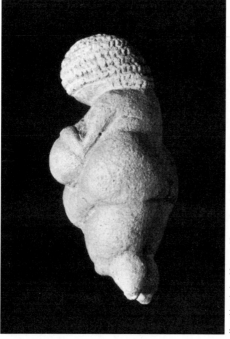

Figure 4-2:
The *Venus*
of
Willendorf.

Kunsthistorisches Museum, Vienna, Austria (Museum of Art History, Vienna)/SuperStock

Around 8000 B.C., major breakthroughs came for mankind — domestication of beasts and the beginnings of agriculture. Then, around 6000 B.C., along the Nile River, societies began to develop. With these profound changes in civilization, art also changed. However, this was not the end to prehistoric art. Nearly a thousand miles away from Egypt, in England, another primitive people, far away from the humid warmth and rich waters of the Nile River, developed what seems to be a huge calendar for predicting the changing of the sun, moon, stars, and planets — Stonehenge, which was probably linked with summer, winter, and other seasonal festivals by these not-so-primitive peoples.

Some 97 feet (30 m) in diameter, Stonehenge consists of 30 stone pillars 13.5 feet (4 m) tall and weighing nearly 25 metric tons (built in several phases around 2000 B.C.). Additionally, there is an earth mound some 320 feet (98 m) in diameter surrounding the compound. It is supposed that the site was constructed — the large stones were sledded dozens of miles from the quarries — over several centuries. In the early 12th century, a writer affirmed, however, that the stones were flown by Merlin the Magician from Africa to Ireland and thence to Great Britain. Maybe so. The site is, along with the great Pyramid, the most magical and romantic ancient place in the world (see Figure 4-3).

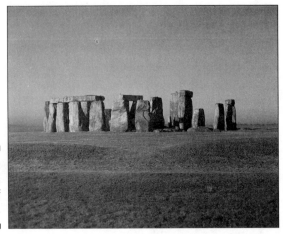

Figure 4-3:
The famed
pillars of
Stonehenge.

SuperStock

Chapter 5

The Ancient World: Still the Most Exciting

*T*he very words "ancient art" make some people cringe. The very thought of having to read up on confusing Egyptian dynasties (Old Kingdom! Isn't all Egyptian art old?) or take a forced march through gloomy galleries stuffed with Greek or Roman sculptures missing most of their anatomy can be discouraging.

Beats me why Greek and Roman art is so far down on the art appreciation scale these days. Maybe it's because dictators of modern times always seized upon classical antiquity as models of their ghastly propagandic art and architecture. (Or, could it be the awful movies?) Perhaps it's because the galleries in museums devoted to the material invariably seem to be the least attractive and the labels deliberately incomprehensible. Take hope, for the Metropolitan Museum, alert to the problem, has just opened some marvelously luminous Greek and Roman galleries with intelligent and readable labels.

The best way to approach ancient art is to relax and enjoy and not be concerned about dates or subject matter or ritualistic or mythological connotations which can be a bit murky — simply look upon ancient art as humanity in all its delightful manifestations, rendered, not by formulas, but by dynamic, thrilling, highly creative, and individual artistic styles. (Even in Egypt, art changed subtly but powerfully.) In short, approach ancient art the way your great-great-great-great-grandparents did back in the 18th century, as remarkable depictions of mankind at his best — and the rest will come.

The Ancient Near East

Generally speaking, the term "Ancient Near East" is applied to the area of the ancient world that extends from Turkey in the west to Iran in the east. The chronology is long — almost as long as Egypt's — and although few of the many artistic styles that sprang from the region impacted the art of the West, there are some fascinating periods and works.

In the following sections, I give you the basic chronology of the Ancient Near Eastern world and some of the more notable works of art associated with the key periods.[6]

Mesopotamia (Iraq)

Sumer c. 3500-2030 B.C.

The art of the Sumerians, who inhabited southern Mesopotamia (southern Iraq) during the 3rd millennium B.C., is well illustrated by a group of gypsum figures of stunning power found at Nippur (the best are in the New Louvre, and a fine one is in the Metropolitan Museum in New York). They are boldly frontal and hold their hands together in what seems to be a gesture of piety. Their broad faces are luxuriously bearded, and their extremely large, wide-open eyes are often inlaid with shell, jet-black limestone, or sparkling blue lapis lazuli. The effect is mesmerizing.

A rich hoard of jewelry in gold and lapis lazuli was found at a royal cemetery at the ancient city of Ur (today's modern Muqaiyir, Iraq) in the early 1930s, and excellent examples are in London's British Museum. A particularly fine example is the so-called Royal Standard of Ur of around 2600 B.C., decorated with scenes of war on one side and peace on the other.

Yet, the best works — and they are amongst the world's art wonders — are to be found in Philadelphia at the University of Pennsylvania's exceptional Museum of Archaeology and Anthropology. Here, in a stately gallery, are knockout works from the royal tombs of Ur dating to around 2650-2550 B.C. They include an amazing lyre ornamented with the head of a bull crafted in gold, silver, shell, and lapis lazuli. Plus a unique sculpture representing a ram climbing into a thicket. Finally, Lady Pu-abi's headdress and jewelry are gloriously ornate.

Akkad c. 2340-2180 B.C.

In the second half of the 3rd millennium, a single Semitic state, Akkad, brought together the multiple city-states that had lived together during the Sumerian early dynastic period. The surviving art is rare, but there are scads of cylindrical seals cut in semiprecious stones with vivid scenes, especially

those depicting various deities fighting fantastic creatures. It's common for museums to press the seals into plaster, thereby giving you crisp and often startlingly theatrical small works of art.

Lagash or NeoSumeria c. 2230-2150 B.C.

The art produced during what is called Neo-Sumerian or Sumerian revival of Ur's 3rd Dynasty in the city-state of Lagash is truly spectacular. The governor of Lagash, Gudea by name, must have been an art lover of singular insistence, because almost every sculpture that's come to light is of him. Seated or standing with his hands held primly clasped, Gudea wears an off-the-shoulder ceremonial cloak that leaves one shoulder bare. On his head is placed, like some wheel, a perfectly cylindrical fur sheepskin cap — perhaps a mark of his rank. The placid face exudes confidence and the power over life and death. The eyes are especially vivid — large and observant. On the robe, which falls straight across his knees, a number of cuneiform inscriptions are incised, proclaiming his greatness, over and over. Every image is cut from jet-black, glistening diorite, which is so hard that a modern diamond drill can hardly penetrate it. The most illustrious examples of this striking image are in the New Louvre's Ancient Near East galleries. Perhaps the finest is at the Metropolitan Museum in New York. The image is so powerful it looks like a ticking time bomb.

Assyria c. 1000-612 B.C.

The somewhat pompous and inflated Assyrian style is best seen in the massive carved limestone reliefs that decorated the walls of royal palaces — such as the Palace of King Ashurnasirpal II at Nimrud, Iraq. The majority of these flat reliefs and the *lamassu* (imposing winged bulls with bearded human faces that flanked palace portals, distinct in having five legs for various views) were excavated in Iraq in the 19th century by the British archaeologist Austen Layard. The Nimrud stones and those of similar appearance from King Sargon II's palace at Khorsabad, Iraq, are spread far and wide throughout the Christian world — the British Museum and Louvre in Europe and in the U.S., the Metropolitan Museum (NY), Oriental Institute at the University of Chicago, Wadsworth Atheneaum (CT), and St. Louis Art Museum.

Missionaries were entranced by them and by the thousands of cuneiform tablets unearthered in the near East because the stones and the tables confirmed the sagas written down in the Old Testament. Muscular, abstract, flat, yet exceedingly powerful, these images of absolute kingship are memorable.

Neo-Babylonia c. 612-539 B.C.

This brief dynasty is famous because of crazed, grass-eating King Nebuchadnezzar II (604-562 B.C.) of the Bible. The city of Babylon was expanded under him, and a series of gorgeous walls lining the streets going towards a great portal called the Ishtar Gate were crafted in glazed bricks of blue, black, yellow, and white — they often depict marvelous striding lions, bulls, and dragons.

One of the high points of the city of Berlin is, indeed, the reconstructed Ishtar Gate, which is on view in the Museum for Ancient Near Eastern Art (Vorderasiatisches Museum) in what is called the Museum Island, a small island housing various museums.

Anatolia (Turkey)

**Neolithic (New Stone Age) and Chalcolithic (Copper-Stone Age)
Early Anatolia 5700-5000 B.C. to c. 6000-5000 B.C.**

One of the important sites is in Hacilar, located in southwestern Anatolia (in today's Turkey), where distinctive burnished reddish-brown and cream colored pottery of high decorative value was found. A rare few human figures, looking rather like birds with sharply-pointed long noses, were also excavated. The best of these (the real ones, because a bunch of fakes were cooked up) are in the Anatolia Museum in Ankara, Turkey.

Persia (Iran)

Achaemenid Persia c. 559 539-331 B.C.

In the 6th century B.C., the Iranian King Cyrus the Great founded the Achaemenid empire. He seized Babylon and ruled over Mesopotamia and Iran. In their centuries of power, the Achaemenids held sway over a territory from Egypt through Anatolia to Afghangistan. The main monument is his great palace at Persepolis (in today's Iran), which is embellished with acres of reliefs, statues, and enormous Ionic columns (one of which is on view in the Metropolitan Museum in New York). In the most famous event to take place in the ancient Near East, Alexander the Great captured Persepolis and burned and pillaged it in 331 B.C.

Seleucid and Parthian Persia periods 312 B.C. to 224 A.D.

Alexander's empire, which literally ruled the Western world right to the borders of India, was divided first by the Seleucid kings and then, among others, by Romans and the Parthians, who had entered Iran from the northeast. In time, they weakened and fell. The art is meager, and only a hint of what they must have created has come down to us.

Sasanian Persia 224-651 A.D.

The Sasanians (also spelled Sassanians), who ruled Iran for four centuries, extended their empire into Armenia, west to the Mediterranean and, briefly, into Egypt. The period ended when the Islamic Arabs defeated the

Sasanian armies between 637-651 A.D. The royal silver-gilt vessels, which have been found in large numbers (quite a few appear to be fakes), are fairly realistic in style, borrowing heavily from Roman models. The favorite subject is the all-powerful king wearing a huge melon-shaped crown, in full hunting regalia, dashing after various creatures whose bodies lie beneath his running horse. The finest Sasanian plates can be seen in the British Museum, the Los Angeles County Museum in California, and in the Oriental Institute at the University of Chicago (once these galleries have been opened after renovation).

A unique image of Sasanian art, found in the Metropolitan Museum (NY), is an almost life-size head of a king. He is completely frontal, staring with wide eyes made of two perfect circles. His ears look like they've been plastered at right angles to his face. On his elegantly bearded head is a lofty melon-shaped crown. It is torn and cut away along the lower edge, so one cannot say how much of the figure once existed. Doubts have been raised about the authenticity of this one-of-a-kind silver — and one hopes and expects that it is real.

Egypt, the True Grandmother of the Fine Arts

The first great Western civilization blossomed along the River Nile. By the 5th millennium B.C., an abundance of prehistoric cultures had flowered along the banks of the life-giving river. Eventually, they came together into the world's first nation-state around 3000 B.C. This unique civilization remained wedded through trade and conquest with areas further south in Africa. At the same time, access to the Near East was made, and during the 2nd millennium B.C., Egypt ruled a vast empire extending from Nubia in the south to Syria and Palestine in the northeast.

From the first seconds of the birth of the stunning Egyptian civilization, art burst forth simultaneously as the letters for a written language and as depictions of the men and women, kings, queens, gods and animals populating the narrow, fertile country.

From the time in the early 19th century when the Frenchman Jean François Champollion deciphered the Egyptian hieroglyphs on the famous Rosetta Stone (in the British Museum), which, luckily, possessed the same text in hieroglyphs and plain ancient Greek, it was recognized that the pictographs comprised both the alphabet and the sounds of speech. In ancient Egypt, art and language were firmly bound together, which may be why the artistic style — vividly realistic, fresh, clear, and joyful — hardly changed in thousands of years.

In many ways, Egypt was the grandmother of all the arts of Western civilization, providing the roots of all artistic forms that followed thereafter.

ART ANECDOTE

Rahotep, Nofret, and *Aida*

The story goes that the famous opera composer, Giuseppe Verdi, got the idea for the last act of *Aida* because of Rahotep and Nofret. He was in Cairo when these sculptures were found. The composer was with an official as the foreman of the dig rushed in to say that the workers had fled the site when their torches revealed a man and young woman in the tomb — still alive! These carved and fully painted people are stunningly realistic. What delivers such a punch are the eyes, which are made out of inlaid rock crystal laid over perfectly painted pupils. (See these sculptures in the section "The best of Egyptian art," later in this chapter.)

The character of Egyptian art

Architecture was invented in Egypt around 2650 B.C. — just south of Cairo at the stepped pyramid at Saqqara, which King Zoser's architect and physician, Imhotep, designed.

This genius got the revolutionary idea to translate the fragile building materials of bundled reeds and mud bricks into carved stone. Many of the architectural elements we see around us even today have some kind of ancestral link with Imhotep's startling innovations. (How he was as a doctor we don't know.)

Most of the art was made for tombs, but don't assume it's gloomy or funereal. Quite the opposite. Egyptians believed that once the mummified remains were lain in the tomb along with scads of representations of food, servants, and all the possessions of the departed, eternal life was a sure thing. That explains why Egyptian art is so naturalistic and so optimistic. It was thought that the more realistic it was, the more certain the deceased would be able to feed off his represented goods forever.

TIP

At first glance, the reliefs and paintings may not look all that real — you know, heads, shoulders, hands and feet always somewhat stiffly in profile or directly frontal with astonishing attention to specific anatomical details. But realism in ancient Egypt meant emphasizing the most obvious view of each part of the body and bunching them all together. The human figure was created by adding up individual, real-looking separate pieces into a sum of parts that doesn't fit together organically. Action is only implied. Once you understand this essential formula, then Egyptian art becomes stunningly lifelike.

Where to see Egyptian art

To see the cream of Egyptian art and architecture you must travel to Egypt to the well-known sites of the pyramids of Giza and Saqqara, and see the painted and carved tombs in the Valley of the Kings, the temples of Karnak at Luxor, and the mammoth sculptures of Rameses II way south at Abu Simbel. Outstanding collections can be seen at the Egyptian Museum, Cairo, and the museum at Luxor (which is the only modern museum in the country).

But since Europeans have been hooked on Egypt since the 18th century and Americans from the late 19th century, and because free exportation of antiquities to foreign lands shut down only in the 1920s, there are many places to see exceptional Egyptian works, including whole buildings and tombs. In Europe, the British Museum (despite the depressing hodgepodge installation) is rich, as is the Louvre in Paris. In Munich, a small but super museum is solely devoted to Egyptian art. In Turin, Italy, you can also find an astounding collection. In the U.S., the Metropolitan Museum in New York is the best, especially because every item in the 5,000-fold collection is on view — and there's even an entire temple, from Dendur, preserved under glass (lots of it). The Museum of Fine Arts in Boston also has a prime collection. In fact, virtually every museum in our country has something ancient Egyptian worthy of seeing.

The best of Egyptian art

If you had the time (and the resources) to see the very best of the best of Egyptian art, here's a chronological list. By the way, Egyptologists divide the art into four main historical categories: the Old Kingdom, the Middle Kingdom, the New Kingdom, and the Late period — all according to various dynasties or rulers. It isn't necessary to learn what these categories are to appreciate Egyptian art, but having a passing familiarity is one way of getting a handle on the mind-boggling ancientness of the civilization.

Old Kingdom: c. 2700-2040 B.C.

✔ One of the oldest human sculptures from the 2nd Dynasty of roughly 2650 B.C. is the penetratingly real seated King Khasekhem, carved out of intensely hard greenish graywacke stone (Egyptian Museum, Cairo). He's old and bowed and worn but has a marvelously vivid eye. The sculpture is smooth and silky, a gripping combination of something poignantly human and also unworldly, something royal as well as godly.

✔ The life-size statue of King Zoser (Egyptian Museum, Cairo) of the third dynasty (2630-2611 B.C.) found in a hidden room at the base of the pyramid at Saqqara. The eyes were gouged out by ancient tomb robbers seeking the precious gold and crystal that artists commonly used.

✔ The seated statue of the high official Rahotep and his beautiful wife, Nofret, (Egyptian Museum, Cairo), shown in Figure 5-1, dating to around 2575 B.C. found in 1871 walled inside a tomb near the pyramid, made for King Snefru, the first king of 4th Dynasty. The eyes of the figures are made of inlaid quartzite and look as if they could blink at any moment. As is the hallmark of this Old Kingdom style, each detail of the anatomy is supremely accurate; it's just that the whole body doesn't quite look like it has come together. Rahotep, who is as handsome as a movie star, was the son of a pharaoh, a general as well as the high priest of the city where the sun was worshipped. His wife has black hair and is a stunner. He's tanned, she's pure white. (A lady of such rank would never sit in the sun!) What is so amusing about the pair frozen for eternity is that they are clearly in love with each other and certain of a delightful afterlife as well.

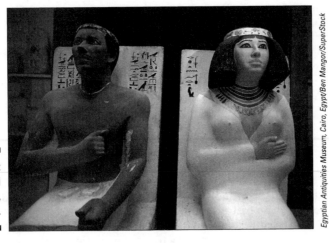

Figure 5-1:
Rahotep and his wife, Nofret.

Egyptian Antiquities Museum, Cairo, Egypt/Ben Mangor/SuperStock

✔ One of the most beautiful and emotionally moving sculptures of any time or civilization is the seated diorite statue of the 4th dynasty builder of the great pyramid, Khafre (2558-2533 B.C.) in the Egyptian Museum, Cairo. Behind the head of this majestically handsome monarch is a falcon, lovingly protecting his head with outstretched wings. The falcon is the god Horus, and his presence transforms the king into the god.

✔ The Great pyramid at Giza, which Khafre caused to be built as his monument for eternal life and possibly his tomb, is one of the most compelling sculptures of mankind. It was shrouded in polished marble, and its summit was covered with gold, symbolizing the sun. The surprising thing to most first-time visitors is that this supposedly incomprehensibly huge shape is in human scale, more so than the Sphinx.

✔ The Sphinx (see Figure 5-2) represents Khafre as the embodiment of the sun god Ra and is immense, some 240 feet (73 m) long and 66 feet (20 m) high. In Arabic, this massive stone is known as "Abu al-Hawl," or the "Father of Terror," which may strike you as apt when you gaze at this mysterious wonder in the dead of night with a full moon to illuminate it. (There's good news for Pyramid-watchers: The great Pyramid, the Sphinx, and the temple in front of the creature are now open again after extensive reconstructions. The Sphinx's 66-foot by 66-foot temple has 24 pillars representing the day's hours. It also has two carved niches that depict sunrise and sunset. The stones, some of which weighed eight tons, had collapsed and are now, once again, standing in position. The Egyptian government will allow tourists into the great Pyramid, but only 300 a day instead of the pre-restoration 5,000 — so plan the visit accordingly.)

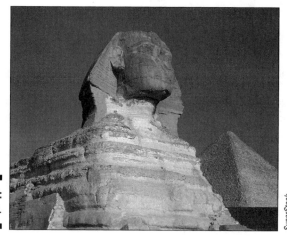

Figure 5-2:
The Sphinx.

SuperStock

✔ From the 5th dynasty of the Old Kingdom (2500 B.C.) is a startling and well-preserved wooden statue with penetrating rock crystal eyes. He's one Ka-Aper (Egyptian Museum, Cairo). He's familiarly called the "Sheikh el Beled" because the worker who helped find him saw a star-tlingly resemblance to a local chieftain by that name. Ka-Aper is shown as a portly, middle-aged man who, aided by a thin walking stick, strides with supreme self-satisfaction and confidence into a blissful afterlife of eternity. This is one of the better portraits of all time. (See Figure 5-3.)

✔ In the Museum of Fine Arts in Boston is the grand seated stone image of King Mycerinus and his wife. He was the builder of the third "great" pyramid. Power and energy.

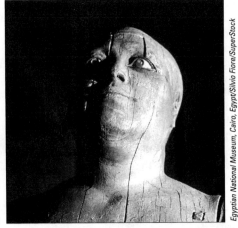

Egyptian National Museum, Cairo, Egypt/Silvio Fiore/SuperStock

Figure 5-3:
Ka-Aper
(a.k.a.
Sheikh el
Beled).

Middle Kingdom: c. 2040-1674 B.C.

✔ For the Middle Kingdom, there's a memorable stone sculpture of King Sesostris III (1878-1843 B.C.) (pronounced sewosret) as a sphinx (at the Metropolitan Museum). He's seen as a weary old soldier and ruler with drooping eyelids and a nose as sharp as a hawk's. Those lined cheeks and heavy eyelids look astonishingly like real flesh.

✔ In the Egyptian Museum, Cairo, don't miss the fragmentary blackish stone sculpture of the muscular, thuggish-looking yet sensitive and thoughtful King Amenemhet III (around 1842-1797 B.C.). You'll see why his subjects customarily prostrated themselves before this tough character.

New Kingdom: c. 1552-1069 B.C.

✔ For the New Kingdom and the 18th dynasty (1503-1482 B.C.), there's a gorgeous, seated, polished stone sculpture of the only female pharaoh of Egypt history, Queen Hatshepsut, in the Metropolitan. She's young and fetching, elegant, delicate, and gracious — more a ballet dancer than a goddess-in-the-flesh. See Figure 5-4.

✔ The most famous pharaoh — other than Tutankhamun — is the oddball visionary of the 18th dynasty who preceded Tut and who started off as Amenhotep IV and ended his enigmatic reign as Ikhnaton (1379-1362 B.C.). This is the man who threw out the myriad gods and their priests and established — briefly — a single god, Aton, the sun. With his divinely beautiful wife, Nefertiti, he altered the style of art radically, calling upon his sculptors and painters to exaggerate his physical characteristics almost to the point of impolite caricature. In one colossal stone head In the Egyptian Museum, Cairo, he's shown as a gaggling, long-faced individual with eyes hooded like a cobra's. His huge lips are pendulous and extraordinarily sensual. Why this brutal study, we have no idea, but perhaps he was depicted so ugly to escape the world of mere man. The thing is horrifyingly captivating.

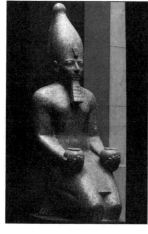

Figure 5-4:
Queen
Hatshepsut.

SuperStack

✔ In Berlin, you will find one of the most staggeringly superb portraits of mankind in the form of the bust of Iknaton's bride, Nefertiti. (see the museum guide color insert, Figure 22). It was found by German archaeologists in 1912 and promptly stolen from Egypt. She is soft, dreamy, and seemingly capable of speech.

✔ There is nothing in the world like the nearly 5,000 objects found in the early 1920s in the tomb of King Tut (1361-1352 B.C.), which had been hidden for thousands of years because a later pharaoh's grave was built over it. They are all in the Cairo museum (except for a few pieces at the Met and in Brooklyn, which the finders stole and sold). These objects are gripping as works of art not only for their grace and suppleness, their perfection of craftsmanship, but for their exceptional degree of psychological awareness. Tut died young and in his short reign restored all those ancient gods to their temples.

✔ The longest-ruling pharaoh was Rameses II, the Great, who sat on the throne for 67 years (1304-1237). He created so many temples, palaces, sculptures, wall paintings, and diverse monuments that he's laughingly dubbed by Egyptologists "Rameses the Inevitable." One of his most ambitious sculptural projects is the ensemble of four seated statues, 60 feet (18 m) high at Abu Simbel, which several decades ago were actually cut up into movable fragments, transported to a place where they would not be inundated by the waters behind the Aswan Dam, and re-erected.

Late Period: c. 1070 BC - c. 2nd c. AD

✔ During the Saitic period of around 600 B.C., there was a sharp revival of the style of the Old Kingdom, and it would take a highly-trained and observant scholar to tell the difference. One of the most beautiful examples of this "renaissance" is in the Cleveland Museum of Art, a relief depicting a boat with rowers and mourners which shows, in almost a photographic manner, a host of grieving men wailing and beating their heads in grief.

ART ANECDOTE

Telling it like it is

The Egyptians were also capable of depicting mankind without idealization. The King of Punt (in southern Africa) came to pay homage to Hatshepsut and brought his number one wife, who was the exact opposite of what the Egyptians considered ideal beauty. She was obese, and her arms and stomach were festooned with huge ringlets of fatty tissue.

The startling image is portrayed on a stone low relief in the Cairo museum. The poor wife had elephantiasis. The inscription translates to something like, "A poor donkey is about to carry a heavy load." Not bad for a 3,500-year-old gag.

✔ The last epoch of ancient Egypt came when the followers of Alexander the Great, the Ptolemies, gained control and ended when the Romans took over. During this time, it became prevalent among the middle classes to have portrait artists paint for their wooden mummy cases astonishingly lifelike images in *encaustic* (made of a wax substance). One of the best of these "modern-looking" pieces is today in the Getty Museum in Malibu, California.

TOM SAYS

What's fun about Egyptian art is that, unlike other civilizations' pieces, the level of quality, even amongst modest examples, is high, and the style over thousands of years remained virtually the same. This means that modest works — beads, scarabs, and the *faience* (earthenware) "shawabti" figures (the diminutive models of servants placed in tombs to wait on the deceased) or animals or the decorated utensils — of any given period are almost as good as the monumental, official works. Of these, my personal favorites are two: the hippopotamus, christened "William," at the Met, the well-known blue faience figure of the hippo covered with Nile waterlilies; and a bronze cat, actually the goddess Bastet, in the Brooklyn museum, a tabby over 1,000 years old who appears ready to purr at any moment. Both are timeless, amusing, and brimming with life.

The Glory That Was Greece

If Egypt is the grandmother of all western art, Greece is the nurturing mother. For in the studios of the painters, sculptors, and vase makers of Athens and Corinth, Olympia, and Delphi — starting as early as the 6th century B.C. — the seeds of human proportion, movement, physical action, the canon of ideal beauty, and emotions were planted. Significantly also, at the same time as the human figure emerged as a moving, breathing entity, a severe, totally abstract style flourished.

No other civilization has had so much of its art pillaged and destroyed than Greece. The art wasn't made for hidden tombs because the Greeks disdained the thought that you could take it with you — thus it was standing in plain sight when the Christian zealots decided that all marks of paganism had to be annihilated. Some of the works now lost were copied by the Romans because they were nuts about Greek art. Virtual replica factories churned out copies of sculptures and even paintings for the Roman art trade. But the glory of the originals can only be dimly understood by these copies because, no matter how accurate, they are lifeless — the sheen of artistic genius can never be mimicked.

To help you come to grips with Greek art, I'm going to urge you to see two categories of works. One are the absolute Greek originals. The other are those few excellent Roman copies that give an inkling of what Greek geniuses created.

Portraying the figure

As for the originals, in the small museum on the Acropolis (warning: it may be under reconstruction and closed) there's a startling sculpture of a young man carrying a calf on his shoulders. The date — 570 B.C. — is not too distant from the Egyptian relief of the Saitic period in Cleveland (see "The best of Egyptian art," earlier in this chapter), but the artistic difference is vast. Whereas the calf-bearer's moonlike, goggle-eyed face is nowhere near as realistic as those of the Egyptian mourners and rowers, the movements of his lithe body (and especially the tension in his arms as he lifts the animal) are marvelously organic.

That's the major difference between the two ancient styles — Egyptian art is basically a formula of realistic body parts pasted together into an inorganic human frame; the Greek artistic experience is movement, muscle, bone and sinew, all working together in an organic man or woman.

The development of the figure was extraordinarily rapid, and in no more than 50 years the *kouros* (the Greek word for a sacred breed of athletic young man) from Anavysos (of around 525 B.C.) in the National Museum of Athens shows a powerful natural body. Yes, the chap may still seem a bit frontal, but we can imagine the young fellow starting to run at any moment. The implied action in developed Greek art is what's unique to the style. Similar to the kouros sculptures are the *kore,* or beautiful young women, and many of the finest can be seen in the Acropolis museum.

But movement wasn't the only great contribution of the Greeks, because by the early 5th century B.C., a soft and subtle soul begins to appear. In Rome's newest antiquities museum, the Palazzo Massimo near the railroad station, you can find a splendid example of this inner spirit, a three-sided relief of Aphrodite being lifted from a sacred well by two acolytes, in which we see

the goddess as a thoughtful human being. The Greek relief dates around 470 B.C. and was presumably bought (or pillaged) by a wealthy Roman by the name of Sallust, whose gardens were famous in antiquity. (By the way, a proven forgery of the 19th century based on this work is in the Museum of Fine Arts, Boston — and the authorities still refuse to admit it.)

In the charming town that was the ancient sacred precinct of Delphi (home of the famous oracle who pronounced the future in cryptic statements), you can find an astonishingly vibrant, bronze, life-size statue of a charioteer who gazes out with supreme confidence at his now-lost horses. (See Figure 5-5.) We can read his concern to keep his charges in control — thoughts never were a part of Egyptian art.

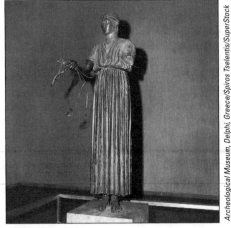

Figure 5-5: Charioteer of Delphi.

Archeological Museum, Delphi, Greece/Spiros Tselentis/SuperStock

The Temple of Apollo at Olympia

ART LINGO

The pride of the entire 5th century, just before the sculptures of the Parthenon, are at Olympia from the Temple of Apollo — those that adorned the *metopes* (the square blocks at the top of the walls of the temple) and the *pediments* (the triangular end pieces above the row of columns). The sculptural cycle is complex, but suffice it to say that the main pediment honors the local favorite, Apollo; the metopes and the bulk of the pediments are devoted to the bloody struggle that burst out at the wedding of a local family — the Lapiths — when a few centaurs got drunk and started to make off with some Lapith women. The good guys win but at a terrifying cost. The battles and eventual outcome are a multiple allegory of good and evil, human and beast, and the constant struggle between the dark and bright sides of mankind.

One of the most stunning sculptures ever made in ancient Greece is the monumental figure of Apollo in the center of the principal pediment, a hunk of a man with a face like the sun, looking towards the fight with a mixture of

anxiety, disgust, and compassion. Just this piece is worth a trip all the way to Olympia; but in the same small and delightful museum, there is another of those rare originals of Greek art, the Hermes, by the 4th century whiz by the name of Praxiteles (see "Praxiteles," later in this chapter).

Today, the Apollo and the Hermes are the whiteness of the marble they have been carved from, but in ancient times they were painted the colors of flesh with red hair and flashing blue eyes. The Greeks had a story of a sculptor, Pygmalion, who was so brilliant in painting his sculptures that one statue of a young, beautiful woman, Galatea, actually came to life. Even the sculptures of the Parthenon were painted. The ensemble may actually have appeared a bit garish with those shocks of red hair and blue eyes, but a sense of naturalism is what the Greek artists were after.

More figures from the 5th century

From the middle of this most active and creative 5th century B.C. is the stunning, life-size, bronze statue in the National Museum of Athens that is either Poseidon hurling his trident or Zeus throwing a thunderbolt. This is surely one of the most thrilling depictions of mankind and godhood ever achieved. This stalwart could be Jehovah as well as Zeus.

Another beauty of the mid 5th century, one of the most renowned sculptures in its time (and one that has survived strongly throughout time), is the *Discus Thrower,* or the Diskobolos, by the Athenian, Myron, who was famed for having established one of the first scientific and organic canons of human proportions. Sadly, no originals by this vibrant creator exist, and this — in the Museo Nazionale Romano, Rome — is an acceptable Roman copy. (See Figure 5-6.)

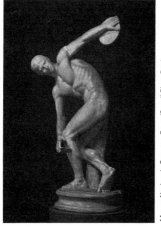

Figure 5-6:
The *Discus Thrower.*

Museo Nazionale Romano, Rome/Canali PhotoBank, Milan/SuperStock

The Parthenon

Crowning the 5th century B.C. (and perhaps all time) are the unbelievable sculptural embellishments of the Parthenon, which was rebuilt for the fourth time on the Acropolis to celebrate the historic victory of the Athenians over the Persians. The work, in part created by his own hand, but for the most part directed by the sculptor, Phidias, began with the metopes in 443 B.C. and continued until 438 B.C. when the pediments were put into place. (See the preceding section for an explanation of these terms.)

Phidias and his legion of coworkers also created for the interior cult image an enormous standing figure of the goddess Athena, the "patron-saint" of the city, in ivory softened and molded around a wooden armature for the flesh parts, and bronze, gold, and silver for the draperies and the shield of the goddess. He also made a huge seated Zeus for a temple at Olympia, which made it through the 4th century A.D., when it burned in a riot in Constantinople. To give an idea of the startling majesty of Phidias' art, here's how a Roman historian of the second century who saw the Zeus described it: "The god is seated on his throne and is made of gold and ivory . . . in his right hand he holds an image of Victory . . . in his left is a scepter inlaid with every kind of metal . . . The sandals of the god and his robe are gold. On the robe are wrought figures and lilies. The throne is diversified with gold and precious stones and ebony and ivory and there are figures on it painted and sculpted."[13] Imagine!

The bulk of the Parthenon's surviving marble sculptures (quite stripped of their original paint) are in the imposing Duveen Gallery of the British Museum (check out the main color insert for a sampling). The institution bought the stones in the 18th century from Lord Elgin, who had purchased them from the Turkish ruler of occupied Greece. Because Greece was under the Turkish heel, the possession by the museum has always been bitterly contested, and the arguments, pro and con, rage even today. The ordering of the sculptures in London is confusing, for, to make best use of the rectangular space, the stones are placed facing inward rather than in their original direction. And once you understand this, the ensemble begins to make sense. (A few sections of the frieze and other fragments can be seen in the Acropolis Museum in Athens.)

These sculptures seem to go to the heart of our civilization and resonate with what is most noble and most civilized in human nature. As works of art, they are matchless. The main subject of the *frieze* (a sculptured band on a building) is a festival in which the citizens of Athens bring a sacred object to the gods and goddesses of Olympus. They are carved with an unequaled perfection and possess an almost uncanny sense of life and movement — from the mortals to the divinities with their rippling draperies (as shown in the color insert) to the horses that seem to gallop across the frieze (see Figure 5-7). The more-than-life-size sculptures on the pediments, such as the Three Goddesses from the east pediment, are carved fully in the round, even though no one in ancient times would ever have seen it. After you have seen

these goddesses, or the lolling, naked Dionysus from the east pediment (the triangular end pieces above the row of columns), or the striking image of the single horse's head symbolizing the eternal power of the sun, you recognize how great an achievement the Parthenon stones really are.

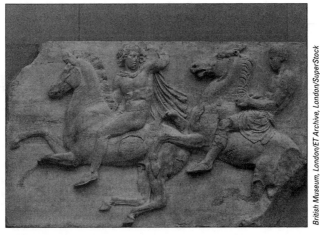

Figure 5-7: Horses seem to gallop across the frieze of the Parthenon.

British Museum, London/ET Archive, London/SuperStock

The miraculous 5th century had a fabulous climax with a series of astonishing sculptures of the figure of Nike, or Victory, carved around 410 B.C. on the balustrade of a temple on the Acropolis dedicated to Athena Victorious. In one of the most famous, *Nike Adjusting Her Sandal,* the sparkling draperies surround the anatomy like the rushing waters of a mountain stream flowing past smooth rocks (see Figure 5-8).

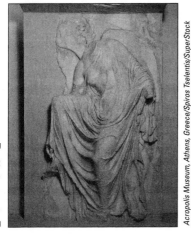

Figure 5-8: *Nike Adjusting Her Sandal.*

Acropolis Museum, Athens, Greece/Spiros Tselentis/SuperStock

Lysippus

After Alexander the Great had come to power in the early 4th century B.C. and conquered the known civilized world, art changed radically. The most famous sculptors of his period are credited with making human figures that are soft, amazingly supple, and subtle, with minds that appear to be full of thoughts. The court sculptor who created Alexander's portrait (as a god) and the most praised sculptor in all of ancient Greek history (far more than Phidias) was Lysippus, who was active from 350 B.C. until Alexander's death in 323 B.C. Not a fragment of his work remains, only copies.

One of his banner works was a bronze depicting an athlete scraping the oil from his body with a small instrument made for the task. It's called the *Apoxyomenos,* and the top Roman copy is in the Vatican Museum, Rome.

The proportions are unlike all previous males, being more delicate, taller and with a far smaller head, giving the piece a sense of height and quickenss. Lysippus is supposed to have remarked about his new style, "The older artists represented men as they are, I represent them as they appear to the eye."[17] With that, pure idealism, the language of the Parthenon, was changed forever, and art was never the same.

Praxiteles

The other sculptor of highest rank of the mid-4th century B.C. who refined the path of Lysippos was Praxiteles, an Athenian whose singular invention was the depiction of human beings at ease, a bit languorous, somewhat laid-back. One of his rare originals has survived, a marble sculpture, *Hermes and the Infant Dionysos,* which was unearthed in 19th-century excavations at Olympia and is housed in the Archeological Museum in Olympia (see Figure 5-9). The archaeologists immediately pinned it down as the work described briefly by a Roman historian who saw it in the exact place a thousand years before. The work is soft; the surfaces smooth and alluring.

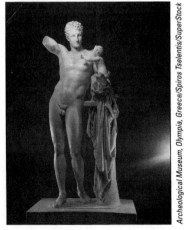

Figure 5-9:
Hermes and the Infant Dionysos.

Archeological Museum, Olympia, Greece/Spiros Tselentis/SuperStock

The Hellenistic period

The Hellenistic period began with the death of Alexander and lasted virtually until the Romans took control in the first century B.C. Art explodes with emotions and action. We see pain and contentedness, anguish and sweetness, withered old age and the flower of youth, victorious athletes and those who have been crushed and, above all, battles royal.

✔ Alexander wasn't buried in the Alexander Sarcophagus, discovered in the 19th century at Sidon in today's Turkey and currently displayed in the National Archaeological Museum of Istanbul, but he should have been (see Figure 46 of the museum guide color insert). This unbelievable marble and delicately painted coffin, dating anywhere from 280 to 200 B.C., is one of the wonders of the world. Everything about it is an eyeful, from the architectural details — it looks like a miniature Parthenon — to the dramatic sweep of the struggles between Alexander and his troops against the Persians, to the details of faces, the exquisitely carved hair, eyes, and even fingernails.

✔ The *Nike,* or Victory of Samothrace (190 B.C.) in the Louvre, which everyone knows from illustrations (or perhaps a walk up the grand staircase where the sculpture is displayed). The date is about the same as the marvelous sarcophagus, and one look is enough to make one believe that Victory really was a young woman with billowing garments and vigorously beating wings (see Figure 5-10).

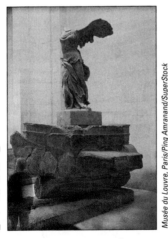

Figure 5-10:
The *Nike* or
Victory of
Samothrace.

Musée du Louvre, Paris/Ping Amranand/SuperStock

Another of the masterworks of the period — around 175 B.C. — is the gigantic altar of Pergamon (today's Turkey), which is in the Staatliche Museum, Berlin, having been spirited away by German archaeologists in the 19th century. The subject is the battle to the death between the giants and the

Olympian gods, and it's perhaps the hottest ever portrayed. The difference between these marvelous stones with their dozens upon dozens of hardbodied fighters, gasping and screaming, and the sculptures of Olympia where the bad-guy centaurs got crunched is that in the Pergamon altar, we aren't sure who is going to win.

The top expression of man's desperate fate in the face of the arbitrary acts of the gods, which seems to have captivated Hellenistic audiences, is the over-restored but still magnificently powerful sculpture of around 150 B.C. in the Vatican Museum of *The Death of Laocoön and His Sons* (see Figure 5-11). Laocoön was a high priest who had angered the gods, and he struggles mightily but helplessly along with his two handsome sons against two ferocious snakes who are devouring them alive. The sculptors were Athanodorus, Hagesandros, and Polydorus of Rhodes.[5] The piece was unearthed in the Renaissance, and Michelangelo proclaimed it the finest sculpture ever made. In a sense, the trio created a work that sums up the turmoil, the twisted human form, and the free expression of the entire Hellenistic period.

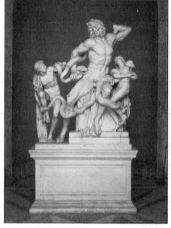

Figure 5-11:
The Death of Laocoön and His Sons.

Vatican Museums & Galleries, Rome/Canali PhotoBank, Milan/SuperStock

Lost-wax bronze casting

In the midst of what must have been a grand (and possibly chaotic) creative explosion while the Parthenon was being completed, other grandiose artistic achievements were happening. One was the invention of lost-wax bronze casting, a process in which a wax model formed the core to be substituted by bronze when the molten metal was poured in the mold. The sculptor Polykleitos is probably responsible for this method, and he is also responsible for the Doryphorus or Spear Bearer (the best Roman copy is to be seen in the sprawling Naples Museum), and it became the new standard for the human figure.

Greek vase painting and jewelry

The Greeks thought their painting — both easel and wall decoration — was far superior to sculpture, but few traces have survived. It used to be fashionable to try to resurrect the spirit of painting through vases. But these days, scholars agree that there's little resemblance between the two media. Greek vase painting is highly esoteric, and, for the most part, only black and a rust-red are the colors used. Yet, for those willing to dive into the specialty, the rewards are significant. Vases have survived in massive numbers primarily because the Etruscans (see "Etruscan influences," later in this chapter) stacked them by the yard in their tombs.

If I were to pick the two finest vases of the lot, I'd select the kalyx krater (an enormous receptacle for seven gallons of wine), painted in 510 B.C. by the genius Euphronios, who ranks with Leonardo da Vinci as a draftsman. This one, which depicts the fallen hero of the Trojan war, Sarpedon, being carried to his eternity by sleep and death, is in the Metropolitan Museum. Shortly after I bought this "finest vase of all" for a million dollars, I was accused of knowing that it had been stolen and smuggled from Italy. I denied it, having proof that it had been in a private collection since World War I. But later, I learned that the dealer who sold it to me switched the documentation of the collector who did own a Euphronios kalyx krater with one freshly (and illegally) excavated from an Etruscan tomb. Yet, the great vase is still in New York.

The second vase is in the small and sublime Glyptothek, Munich's antiquities museum. It's a bit later than the kalyx krater and is a huge round plate showing the profoundly moving scene of Achilles stabbing to death the Amazon queen Penthesilea. The eyes of both combatants are locked as the gorgeous queen breathes her last. It makes tears come to your eyes.

Another specialty of Greek art is jewelry, but there are tons of fakes, especially delicately leafy diadems, the gold pieces made by Greek artists for the overlords of the Scythian tribes — those awesomely awful nomads who populated what is now the Ukraine and who delighted in cutting off the heads of their enemies to use the craniums as drinking bowls.

The Scythians, always on the move, had to have their "Parthenons" portable and made of gold. Thus, they commissioned the finest Greek craftsmen (in exchange for grain) to fashion the most breathtaking jewelry that has survived. It's all in Russia, and the most glorious works are a large chest piece in Kiev, showing warriors making a sheepskin cloak and training horses, and a stunning little solid gold bowl in the Hermitage "secret" Gold Room showing warriors tending to each other's ills, including the extraction of a tooth. The figures in both these magnificent objects could easily have stepped out of the frieze of the Parthenon itself.

The Art of Rome

A couple of decades ago, it was fashionable to look upon Roman art as a pale reflection of the Greek classical tradition and even a plummet from the heights of the Parthenon. The artistic genius of Rome was thought to reside principally in architecture and construction — the invention of concrete and the subsequent birth of soaring arches and the creation of the dome, as in the marvelous Pantheon started by Agrippa but conceived in its present dynamic form by Emperor Hadrian.

Today, art historians are kinder and agree that Roman art, although influenced by Greece, was inventive and complex and, in certain areas, especially wall painting and in the development of narrative (or "news" art), equal to what the Greeks had achieved.

Etruscan influences

Early Roman styles are combinations of Etruscan and Greek influences. The Etruscans were the indigenous natives who you could say greeted the Romans when, according to legend, they arrived in Italy fleeing demolished Troy. Etruscan art, which manifests itself in spectacular bronzes, terra-cotta statues, pottery, and jewelry, started in the 7th century B.C. and disappeared in the 1st century B.C. when the Etruscan people vanished — probably because of a deliberate Roman eradication policy.

Etruscan art is bold, direct, and throughout its life span, never shucked off the feeling of archaic Greek art. Yet, it is far more poetic. The finest examples are to be seen in Rome and Cortona in Tuscany. There's a museum devoted to Etruscan art in the Borghese gardens called the Museo Nazionale die Villa Giulia, Rome, where you'll see the best of the best. Don't miss the attractive jet-black pottery, called Bucchero (bewkero), made from a distinctive Etruscan black clay, or the life-size terra-cotta statues of various gods, and the charming sarcophagus with a bearded man and his lovely spouse reclining together on a bed sharing a cup of wine as they smile throughout eternity. What a way to go! (See Figure 5-12.)

In the Capitoline Museum, Rome, in a special one-object gallery, you can find a famous bronze she-wolf of around 600-500 B.C. (outfitted since the 15th century with bronze statues of Romulus and Remus suckling away). The babes, and especially Romulus, after whom the city is supposed to have been named, were the legendary founders of Rome. (See Figure 27 in the museum guide color insert.)

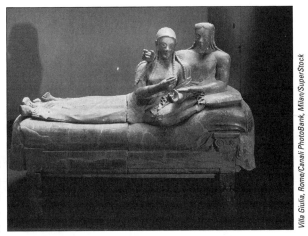

Figure 5-12:
Etruscan
sarcophagus.

Villa Giulia, Rome/Canali PhotoBank, Milan/SuperStock

Powerful, with exceptionally fine details of hair and eyes, she is one of the most expressive animals to have survived. The unknown Etruscan artist has implanted in her a fearsome feeling of ferocity combined with a memorable tenderness — a killer with a heart of gold.

In the small civic musum in Cortona, you can find a bronze lamp of the 6th-5th century B.C. that is truly a marvel. It's called the Lampadario, or grand lamp. It's almost three feet (.9 m) across in bronze and weighs over 125 pounds (56 kg). The decoration of this monumental array, found in 1840, is impeccably refined. It consists of 16 spouts around a double-tiered circle of bronze, and the spouts are in the form of eight Silenus figures (hirsute, randy old men) chasing alternate eight rapturous Sirens. Between these innovative forms are 16 heads of Bacchus, the god of wine.

America is, too bad, not the place to see many prime Etruscan works. As a matter of fact, several flamboyant forgeries of terra-cotta statues were bought by gullible museums in the early 20th century, notably the over-life-size so-called Etruscan Warrior, now stashed away in the bowels of the Metropolitan since it was exposed as a phony in the early 1960s.

Discovering Roman art

If you want to gain an appreciation for Roman art, start with the portraits made in Republican times (from the 3rd century B.C. until the assassination of Julius Caesar), because they are stunning for their warts-and-all realism that depicts a pleasing race of honest, no-nonsense men and women. Not a trace of decadence or decline to be seen.

Yet, once the empire was born and idealism in art became the formula, the art didn't slip. Augustus' artists created some of the most breathtaking works in western civilization. In Rome, on the via di Ripetta across from the pines marking the remains of Augustus' round mausoleum, are the remnants of the Ara Pacis — or the altar of peace that Augustus erected between 13 and 9 B.C. to celebrate the peace that had come to the Roman world after the brutal conquest of Gaul and Spain. The low reliefs in marble depicting the fertile Earth and Augustus and his family walking in a religious procession are, to me, every bit as satisfying as the frieze of the Parthenon.

Another spectacular work commissioned by Augustus is in the Kusthistorisches Museum in Vienna, the renowned Gemma Augustea, shown in Figure 5-13 (the jet and snow-white onyx cameo of the emperor), which dates around A.D. 10. This cameo shows him enthroned with the goddess Rome as Tiberius, as victor, descends from a chariot. The figures and draperies are stunning.

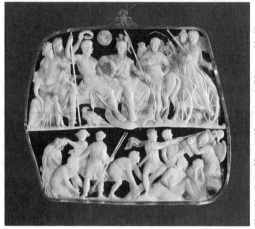

Figure 5-13:
The Gemma
Augustea.

Kunsthistorisches Museum, Vienna, Austria (Museum of Art History, Vienna/SuperStock

The Romans probably found their impetus for the "news," or narrative art, in the Greek depiction of myths, but the telling difference is that in Rome, the moment-by-moment, almost cinematographic, renderings are of contemporary Roman events. The most striking example is in the full, detailed — ad nauseum (but thankfully, you can't see much of it) — Column of Trajan, where every battle in Trajan's successful Dacian war is depicted round-and-round, incorporating 2,500 figures in exquisite low relief, all the way up the 128-feet-high (39 m) column (see Figure 5-14 for a detail).[5]

There's a second "movie" column with the exploits of emperor Marcus Aurelius, but for him, see the imposing sculptural fragments from his triumphal arch in the Capitoline Museum along with his equestrian bronze statue that used to grace the center of the Campidoglio.

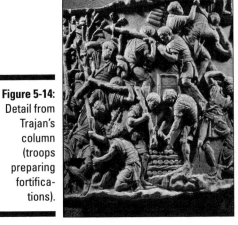

Figure 5-14:
Detail from
Trajan's
column
(troops
preparing
fortifica-
tions).

National Historical Museum, Bucharest, Romania/ET Archive,
London/SuperStock

Art under emperor Hadrian (A.D. 117-138) became devoted to the most ideal-
ized Greek classical traditions, and his artists churned out more sculptural
tonnage than for any patron in Western history. Particularly striking are the
series of portrait busts and statues of his Egyptian boyfriend, the young and
gorgeous Antinouos, some remarkably good examples of which are on view in
the antiquities section of the Vatican Museum.

The Romans may not have invented landscape painting — one of those famed
Greek painters whose works are lost did — but they elevated it to exceptional
heights. If in Rome, try to see the wall paintings in the "House of Livia" near
the Prima Porta (named after Augustus' consort, Livia), which rival the sun-
light and atmosphere of the Impressionists. You can almost hear the chirping
of the myriad birds.

Pompeii and Herculaneum

Pompeii is, of course, the most famous archaeological site for Roman domes-
tic architecture and for wall paintings up until A.D. 79 when Vesuvius
cracked, and the lava, mud, and ash buried the region. The reason for the
preservation of Pompeii's art is that this small, second-rate manufacturing
city was inundated by hot ash, which was relatively easy for archaeologists
to remove. Some wonderful wall paintings are still impressively intact, and
the finest are probably those in the House of the Mysteries, referring to
scenes of completely unknown meaning, which may illustrate the mysteries
of the cult of the god Baachus (Dionysos). This is the much-reproduced one
with the charming nude and half-nude figures (see Figure 5-15).

Villa of The Mysteries, Pompeii/SuperStock

Figure 5-15:
House of the
Mysteries.

The far more worthy site — artistically-speaking — was the seashore vacation spot populated by the wealthy, Herculaneum. But this town was inundated by a river of super-hot mud that cooled and congealed and swathed everything in yards of hardened, stone-like clay, which is almost impossible to chip away. The few paintings which have been hacked out are breathtaking, as are those from a rich villa nearby at Boscoreale. The Metropolitan Museum is the lucky owner of a host of life-size female portraits from there.

One of the most famous Roman frescoes of all was found in the Renaissance and is to be seen in the Vatican antiquities collections. It's the so-called *The Aldobrandini Wedding,* because it was excavated on lands owned by the Aldobrandini family. What's really going on in it isn't known, but a captivating young couple sit tenderly looking into each others eyes while various goddesses and nymphs look on approvingly.

Roman silverworking

Romans were daft about fine silver for elaborate dining parties (which lasted for days at a time and were consumed from the couch). A number of superior examples have made it down through the ages. Remarkable are two. First, I must mention the dozens of silver cups found at Hildesheim, Germany (and since the 19th century, on view in the Louvre). Their subject matter is a delightful congregation of skeletons — sounds odd, but it's very attractive. The other marvelous silver is in the late antique galleries of the British Museum, and there, you will be overwhelmed by the finesse of a huge plate — nearly two and a half feet in diameter — found at Mildenhall, depicting a charming series of dancers.

Christian influences

As the empire staggered to an end — the finale would come in A.D. 476 with the death of emperor Romulus Augustulus in Ravenna — art became more and more dogmatic in tone and abstract in feeling. By the 4th century, when Constantine crushed his rivals and proclaimed Christianity a tolerated religion, the old Greek idealism was rapidly dying. Human figures became harsh, even brutal. For an idea of the tough, spare new look, just check out the porphyry (purple marble) sculpture representing two embracing emperors (if they're so friendly, why are they both packing swords?) embedded into the west side of the cathedral of San Marco in Venice.

The art of Constantine the Great is great and is characterized by a rather violent swing between lyrical sweetness and raw brutality. For the former, take a look, when in Rome, at the soft and sinuous mosaics made with extremely tiny *tesserae* (pieces of stone), showing wine-making, on the ceiling of the round tomb of Helena, his mother, next to the church of Santa Costanza.

The most famous portraits of her son, who, although an admirer of Christianity, was also a blatant killer, are in Rome. One, a huge and gloriously rugged marble head (and parts of his arm, a hand, legs and a knee) is displayed in the placid courtyard of the Conservatori Museum on the Campidoglio (see Figure 5-16). The other is a six-foot-high (1.8 m) monumental green bronze head in a gallery of the contiguous Capitoline Museum across the Campidoglio square. In both, there's an uncanny combination of stark reality and the other-worldly.

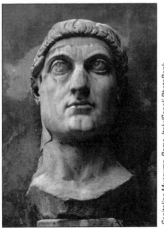

Figure 5-16: Constantine the Great.

Capitoline Museums, Rome, Italy/Canali PhotoBank, Milan/SuperStock

In the struggle to the death between pagans and Christians, certain wealthy, aristocratic families took sides and fought it out. The dwindling pagans made a series of ancient-looking monuments lauding the old pagan rituals, and these works are extraordinary. Two of the most beautiful are ivory carvings showing ancient sacrifices made for the Symmachorum and Nichomachorum clans. One is on view in London's Victoria and Albert Museum, and the other in Paris' Cluny Museum. They are both 4th century A.D., but their style could almost be 5th century B.C. in perfection of anatomy and drapery.

In the early 4th century A.D., when Christianity was all but victorious, a wealthy Roman landowner named Junius Bassus erected a church filled with sensational marble revetments (retaining walls) illustrating wild beasts. For himself, he had sculptors create an incredible three-tiered sarcophagus that is in the small museum right in the heart of Saint Peter's. It must be seen, for here are, in stunted and strangely primitive yet profoundly moving figures, various miracles of Christ. The Savior is shown as a youthful, beardless sort of Hercules character, a last fading reflection of pagan art. It's splendid and marks the perfect transition to early Christian art.

Chapter 6

Medieval Art (Definitely Not the Dark Ages)

. .

. .

*T*o most people, the art of the European Middle Ages and the Byzantine empire (roughly A.D. 300-1453) is murky, obscure, and so overwhelmingly religious that you need a batch of Ph.D.s to fathom the subject matter. This art is considered by many to be just "brown things," you know, tarnished *reliquaries* (relics) in the shape of an arm or a chopped-off head, ivory book covers the color of tobacco juice, beige manuscripts full of incomprehensible forms, and chocolate-colored paintings with endless Virgins and Christs all depicted in a forbidding style.

Nothing could be further from the truth. In many ways, medieval art of Europe — a bit less so with that of Orthodox Eastern Europe — is exuberantly optimistic and experimental, even more so at moments than that of the Italian Renaissance. It is also colorful (even artistically garish), energetic, and always devoted to a straightforward message. Medieval art was intended to teach when it was created and still does today. Anyone who wants to give medieval art half a chance can easily understand it. In medieval times, as with any era, great artists created new styles that were followed for decades. The sole difference is that we seldom know the names of these geniuses.

In the West, there are four essential periods and styles — Early Christian, the "Dark Ages," Romanesque, and the Gothic. In Eastern Byzantium art, there are essentially three significant moments—the period of emperor Justinian in the 6th century A.D., the 10th-century classical revival called the Macedonian renaissance, and the 14th century.

Early Christian Art

It used to be taught that the "primitive" artists of the Early Christian period — that is, from Constantine's *Edict of Milan* in A.D. 313 until the late 5th century — had no traditions to draw upon when depicting Christ's miracles or other scenes from the New Testament and thus borrowed pagan figures and scenes for inspiration. They didn't borrow very successfully either, for their figures are frontal, blocky, unproportionate, and covered by flat draperies. They have lima bean faces with wide staring eyes, and their gestures are awkward. It was also taught that the earliest Christian art from A.D. 100 until Constantine's landmark edict was small in scale and obscure because of widespread persecution.

Today, these generalizations have been discarded. Persecutions were far less prevalent than once supposed (in fact, more Early Christians were slaughtered in sectarian disputes over how many godly attributes Christ possessed than at the hands of Roman butchers or by the fangs of lions in the Colosseum). And Christian art from the 2nd to the 4th centuries shows a spritely variety of subject matter, from poignant praying figures called *orants* to a host of miracles — and the style is often a soaring spiritual one.

The early Christian "look"

Christian artists were eminently capable of depicting whatever they wanted. The abstract and dogmatic look was deliberate, and its appearance marks one of the most profound changes in art history. A quick glance at the sculptures plastered over every inch of the arch of Constantine (unfortunately presently draped with plastic in Rome's ongoing renovation crusade) tells the story. In the stones of the main frieze, the first "Christian" emperor and his retinue look like flattened cookie cutouts. They are surrounded by tons of sculptures, pirated from the monuments of earlier emperors, that are emphatically realistic in style. The dramatic difference was calculated — the new Christian spirituality had to be expressed by a flat, incorporeal style befitting believers in a Messiah who preached the spirit over the flesh, devotion over muscle. And by placing that style in the center of the triumphal monument, the classical and realistic figures of the pagan emperors were intended to be destroyed, at least symbolically.

The rise of the mosaic as a medium

In Constantinian times, there was also a startling change in artistic material that enhanced this new spiritual expression. Throughout Greek and Roman times, sculpture was the material of choice, but sculpture in the round began to fade away rapidly as the Christian faith conquered the civilized world.

Mosaics, which in Roman times had been used mainly to decorate floors, became the principal artistic medium and were used as lavish and enormous wall "paintings." The reason is twofold: mosaic is the most colorful art material there is, fashioned out of rich chips of deeply-glowing ruby, aquamarine, purple, gold, and silver. The flamboyant colors fit perfectly with the adoration of Christ, the light of the world, and his flock of brightly shining angels — the New Testament is filled with references to dazzling color and light. Mosaics emphasized the flat, incorporeal, almost otherworldly, look which had been chosen to depict Christian subject matter. (See Figure 6-1.)

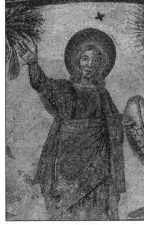

Figure 6-1:
A detail
of Christ,
Santa
Costanza
(Rome).

Santa Costanza, Rome, Italy/Mauro Magliani/SuperStock

The best place to see early Christian and Byzantine (can't just say early, because that would be Roman) mosaics is the small northeastern Italian town of Ravenna on the mainland almost directly opposite Venice. In the extraordinary mausoleum ornamented in the 4th century by a wealthy Christian, Galla Placidia, the mosaics gleam like thousands of perfectly cut and polished gems.

In the early Christian early Byzantine church of Sant' Apollinare Nuovo, also in Ravenna, the entire long nave of the structure is bedecked with mosaics dating to the 5th century, which are extraordinarily spiritual in visual language.

The early Christian style in Rome

Rome, the heartland of early Christianity because of the arrival of the apostle Peter, is almost empty of works of art, offering up, instead, a stunning array of early Christian churches, most of which, however, are hidden behind later expansions. Three works of art are sublime and universally symbolic of the early Christian style. One is a deeply undercut marble sarcophagus in the tiny museum inside St. Peter's showing various miracles of Christ carved in the early 4th century for a rich Christian by the name of Junius Bassus. The

wraithlike, frontal figures, with their formulaic gestures and wide-open staring eyes, are typical of the new style.

The second work is the carved and unpainted wooden doors in the church of Santa Sabina on the Aventine illustrating scenes from the Old Testament in that powerful and spooky ethereal, flat style.

The third are the mosaics in the nave and triumphal arch of the transept of the church of Santa Maria Maggiore — which is now being totally restored and is virtually closed to the public. (See Figure 6-2.)

Figure 6-2:
Nave mosaics in Santa Maria Maggiore (Abraham and Lot).

Santa Maria Maggiore, Rome/Canali Photobank, Milan/SuperStock

The apogee of Early Christian art

As the 5th century passed into the 6th, this style produced some phenomenal artistic wonders — as good as it gets. One is to be found in Santa Francesca Romana, the church in Rome at the end of the Forum looking towards the Colosseum, a Christian church in the ruined Forum of ancient Rome. In the sacristy, seek out the spectacular painted image of the head of the Virgin four times life-sized — bone-white looking like a magical egg, like some hot-air balloon with ghostly staring eyes fixed straight out — a most stunning and moving image. It was found several years ago on a panel underneath a mediocre Virgin of the 13th century and is today generally recognized as the most advanced Christian style of the 6th century, pure dogma translated into artistic form. A Protestant acquaintance of mine in his late years was present when the startling face was found by the art restorer and was so overwhelmed that he converted to Catholicism.

The "Dark Ages"

The common knowledge is that Western art went down the tubes in a time known as the "Dark Ages" (roughly the epoch of the Merovingian kings of the 7th and 8th centuries), a time during which artists created miserable, paltry works in an inept style with the human figure, even Christ and the Virgin Mary, no more dynamic than pudgy stick figures. The facts are different. The "Dark Ages" did produce some downright childlike manuscript illuminations and an alphabet that virtually can't be read. But some amazingly sophisticated works of art were born. The two most beautiful are the Lindisfarne Gospels (in the British Museum) and the Book of Kells (in the library of Trinity College, Dublin).

The Lindisfarne Gospels

Dating to the 7th century, the Lindisfarne Gospels were named for the lonely island outpost monastery where the manuscript was painted. The average viewer will find it hard at first to recognize the human form in the colorful, twisted, inorganic shapes that look like letters of some crazed alphabet. In time, one realizes that the shapes are both highly abstracted human figures and letters mixed together. The raw beauty of the illuminations comes from their colors and abstract verve. (See Figure 6-3.)

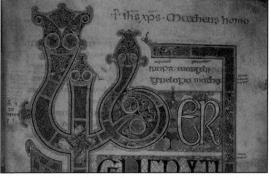

Figure 6-3: The Lindisfarne Gospels (detail).

British Museum, London/Bridgeman Art Library, London/SuperStock

The Book of Kells

The full-page illuminations of the 8th-century Book of Kells — 16 inches by 12 inches (41cm x 30 cm) — are made up of thousands upon thousands of lines in a stunning variety of colors with gilding and silvering drawn on the vellum

with a pen the width of a human hair.[5] The forms are madcap and wonderful — made up of the most bewildering number of curlicues and lozenges and shapes of every geometric kind populated with dozens of tiny abstract animals and figures — as complex and thick as the Milky Way. (See Figure 6-4.) Most of the full-page illuminations form large initials which begin the first word of each one of the Holy Gospels, for example the "I" of the Latin word *Incipit* for Genesis. During the Middle Ages, it was believed that the Book of Kells had been created by angels — perhaps.

Figure 6-4:
The Book of
Kells
(detail).

Trinity College, Dublin, Ireland/ET Archive, London/SuperStock

The decline of the "Dark Ages"

The "Dark Ages" came to a sudden halt in A.D. 800 by the crowning of one of the most accomplished military, religious, and artistic *tyros* (novices) of all history, the emperor Charlemagne, who created the Holy Roman Empire. Like Constantine the Great, his idol who had defeated his pagan rival by using a special sign of the cross that had come to him in a dream, Emperor Charles the Great slaughtered tens of thousands of pagans while converting them to Christianity. He also goaded his artists to create a wholly new artistic style to memorialize his love of Constantine and his profound Christian fervor.

Charlemagne copied the highly legible Roman alphabet that existed during Constantine's time, and all of a sudden people could read again. He ordered his artists to choose ivories and small sculptures of the Constantinian era as models for the new art. Indeed, Charlemagne's great church in Aachen, Germany, is a direct copy of all the measurements of Constantine's baptistery adjoining San Giovanni in Laterano in Rome. What art came forth is sometimes such mimicry that it's impossible to tell if the work is 4th or 9th century. At other times, the works are wildly expressionistic. The two finest examples of the Charlemagne's court workshop are a pair of ivory bookcovers for the same grand gospel book, one in the Victoria and Albert Museum and the second in the Vatican Museum. They are modeled after a five-part *diptych* (composed of two hinged panels) like the one in the Louvre, with the

emperor zapping his enemy, but in this case Christ and the Virgin and Child are featured in the center as victors flanked by angels. The faces are stark masks with enormous open eyes, and the draperies have become a maze of narrow, deeply undercut furrows with no connection to human anatomy. This is the culmination of the "religious" style begun by Constantine.

The Romanesque

The Carolingian dynasty was followed by the Ottonian, where one sees the slow emergence of bulk and weight behind the rippling, concealing draperies. The period that followed the Ottonian period in the West is called the Romanesque, literally "ancient-Roman-like." In the early 12th century, on the continent and in England, incredible numbers of stone churches were built. All were somewhat similar with imposing western entrances with three great arches, on the interior barrel vaults (perfectly hemispherical shapes) with tiny windows and arcades for the nave and two side aisles, and a domical apse (one or more projecting parts) at the end. This massive expanse of stone had to be supplied with Christian decoration primarily to teach the unlettered masses — and thus dynamic, monumental sculpture was reborn from the ancient past.

Virtually hundreds of thousands of tons of the most gorgeous Romanesque sculpture exist. So you'll not be overwhelmed, I shall single out the best of the best.

Gislebertus

In the village of Autun in the French region of Burgundy, a singular genius, equal to Michelangelo, by the name of Gislebertus (it's frightfully rare to know the name of an artist of the 12th century) carved around 1100 of the sculptures of the cathedral facade and most of the columns holding up the nave (the main central longitudinal space flanked by colonnades). His grand efforts show an uncanny knowledge of the human body — the first glimmer of understanding of anatomy since the fall of Rome. They have survived only because a forward-looking town councilman in the 17th century persuaded the church fathers to brick over Gislebertus' "primitive" carvings instead of ripping them down, and these carvings were found in the 19th century. The most vibrant is a very naked (my goodness!) Eve, crawling along on her knees to grab the prized apple, her masklike face set in an expression of timeless greed and desire. Gislebertus carved the Three Magi in a most entertaining way, asleep in a triple-king-sized bed, side by side like cordwood, the trio covered by a single blanket. Gislebertus' new realistic style was handed down through generations of Romanesque sculptors.

Master Hugo

The second Romanesque artist of stunning inventiveness and profound influence is a man named Hugo, who worked between 1125 and 1140 principally at the wealthy monastery of Bury St. Edmunds in Suffolk, England. (The style he invented endured for well over a century and a half, so he may be one of the most influential artists of all times.) His exploits are chronicled in Bury writings (histories and chronicles), which is exceedingly rare for a mere artist, for artistic efforts were seldom even mentioned in the early Middle Ages. He cast a pair of huge bronze doors, the great monastery bell, a magnificent gospel book with illuminations measuring an unprecedented two feet (.6 m) in height, a silver seal impression, and an ivory cross flanked by ivory statuettes of Mary and John the Evangelist carved "in an incomparable fashion."

Master Hugo changed art as fundamentally as Pablo Picasso did in the early 20th century (see Chapter 15). In the first quarter of the 12th century, he invented what art historians call the "damp fold style" in which the drapery doesn't cover but reveals the body by a series of hypersophisticated contourings. The drapery is carved or painted or drawn to outline and contour the structure of the human body underneath. Every part of an arm, for example, is surrounded and made three-dimensional by lines of delicate drapery — the knob of the shoulder is shown by a perfect circle of drapery, the upper arm with its muscle structure is a strong oval, and the lower arm will be an elongated lozenge (oval-shape) made by the fabric. The result is the creation of astonishingly vibrant, tall, and elegant human figures.

Hugo's great Bible is in the library of Corpus Christi College, Cambridge, England, and not always on view. His bronze doors and bell have vanished, melted down, no doubt, by the vile King Henry VIII. The marvelous cross — but not the flanking statuettes of Mary and John — has survived.

I had the good fortune when I was a very young curator of the Cloisters in 1963, the Metropolitan's uptown medieval sanctuary, to resurrect Hugo's cross. I found it, proved its authenticity (some scholars branded it a fake, thank goodness) and its undeniable link to Hugo, and acquired it for a mere $600,000. It had been out of sight since the crusade of Richard Lionheart. The cross is today at the Cloisters in Manhattan. The original figure of Christ, today in the Art and Industry Museum of Oslo, was identified by a colleague.

On this fabulous cross, the dozens of diminutive figures of Old Testament prophets proclaiming the truth of the Messiah to come, and those in the New Testament scenes all demonstrate that signature "damp fold style" that will appear in some form in thousands of Romanesque works of art until the dawn of the Gothic period.

Pinpointing the greatest Romanesque works

Gislebertus' carvings for Autun Cathedral and the Bury St. Edmunds cross at the Cloisters (described in the preceding sections) are two of the top five monuments to have come down from Romanesque times. And, as I have said, there are tons. Be sure to note down the next three works for that dream tour of Europe.

ART LINGO

✔ The first is the entire sculpted facade and *tympanum* (the space within an arch and above a lintel, or top of a door) of the main portal made by an unknown artist for the church of St. Foy in the tiny town of Conques in the Dordogne region of France. The subject is the Last Judgment, and the sinners that a radiant and athletic Christ casts down into Hell (which is truly awful) include a few presumably corrupt local priests. The carvings have always been well protected by a porch and are breathtakingly fresh, retaining some of their original paint.

✔ The next is also a sculptured *trumeau* (the central post in a portal) and dozens of carved capitals on the peaceful church of Moissac, also in the Dordogne region of France, and not too far from Conques.

✔ The third is a series of enamels on gilded bronze in the crypt of the monastery of Klosterneuberg (literally, "monastery of the new mountain") on the outskirts of Vienna. The artist named Nicholas of Verdun created in 1173 a magnificent, shining altar frontal decorated with a bountiful host of enamel plaques in a thunderously "damp fold style" portraying the high moments of both testaments, with the Old prefiguring the New. When you see this exceptional series of brightly colored plaques — the reds are on fire — your blood will race faster through your veins.

The Gothic

The next banner style of this restlessly inventive Middle Ages — the Gothic (a derogatory name conceived by a Renaissance art pundit to put down the supposedly lesser art of the North) — came to life around 1140 and was heavily influenced by a dramatic change in architectural style. One genius made it happen. He was Suger, the Abbot of the royal monastery and church of St. Denis (on the outskirts of Paris today). Suger found spiritual inspiration in the gleaming, bejeweled objects in the church treasury and in stained glass that was just being used extensively in the first third of the 12th century. His view was that through the contemplation of luxurious secular materials, one's spirit might soar upward to contemplate more fully the realm of God.

This philosophy eventually gave birth to the Gothic style, a radical and soaring turn-away from low, dark, thick-stoned, dimly illuminated Romanesque churches. The Gothic style is epitomized by precipitous, severely pointed, ogive-shaped (pointed arch) structures with acres of radiant stained glass windows set into miraculously thin walls barely held in place by a phalanx of flying buttresses thrusting out from the sides of the churches and looking like immense spiders' legs.

There are, of course, tens of thousands of Gothic monuments, and if I had to choose five as the prime exemplars of the style (and towering art treasures to boot), here they are.

- The finest combination of everything Gothic in my opinion is Chartres Cathedral in France. The stained glass — the wondrous great rose window on the west wall is like a multicolored gemlike series of spotlights that becomes in the viewers' mind, no matter what the religious persuasion, the window to the Almighty. The stone sculptures on the various portals of the western facade exemplify every stylistic movement of the Gothic period. Most fascinating, to me, are the columnar figures of saints that have been carved to be truly part of the uplifting architecture. Some of these impossibly elongated figures look like thin columns delicately painted with visages (faces) and draperies.

- Another thumping Gothic creation is a two-foot (.6 m) high ivory carving of the early 13th century in the medieval section of the decorative arts department of the New Louvre showing the seated Madonna and Child swaying as if in some divine breeze, totally abstracted, yet vital all the same.

- In flashing colors that look downright contemporary are the fragmentary yet superb tapestries showing various heroes of Christian antiquity (among them Charlemagne) dating to the late 13th to early 14th century on view at the Cloisters in New York City. They were saved after World War II during which they'd been used to wrap potatoes against the cold.

- When it comes to tapestries of the Gothic age, there are none finer than the virtual scores (each 20 by 12 feet, or 6 m by 3.7 m) of gorgeous tapestries of the late 14th century preserved in beautifully lighted galleries in the Chateau of Angers in central France. These radiant beauties depict dozens of episodes in the most incomprehensible book of the New Testament, the Apocalypse, so don't feel you have to know what's going on. There are fearsome dragons with seven heads and beauty-queen angels, slithery serpents and saintly ghosts, slices of landscape Peter Paul Rubens would have envied, all woven in the most breathtaking and delicate pastel colors that were made, I almost believe, in the Garden of Eden and transported to the workshop. (See Figure 6-5.)

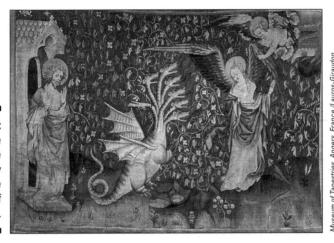

Figure 6-5:
Apocalypse
Scene
tapestry
from the
Chateau of
Angers.

Museum of Tapestries, Angers, France./Lauros-Giraudon, Paris/SuperStock

✔ During the 14th century in France, especially at Reims, there was a sudden, explosive appearance of sculpture that looks almost like those from the *pediments* (triangular space forming a roof) of the Parthenon because the draperies flutter and curl like those of Phidias (see Chapter 5). The most stellar exemplar of this unexpected development is the magnificent Annunciation on the *trumeau* (central post) of the main portal of Reims Cathedral in which a heroic-sized angel swoops down on a Virgin who looks like Hera, the wife of Zeus.

The Gothic style did come to roost in England and Italy as well as France and Germany (where, by the way, Naumburg Cathedral has an absolutely heart-stopping 13th-century statue in stone of a knight on a handsome horse and a columnlike sculpture of Queen Uta who may be the loveliest woman since Helen of Troy).

English Gothic is very slender and delicate with intricately carved wooden bosses affixed to the arches on the stratospherically high ceilings — one of the periods is appropriately called "Early Perpendicular." Italy never espoused the full high-peaked, soaring Gothic manner, and some works of art of the 13th and 14th century seem so Roman as to have jumped off some monument ordered by the emperor Augustus. The most exceptional of these is the octagonal marble pulpit carved by the super-master Nicola Pisano in the 13th century for the cathedral of Pisa in which the figures look as if Augustus had cast characters for a passion play.

Whatever the merits of Gothic, it is without doubt, after classical and Egyptian art, the longest-lasting style of history, from 1200 or a little before into the first quarter of the 16th century, particularly in Germany where some of the grandest works of painted and lavishly gilded wood were created. (See Chapter 8 for information on the Northern Renaissance.)

The International Style

Every style in the long Gothic era has a devoted fan. My favorite is the one that spread across the civilized world in an all-but-identical excellence — from Bohemia in today's Czech Republic to London, through France, down through Italy, and up to Sweden. It came to life because of the singularly lofty artistic tastes and massive wealth of a host of royal patrons, such as Jean, the Duke of Berry, and Charles IV, King of Bohemia and Holy Roman Emperor from 1355 to 1378. This moment flourished from about 1370 until 1410 and is known both as the "International Style" or the "Beautiful Style."

In general, the style is refined, elegant, supple, and wondrously crafted, because technique was highly prized. The female figures are sensual, more beautiful than today's movie stars or supermodels, wearing clothing that falls in the most sinuous trumpet-folds. The men are thin and agile with chiseled faces and are dressed in stunning, colorful costumes marked by tights and very pointed footware. Colors are melted-down gemstones. Landscapes are more dreamlike than even the most lyrical reality. The International Style is an art with sun in its face, wind at its back, and never a care.

One key patron was the fabulously rich Duke of Berry, brother of the king of France, who owned all of Burgundy, today all of southeastern France. The Duke of Berry commissioned three brothers from the Netherlands who were goldsmiths and manuscript illuminators — painters of miniatures in manuscripts — Pol, Herman, and Jehanequin **Limbourg** to create the Très Riches Heures, roughly, the "Very Richly Adorned Book of Hours." These books, widely popular in the late Middle Ages, contained various prayers to be said at the canonical hours (morning, vespers, and the like) in honor of the Virgin Mary. Today the manuscript is a prized possession of the Musée Condé in Chantilly, which is not too far from Paris and is definitely worth a trip. Although, unfortunately, the brothers died before the manuscript was finished, they produced for it some of the greatest small paintings the world has ever seen. This is the manuscript in which every one of the priceless chateaux the Duke owned is depicted in magnificent miniature form with lords and ladies adorned in unbelievably gorgeous finery hawk-hunting or peasants hacking away in verdant fields (see Figure 6-6).

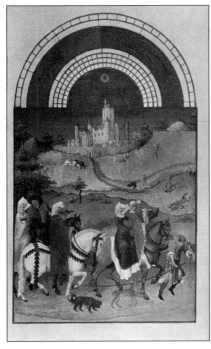

Figure 6-6:
August, page from the Très Riches Heures.

Another breathtaking work by the Limbourg brothers commissioned by that connoisseur of connoisseurs, the Duke of Berry, is in New York's the Cloisters, the medieval branch of the Metropolitan Museum of Art. This Book of Hours is known as the Belles Heures, or the Beautiful Hours. It is equal in quality to the other. The pages are turned on a regular basis and, presumably, one can see the entire manuscript over time.

A giant in sculpture of the period is **Claus Sluter,** who was born in the Netherlands around 1340 and died in Dijon, Burgundy, in 1406. His surviving masterpieces are works made for his patron Philip II the Bold, Duke of Burgundy who founded the monastery of Champmol at Dijon — the figures on the portal of the chapel, the so-called "Well of Moses," and the duke's tomb, which is in the Museum of Fine Arts in Dijon.

The wellhead is adorned by monumental figures of key Old Testament prophets, such as Moses and Daniel, who have strongly-carved, naturalistic faces and marvelously bulky draperies that cascade over the figures in deeply-carved folds. The prophets formed a base for a splendid Calvary, and the head and torso of the Christ have survived. In these fragments, there's a power and intensity of religious expression and grandeur that has seldom been matched.

For the tomb of his patron, Sluter carved in alabaster 40 sixteen-inch-tall (40cm) mourners who are garbed in voluminous cloaks with hoods that partially hide their faces. Each one is different, and the overall impression is so striking that, upon seeing them standing in their niches beneath the black marble slab with the effigy of Philip, you get a genuine feeling of sorrow. There's one of these mourners, called in French, a *pleurant,* literally, a "weeper," in the Cleveland Museum of Art — and it's a stunner.

Another hotbed of the International Style was in Prague and Bohemia, patronized enthusiastically by Charles IV. The most skilled painter of the period 1360-1380 is Theodoricus of Prague, who combines a lyrical tenderness with a stout realism. His most imposing works are a vibrant series of images of saints and a large crucifix in the Chapel of the Holy Cross at Karlstejn Castle near Prague.

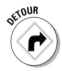

In Prague's National Museum, on the heights overlooking the city, are a number of exceptional paintings by anonymous masters of this sinuous, elegant International Style that are well worth a lengthy visit, especially for several paintings of the Madonna and Child of around 1400, which manifest unparalleled vitality and elegance. The International Style was in a real sense the waning of the Middle Ages, but what a sweet way to go!

Byzantine Art

The best examples of early Byzantine art are to be found in the Louvre, the British Museum in London, and in Ravenna, Italy. There's a mammoth (12-inch high, 30 cm) ivory plaque in the decorative arts galleries of the New Louvre dating to the 5th century depicting an emperor on a rearing charger lancing a cowering pagan enemy.[5] On each side are members of the imperial guard in full Roman armor, each as flat as a shadow — the epitome of the new Christian style. Above this Christian conqueror are two angels who fly right and left (as angels tend to do) offering him crowns of triumph. The emperor is unknown but may be just a symbol. His blunt, triangular face has a look of confident faith.

In the British Museum, there's another early ivory — 5th century A.D. — with the most alert and athletic Archangel Michael stomping on (and pinning with his staff-lance) a loathsome serpent in a portrayal of the 13th Psalm. His voluminous draperies ripple and surge like some drip painting by Jackson Pollock (see Chapter 16) and completely obscure his anatomy. But real anatomy isn't what was wanted — the anatomy of the spirit was.

Ravenna's superb octagonal church of San Vitale, built during the time of emperor Justinian (A.D. 526-547), contains mosaics that rival any surviving. Christ in Majesty is in the dome, which became the model for virtually every

dome or *apse* (projecting part of a church) mosaic from then on. The two large secular mosaics are the prime attraction. One shows the emperor and his aides, administrators, and generals momentarily halted as if posing for a snapshot just before entering the royal box (see Figure 6-7). The other is probably the most colorful early medieval art in existence — it shows empress Theodora (a former actress and maybe worse) crowned and bedecked in a ton of jewels and wearing a sumptuous court dress. All figures are flat as playing cards — their feet never touch the ground — and for that reason are perfect examples of the style of the time.

Figure 6-7:
Mosaic from
the church
of San
Vitale.

Church of San Vitale, Ravenna, Italy/Canali PhotoBank, Milan/SuperStock

In the 7th and 8th centuries in the Byzantine world, the church was rocked by fights between supporters of artistic images and those who considered them blasphemy. The anti-imagists won. The period is called Iconoclasm, and for many decades, the church banned images of any kind. But in places like Saint Catherine's, so far removed from Constantinople that no high church image-police ever showed up, icons (supposedly miracle-making images of the Virgin or Christ painted on panels) were created throughout the ban. They are quintessential spirituality.

Macedonian Renaissance

In the Byzantine east there was never a revival like that of Charlemagne's, but in the 10th century under the Macedonian dynasty, a mini-renaissance took place during which the works, mostly ivory carvings and several manuscripts, exhibit startlingly ancient classical attributes.

Late Byzantine Art

This is the age of the "Greek Manner" as the icon painting is called. This was also when infinitely complex and shimmering mosaic cycles were created. Some of the best — of the 13th century — are in San Marco in Venice or in Rome, in Santa Maria Maggiore and Santa Maria in Trastevere. To me, however, the finest mosaics of all were made in the 14th century for Constantinople's (modern day Istanbul) Church of the Chora or as it is known today, the Kahrie Djami. These profoundly delicate, golden stunners were discovered rather dramatically underneath walls whitewashed by Muslims in the 15th century who, understandably, could not live with such forceful emblems of a rival religion inside a church transformed into a mosque. Like the prescient town father at Autun who had Gislebertus' sculptures bricked over (see "Gislebertus" earlier in this chapter), some unknown Imam advocated whitewash rather than destruction. The Kahrie Djami mosaics of the 14th century were discovered by Princeton University art historians in the postwar period, and their discovery added one of the greatest works of all time to the roster (see Figure 6-8).

Figure 6-8:
Samples
from the
Kahrie Djami
mosaics of
the 14th
century.

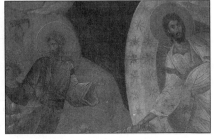

Bridgeman Art Library

The technique is the finest imaginable. The craftsmen used the tiniest pieces of glass — half the width of the nail on a little finger of a three-year old child — the bulk of which are silvered and gilded. The wispy, magical figures seem to be alive in their mysterious, ethereal realms of heaven. I would say that after Kahrie Djami's mosaics, Byzantine art fell apart even though it would take until 1453 for the Ottoman Turks to give the death blow to the empire begun in A.D. 320 by the doughty Constantine, the man who created official Christian art in the first place.

Chapter 7

The Renaissance and Revivals

*T*he Italian Renaissance is one of the more profound intellectual, economic, philosophical, and cultural shocks to hit mankind. The art of the whole Western world changed because of it. Yet the Renaissance didn't happen overnight, and it was relatively short-lived. It is fundamentally an Italian style, and although Renaissance influences were felt throughout Europe, individual European territories grasped tightly to their own artistic personalities.

One of the renowned art historians of modern times, Erwin Panofsky, wrote that long before the Renaissance in Florence and Rome, there were numerous, somewhat similar, revivals of classical antiquity in Italy. He dubbed them "renascences" to distinguish them from the big "R." Yet, there was one big difference between these classical revivals and the main event.

During the High Renaissance, artists, philosophers, and scholars recognized for the first time in Western history that classical antiquity had died — its literature, its architecture, and its artistic emphasis upon man — and that the dead past deserved to be reborn. The fact that the ancient Roman world still existed in Italy in ruins only added to the sense of cultural loss that struck the founders of this profound rebirth. That's one key to knowing what the High Renaissance was all about and why it was so significant. It lasted from 1480 to 1527 and gave birth to an unruly, heady, and explosive style called Mannerism.

Renascences

Of the key "renascences," one was Charlemagne's (see Chapter 6), intending to revive the Christian Rome of Constantine the Great. Another blossomed in Capua in the South of Italy in the 13th century under the banner of King Frederick of Hohenstaufen, who recruited artists to make stunningly classical-looking works of art and even erected a triumphal arch that's very like the classical Roman ones. He may have received inspiration from a striking revival of ancient Roman and early Christian art that took place in Tuscany — in the vicinity of Lucca and Pisa — during the last quarter of the 12th century. This was propagated by a spectacularly talented sculptor and mosaic maker by the name of Biduino (he signed his works, something rarely done at the time).

I had a run-in with one of Biduino's finest carved marble doorways when I was a fledgling curator at the Cloisters, the Metropolitan's medieval site in upper Manhattan. By chance in 1960, I'd come across the note in some article that an old, aristocratic Russian family had bought, in the 19th century, an entire Biduino doorway from a church in North Italy and had moved it to their splendid garden in Nice, which was at the time Nizza, Italy. I soon learned that the family palace and gardens had been bought by a developer. I went to Nice and, to my astonishment and joy, found Biduino's doorway lying among overgrown weeds in prime condition carved out of two halves of an ancient Roman sarcophagus. I arranged for its purchase for a pittance and had no trouble exporting the 12th century lintel and jambs from France to the Cloisters. I argued that the work had never left Italy but that Nice had moved to France (Nizza having become Nice after the Treaty of Versailles). The lintel represents the Entry of Christ into Jerusalem. Two heads of adulators were missing. I found one in a barbershop in Nice near the destroyed palace; the other is in the Berlin Museum labeled Early Christian.

Biduino adapted in a stunning way the figures from Roman and early Christian sarcophagi for his revival. One of his most compelling works is in the Camposanto in Pisa where one sees a host of Roman sarcophagi reused as tombs of the 12th through the 14th centuries.

The Italian Proto-Renaissance

In the late 13th century in Pisa and Florence, there was a virtual explosion of Roman-looking monuments created by the sculptor **Nicola Pisano,** the most striking of which is his superb pulpit in the cathedral in Pisa, and others following his lead. The period has gotten to be known by the forbidding term, "proto-Renaissance." Late medieval painterly geniuses like **Duccio di Buoninsegna** and **Cimabue** were heavily influenced by Pisano's "Roman"

sculptures, yet their works are still cast in a style that was called in Early Renaissance times, somewhat derisively, "maniera greca," or "the Greek manner," meaning the flat and hieratic Byzantine style.

The painters who cast aside that Greek manner for good were the brothers **Pietro** and **Ambrogio Lorenzetti** from Siena, and **Simone Martini** of Siena.

- ✓ Pietro Lorenzetti was probably a pupil of Duccio's, but his works — the altar in the church of Pieve di Sta. Maria in Arezzo and his mature *Birth of The Virgin* of 1342 in the Museo dell'Opera Metropolitane, Siena (the Cathedral Museum) — show penetratingly real human beings who show genuine emotion. At this early date, he even shows some appreciation of linear perspective and pulls off a convincing placement of figures in real space.[5]

- ✓ Ambrogio Lorenzetti's most memorable work is in Siena, in the grand Palazzo Pubblico, a series of frescoes (c. 1337-39) of exceptional vitality and charm decorating the Hall of Peace (Sala della Pace) illustrating the theme of Good and Bad Government. These works are fabulous, and in them Ambrogio comes across as an observer who was fixated — in a good way — by perspective and classical works of art.[5]

- ✓ Simone Martini was also very likely one of Duccio's pupils and shared with him his affection for sinuous line and pure colors. One of his most impressive works is a large fresco (c. 1315-1321) in the Hall of the World Map (Sala del Mappamondo) in the Palazzo Pubblico, Siena. It shows the Madonna and Child on a throne and surrounded by saints and angels. His Virgin is no longer a depiction of religious dogma, which it would have been a half generation before, but a worldly queen who seems to be holding court for the observers. His Annunciation *triptych* (three-panel painting) of 1333 in the Uffizi Museum in Florence is both human and unreal, demonstrating his unique genius for portraying humanity and religion simultaneously.[5, 18, 19]

The king of the proto-Renaissance was the man who invented "modern" Western painting, **Giotto di Bondone.** He was a child prodigy and was said to have been discovered by his teacher while tending sheep and doodling extraordinarily realistic scenes on a rock. Giotto, who is renowned for his frescos in the now badly damaged church of St. Francis in Assisi, was a keen entrepreneur and cornered the market on pigs' bristles and made fabulous brushes that made him rich. His figures, although not strictly anatomical, for the first time since ancient Rome possess bulk and volume. They show an awesome sense of place and a tangible three-dimensionality. They also express emotions. Giotto's masterwork — one of the top five works of art in the West — is the expansive cycle in the Arena Chapel in Padua dating to around 1305 (see Chapter 20 for more details). These murals portray scenes from the life of the Virgin and the life of Christ (see Figure 7-1) with the Last Judgment as a climax.

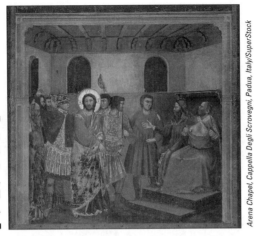

Figure 7-1:
Jesus
before
Caiaphas,
as portrayed
by Giotto.

The most famous work of Giotto, perhaps, is the *Lamentation* which has become one of the universal symbols of grief. (See the main color insert.)

Italian Early Renaissance

These are the main elements of the Renaissance.

- ✔ **Antiquity:** The artists of the Early Renaissance had no dearth of ancient models because they were surrounded by ancient remains — mostly sarcophagi used as water troughs and fountains — and fragments of architecture primarily in aqueducts and bridges and, of course, the entire Pantheon in Rome with its soaring dome capped by a giant, open-to-the-sky oculus.

 The Renaissance architects also had the writings of the ancient Roman architectural historian Vitruvius who described how to design the "proper" classical building right down to the specific orders to be used for the columns — Doric, Ionic, or Corinthian. There was also an abundance of ancient coins to be used as models and the occasional wall painting, even though Pompeii would not be discovered for several hundreds of years.

- ✔ **Observation of the physical world:** Importantly, antiquity was not the only vital ingredient of the Renaissance. The following elements were key: the human body and correct anatomy unveiled by dissections that allowed artists for the first time to render the human figure with a solid underpinning of muscles, veins, and bones; realistic proportions; perspective made feasible by the rediscovery of vanishing points and the

use of a machine called the "camera obscura," a box in which perspective distances of the subject an artist was working on could be imaged correctly; ancient histories, philosophy, and especially the works of Plato; and a profound shift in economic power from wealthy aristocrats to upper-middle-class bankers.

The Italian Renaissance has two chapters. The early phase lasts from the middle until the last quarter of the 15th century and is hallmarked by a roster of superior artists. Prime among them are the architect **Filippo Brunelleschi,** the painter **Masaccio,** the sculptor **Donatello,** the painters **Piero della Francesca** and **Sandro Botticelli,** and the sculptor **Lorenzo Ghiberti.** The second phase — lasting only from 1490 to 1527, the date of the sack of Rome — had even more artists (many relatively obscure), but the period was dominated by architect **Donato Bramante,** who has sometimes been called the "father" of perspective, and later the architect **Andrea Palladio,** the painters **Giorgione, Leonardo da Vinci, Michelangelo Buonarotti, Titian, Raphael,** and **Correggio.**

Around 1420, the three great creative spirits — Brunelleschi, Masaccio, and Donatello — who shared a fascination in humanism and antiquity, developed an outlook and a style that were thoroughly modern, even avant-garde, meaning they were the keenest of scouts, way out in advance of the artistic main guard.

Brunelleschi

Brunelleschi, a painter, sculptor, architect, and engineer — the authentic "universal man" — was a pioneer of Early Renaissance architecture in Florence. His great achievement was in figuring out how to complete the soaring dome on the cathedral of Florence. He invented the technique and tools to finish the dome and lantern. His solution was a construction technique used by the Romans, which Brunelleschi is said to have observed on a trip to Rome in 1401. It involved placing the brickwork in herringbone patterns inside a framework of stone beams, which didn't need extensive scaffolding or support structures that might not have worked, anyway.[5]

He suffered a severe disappointment in his early career, failing to win the sculptural competition for the bronze doors of the Florentine Baptistery. Lorenzo Ghiberti won the prize (see Florence in the European museum guide section), which turned Brunelleschi to architecture and science. Around 1415, he rediscovered linear-perspective, which had been known to the Greeks and Romans but which had long since died out. He painted two panels, now lost, of the streets and buildings of Florence using a single vanishing point, towards which all parallel lines on the same plane seemed to meet. Suddenly, space was very real, and the structures appeared shockingly

to diminish as they seemed to recede into space. An illusion of three-dimensional space allowed works of art to seem a part of the real world.[5]

Masaccio

Masaccio was a special friend of Brunelleschi's who used one-point perspective virtually for the first time in a remarkable series of religious paintings. Masaccio, which means "Clumsy Tom" (supposedly because of his casual personal appearance and laid-back behavior), was born Tommaso di Giovanni di Simone Guidi.[5] Sadly, from his birthdate until 1422, absolutely nothing is known about him.

His first recorded painting is a small and powerful Madonna enthroned between angels and saints now in the Uffizi Gallery. It shows influences from Giotto but displays a new sense of mobile corporeality that comes directly from the sculptures of Donatello. His next work is a large altarpiece for a church in Pisa that was dismantled in the 18th century and scattered widely. The center, *The Madonna and Child,* is in London's National Gallery and is notable for its sense of volume and depth.[5]

Masaccio's triumph are the frescoes he executed in the Brancacci Chapel of the Florentine church of Santa Maria del Carmine (around 1427). He was accompanied by an associate named Masolino. Who did what has been one of the tougher art historical puzzles ever, but now, especially after the cleaning a decade ago, it's agreed that Masaccio painted the works that are dramatic, expressive, and firmly placed into a tangible natural environment showing strong natural lighting, sharp perspective, and emphatic human volume. Masolino's figures are dainty and elegant (right out of the International Style, as explained in Chapter 6).[5]

Masaccio's two frescoes that have become icons of art history are *The Expulsion of Adam and Eve from the Garden of Eden* and *The Tribute Money.* Adam and Eve are truly human beings reacting expressively to their fate — seldom has there been such a portrayal of crying, moaning, gnashing, weeping grief (see Figure 7-2, as well as Figures 25 and 26 in the museum guide color insert). In *The Tribute Money,* which portrays the debate between Christ and the apostles about the ethics of paying tribute to secular authorities, the lighting comes from the upper right (in perfect tune with the actual lighting of the Brancacci Chapel). The mountain background is executed with flawless perspective.[5] The figures exist in a space that is no longer a conception, but startlingly real. Masaccio's breakthrough is in the way he established a painted surface as a continuation of the actual world by using the same laws of space, light, and atmosphere.[5]

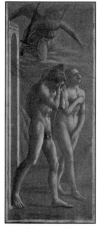

Figure 7-2:
The Expulsion of Adam and Eve, by Masaccio.

Masaccio's last-known work, *The Holy Trinity,* a fresco of around 1427 in the Florentine church of Santa Maria Novella, is a further refinement of one-point perspective. The architectural setting comes from contemporary buildings designed by Brunelleschi but inspired by ancient Roman structures.[5]

Donatello

In sculpture, the true creative spark of the Early Renaisance was Donatello. He combined a keen knowledge of antiquity, an appreciation for medieval art, anatomy, and an awareness of psychology to create a world of heroes and saints, rulers and gods of the likes that had never seen before. His most striking works are the Cantoria in the Duomo Museum of Florence; the astonishing figure of the very adolescent *David* in Florence's National Museum; a grandiose equestrian bronze statue, his famous *Gattamelata* in Padua of 1450 (translates as "The Honeyed Cat" and refers to a wily many-lived Venetian general-of-fortune, or Condottiere, named Erasmo da Narmi); and a startling frontal, medieval-in-spirit, bronze *Virgin and Child* of the 1450s for the high altar of the Cathedral of Padua, which is probably Donatello's "copy" of a miracle-making Romanesque *Virgin and Child* now destroyed. This is today considered to be one of the most expressive works of the Renaissance. Another extraordinary work full of poignancy and horror is his painted, wooden *Mary Magdalene* in Florence's Cathedral Museum, the Museo dell'Opera del Duomo (see the museum guide to Florence for a host of Donatello's works, including the *David* in the Bargello).

Ghiberti

I think Lorenzo Ghiberti's great golden gates for the Florentine Baptistery are the single finest sculptural achievements of the Early Renaissance — Michelangelo cleverly dubbed them the "Gates of Paradise." All the elements are there — from references to classical antiquity to perspective and the throb of humanism. Check out the main color insert for a view. (See the Florence section of the European museum guide for more on the doors.)

Piero della Francesca

Piero della Francesca created some of the most breathtaking paintings of all time. Chief amongst them is *The Flagellation of Christ* (1453) in the Galleria Nazionale, Palazzo Ducale, Museum in Urbino, which shows the Savior, looking like a Greek statue, tied to a column in the center of a dreamlike palace interior being whipped by a pair of thugs dressed fancifully like Greek warriors (see Figure 7-3). The scene looks like a scene in some ancient Homeric hall. (See the section on London in the European museum guide as well as the entire guide to Italy where more works are described.)

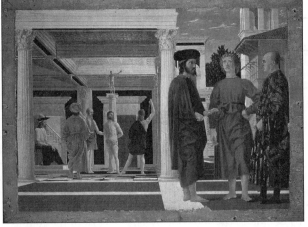

Figure 7-3:
The Flagellation of Christ, by Piero della Francesca.

National Gallery, Urbino, Italy/Canali PhotoBank, Milan/SuperStock

Alberti

A key member of the Early Renaissance formation team was architect Leon Battista Alberti. He was probably even more the "universal man" than Leonardo da Vinci. He used his gifts for what he called "useful" works[5] —

architectural history and theory, language, humanism, and even cryptography. His formal education was humanistic, but he entered the service of the church, eventually attaining the powerful position of Papal secretary and architectural advisor to Pope Nicholas V. Together they planned the reconstruction of St. Peter's.

As a medievalist, I must say, I groan at the destruction of the stately early Christian edifice which was one of the wonders of Christendom, with its vast nave and multiple side-aisles. One of the few traces of the great basilica is the enormous bronze pine-cone fountain head that stood in front of the old facade and now in the Belvedere Court.

He was close to Donatello and Brunelleschi, and the friendship led to a significant achievement — the spelling out of the painters' perspective in his book *On Painting* of 1435 that established the rules for how to paint a three-dimensional subject on a flat panel or wall.[5]

He had a series of top-flight patrons — the Marchese Malatesta, for whom he designed a classical Temple in Rimini (which is, by the way, worth a detour); the Marchese Leonello in Ferrara where, in 1438, he constructed a little gem, a still-standing "Roman" triumphal arch; and Nicholas V, to whom he dedicated his vastly influential redoing of the Roman architect Vitruvius' *Ten Books on Architecture*, which influenced architects for decades; and Lorenzo de' Medici, for whom he wrote a book entitled *On the Man of Excellence and Ruler of His Family*.

Andrea Mantegna

The perfect translation of the identity of ancient Rome into 15th century are the crisp, often metallic, tense, and profoundly moving paintings of Andrea Mantegna, the master of Mantua and Padua. A child prodigy, he set up his own studio at 17 and won an important commission for a major Paduan church. He was close to Donatello, and there are similarities between his sculptures and the exacting surfaces of Mantegna's paintings.[5]

His major achievements are the following:

- ✔ In the church of the Eremitani in Padua, the grandiose fresco of the martyrdom of Saint James in the apse.

- ✔ The magnificent cool and perfect three-part altarpiece in the church of San Zeno in Verona depicting Saint Christopher and other saints. Verona has an abundance of Roman remains — a large amphitheater and countless fragments of sculpture that Mantegna studied and incorporated into his works in the utmost detail.

DETOUR

➤ A triumphant and widely influential set of frescos in Mantua. Mantegna's best patron was Ludovico Gonzaga, the marquess of Mantua, and around 1459, he painted the amazing *Room of the Newlyweds* or *Painted Room,* as it is sometimes called, in the Ducal Palace. (Camera degli Sposi or Camera Picta in the Palazzo Ducale, as they say it in Italian.) By his paints he transformed the small flat-ceilinged room into an elegant open-air pavilion. Directly above the center of this totally painted chamber is a painted dome with a painted oculus, or round opening, to the sky. There's a balustrade painted in dramatic foreshortening just under it and standing there looking straight down — to the observers — is a host of little angels and beautiful young women. The striking realism of this worm's-eye view going dramatically upwards (in art historical Italian, "di sotto in su" or "from below way, way up") made this fresco the most influential illusionistic ceiling decoration of the Renaissance — and, indeed, virtually forever after. This is one work of art that should be highest on your developing list of absolute must-sees. (See Figure 7-4.)

Figure 7-4:
Mantegna's
ceiling
oculus in
the Ducal
Palace.

Palazzo Ducale, Mantua, Italy/SuperStock

➤ In the Louvre, a diminutive painting of the Crucifixion, towards the end of the 15th century, that masterfully brings together the glory of ancient Rome and Christianity. It is deeply moving.

➤ The life-size *Saint Sebastian* (1480) studded with arrows in the Kunsthistorisches Museum, Vienna, in which the Roman ruins must be taken from life.

➤ Near London, at Hampton Court Palace, there are spectacular fragments of paintings Mantegna completed around 1486 for the Gonzagas depicting *The Triumph of Caesar,* which bring back to life the pomp of what a Roman official victory triumph must have been like.

Sandro Botticelli

TAKE A LOOK

Sandro Botticelli is something of a puzzle — being part late-medieval, part Early Renaissance, and part modern expressionist. In his early career, he painted some small pictures that have all the willowy grace and lyrical colors of Bohemian works of the International Style of 1400. (See Chapter 6 for the

International Style.) Then he produced a never-never land monumental classicism in triumphant works like his famous *Primavera* (c. 1482), shown in the museum guide color insert, or *The Birth of Venus* (c. 1482) in the Uffizi (see Figure 7-5) and in his charming portraits in which the sitters are shown in emphatic profile looking like brightly-colored Roman coins. Finally, under the dour influence of the fundamentalist monk Savonarola who was burned at the stake in Florence's Piazza della Signoria for heresy, Botticelli created a series of dark, brooding, and intense religious works that have the same apocalyptic flavor of doom as some of the German Expressionists of the 20th century (see Chapter 15 for a couple of names of these chaps) who depicted the sinking world of the Weimar Republic just before the rise of Nazism.

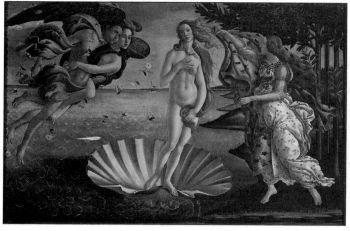

Figure 7-5:
Botticelli's
*The Birth of
Venus.*

Galleria degli Uffizi, Florence, Italy/SuperStock

Italian High Renaissance

If you are familiar with any Renaissance, it is with the Italian High Renaissance. In this section, you may encounter names that have become household words.

Leonardo da Vinci

Leonardo da Vinci's most Renaissance work is probably not his *Mona Lisa* or my favorite, *Woman with an Ermine,* in Krakow, Poland, or even the *Annunciation* in the Uffizi. It's his manuscript with mind-boggling drawings in the collection of the Queen of England and sometimes on display in the Queen's Gallery near Buckingham Palace. This has his studies of waves — symbolic of the penetrating scientific searchings current in the late 15th and early 16th centuries, a phenomenon paralleled only in antique times.

The decade-long restoration of the *Last Supper* was finished in 1999. Some of the original, bright colors of the master have been revealed. (The *Last Supper* in Santa Maria delle Grazie in Milan was already falling onto the floor in pieces during Leonardo's lifetime and was a shadow of its true imagery, as shown in Figure 7-6.) Unlike other restorations, glue — which tended to dull the fresco — wasn't used, and the parts that had dropped off from the wall haven't been repainted. Visitors should be warned that the wait to see the work may be long because only very few people will be allowed in the former refectory in Santa Marie delle Grazie at one time per day. (See the guide to European museums and Milan for more on the history of the disaster by Leonardo.)

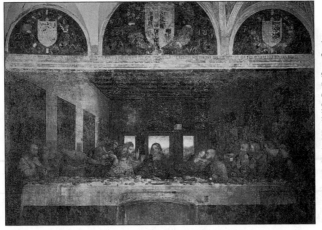

Figure 7-6: Leonardo's *Last Supper,* before restoration.

Santa Maria delle Grazie, Milan/A.K.G., Berlin/SuperStock

Far more authentic and exciting is another series of Leonardo frescos in Milan that depict nothing more than the intertwining tops of ash trees, yet in an unbelievably expressive way — they are in the Castello Sforzesco under *Sala delle Asse (Salon of the Ash Trees).* No one ever sees them, and to do so is something of a coup. (See Chapter 21 for more on Leonardo as one of the most interesting artists ever.)

Raphael

Today the reputation of Raphael Sanzio — in the 19th century known as "the divine" — has somewhat faded. There's no apparent reason, although I half suspect that what has, wrongly, been interpreted as his sweetness — and therefore weakness — since the 1920s when the harsh and crude in art were much appreciated may have helped put him in the shade.

His works are not overly sweet. Just pop into the dynamically powerful frescoed stanze (rooms) in the Vatican Palace to see the fresco of *The School of Athens* or the *Disputa* (1510-11), both in the Stanza della Segnatura, to see that Raphael was equal to his competitor Michelangelo whom he rather admired, although Michelangelo rather didn't like Raphael. (See Figure 7-7.)

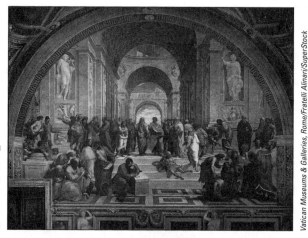

Figure 7-7:
Raphael's
*The School
of Athens.*

For the thrill of an art lifetime, I suggest, when in Milan, do not miss the small and gemlike museum, the Ambrosiana, in which there are Raphael's enormous preparatory drawings, called "cartoons," for the famous Vatican *Disputa* arranged in a theater like some Imax presentation. (***Note:*** All the paintings in this blockbuster of a museum are in about the best condition ever because they have never been mucked about over time. Professionals, when thinking about the purchase of a work by Caravaggio or Jan "Velvet" Brueghel or Jacopo Bassano — they should be so lucky! — go to the Ambrosiana to see what perfect state really is.)

Andrea Palladio

A later Renaissance architect of enormous influence was Andrea Palladio who transformed the essences of ancient Roman buildings into a new canon of architecture in harmony both with the past and the future. His villas and palaces near Vicenza made a mark upon the great 18th century English architect Christopher Wren whose triumphant St. Paul's is distinctly "Palladian" in feeling. Thomas Jefferson's deft architectural recollections of classical times in his buildings at Monticello and at the University of Virginia owe certain debts to Palladio.

The Little Temple

I think the architectural epitome of Renaissance fascination in proportion, perspective, and space is brilliantly realized in a tiny round church called "the Tempietto" (the little temple), designed by **Donato Bramante** in 1508 and hidden in the court of a cloister in the Roman church of Saint Peter in Montorio. It's like a large doll's house; its diminutive Doric columns surround it like a devout embrace and a perky dome. This is a "temple" similar to those that appear in the dead center of a host of 15th-16th century paintings depicting the *Marriage of the Virgin* and is the hallmark of the Renaissance, symbolizing rationality, order, and purity.

He was an intellectual and a practical engineer as well as an architect. His villas were constructed with a series of complex hidden ducts that allowed the buildings to be cooled by the breezes in a way that works almost as efficiently as modern air-conditioning. His four-volume treatise on architecture — *The Four Books* — secured his lasting influence on Western architecture.

One of the better art tours in Europe is the two-day leisurely journey up and down the roads that connect Vicenza with Venice for Palladio's stunning villas and public monuments. Standouts are the Villa Valmarana of 1565 near Vicenza and, above all, the Villa Rotonda in Vicenza (1566-69). The latter was a hilltop summer house made for Giulio Capra, incorporating a symmetrical plan with what is called in architecture, with hexastyle, or porticoes (six-columned porches) on each of four sides with central circular halls surmounted by domes. It looks, in fact, like four Pantheons brought together.

Giorgione

The painter, Giorgione (known as "Zorzo da Venezia" — I suppose something like "Georgie from Venice") is a major enigma because his absolutely-signature works number only around a dozen. The best and largest is the massive oil on panel altarpiece in the cathedral in Castelfranco, the *Madonna Enthroned Between St. Francis and St. Liberalis* (1504). There's an aura of serenity that matches the sculptures of the Parthenon.

Other splendid examples of Giorgione's works may be found in the Accademia in Venice, his haunting and totally puzzling *Tempest* (c. 1510) in which a soldier — perhaps he's a German mercenary — stands guard over a nearly nude woman with her baby while a thunderstorm threatens the sky (see Figure 7-8). In Vienna's fine Kunsthistorisches Museum (Art History

Museum), you'll delight in a most pleasing Giorgione depicting three gentle-men of varying ages in a lush landscape who may be philosophers, or astronomers, or the three Magi, or even "a statement about the intellectual growth of humankind through the stages of youth, maturity, and old age" — but no one knows for sure. It dates around 1508-10.

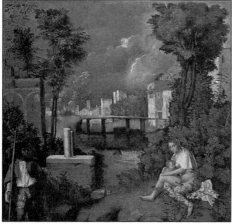

Figure 7-8:
Tempest, by
Giorgione.

Galleria dell' Accademia, Venice/Bridgeman Art Library, London/SuperStock

Titian

Titian is the least "Renaissance" of the greats because his glowing color and apparent disinterest in creating "proper" anatomy are a bit at odds with what was considered important. He's more a Romantic than a strict Renaissance man. He could create sweet images, devout religious scenes, earthy nudes, steamy mythological images, and works in which there's a sub-text of horror. In the United States, Titian's best work (in fact, it's one of the finest old masters in the entire country) is the brilliantly colored and vigorous *Rape of Europa* (1559-62), in Boston's Isabella Stewart Gardner Museum. Second to none is his late *Christ Crowned With Thorns* (1573-75) in Munich's Alte Pinakotek in which the swirling paint looks like a painting by the 20th-century German Expressionist Oskar Kokoschka.

Correggio

A Renaissance artist who was praised lavishly in his lifetime and who is now overlooked is Parma's Correggio. His style combines a lyrical naturalism with a particular use of light and shade creating a remarkable softness of con-tour and a dazzling atmospheric effect. His night scenes are particularly memorable.

His finest works are to be seen in Parma, in the ceiling of the convent of S. Paolo, which depict humanistic allegories (1518) and in the cathedral. There, his frescoes (1523) in the dome portraying *The Assumption of the Virgin* are strikingly illusionistic. He treats the whole surface of the dome as a single all-encompassing "canvas" comparing the dome with heaven. The astonishing way the figures in the clouds seem to come right into the spectators' space is, for his time, a daring use of foreshortening.[5]

Correggio's altarpieces are splendid, and many became so famous that they now have nicknames. I urge you to see his *Day,* or *The Madonna of St. Jerome,* (1530) in the National Gallery of Parma, and the superb *Night,* or *The Adoration of the Shepherds,* in the Picture Gallery of Dresden.[5]

Correggio could be almost unbelievably sensual, too, in his mythological paintings. One is in the Kunsthistorisches in Vienna, representing *Jupiter Coming to the Nymph Io* (1532) in the form of a lusting thunderhead.[5] (See the section on Vienna in the Europe museum guide.) Another is in the Borghese Gallery in Rome showing *Jupiter Coming to Danae as a Shower of Gold* (both date to c. 1530).

Michelangelo

No other artist than Michelangelo symbolizes the pure and ideal Renaissance — not only because of his sculpture, which contemporaries said was imbued with a special strength they called "terribiltà," but because of his incomparable architecture seen in the dome of Saint Peters in Rome (1546-64) and, in Florence, the Laurentian Library (for Lorenzo de' Medici) with its soaring stairs. (See Chapter 21, where he is listed as one of the 10 most interesting artists; see also the Italy section of the European museum guide.)

If the Renaissance was striving to capture the central importance of mankind, anatomy, movement, religious emotion, the classical ideal, the monumental, and the unforgettable, what sculpture more perfectly resounds with all that than the glorious *David* (1501-1504) in Florence's Galleria dell' Accademia? (See the main color insert for a great view!)

Michelangelo was of the Renaissance and at the same time far beyond it. Indeed, after the successful cleaning of the Sistine Ceiling and the Last Judgement and the revelation that his true colors are, to the contemporary eye, more garish than suspected, running to somewhat harsh tones of fuschia and puce with lemon-yellow and crackling blue, he is already becoming known less as a High Renaissance artist than all of that plus the genius who gave birth to the style called Mannerism, which I deal with in Chapter 9.

ART ANECDOTE

The cleaning of the Sistine

The cleaning of the Sistine Chapel in the Vatican Palace has its harsh critics and nitpickers who are convinced that the old flavor of the muted, brownish "Michelangelo" true colors have been wiped away forever. Nonsense. I had the good fortune of ascending to the vault and being able to clean a one-foot-square area of the Separation of Light and Darkness. The old grime, mostly years of coal dust, came off immediately. I was convinced that nothing was being taken away or disturbed. Another thing that confirmed for me that the cleaning was proper and safe was that the massive architectural elements Michelangelo painted for the figures to sit upon were fresh marble after cleaning. Now, would Michelangelo — who sure knew his marble — have painted for the Pope acres of dirty, brown marble?

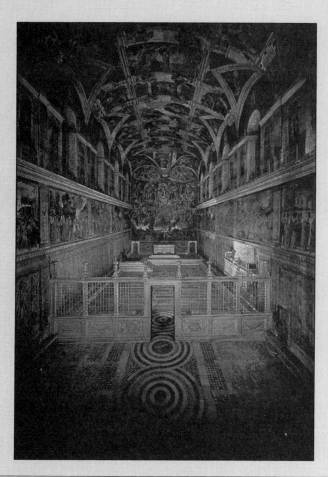

Chapter 8

The Northern European "Renaissance"

Art historians have tried to establish that a Renaissance also took place In the countries north of Italy. Yet if it did, and it is open to question, it was not a big "R" but an "r" — a renaissance. The driving force of the Italian "R," Roman antiquities, were, naturally, nowhere nearly as profuse in Germany, France, Flanders, the Netherlands, and England. I'd say that whatever traces of Roman antiquity that do show up in Northern art are, by and large, adapted from works made by Italian Renaissance artists — a sort of second-hand classicism. In addition, the discoveries of linear perspective, anatomy learned by means of dissections, and an obsession for classical texts of all kinds were sparse in the Northern countries.

How then to characterize the styles that came to life up north in the 15th and 16th centuries? Simply, German art of the 15th and 16th centuries, Flemish art (meaning the art of Flanders — modern day Belgium), and so on.

The Grandeur of the Northern Renaissance

Do we, like the artistically chauvinistic Italian Giorgio Vasari, who slighted Northern art as "Gothic," look down on the art of the North for having, well, distinct traces of Gothic style all the way through the end of the 16th century? Not at all. Northern art of the 15th and 16th centuries is every bit as grand as Italian work and in some cases far, far grander.

Robert Campin

If there is one artist who spurred the Northern renaissance and moved it from the idealistic elegance of the International style (see Chapter 6 for International style info) towards a greater understanding of the human figure existing in a real three-dimensional space, it was Robert Campin of Flanders. He is documented as a master painter in 1406 in Tournai and as the teacher of Rogier van der Weyden, who will become one of the leading lights of 15th century Flemish painting.

Campin is known for his down-to-earth figures placed in a convincingly real space often surrounded by many objects of daily life, which he manages to transform into poetic images. One of his best works is in the Cloisters, the medieval branch of the Metropolitan Museum of Art in Fort Tryon park. The work, a *triptych* (three-paneled painting on wood), is known as the *Mérode Altarpiece* (1428), after a family of Flanders who once owned it. The altarpiece depicts the Madonna and Child in the center panel and St. Joseph in the right one. There are two donors depicted in the left panel in a charming garden, but it would seem that this part was painted later, perhaps not by Campin. The Virgin is almost wholly different from a refined lady of the court, as she is usually represented in works of the International style. Here, she is a woman who breathes, moves, and thinks. Joseph is shown as a grizzled but endearing maker of wooden mousetraps, one of which he displays in the window of his shop. The picture is loaded with visual religious symbols, and the mousetraps may be not only a reference to Joseph's trade as carpenter, which Christ will follow, but also a reference to a line in the writings of the early Christian Church father, Saint Augustine, who observed that Christ would trap the devil the way mice are entrapped by clever mousetraps.

Jan van Eyck

At about the same time or just a bit later than Campin, came a wonder of wonders by the name of Jan van Eyck. He (and possibly his brother Hubert) painted what is arguably the most gorgeous and triumphant masterpiece of Western civilization, the *Altar of The Mystic Lamb* (1425-1432) today in the cathedral of Saint Bavo in Ghent (also called the *Ghent Altarpiece*). (See the main color insert as well as Chapter 20, where I discuss the greatest works of Western civilization.)

Van Eyck is said to have refined the use of oil paint to the highest level.

Van Eyck was also something of a combination of a secret agent and marriage broker, for on behalf of his patron Philip the Good, Duke of Burgundy, he traveled clandestinely to Spain to try to contract a marriage between his patron and Isabella of Spain, and then later to Portugal to do the same with Isabella of that country.[5]

Other works by this genius are the following and should definitely be seen:

✔ *The Marriage of Giovanni Arnolfini and Giovanna Cenami* (1434) in London's National Gallery.[5] Actually, it's not a wedding but the portrait of Arnolfini, a member of a wealthy Lucca family who was the Medici monetary representative in Flanders, and his young wife. They stand with their pet terrier in their bedroom about to greet some visitors. The portraits are penetrating and gracious. The details, as usual, are depicted with near-miraculous realism. See Figure 8-1.

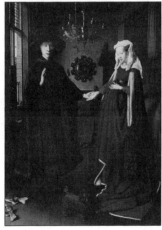

Figure 8-1:
The Arnolfini marriage, by Van Eyck.

National Gallery, London/Bridgeman Art Library, London/SuperStock

✔ In the Musées Communaux Bruges, Belgium, *Madonna with the Donor Canon van der Paele* (1434-36).[5]

✔ *Madonna and Child with the Donor Chancellor Nicolas Rolin* (c.1436).[5] Rolin was chancellor for Philip the Good, Duke of Burgundy. The work is in the Louvre.

✔ A foot-high (30.5 cm), two-paneled work in the Metropolitan Museum showing *The Calvary and Last Judgment* (c. 1440).[5]

✔ A spare and uplifting *Crucifixion* (1455) in the Philadelphia Museum of Art.[5]

Rogier van der Weyden

Robert Campin's student Rogier van der Weyden, who was also influenced by Van Eyck, became the most famous painter of his generation, creating grand religious subjects and some splendidly perceptive portraits. The Prado is today's home of his magnificent large altarpiece made for the chapel of the Archers' Guild of Louvain, Belgium, the *Descent from the Cross* (1435-40). It is one of the most moving portrayals of the moment when the dead Christ's body is being tenderly removed from the cross while the Virgin and Saint John mourn (see Figure 8-2.) In the French town of Beaune, in what in the 15th century was a hospital (today it's called the Hôtel Dieu), is a huge multi-paneled painting of the *Last Judgment* finished in the 1440s — the sufferings of the damned are vivid, and one can imagine how they must have appeared to the afflicted patients.

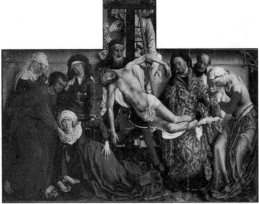

Figure 8-2: *Descent from the Cross,* by Rogier van der Weyden.

Museo del Prado, Madrid, Spain/Bridgeman Art Library, London/SuperStock

ART ANECDOTE

The one that got away

In the National Gallery in Washington is a tiny oil panel by van der Weyden — perhaps 5 by 3 ½ inches (12.7 by 8.9 cm) — showing a most vigorous Saint George on a rearing warhorse, destroying a foul dragon. The condition is matchless; the image is perfection itself as is the landscape in which the scene is set. As a youthful curator at the Cloisters in the 1960s, I found the piece in a dealer's shop and begged my then boss to buy it. The Cloisters had plenty of money in the bank, and the painting cost a mere $750,000, not especially high for such a rarity (and today worth maybe $2-3 million). I was turned down with a brusque, "it's too small, the public will never appreciate it," and it was snapped up by Washington. Every time I see it, I groan to have lost it, especially when I see the crowd of admirers around it.

Hugo van der Goes

Rogier van der Weyden's followers of the succeeding generation were Petrus Christus, Dirck Bouts, Hans Memling, and Hugo van der Goes. In each, the strong mark of Rogier's genius can be observed.

Hugo van der Goes is by far the most dynamic of the group. I find it pleasantly ironic in light of Giorgio Vasari's badmouthing Northern artists as "Gothic," that in today's Uffizi Museum — which he designed as offices for the Medicis (*uffizi* means "offices" in Italian) — a painting by Hugo van der Goes hangs cheek-by-jowl with the most exalted masters of the Italian Renaissance — and puts many of them to shame. This is the astonishingly colorful altarpiece painted by Hugo around 1475 in Bruges for Tomaso Portinari who was a Medici moneyman assigned to Flanders. (The subject of this oil and tempera panel, in which the figures are virtually life-size, is the Adoration of the Shepherds; all the herders rushing to adore Christ in the joyous drama are rough-hewn and highly individualized.) The Portinari family has been depicted in the wings of the altar, and few young women of rank have ever been painted so gloriously. The baby Christ Child is surrounded by gold rays that would have made King Midas drool; the still-lives of lilies and other flowers have few parallels in art, and the flight of Angels above the Madonna has come straight from Heaven itself. (See Figure 8-3.)

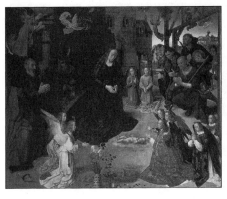

Figure 8-3: The central panel from the Portinari Altarpiece, by Hugo van der Goes.

Galeria Degli Uffizi, Florence, Italy/Bridgeman Art Library, London/SuperStock

Hiëronymus Bosch

The Northern artist of the 15th to 16th centuries who has most dazzled and puzzled virtually everyone from art professionals to amateurs alike is Hiëronymus Bosch. He was born in 1450 in a tiny hamlet in Holland's Hertogenbosch and died there 66 years later. He has been christened the "creator of devils" because of the outlandish, "alien" creatures that populate so many of his works.[5] Although his works are religious, dealing for the most part with the evils that have been visited upon mankind after the expulsion

from the Garden of Eden and the perils of Hell, the symbols he used to portray these themes are so bizarre that it was thought for a long time that he was into the occult. Certainly not.

The way to view his paintings is to look upon them as imaginative, astoundingly diverse, seductively beautiful, and downright funny illustrations of how bad are lust, vanity, heresy, and unmannerly behavior of all kinds.

To me, the Bosch blockbuster is an enormous oil painting on three wood panels — the center is 7 feet high and 6 feet wide (2.1 m by 8.9 m); each wing 7 feet high by 3 feet (2.1 m by .9 m) — its name is *The Garden of Earthly Delights* (c. 1505-1515); it hangs in the Prado and is both a pleasant daydream and a dark nightmare.[5] See the museum guide color insert, Figure 38, for a detail.

The left panel shows a happy-faced Adam and Eve with God the Father lolling about just after creation. In the center, a multitude of pretty human beings dance, ride, play, and enjoy (see Figure 8-4). But the right wing is where time runs out, where the price of frivolity, adultery, singing, and dancing is paid. Here you'll see a horde of trapped, tortured, and anguished people. This ugly dark view of Hell is dominated in the center by a chalk-white, warped, and twisted eggshell with legs, fitted out with a grotesque, evil human face that looks right into the viewers' eyes and seems to say, "You're next." The place is filled with your worst fears. Knives walk. Musical instruments have become weapons of destruction. Fire sweeps the skies. The damned — who are mocked and threatened — are being stuck, pricked, squeezed, and mouthed by a host of foul monsters, but, of course, nobody dies. In Hell, they suffer for eternity.

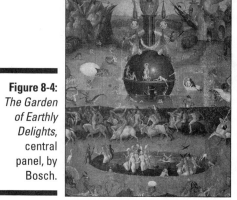

Figure 8-4:
The Garden of Earthly Delights, central panel, by Bosch.

Museo del Prado, Madrid, Spain/Giraudon, Paris/SuperStock

Pieter Breughel the Elder

Pieter Breughel the Elder was the most energetic, accomplished, amusing, heady, and profound painter from the north — he worked mostly in Flanders and the Netherlands — of the entire 16th century. An extraordinarily rich lode of his oil paintings on wooden panels, no less than a third of his entire surviving output, 12 in all, is on view in one large gallery in Vienna's Kunsthistorisches Museum. That room is alone worth the trip to this incredibly art-wealthy city. (See the Europe museum guide for info on Vienna.) The three best are *Hunters in the Snow (Winter)* (1565), *The Peasants' Wedding* (c. 1565), and *The Carrying of the Cross* (1564). The latter may be the most captivating rendition of Christ on the way to Golgotha ever made. The raucous parade from downtown Jerusalem into the killing field of Calvary — filled with revelers, drunks, and playing children — is filled with as much frivolity as it is with terror, all set in an incredibly beautiful and haunting landscape. In the right foreground, Mary, Saint John, and Mary Magdalene are grouped in mourning. In the center is Christ struggling with the heavy cross. In a wagon the two thieves are tied. The symbol of all wretched humanity is in the gray-faced, absolutely terrified thief who throws back his head in an anguished howl. The end of the drama is in the upper right in the gathering circle of citizens who just can't wait for the agony to begin. For them it's merely an outing on an overcast afternoon.

Hans Holbein the Younger

Don't miss out on the splendors Hans Holbein the Younger, a German painter known for his exactingly-rendered, yet vital, portraits. Holbein recorded in about 150 superb works the personalities of the fabulous court of King Henry VIII. The major collection of these is in the possession of the Queen of England. Numbers of them are shown from time to time in the Queen's Gallery near Buckingham Palace. The National Gallery in London has several great Holbeins, of which one is the especially intriguing large portrait of two young and wealthy Frenchmen, Jean de Dinteville and Georges de Selves, called *The Ambassadors* (1533), shown in Figure 8-5. The work is rich in visual symbolism, which was much revered at the time. (See the Europe museum guide for details on London.)

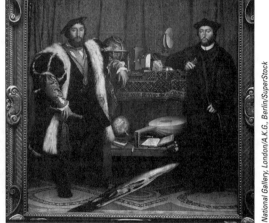

Figure 8-5:
The Ambassadors, by Holbein.

Matthias Grünewald

Matthias Grünewald is a genius of the period who is very little known, perhaps because his works are rare and relatively isolated. His masterstroke is one of the top works of Western history, his moving religious work called the *Isenheim Altar* (c. 1510-1515) now in the Unterlinden Museum at Colmar, France (see Figure 8-6). It shows in radiant style Christ Crucified and Resurrected and may be the most powerful and successful rendering of the basic Christian belief that Christ, in giving up his life for mankind, conquered death. (See Chapter 20 for more details on this work.)

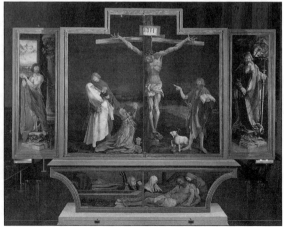

Figure 8-6:
The *Isenheim Altar* of Grünewald.

Albrecht Dürer

In the North, the greatest artist — also one of the most important of all Western history — was Albrecht Dürer, who was revered by no less than Leonardo, who seems to have painted his moving *Lady with an Ermine* (Czartoryski Museum, Krakow, Poland) in Dürer's homage. (See also Chapter 21 for a discussion of Dürer as one of the most interesting artists ever.) His drawings and magical watercolors in Vienna's Albertina Museum are sensational, especially the study of a bird's wing and a slice of grass called *The Great Piece of Turf* (1503).

His *Self-portrait* (1500) in Munich's Alte Pinakothek is both penetrating and nerve-wracking, for he has portrayed himself as part creative artist and part Christ. While some artists had previously painted themselves into a background of a work or as penitents, Dürer shows himself as he really is and goes further, showing himself frontally, in rich robes, as Jesus, to signify his firm belief that artists' creativity derived directly from God's creative powers. (See the main color insert for a great view.)

Northern Sculpture

In the North, sculpture in the 15th and 16th centuries — mostly wooden pieces that were either painted and gilded or left in a soft beige natural state — is radically different in style from Italian works, and that is its strength. I suppose you can call them Late Gothic because, in general, they are still religious dramas acted out by people whose bodies are incorporeal and unreal. The faces are idealized and sharply carved; the draperies are dynamic swirls and great looping, abstract forms which have a life of their own and sometimes tend to conceal the human anatomy underneath. There is a host of grand sculptors who worked from Sweden to Switzerland and from Germany to Bohemia, because the commissions to decorate huge altars were numerous. Of the populous group, two — both Germans — stand out for their power of expression. They are **Tilman Riemenschnieder** and **Veit Stoss**.

Viet Stoss

One of the most thrilling experiences in the Western world is a visit to the church of St. Mary's (Kosciol Mariacki) in Kraków, Poland. Every day at the stroke of noon, a nun approaches the closed gigantic painted wooden altar, the exterior of which is decorated with painted low-relief carvings of the lives of Christ and the Virgin Mary. Trumpets sound (on a tape recording) as she opens the huge wings of the immense piece and folds them back on their

hinges. For a visitor admiring the exquisite reliefs by Viet Stoss on the outside of the altar, this might seem to be an inconvenience. Then the full interior of the 46-foot-high (14 m) structure is revealed, and it's a shock of beauty.

Carved in heroic size, each about 15 feet (4.6 m) high, the Apostles are seen preparing for the death and the Assumption of the Virgin who kneels in the center of the work. Crisp, powerful, and delicate, with poignant faces expressing deep emotion, these figures are overwhelming. They are deftly painted, wondrously gilded, and covered and surrounded by storms of crackling drapery, which add to their intense emotional fire.

Tilman Riemenschneider

Equally expressive and brilliantly carved, another extraordinary sculptural achievement is the *Creglingen Altarpiece,* by Tilman Riemenschneider. It's in the Herrgottskirche (literally God the Father's Church) in Creglingen in southern Germany. It measures 32 by 16 feet (9.8 m by 4.9 m) and was carved between 1495 and 1499 in limewood and pine with the wood left generally unpainted and unstained with only the lips, eyeballs, and eyebrows tinted red or gray. The energy of the carving, its perfection, and the deeply undercut draperies, which look like mountain ranges and valleys, are simply breathtaking. The main subject is the Virgin being taken into heaven by five angels, rising from the earth away from where the Apostles stand. Almost everyone who encounters the magnificent piece is flattened by the clarity of the artistry, an experience comparable to seeing Lorenzo Ghiberti's *Gates of Paradise* on the Baptistery of Florence for the first time (which can be seen in the main color insert).

Chapter 9

Mannerism: Sensuality and the Bizarre

Mannerism is a term sometimes used to label everything created between around 1520 and 1590 not only in Florence and Rome, but throughout Europe. And that is highly misleading, even inaccurate. It would be far better to say that in the 16th century, a host of styles existed, of which Mannerism was only one, and a rather specialized one, too.

There are actually two Mannerist styles. One, the genuine article, was cooked up in the 16th century, primarily in Rome, and the other was invented in the 1920s in Germany.

The Real and the Invented Mannerism

The real 16th century Mannerism was cooked up by **Giorgio Vasari,** a Florentine art biographer, painter, and architect (he designed the Uffizi, the Medici offices). He used the Italian word *maniera,* which means "style" or "grace," to indicate a super-refined stylishness in art. (He also coined the word *Gothic* to designate the inept art of the barbarian North.) To him, the stylish ones were Leonardo, Michelangelo, and Raphael — plus anyone in his day who used the works of these greats as inspiration and who had become obsessed with ancient Rome through the tons of new discoveries made since Michelangelo's period. A figure in Vasari's Mannerism, for example, was distilled from the often tortured complexity of Michelangelo's writhing characters, the flawless beauty of Raphael, the perfection of Leonardo's technique, and the grandeur of

Roman sculpture. Great value was given to portraying the nude in ever more complex poses.[5] The finished work was supposed to show a rhythmical, sensual beauty going far beyond the beauty of nature. With no rough edges or seams showing, either.

For decoration, Mannerism borrowed heavily from Roman art and used it non-stop. To load a painting down with cute visual quotations from antiquity was considered great. Extremely obscure subjects filled with all-but-incomprehensible symbols were prized. The style, which had its practitioners throughout Europe, is marked by a self-indulgent display of artificiality, super-elegance, meager substance, and a delight in the bizarre and enigmatic.[5]

Pure Mannerism was a hothouse art. Private collectors adored it, and it was looked upon with disfavor by the Church for not telling straight religious stories. During the Counter-Reformation of the 17th century, when the Catholic Church was urgently using art to woo people away from Protestantism and back into the churches, Mannerist works, like those by Vasari and his stylish colleagues, were condemned for their vapid virtuosity. Even Michelangelo was roasted by one critic who called him "the inventor of obscenities, who cultivated art at the expense of devotion." (Art critics can be unkind.)

The second Mannerism was coined by the German art historian Max Dvorak in a 1921 book to describe the works of the young Florentine painters **Agnolo Bronzino, Jacopo da Pontormo, Rosso Fiorentino,** and **Parmigianino of Parma** who had deliberately broken away from the harmony and naturalism of the High Renaissance. Dvorak was fascinated — overly — with stylistic similarities in the works of these painters and those by contemporary German Expressionists (see Chapter 15). Thus, when Mannerism is identified with the *maniera* of Giorgio Vasari, it defines a distinct 16th-century style. If applied to Rosso, Bronzino, da Pontormo, and Parmigianino as some distant prelude to Expressionism, the word doesn't say anything about how people in the 16th century thought about Mannerist painters in Florence and Rome.[6]

Jacopo da Pontormo

The most striking example of the refined and bizarre style of Mannerism can be seen in Florence in a dazzling, large painting representing the *Deposition of Christ* (1525) by Jacopo da Pontormo (see Figure 9-1) in the church of Santa Felicitá. The figures are long and attenuated, their limbs twisted into all but impossible poses, their staring faces gaunt, their eyes ghostly-dark and hollow, the colors — puce, fuschia, lavender, and off-pink — unworldly and electrifying. It sounds weird but, actually, the effect is far from off-putting, and one is immediately lifted into a higher spiritual zone by gazing at this powerful work.

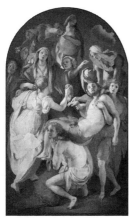

Figure 9-1:
*Deposition
of Christ* by
da Pontormo.

Capponi Chapel, Santa Felicita, Florence/Canali PhotoBank, Milan/SuperStock

Rosso Fiorentino

Another top early Mannerist, known as Rosso Fiorentino, was a contemporary of da Pontormo's and combined influences from Michelangelo and motifs from northern Gothic engravings into a highly emotional and decorative style.[5] His exemplar is an electrifying work in the Uffizi, *Moses Defending the Daughters of Jethro* (1523). Rosso would end up in France in the service of Francis I and would be the leading force in the invention of a new style associated with the School of Fontainebleau.

Bronzino

The third principal Mannerist artist you ought to be aware of is Bronzino, or as he was called, *il Bronzino,* meaning "the little bronze guy" (many Italian artists are known primarily by their odd nicknames). His given name was Agnolo di Cosimo. He was a pupil of daPontormo, and he produced extraordinarily polished and elegant portraits of individuals in the Medici court. Two beauties are in the Uffizi and the Getty Museum in Los Angeles.

The one in the Uffizi depicting *Eleanor of Toledo with her Son Giovanni* (c. 1540) is a landmark of Mannerism. In London's National Gallery, Bronzino's allegorical work, a veritable puzzle of semihidden symbols, *The Allegory of Venus, Cupid, Folly and Time (The Exposure of Luxury)* of 1546 shows a milky white nude Venus with a blank look on her face. She's crouched in a near-impossible pose while a leering, evil-looking Cupid cavorts nearby and Father Time scowls in the background. I really don't care what it all means, for it's utterly captivating. See Figure 9-2.

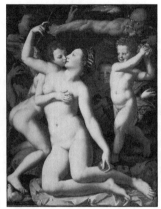

Figure 9-2:
The Allegory of Venus, Cupid, Folly and Time, by Bronzino.

National Gallery, London/Bridgeman Art Library, London/SuperStock

Parmigianino

My favorite Mannerist painter — who later in his career denied that he was ever a follower of the style — is Girolamo Francesco Maria Mazzola, or Parmigianino, which means something like, "the little chap from Parma." He took Raphael's ideal forms and exaggerated them, elongating limbs and torsos and especially necks. He was apparently fixated by painterly distortions. When he moved from Parma to Rome in 1542, he took several examples of his work with him to impress the papal art advisors. One was a self-portrait painted on a round and convex panel depicting his distorted appearance seen in a convex mirror — the small picture is in the Kunsthistorisches Museum in Vienna.

His most exceptional works are the following:

✔ *Madonna with the Long Neck* (c. 1535), in the Uffizi, in which the beautiful young Virgin is so attenuated she looks like a wisp of smoke and her neck so long and sinuous that it's like some lovely ribbon hanging down from heaven. See Figure 9-3.

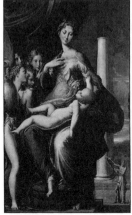

Figure 9-3:
Madonna with the Long Neck, by Parmigianino.

Galleria Degli Uffizi, Florence, Italy/Giraudon, Paris/SuperStock

> ✔ The portraits of *Gian Galeazzo Sanvitale* (1524) and a gorgeous young woman by the name of *Antea* (1537), both in the wonderful paintings gallery of Naples, the National Gallery of Capodimonte.

Veronese and Tintoretto

Mannerism wasn't all-pervasive and, depending on the commission, artists could paint in the style or not. Bronzino and Pontormo also produced sedate pictures along with their more eccentric works. And in Venice, Veronese and Tintoretto were creating sublime religious works and riveting portraits that combine an intense scrutiny of mankind with only an occasional exaggerated touch.

For Tintoretto, I'd go to Venice for his large cycles of religious paintings in the Scuola di San Rocco (1577-1581) and the *Last Supper* (1592-94) in San Giorgio Maggiore. If I were to single out one not-to-be-missed work, I'd go to the Kunsthistorisches in Vienna for the Tintoretto. His *Susannah and The Elders* (c. 1550) ratchets up the raunchy Old Testament story into an image of blatant voyeurism — Susannah's lissome body is surrounded by a most sensual silhouette which looks like a map of where the elders would dearly like to touch the beauty.

For Veronese, I'd go to Venice, Paris, Madrid, London, and Baltimore. My favorites are:

> ✔ The *Baptism of Christ* (1561) in the Church of the Redentore in Venice; it has recently been cleaned and is radiant.

> ✔ The *Feast in the House of Levi* (1573) in the Accademia in Venice. This huge painting glows because of a recent cleaning. Veronese liked to fill some of his works with whimsical details, such as defecating dogs and oddly costumed, ugly-looking characters hanging around. This work, originally commissioned as a Last Supper for the monastery of Saints Giovanni and Paolo in Venice, made the nabobs of the Inquisition nervous because, to them, there were too many bizarre touches — a servant with a bleeding nose, several uncouth-looking German mercenaries, a jester with a parrot — that were thought not to be fitting for the sacredness of the event.[5] He refused to overpaint any objectionable element in the work and, to get around the gripes, simply changed the title of the work to *Feast in the House of Levi*. The Inquisition bureaucrats went away.

> ✔ In the Louvre, you'll see another recently cleaned, enormous work by Veronese, the *Marriage at Cana*, originally executed in 1562 for the church of San Giorgio Maggiore in Venice but "liberated" by Napoleon in the early 19th century and brought to Paris. See Figure 9-4. See also Figure 15 in the museum guide color insert for the entire work.

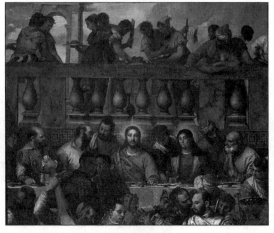

Figure 9-4:
The
Marriage at
Cana
(detail), by
Veronese.

Musée du Louvre, Paris/SuperStock

- The Prado has his small and smashing *Judgment of Paris* (c. 1550), a gem-like rendering of the myth with the three goddesses depicted like movie stars.

- *Mary Magdalene Laying Aside Her Jewels* (1553) in London's National Gallery is a gem with splendid colors and a quietly dramatic scene of religious conversion.

- *The Portrait of a Lady and Her Daughter* (1566) in Baltimore's Walters Art Gallery showing ineffable sensitivity and the charming self-consciousness of youth is the finest work by the painter in America. (See the Awesome Americas museum guide for info on Baltimore.)

French Mannerism

In France, Mannerism was perhaps more popular and extensive than anywhere else because of the love of art manifested by King Francis I. He had induced **Leonardo da Vinci** to come to his court and, in fact, the painter had died, some stories say, in the king's arms. **Benvenuto Cellini** also worked for the king (see the Europe museum guide for Vienna and the Cellini Saltcellar). Francis started rebuilding the old palace of Fontainebleau in 1528 and brought in artists from France and Italy to create its flamboyant decorations. This period is called the First School of Fontainebleau. **Rosso Fiorentino** and a colleague of similar Mannerist tendencies, **Primaticcio,** arrived and helped

to create a stunning, very, very refined series of decorations. They created lissome, elongated nudes, tangled garlands, and adaptations of Roman decorations in plaster all tied together with what's called "strapwork" or plaster treated like strips of leather that looked like they were folded and cut into fanciful shapes. "Strapwork" is a hallmark of the Mannerist style and became highly popular. At Fontainebleau, a goodly amount of this special Mannerist work can be seen in the Gallery of François I and the Ballroom.[5]

Another place to see French Mannerist works is in the sculpture galleries of the Louvre (see the Europe museum guide to the Louvre), especially **Jean Goujon's** classical-style reliefs for the *Fountain of the Innocents* (1547-1549), which takes the ancient Greek canon of proportions and extends it into a new image of feminine beauty. Italian sculptor Benvenuto Cellini's marvelously distorted *Nymph of Fontainebleau* (1543) is also on view in the Louvre.

El Greco

One of the finest painters of the 16th century — or of any century in Western history, for that matter — was El Greco. His real name was Doménikos Theotokópoulos, and he was born in Crete. He never forgot his Greek heritage and frequently signed his works with his full name in Greek characters. In the 16th century, Crete was a Venetian possession, so since he was a citizen of Venice, he went there and studied — possibly under Titian. I have the feeling he may have studied under Giulio Clovio, a painter of miniatures, for his smaller works, although in oil, indicate a miniaturist's skill.[5]

El Greco went to Spain around 1577 ("El Greco" is, in fact, Spanish for "the Greek"), having been attracted by the possibility of working for King Philip II, who was building the giant palace, El Escorial, about 26 miles northwest of Madrid. He was no journeyman painter, and the records show that El Greco was a well-trained humanist steeped in classical antiquity, able to read and write in Latin and ancient Greek as well as the Greek of his day. From 1577, El Greco lived and worked in Toledo in a building that partially exists today — and which is erroneously labeled his house (a few fascinating works are there).[5]

He received some important altarpiece commissions after he painted two large canvases for El Escorial — one an enormous scene of the *Martyrdom of Saint Maurice* (1580), notable for its brilliant yellows contrasting harshly with ultramarines. The king hated the painting and replaced it with another.[5] (Thank goodness, El Greco's masterpiece is now hanging in El Escorial.) That finished the royal patronage for the wandering Greek.

Because of his singular style of elongated figures, acid colors, and swirls of unreal atmospheric effects, Philip hasn't been the only person puzzled by his works. He's been called an astigmatic, a violent Mannerist, and even a painter who was the last of the Byzantines (see Chapter 6 for late Byzantine art). None of this makes sense — he crafted his personal style relatively free of strong influences and painted some of the most gripping and universally exalted paintings ever.

Here's my list of what should not be missed.

- ✔ *Burial of Count Orgaz* (1568-1588) in Santo Tomé in Toledo. I have chosen this, shown in Figure 9-5, as one of the best works of all time — see Chapter 20.

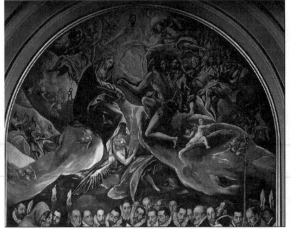

Figure 9-5:
Burial of
Count Orgaz,
(detail), by
El Greco.

Iglesia Santa Tome, Toledo, Spain/SuperStock

- ✔ *The Adoration of the Shepherds* (1612-14) in the Prado, painted for his own burial chapel, which is one of the most uplifting renditions of the scene ever painted.

- ✔ In the Metropolitan Museum of Art, the dreamlike *View of Toledo* (1595), in which he has completely rearranged the city into both a powerful abstract and realistic image with storms clouds that make you shudder with delight to see them. (See Figure 5 in the museum guide color insert.) His fragmentary *Vision of Saint John* (1605), where the evangelist is the perfect embodiment of the wild and traumatic visions of his Apocalypse. The portrait of *Cardinal Niño de Guevara* (1600) is electrifying. The ethereal, tensile-thin and powerful *St. Jerome* (1585) in the Lehman Pavilion is, along with the version in New York's Frick Museum, the most stunning concept of the great church father — wise, sympathetic, and full of humanity.

✔ Finally, in Washington D.C.'s National Gallery of Art, *The Laocoön* (1610-14) shows the grim Greek legend, in which El Greco may have become interested from his *Aenid* of Virgil, which was in his library. Laocoön of Troy was the brother of Aeneas' father, who had offended Apollo by breaking an oath of celibacy and having twin sons. Apollo, always anti-Trojan, was also furious at Laocoön's warning against accepting the Greeks' wooden horse. The enraged god sent two sea serpents after Laocoön and his sons, and the three were crushed to death. (See the Europe museum guide for details on the Vatican, where the Hellenistic statue of Laocoön of the 2nd century B.C. by Agesander, Polydorus, and Athenodorus is mentioned.) El Greco places the scene in front of the imposing walls of Toledo, and the work is at the same time full of fantasy and chillingly real — one can almost feel the crunching of the bones and experience the terror of the afflicted. See Figure 9-6.

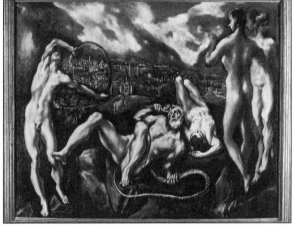

Figure 9-6:
The Laocoön, by El Greco.

National Gallery of Art, Washington, D.C./SuperStock

Chapter 10

The Baroque: The True Golden Age

In This Chapter

▶ The beginnings of Baroque art

▶ The greatest artists of the Baroque: Caravaggio to Rembrandt

▶ The Baroque in France: Puget and Poussin

▶ The special contribution of Velázquez

The style prevalent in the late 16th and 17th centuries is called Baroque. It's not known for sure who came up with the name, but it seems that it was intended to be something of a put-down. The word is related to the Italian word *barroco,* meaning a natural pearl of bizarre colors and grotesque shape.

The Birth of Baroque

Sometimes artistic styles form slowly — like the Renaissance. Sometimes they crack suddenly like an earthquake, shaking up everything around, ripping out all that came before by the roots. Such is the case with Baroque art. The artist responsible for the tremors was the Roman painter **Michelangelo Merisi da Caravaggio.**

Caravaggio

Caravaggio changed painting forever throughout the Western world by rendering his subjects in a naturalistic manner — warts and much more — and by treating the light and shade around his figures as violent contrasts of deep, brooding shadows and brightly illuminated areas. The technique is called *tenebrism* by art historians.

Caravaggio's finest works are in Rome, Malta, and the Louvre. But spectacular works are in Naples and the Kunsthistorisches in Vienna as well. In the United States, the pickings are slim, but there's one painting well worth a detour — in Hartford, Connecticut, at the Wadsworth Atheneum, his early *Death of Saint Francis of Assisi,* which is a scene of amazingly poetic sensibility.

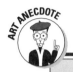

Artemisia Gentileschi

The role of women artists until the 19th century was meager, principally owing to the patronage of art by the church and the artists' guilds that were exclusively male oriented. One sensational Baroque artist was a woman, **Artemisia Gentileschi** (1593-1652), the daughter of Orazio (see the Vienna section of the Europe museum guide for one of his best). She was raped by her teacher and was tortured into giving evidence in the subsequent trial — a common procedure.[5] The most powerful in a series of strong, profoundly Caravaggesque works is in the Uffizi. It is an emphatically tenebrist painting showing the Old Testament story of Judith cutting the head off her enemy Holofernes with an enormous sword while a female servant helps hold down the victim.

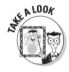

You can see Caravaggio's *The Calling of St. Matthew* in the main color insert of this book. (Be sure to also check out Chapter 21 as well as the museum guide section on Europe for more on Caravaggio.)

Georges de la Tour

Caravaggio's blend of raw realism and flamboyant light and darkness swept through Italy and Europe. In France, the painter from Nancy, Georges de la Tour, concentrated on Caravaggio's dramatic lighting to produce a host of exciting works. Among the most captivating are those in the Metropolitan Museum and the Louvre. In the Met, the amusing *Gypsies Fleecing a Dandy* in which a brain-dead, fancily-dressed and beribboned young heir is having his palm read by a troupe of gypsies who are actually stealing him blind. In the Louvre, the moody and startling *Saint Sebastian,* being tended to by the gentle woman who gingerly removes the arrows piercing his body, will never leave your mind.

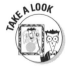

See Figure 11 in the museum guide color insert for *The Cheat with the Ace of Clubs.*

A decade ago, the Metropolitan's painting was proclaimed a fake with some very convincing points against it. But the authenticity was assured by the discovery of documents that proved the picture was in a private French collection many years before la Tour's identity was discovered (which happened only in 1935) and because of the presence of a paint never used after 1700.

The Caravaggesque Style Elsewhere

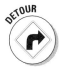

In Holland, the Caravaggesque style was taken up with enthusiasm by the first generation artists of what eventually would become known as the Golden Age of Dutch painting. **Gerard Honthorst** and **Hendrick Terbrugghen** were fervent followers. The finest surviving work by Terbrugghen is another *Saint Sebastian* in the Allen Memorial Art Museum at Oberlin College in Oberlin, Ohio and is definitely worth going out of your way to see.

In Spain, the style was deftly put to work by **José de Ribera.** I once encountered in the convent Palace of the Hospital de Tavera in Toledo, Spain, his most startling painting, which is in such perfect condition that it seems to have just come from his easel. The work has for hundreds of years been covered by a cloth and hidden away in a dark room. The reason is that the subject of the portrait is a Neapolitan woman who experienced a hormone change. The character, shown with a full beard and a perfectly formed naked breast, is nursing a babe. See Figure 10-1.

Francisco de Zurbarán is a fine Spanish tenebrist known for his gripping portraits of hooded monks. In the Wadsworth Atheneum in Hartford, Connecticut, one of his most emotional and beautifully painted works can be seen. The subject is an obscure saint, Serapion, who was martyred by being hanged upon a tree, and the moment chosen by the artist is the saint's last gasp. It is very well done.

The Flourishing of the Baroque

The Catholic church had a seminal role in the flourishing of the Baroque in the movement called the Counter-Reformation. At the Council of Trent (1545-1563), the Catholic Church codified sweeping self-reforms and clarified every doctrine contested by the Protestants. These included guidelines for artists on how to combine realism with religious sensibility.

Vast commissions were initiated to decorate churches throughout Europe with religious imagery intended to teach the masses about the faith and to draw them back into the church after the charges of corruption made by Martin Luther had diminished belief.

If one were to pull out one phrase to describe this gilded art age, it would be — the celebration of education. Most of the works of art are made to teach the faith in the most captivating way. The style is also exuberant, at times lusty, and often frighteningly realistic. It's as if the most capable artists/teachers in history were proclaiming to the world how to live and worship with an untrammeled sense of joy.

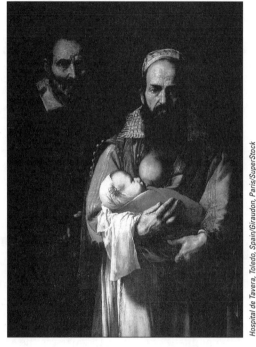

Figure 10-1:
Ribera's
*Bearded
Woman
Nursing.*

Hospital de Tavera, Toledo, Spain/Giraudon, Paris/SuperStock

Gianlorenzo Bernini

The center of the movement was in Rome and at the Vatican where the genius architect and sculptor Gianlorenzo Bernini literally transformed St. Peter's from an awesome yet somewhat forbidding house of God into an hospitable environment. His twin curving, beckoning colonnades reach out to the visitor like welcoming arms, and the space, once crowded with scruffy buildings, is a place where the glory of the Pope and the Church has been celebrated ever since.

To gain the full flavor of the Baroque, I recommend a tour of Rome looking only at the dynamic works of Bernini.

✔ St. Peter's, for the colonnades and, inside, Bernini's breathtakingly beautiful Baldacchino (1624-1633) soaring over the high altar. And its culmination — the Throne of St. Peter — is the most spectacularly theatrical part of Bernini's plan.

✔ For the pure orgasm of total faith, the famous sculpture of *Saint Teresa in Ecstasy* (1645-1652) in the Cornaro Chapel in the church of Santa Maria della Vittoria (see the main color insert for a view).

Baroque ceiling painting

One of the most dramatic painterly forms of the Baroque appears in vast and exceedingly dramatic frescoes filling the ceilings of certain churches, especially of the Jesuit order. In Rome, the Gesù is the most thrilling example. The painter **Baciccia** (1639-1709) painted in the vault of the long nave the triumph of the name of Jesus, a grandiose, and dazzling series of images which are full of movement and theatricality (1672-1685). The effects of perspective soaring into the vault which seems to explode into the stratosphere are simply marvelous.

✔ The sculptures in the Galleria Borghese of *Aeneas Carrying Anchises from Troy* and the violent and gorgeous *Pluto Taking Proserpina into Hell*, in which marble becomes convincing flesh and the action thunderous.

✔ *The Fountain of the Four Rivers* (of the then four continents, namely, the Danube, the Nile, the Ganges, and the De la Plata) in the center of the Piazza Navona, which, with its sweeping forms and athletic figures and beasts, might be said to provide the perfect visual description of the tangled, energetic, ever theatrical Baroque style.

Peter Paul Rubens

The 17th century, which some art historians call the artistic summit of Western civilization (I may be one of them), nurtured a uniquely long list of fabulous artists in part because of the constant and unswerving patronage of the church and wealthy art lovers.

One of the most gifted and exciting artists of all history, not to speak just of the Baroque Age, was Peter Paul Rubens of Flanders (modern day Belgium). (See Chapter 21, where I discuss Rubens as one of the most interesting artists of all time.) He was not only a painter of unequaled stature but he was also an accomplished diplomat (being a special ambassador for the ruling Hapsburgs in negotiating various peace treaties).

Rubens is sometimes criticized for his beefy women and overweight, red-nosed gentlemen, but that's unfair and probably comes from Rubens' followers and studio assistants of which he had plenty, for his studio was something like a painting factory. Besides, the canon of beauty of Rubens' time demanded fuller physiques.

The best possible places to see Rubens' grandest efforts are:

- ✔ The Kunsthistorisches Museum (Vienna)
- ✔ The Cathedral of Antwerp
- ✔ The Louvre (Paris)
- ✔ The Prado (Madrid)

Vienna has his incomparable portrait of his 16-year-old bride, Hélène Fourment clad only in a fur cape. Antwerp Cathedral (Rubens' hometown is Antwerp) is the home of three blockbusters by this master of the Baroque — *The Raising of the Cross* (1610-11), *The Descent from the Cross* (1611-14), and the emotional *Assumption of the Virgin* (1624-27).

My favorite works are the series of 21 giant oil paintings, each measuring an average 15 by 25 feet (4.6 m by 7.6 m), illustrating episodes in the tangled reign of Marie de Médicis as the queen of Henry IV of France, from 1589 to 1610 and regent for her son Louis XIII from 1610 until 1614.[5] (See Figure 10-2 as well as Figure 18 in the museum guide color insert for some samples.) They are in the Louvre in brand new quarters and look like a host of multi-million dollar Hollywood productions combining the diverse royals, nymphs, and Olympian Gods — the "A" list.

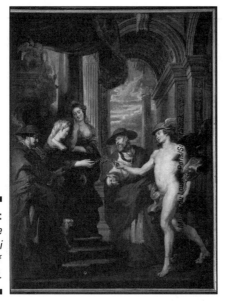

Figure 10-2:
Life of Marie de Medici (Treaty of Angouleme).

Rubens' landscapes of his beloved country estate, Het Steen (or the Château de Steen) rank with the finest ever created. The top three are in London — the Wallace Collection, the National Gallery and in the Queen's collection, which is beyond belief because it's so luminous.

Jan Vermeer

In the Netherlands, which had become monumentally wealthy from trade and banking, a host of sublime painters shone forth. As sometimes happens, one of the geniuses was not especially known or popular in his own day — for it seems he was a recluse. He came into prominence only in the late 19th century. This is the painter Jan Vermeer of Delft, about whom we know virtually nothing — meager notices suggest he was a humble man who often used his works as payment for his bills.[5] Yet he also painted the high life, and in some works, wealthy burghers pridefully show off their finery and jewelry. Along with his sparklingly clear and infinitely poetic images of humanity, he painted two known cityscapes. One is the *View of Delft* of 1660 (see also the Europe museum guide to Holland, the Mauritshuis in The Hague), in which the town clock registers the exact moment of the morning, 7:10, but in which the shadows appear to be relevant to every hour of the day. The second cityscape, *A Little Street* (1658) is in the Rijksmuseum in Amsterdam and is a tiny, gemlike rendering fairly pulsating with light. His figural subjects are marked by intense realism and an illumination crafted by brushstrokes that look like diminutive pearls.

His best figure studies are to be found in Washington's National Gallery, in the Metropolitan Museum, *Woman with a Water Jug* (c. 1665), and in the glorious Kunsthistorisches Museum in Vienna, the extraordinary self-portrait, in which we see the shy painter only from the back as he works on a painting portraying a model posing as the muse of *Art in the Allegory of Painting* (1665).

Not by Rubens?

In Toledo, Ohio, is one of the finest Rubens anywhere, the feathery and sweet *Adoration of the Magi* that the Metropolitan Museum was offered in the late 1950s and didn't acquire because the then chairman of the board of trustees thought it couldn't be by Rubens because its brushstrokes were so light and delicate. The director of Toledo, an ace collector, incredulous at the mistake, snapped it up immediately and easily substantiated its being a masterwork by Rubens.

Baroque landscape

The Baroque era produced some distinguished landscape painters — other than Rubens, who still seems to be the ace of the lot. In Holland I'd single out **Jacob van Ruisdael** (1628/29-1682) and his grandest work titled *Jewish Cemetery* (1660), which is in the gallery of old masters in Dresden (there's also a lesser, yet interesting version in the Detroit Institute of the Arts). The lovely picture with a gifted rendering of atmospheric effects is dominated by the presence of three ruined tombs, and in just the right way, makes a poignant statement about how quickly man-made things fade away.

His pupil, **Meindert Hobbema** (1638-1709), preferred quieter scenes of the country-side with many trees and shafts of the sun illuminating the darkness with pleasing intensity. For an excellent example, travel to London, to the National Gallery and his *Ruins of Brederose Castle* (1671).

Rembrandt van Rijn

The prince of painters of the Dutch Golden Age is Rembrandt van Rijn (see Chapter 21, where he is listed as one of the all-time most interesting artists). Upon the head of this supremely gifted artist — and wholly disreputable man — not enough praise can be heaped. Yes, he stole his first wife's dowry and yes, he cheated on his taxes and seldom paid his bills and died a pauper, yet his twisted personality and vile actions only enhanced his work (which seems always to be the case with art geniuses). There has never been an oil painter like him and never will be. His etchings rival the engravings of Albrecht Dürer. In the power and quickness of his drawings he has never been surpassed — even by Leonardo da Vinci.

If I were going to make a world tour only to see Rembrandt, these are the works I'd visit.

- ✔ In the Getty Museum, the recently acquired (for $36 million) early landscape *Rape of Europa* (1636), in which the luscious colors reflecting from the azure, pink, and silver dresses shine like precious stones under candlelight in the tumultuous waters where Jupiter takes the not-so-frightened young nymph.

- ✔ In Krakow, the lovely landscape, *The Good Samaritan*. Storm clouds have seldom been painted with such loving care.

- ✔ The Louvre's *Bathsheba Reading the Letter from David*. The lovely naked woman reads King David's love letter and knows the agony and the ecstasy of her coming life, the murder of her husband, and the love of the king.

- ✔ In the Rijksmuseum, the *Anatomy Lesson of Dr. Nicolaes Tulp* (1632) and *The Jewish Bride* (c. 1665). Clear, enlightened, and stunning images of all mankind.

✔ *The Return of the Prodigal Son* (c. 1665) in the Hermitage Museum, St. Petersburg. No biblical scene has ever been depicted with such a sense of bravado and poignancy. See Figure 10-3.

✔ His 1652 self-portrait in the Kunsthistorisches Museum in Vienna showing him as a briskly confident middle aged man at the pinnacle of his powers, still wealthy, still handsome, yet in those deep eyes a sadness of the life to come.

✔ Finally, the self-portrait in the Frick Museum in New York, a wreck of a man, still with a spark of defiance and a twinkle of delight in his eye, perhaps thinking about his next financial scam. (See Figure 10-4.)

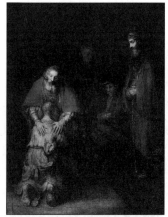

Figure 10-3:
*The Return
of the
Prodigal
Son.*

Hermitage Museum, St. Petersburg, Russia/SuperStock

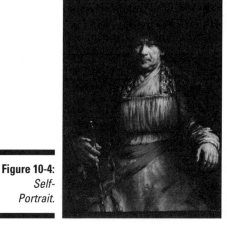

Figure 10-4:
*Self-
Portrait.*

Frick Museum/SuperStock

Baroque Tendencies in France

In France, the Baroque style expresses itself most powerfully in architecture and sculpture. Architect **Louis Le Vau** was the best. He created for Nicholas Fouquet, Louis XIV's finance minister who was toppled because of his arrogance, a startlingly fresh chateau at Vaux-le-Vicomte in which elements of the Pantheon and rusticated Florentine Renaissance palaces are combined into a new stage setting of surprisingly entertaining luxury, a lushness with heart, soul, and wit. When in France, a visit to this charming place, which isn't that far from Paris by rented car, is almost mandatory, and the proprietor, Count Patrice de Vogué, is the very symbol of hospitality.

Le Vau also helped design the palace of Versailles, the building of which continued into the 18th century and which is an exercise in pure architectural exaggeration. I must admit I have to suppress a groan when I think about spending the countless hours needed to get just a glimpse of Versailles and the interiors.

Pierre Puget

For Baroque French sculpture there's the exceptional and often overlooked master, Pierre Puget, who worked primarily in Marseilles and Toulon, where his *Caryatids* holding up the entablature at the City Hall are marvelous quotations of the ancient Greek statues of human beings becoming part of the architectural construction — something that delighted Baroque artists.

In the New Louvre, Puget's most exciting work, a huge marble representing *Milo of Crotona* (1671-1684), dominates the second enclosed courtyard (see Chapter 22 for the guide of Paris and the Louvre). Check out Figure 17 of the museum guide color insert for a view of this work. The classical tale depicted is something of a horror story — for Milo, a champion strongman and hunter of ancient Greece, tried to split a tree trunk with his bare hands. But he got caught when the wood snapped back on his hand and along came a lion, and the rest Puget leaves, thankfully, to our imaginations. This is sheer energy and the most gripping drama.

Nicholas Poussin

One of the finest painters in French history flourished during the Baroque period, and he wasn't very Baroque, indicating that generalized names for artistic movements can go awry. This is the great classic painter Nicholas Poussin who was a relative bust in his homeland, working two years as court painter to Louis XIII and achieving little during the time. He spent almost his entire life in Rome and managed to bring together the spirit of classical

antiquity and a range of delicate colors that have seldom been equaled, plus an invention of subject matter in both religious and mythological areas that is unparalleled.

His early work in Rome, in which he tried to emulate the Baroque splash of his Italian colleagues, was looked down upon and for good reason. It's fun to go to the Vatican Museum and see his early bomb, the stilted and quite horrid *Martyrdom of Saint Erasmus*, who was done in by having his bowels slowly taken from his body by a windlass. The painting is bland and doctrinaire.

Then under the careful patronage of Rome's most influential man, the secretary to the all-powerful Cardinal Barberini, who was a lover of all things classical, Poussin found himself and until his death created heavenly scenes from Roman history and the Bible. I would single out the following as his most exciting achievements:

- ✔ *The Rape of the Sabine Women* (1637) in the Metropolitan.

- ✔ *The Four Seasons* — four large paintings (see Figure 10-5 for one of these seasons) — and his penetratingly beautiful *Self-Portrait* in which Poussin's direct gaze and the rectilinear arrangement of various picture frames in the immediate background make him look like a modern version of an ancient Greek super-master.

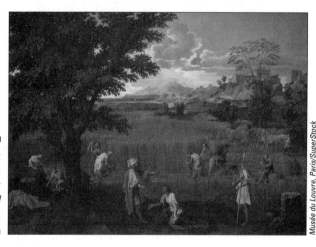

Figure 10-5: Poussin's *Summer,* or *Ruth and Boaz.*

Musée du Louvre, Paris/SuperStock

Poussin was dedicated to reason as the foundation for art, but his figures are never lifeless or drab, even though they draw upon Raphael and the antique for inspiration. Intellectual, even somewhat arrogant, his compositions nonetheless are lyrical and never to be forgotten.

The Best of the 17th Century: Diego Velázquez

Who else but the Spanish master Diego Velázquez is the best of the finest of the entire, glowing 17th century? (See Chapter 21 for the story of his life.) He brought together the verve and theatricality of the Baroque style, the cunning and subtle colors of the Venetian Renaissance, the stark realism of Caravaggio, the rational compositions of the ancients and cooked up, as if by an alchemic miracle, the most sinuous and compelling painterly style in world history.

To see Velázquez, go to the Prado in Madrid, certainly, especially for *Las Meninas* (1656) and *The Surrender of Breda*, and the portraits of court dwarfs, so brimming with humanity. (For a view of *Las Meninas,* see Figure 39 in the museum guide color insert.)

But the Kunsthistorisches in Vienna has some excellent works, particularly the portraits of the Infanta; and these, unlike many at the Prado, which have not been cleaned very carefully over the years, are in matchless condition. London is also a Velázquez showcase. The *Rokeby Venus* in the National Gallery is an ever-mysterious view of the nude Venus (or some gorgeous young lady) coyly looking at us, the viewers, by means of a mirror held by an enchanting Cupid. In Apsley House, the house-museum of the Duke of Wellington, there's an early painting showing a *Water Seller* who has by his side a huge terra-cotta jar glistening magically with beads of moisture. It's a tour de force and an act of painterly genius, just like every work Diego Velázquez created.

My personal favorite has to be the portrait of *Juan de Pareja* (1651) at the Metropolitan, a portrait of his friend and traveling companion who was a young handsome Moor (see Figure 6 in the museum guide color insert). The master dashed off the unbelievably realistic work, as he said (no doubt to cause a stir), to limber up his fingers and to impress the Italian authorities so he could gain the commission to paint Pope Innocent X. I was able to buy the work at auction in 1971 for a robust $4.5 million after several acts of mild skullduggery, during which I was able to find out the exact figure our main competition was going to spend at the auction — then it was easy to go just one bid more. (Be sure to see the section on Rome in the museum guide section on Europe.)

Once the portrait was finished, Velázquez had Juan de Pareja carry it from studio to studio of the most illustrious Italian painters, knock on the door, and stand holding the canvas in exactly the same pose. The reaction was explosive. One artist remarked, "I didn't know to whom to speak, the man or the painting, or which would answer." The Pope was dazzled, too, and soon asked Velázquez to paint his portrait. This work is hanging in a gallery by itself in the private painting gallery of the Doria-Pamphili family in Rome

(which is open three days a week), and the Velázquez is an absolute must. When one enters the special room where the Pope is displayed, it's hard not to go down on bended knee before this awesome pontiff. When I first saw it, I was convinced that the Pope would order me to "speak up, speak!"

Chapter 11

The Sparkling 18th Century

In This Chapter

▶ The Rococo in France

▶ German and Italian contributions

▶ England comes alive

▶ America's early efforts

*I*f the 17th century was the Golden Age, the 18th century can be considered the Diamond Age, sparkling, multifaceted, and perpetually glittering. The predominant style is often called the Rococo.

The 18th century marked the deepening appreciation of so-called "Primitive Art" — the art of Africa, the Pacific Ocean civilizations, Latin America, and even the Native Americans. German art made a powerful impact, and Italy soared once again after the glory days of the Renaissance. America the Beautiful started its long and exceptionally fruitful artistic journey.

France and the Rococo Style

If you read standard art history and if you're not willing to look to the far horizons of 18th-century art and explore boldly, it might seem that the only art in France was made for indolent, self-indulgent kings, queens, and royal mistresses. It was more subtle than that and, at times, even possessed what you might call a common touch.

The word *rococo* is a fanciful treatment of the French word "rocaille" or "pebble-work" and refers to the intricate curlicues and scallop shell-and-scrollwork of the time. In the 19th-century the term was faintly derogatory, meaning tastelessly florid or overly ornate decoration.

French art of the 18th century surely is, in general, light and airy, frilly and bejeweled. Much, yet not all, was created for a very rich and excessively indolent powerful aristocracy and a wealthy upper-middle class. But that doesn't mean that it couldn't at times be profound.

Jean-Antoine Watteau

The greatest artist of the first half of the 18th century was Jean-Antoine
Watteau, who died at only 37 from tuberculosis. He was a child prodigy
whose giant talent never dulled for a second. Watteau specialized in depicting
what art historians call fêtes galantes, scenes of dreamy amusement and styl-
ized indolence in a mysterious, slightly melancholy world populated by
people dressed in shimmering satins who flirt and play gracefully in Garden
of Eden surroundings. One triumphant example is in the Louvre, titled *The
Return from Cythera* (1717). They are leaving after visiting Cythera,
Aphrodite's legendary island of love. The image speaks about the pain of
leaving, the interrupted tryst. But I think it may also be an allusion to the
approach of death. (See Figure 11-1.)

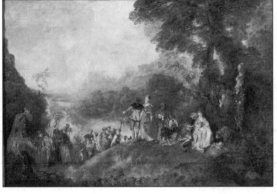

Figure 11-1:
Watteau's
*The Return
from
Cythera.*

Musée du Louvre, Paris/ET Archive, London/SuperStock

His life-size painting of an actor-comedian from the Italian Commedia
dell'Arte, *Gilles* (1718), also in the Louvre, is frilly and satiny, but is at the
same time a powerful portrayal of the classic amusing-yet-infinitely-sad
clown.

Watteau's most captivating work is in the Charlottenberg Palace in Berlin. It's
a large sign he created for his lifelong friend, the art dealer, Gersaint (c. 1721).
One sees a painting of King Louis XIV being stored away, as if to signal the
end of the remarkable era.[5] The true subject of this large and magnificent oil
painting — probably more a symbolic sign than one intended actually to hang
out-of-doors — seems to be the art of painting itself. It's as if Watteau were
consecrating his own art to eternity, for he would die very shortly after creat-
ing it.

In the United States, there are a number of Watteau's fabulous drawings in major collections and one delightful picture the size of a playing card in the Kimbell Museum in Fort Worth, Texas. This shows an impoverished young artist, his clothing full of holes, hunched over, his back to the viewer, painfully attempting to sketch some scene. It is a grand statement about the agony of creating any art.

Watteau had a number of followers, some of whose works are conveniently attributed to him, who successfully depicted the fêtes galantes, the likes of **Jean-Baptiste Pater** and **Nicholas Lancret** who, in some instances, almost surpassed the master. Fine examples of their works can be seen in London's Wallace Collection, which may be the prime site for 18th century French paintings of the Rococo style.

François Boucher

The predominant artist of the next generation in France was François Boucher. He could do it all — he was an engraver and the director of the Gobelin tapestry factory, which produced acres of exceptional tapestries. His first accomplishment was to engrave one hundred and twenty-five drawings by Watteau, and thus he became immersed in his style.[5] Boucher became "first painter" to King Louis and was frenetically active in the post. Most of his works are fashionable portraits of aristocrats, mythological paintings, and pastorals.[5] Of compelling quality are two small pictures (definitely by Boucher) depicting seasons in the Walters Art gallery in Baltimore.

Boucher's work is seemingly endless — beware, for there are many non-Bouchers out there because he was faked a great deal and had a large workshop during his heyday.

Jean-Honoré Fragonard

Boucher's most talented pupil and a man who would, in time, far surpass the master, was Jean-Honoré Fragonard. He retained Boucher's frivolous, giddy style and those light-hearted subjects, yet developed into a grand master of painterly techniques, transforming his brushstrokes into dense thickets of powerful, agitated lines marked by vibrant colors. Two works stand out above all others. One is the often-reproduced, *The Swing* (1766), in the Wallace Collection in London. (See Figure 11-2.) This is the one in which the charming young woman swings far up and out in the forest literally exposing her charms to her hidden lover while a man who has been identified as her dullard husband pulls the cord that makes the swing move.

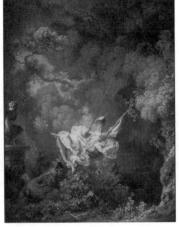

Figure 11-2:
Fragonard's
The Swing.

A.K.G., Berlin/SuperStock

In the Frick Museum in New York, there are the four paintings called *The Progress of Love* (1770) intended to decorate the fancy Pavilion de Louveciennes erected by Mme du Barry, the king's mistress. The imperious woman who was the prime French tastemaker of the second half of the 18th century disliked them for their busy-busy, whirligig Rococo style, which was at odds with the straitlaced and subdued neo-classical style of her palace. Fragonard's remarkable star faded after the Revolution, and he ended his life in the shadows, painting a series of pictures with moralistic subjects, which was rather ironic for the man had fallen passionately in love with his wife's 14-year-old sister.

Painters of the middle class

In 18th century Europe, even during the glory years of the aristocracy, there were artists who painted the middle class and humble scenes of the family. One was a Swiss artist who specialized in pastels, **Jean-Etienne Liotard.** He was called "the Turkish painter" because he insisted on wearing outlandish costumes he'd become fond of while painting in Constantinople.[5] His works are rare and extraordinarily beautiful. There are scads of Liotard's fine pieces in Dresden and one great one in the new Getty Museum, a captivating portrait of delightful 7-year-old, Maria Frederike van Reede-Athlone, dating to around 1755. By the way, pastel-making was equal in importance to oil painting. The most accomplished master was **Maurice Quentin de la Tour,** who depicted the aristocracy and influential clerics and officials. In the Getty Museum is a splendid example of his gifted work — it's also thought to be the largest known pastel as well — a portrait of an arrogant nobleman.

Another of the genre painters who worked both for royal patrons and for middle class clients was **Jean-Baptiste Greuze,** whose works possess a glowing finish. One fine painting is in Fort Worth's Kimbell Museum, a portrait of a young woman. it's entitled *Simplicity* (1759) and depicts a young maiden pulling off the petals of a daisy in the time-honored gamble of learning if her love will be reciprocated. The companion piece (in the Petit Palais museum of Paris) shows a young shepherd lad about to blow on a dandelion gone to seed.

Another French painter of great interest is **Jean-Baptiste-Siméon Chardin,** whose still-lives and scenes of everyday life are gentle, poetic, and universally compelling. Two marvelous paintings are in the Louvre — *Pipes and Drinking Pitcher* (1737) and a wonderful study of a maid who has just returned from market laden down with provisions, *The Return from Market* (1739). See Figure 11-3 and Figure 11-4.

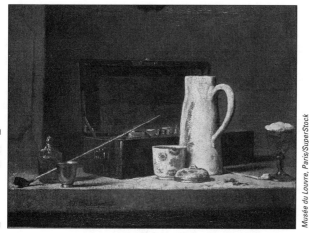

Figure 11-3:
Chardin's
Pipes and Drinking Pitcher.

Musée du Louvre, Paris/SuperStock

French sculpture

There were a large number of accomplished sculptors in France during the 18th century working ceaselessly to decorate sumptuous chateaux and gardens. One of the standouts is **Etienne-Maurice Falconet,** who was, in addition, the chief sculptor at the royal porcelain factory at Sèvres. His most monumental work was done for Czarina Catherine the Great in St. Petersburg, a monumental bronze equestrian portrait of Peter the Great rearing up on a great stallion, dating to 1778.

Figure 11-4:
Chardin's
*The Return
from
Market.*

The other premier sculptor of 18th century France was Claude Michel, better known as **Clodion.** He specialized in terra-cottas (low-fire ceramics), and his signature style is a highly-finished, intricately-worked combination of realism and idealism that teeters on — but never falls over — the edge of the saccharine. There's a triumphant example of his work in the Walters Art gallery in Baltimore, a small terra cotta with the delightful yet incongruous subject of a young woman Satyr carrying two Putti. In Paris, the Louvre has abundant examples of his work (see Figure 11-5). And don't miss the seldom-glanced-at small Triumphal Arch of the Carrousel of 1798, which carries his fascinating relief depicting the entry of the French into Munich.

Figure 11-5:
*Penitent
Mary
Magdalene,*
by Clodion.

French decorative art

France was noted for its excellent decorative arts, and the porcelain, furniture, costumes, and jewelry often attained heights of quality equal to painting and sculpture. Some Sèvres porcelain (lots of it is cloying) is marvelously delicate and perfectly proportioned and decorated with gemlike colors. By far the best Sèvres in the United States is to be found in the Walters Art Gallery, and I must admit that my lifelong aversion to Sèvres was dramatically changed by a visit to this rich collection.

French furniture of the *ancien régime* has become frightfully popular since the 1960s, and sums well into seven figures are spent for pieces by the likes of Roentgen, Carlin, Molitor, Oeben, Riesener, and Weisweiler. Amusingly, they were not French but Germans who established workshops in Germany or in Paris to make furniture for the wealthy French aristocrats.

The top furniture maker was **David Roentgen.** No less an art connoisseur than Goethe, the great German 18th century writer, philosopher, and connoisseur, called his cabinets, "palaces in fairyland." His workshop in Neuweid, a port on the Rhine north of Koblenz, made furniture, clocks, and musical instruments for Louis XVI and Marie Antoinette, Pope Pius VI, and Catherine the Great. Roentgen excelled at *trompe l'oeil* marquetry, that is, pieces veneered with bits of ivory or wood — Caribbean mahogany, ebony, cherry, walnut, rosewood, beech, birch, and maple — in the form of pictures. The casework was enhanced with ormolu mounts, inlaid brass flutes, and brass fillets. The feeling was not overly-ornate Rococo but a pure and crisp neo-classicism, which was the first breath of modernism.

The Metropolitan boasts a superior collection of French 18th century furniture, but the most breathtaking example in America, I believe, is in the Walters Art Gallery. It's a perfect model in wax, wood, and paper for a jewel cabinet given by Louis XV to grace the wedding of the future Louis XV and Marie Antoinette.

Germany and the Rococo

Banner works of the Rococo style were created in Germany. One major stylist was the architect and designer **Johann Balthasar Neumann,** who created the magnificent church of Vierzehnheiligen (literally, the 14 saints, meaning those who were believed to come to the aid of people of need) built over the decade 1743-53 near Würzburg. There is nothing in Christendom like Neumann's ingenious use of domes and barrel vaults to create amazing round and oval spaces.[5] The walls and the bearing columns are disguised, diminished, or opened up to create startling and often playful effects while also being harmonious and symmetrical. Daylight streams into the church

through huge windows. Seeing this church will be an unforgettable artistic experience. The Archbishop's Palace at nearby Würzburg, is in part a Neumann design. The massive ceilings of the building are painted grandly by the Italian 18th century super-master Giovanni Battista Tiepolo and is another must-see. (See the Europe museum guide for more information.)

Sadly, the clever German 18th century sculptors who worked primarily in wood, lavishly painted, gilded, and silvered, have never received the credit they are due by non-German art historians. But for sheer splash, explosive drama, the visual punch of the sharp cutting of jagged draperies, and an almost unbelievable delicacy of paint and gilding, the wooden sculptures of the genius **Ignaz Günther** have no equal in art. In Munich's Bürgersaal, you can see his monumental sculpture dating to 1763 of a so-called Guardian Angel that very well might have you reassess everything you know about sculpture.

The Impact of Italy

For the 18th century in Italy, Venice was the artistic capital and, with **Tiepolo,** her artistic influence spread widely throughout Europe.

Piazzetta and Tiepolo

First, there's Giovanni Battista Piazzetta whose vivacious figures and electric colors are best seen in the fresco of the ceiling in the chapel of the Sacrament in Saints Giovanni and Paolo created in 1732.

Piazzetta profoundly influenced Giovanni Battista Tiepolo, who is probably the quintessential artist of the entire 18th century. His figures possess lovely lines and proportions, and his colors have a depth and an inner glow that have never been surpassed. The amazing thing about Tiepolo is that his vast fresco works show the same attention to detail as his small, intense studies. My idea of the most ideal art trip would be to go to Venice and Würzburg and spend a month looking only at Tiepolo's incomparable paintings. Then again, I might just spend the entire month in Würzburg gazing at his grand frescoes.

Caneletto, Guardi, and Belotto

Venice of the 18th century also gave us three of the most enchanting land-scapists in art, Giovanni Antonio Canal or Canaletto, Francesco Guardi, and Bernardo Bellotto. The first captured the imagination of the collecting world from the 18th century until today with his sharp and luminous views of what

is the most intriguing city in Europe, many of them painted out-of-doors, which was rare until the coming of Impressionism.

Guardi (who is, by the way, the most-forged artist in history) perfected a style that is fuzzier and more poetically atmospheric than Canaletto's.

Bellotto's works, which I happen to favor more than those of Canaletto, are sharper and darker in tones than his uncle Canaletto's and are so accurate that his lovely series of paintings of Warsaw were extensively used after WWII to restore the historic town.[5] Both the National Museum of Warsaw and the Hermitage possess unforgettable works by Bellotto. In America, by far the most resplendent work by Bellotto is in the Getty Museum, his sweeping *View of the Grand Canal Santa Maria del Salute and the Dogana from Campo S. Maria Zobenigo* (1740), which is so fresh it looks like it just came off his easel.

English Contributions

17th century painting in England had been lackluster, except for the happy arrival from Flanders of **Anthony van Dyck** and **Rubens.** England came alive in the 18th century and produced some giants and unparalleled treasures.

William Hogarth

My favorite, the maverick and full-time curmudgeon (he angered virtually the entire art establishment) William Hogarth, was the kind of painter who cannot be categorized. His raucous scenes of life in teeming London and his entertaining satires of the customs of the nabobs will live forever. I particularly admire the seven-part series of oil paintings entitled *Marriage à la Mode* in London's National Gallery, which shows what happens to a rich young merchant's daughter and a young lord, very much a "lordy" but very strapped for cash, she marries. Nothing good, which is depicted in the most exuberant and amusing manner. (See Figure 11-6.)

Thomas Gainsborough

Few painters hit the heights attained by Thomas Gainsborough. His *Blue Boy* ranks among the most appealing five or so portraits ever created — it's in the awesome Huntington Art Collections in San Marino, California (see Figure 11-7). Nor will there ever be a more charming portrayal of proud, young landowners like his flashing *Robert Andrews and His Wife* in the National Gallery of London (see Figure 11-8).

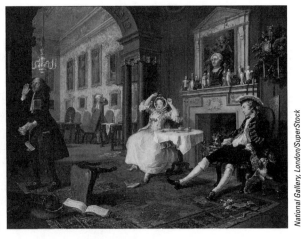

Figure 11-6:
Hogarth's
*Marriage à
la Mode*
(Early in the
Morning).

National Gallery, London/SuperStock

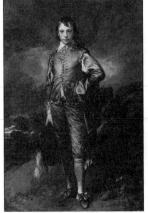

Figure 11-7:
Gains-
borough's
Blue Boy.

The Huntington Library, Art Collections, and Botanical gardens,
San Marino, California/SuperStock

English decorative arts

Eighteenth century England was also the home of some exceptional creators
of the decorative arts, among them **Thomas Chippendale,** whose book pub-
lished in London in 1754, *The Gentleman and Cabinet-Maker's Director,*
brought about a revolution in furniture design. His classic modern chair was
based on a Louis XV type but was very English, having much more verve.
This is the broad-seated ribbonback chair with a back rail in the form of a
cupid's bow and with the pierced center support in the back composed of
carved interlacing ribbons.

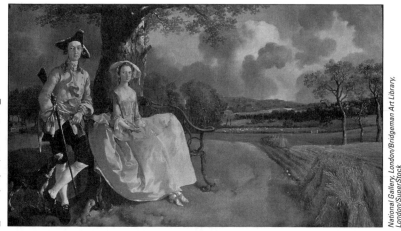

Figure 11-8:
Gains-
borough's
*Robert
Andrews
and His
Wife.*

*National Gallery, London/Bridgeman Art Library,
London/SuperStock*

The Emergence of America

Finally, in the 18th century, America was just beginning to emerge with her first generation of gifted artists and designers. Prime among them was **Thomas Jefferson** and another was, surely, that legendary Revolutionary War hero, **Paul Revere,** whose silver stands on a par with that of the best crafts-men of Europe. Revere's portrait in Boston's Museum of Fine Arts, brilliantly painted by the American **John Singleton Copley,** shows him looking out with a most appealing direct and no-nonsense look, the very spirit of the New World with its egalitarian form of government.

I would single out as the premier American painter of the 18th century the somewhat slighted **Gilbert Stuart,** who has been the butt of casual jokes about how stiff he portrayed his principal sitter, General George Washington. Not true. Born in Newport, Rhode Island, trained in England, he came under the influence of his teacher the American neoclassicist, **Benjamin West,** but, thankfully, even more under the sway of Thomas Gainsborough. His portraits of Washington are accurate, graceful, and exceptionally deft, especially for their lightly-applied and subtle colors. The best one, to me, is the unfinished study of the head of the President in the Boston Atheneum dating to 1796. In Washington's National Gallery, there's a smashing portrait of *Mrs. Richard Yates,* no beauty, but a dynamic human being. The small but excellent museum in Worcester, Massachusetts, has a superior portrait of *Mrs. Perez Morton.*

The End of the Rococo

The joyful 18th century came to a crashing end with the French Revolution and with the subsequent rise of the neoclassic style. The major artist of neoclassicism and the man who chronicled the death of the *ancien régime* was the remarkable Jacques-Louis David, who was a member of the dreaded revolutionary council that signed the death warrants of those who were dragged off to the guillotine. In 1793, he painted the unforgettable scene of the *Death of Jean-Paul Marat,* a friend of Robespierre and a supporter of the Reign of Terror and the worst demagogue the revolution of 1789 produced. He was stabbed to death by a disillusioned young woman, while in his bathtub, where he spent most of the day treating a skin disease. After he was killed, his adherents celebrated him as a martyr, and David, his friend, painted the grisly portrait and presented it to the National Assembly. It became the symbol of the Revolution, with copies placed in churches and public offices. The painting is in the Musées Royaux des Beaux-Arts in Brussels.

Jacques-Louis David and Mme Lavoisier

The Metropolitan possesses one of Jacques-Louis David's greatest pictures, the life-sized portrait of the scientist Antoine Laurent Lavoisier and his adorable wife. I was able to acquire it for the museum by appealing to the tender feelings of the wife of a wealthy patron who had brusquely refused to come up with the $4 million necessary to purchase the painting from the Rockefeller collection. His wife, a trustee, apparently didn't know of the turndown and so I sadly showed her a slide of the David (projected to the exact size of the original) and explained that the museum had just run out of funds. Tears came to her eyes. I sat in my office watching the clock, figuring how long it would take her to limo home and talk to her husband. In just the time I expected, the phone rang, and it was the patron with the $4 million in hand.

David was secretly in love with Lavoisier's comely wife and began to pursue her moments after the scientist was guillotined. It's fascinating that the only time ever a death warrant was signed by less than the five revolutionary tribunal members — it was mandatory to have all five — was in the case of Lavoisier's murder. Of course, Jacques-Louis David's was the missing signature. Luckily, Mrs. Lavoisier escaped to England before the painter got her in his clutches.

Chapter 12

Neoclassicism and the Romantic Twinge

In This Chapter

▶ Neoclassicism takes hold of the late 18th century

▶ The reaction that was Romanticism

*N*eoclassicism and Romanticism used to be considered artistic opposites, even enemies. The former was thought to portray the absolute truth of life as seen through the mirror of the "pure and simple" verities of ancient Greece. The latter was believed to depict reality through images of the wild and raw emotions that prevailed in the turmoils after the Revolution. Today, these seemingly disparate styles are recognized as being two sides of the same coin.

Neoclassicism

Neoclassicism was a word coined in the 1880s to describe the style born in the mid-18th century that toppled the Rococo and which was the last "renascence" of the classical tradition in art. To its proponents, Neoclassicism replaced the frivolity and superficiality of the Rococo (see Chapter 11) with an art of all-encompassing seriousness and moral commitment. The movement was a profoundly educational one, for its devotees believed that the fine arts could — and should — spread knowledge and enlightenment. Romanticism followed soon after and flourished from the early 19th century until the advent of Impressionism. Neoclassicism has never entirely vanished, nor has Romanticism. Most recently in history, it cropped up as the official Aryan style of the Nazis and Fascists and even more recently in the modern works of the purist architects (like Meis Van Rohe and Richard Meier), who insist on order beyond all else.[6]

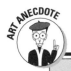

Winckelmann and the Greeks

An influential art historian, Johann Joachim Winckelmann, gave birth in the mid-18th century to an acute awareness of Greek art and civilization with the publication of a poetic, emotional, and persuasive volume on the nobility of Greek life and art. He saw in Greek sculpture a noble simplicity and quiet grandeur and called upon artists to imitate the Greeks. In 1755, he asserted that the only way for the moderns to become great was by imitating the ancient Greeks.[5] At once, everything had to be "ancient."

The 18th century "renascence" of Neoclassicism differed from earlier revival movements and even from the High Renaissance, which was unique in that it fully recognized that both Greece and Rome had died and should be resurrected. This 18th century one was stimulated by an unprecedented range of publications about a flood of scientific archaeological discoveries in Pompeii and Herculaneum in southern Italy, in the eastern Mediterranean, in Egypt, and in the Near East. The digs made people realize that the antique world was far more complex than just Rome or Greece and included ancient Persia, Egypt, and even the medieval and the Oriental worlds. Antiquity was no longer regarded as finite, either in time or place. The fresh discoveries evoked powerful emotional and romantic responses to the past, and for that reason, Neoclassicism must be understood as a part of the broader movement of Romanticism.

Among the intellectuals of the period, there were often bitter struggles over which ancient model was purer, Rome or Greece. The amazing discoveries of entire frescoes and virtually intact bronze furniture at Pompeii and Herculaneum prompted in art wholesale evocations and interpretations of all things Roman. But Greece — especially with the discovery of the Archaic Greek Doric temples at Paestum in south Italy — became dominant.

Note: Although Neoclassic style is closely linked to the French Revolution, the fading aristocracy toyed with it — Mme du Barry had her new château decorated by Fragonard created in the new pure Greek style, and even Marie Antoinette played a simple shepherdess in a pavilion that possessed a Greek aura.

Jacques-Louis David

The very symbol of Neoclassicism was the French painter Jacques-Louis David. In his formative years, he pooh-poohed the antique, saying that it

lacked liveliness, but after an extended trip to the new archaeological sites in Italy a few years later, he felt he had seen the true clear light of the ancient past.[5]

His most famous early Neoclassical work is the *Oath of the Horatii* (1785) in the Louvre, which depicts the solemn moment, laden with stoicism and courage, when the three Horatii brothers, swords held in the air, face their father, and offer their lives to guarantee victory for Rome in a war with Alba. The frieze-like placement of the figures in an archaeologically correct interior with the details of armor and furniture seemingly drawn from the pages of an excavation report is the essence of the Neoclassic style and made enormous waves through France and the world. (See Figure 12-1.) David became a cult hero — he was even called an art Messiah. He followed this triumphant work with the *Death of Socrates* (1787) in the Metropolitan Museum in New York, which shows the rugged stoicism of the philosopher at the moment he drinks hemlock and dies. From this moment, antiquity became the rage — every up-to-date house had to have Pompeiian style furniture or wallpaper, and certain young, fashionable women even took to exposing one of their breasts in homage to the similarly-dressed Sabine women in David's famous painting in the Metropolitan, the *Rape of the Sabines* (1799).[5]

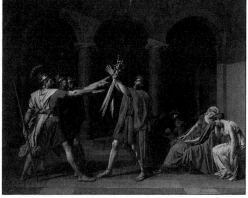

Figure 12-1:
David's
*Oath of the
Horatii.*

Musée du Louvre, Paris/SuperStock

In the early years of the Revolution, David was a member of the extremist Jacobin cell led by the madman Robespierre and was elected to the National Convention in 1792, where he voted for the deaths of Louis XVI and Marie Antoinette.[5] He made a drawing showing the unfortunate queen, face drawn, back stiffened like a ramrod, sitting with bound hands in the cart taking her to the guillotine — it's in the Louvre.

When Robespierre got his at the guillotine, David was imprisoned several times. Yet, after Napoleon wrested power, David became his prime art propagandist, painting the enormous work now in the Louvre, *Napoleon Crowning the Empress Josephine* (1805-07). After Napoleon's fall in 1815, David was exiled to Brussels.[5]

The reach of Neoclassicism

The style consumed Europe and America and is one of the most indelible (though faintly stiff) artistic signatures ever created. It shows up in French furniture designed by the German **Jean-Henri Riesener,** in the Petit Trianon at Versailles designed by **Ange-Jacques Gabriel,** which is a masterpiece of geometric harmony and restraint, in the Pantheon in Paris by architect **Jacques-Germain Soufflot,** and in English architect and designer **Robert Adam's** extraordinary Syon House (1760-69) near London, where Greek and Roman decorative elements were manipulated to become a contemporary example of aristocratic purity and opulence. The prolific designer of porcelain and ceramics, **Josiah Wedgwood,** adored the Neoclassic style and borrowed extensively from Greek vases, Etruscan bronzes, and Roman cameo glasses for inspiration.

Antonio Canova

Sculptors enthusiastically embraced the Neoclassic style. The foremost proponent of it was the sculptor Antonio Canova. His fame was assured after he executed for the church of the Apostles in Rome Pope Clement XIV's tomb in a vivid "Greek" manner with a striking nude young man as the symbol of the ancient "genius of death." His most famous image is the sculpture in the Villa Borghese Museum in Rome, the portrait of *Paolina Borghese Bonaparte* (1804-8), Napoleon's sister, as Venus Victorious lying back on a Roman bed. The figure is sensuous, captivating, soft, and truly sensational.

In America, Canova's best piece is an over-life-sized marble at the Metropolitan Museum, *Perseus with the Head of Medusa.* Finally, for sheer pomp and size and political bravado, see the huge white marble naked statue of Napoleon depicted, ironically, as *Mars the Pacifier* in the Wellington Museum, Apsley House, London. This was one of the treaures given to the Duke of Wellington by a grateful nation after the Battle of Waterloo.

Jean-Auguste-Dominique Ingres

The second generation of Neoclassicism is brilliantly exemplified by the French painter Jean-Auguste-Dominique Ingres. His oil paintings and pencil drawings were completely opposite the emotional works of the Romantics. His works, based on history and mythology, show his infatuation with line and contour, while his female nudes display an overpowering sensuality somewhat at odds with the Neoclassic style.[5]

His largest and most influential work is the grandiose (and highly formulaic) *Apotheosis of Homer* (1827) in the Louvre. It's a huge historical group portrait, the goal of which was to summarize the development of classical

culture. The work stands as the most emphatic exemplar of the Neoclassic style — and also as a symbol of the stiff artistic conservatism that Neoclassicism eventually stood for.[5]

Ingres was a master portrait painter, and two of his very best are in New York City collections. One, at the Metropolitan, is of the *Princesse de Broglie* (pronounced 'broy') of 1853. The other, *The Comtesse d'Haussonville* (1848), is in the Frick Museum. Both combine a magical rendering of silks and satins with penetrating psychological treatments of the subjects.

Romanticism

Romanticism is a complicated, essentially literary and philosophical movement, which is only partly (and unclearly) represented in art.

It flourished in the late 18th and early 19th centuries probably as a reaction against Neoclassicism, which was too closely wedded to the two prime human disasters of all time, the French Revolution and the barbaric Napoleonic conquests and tyranny. What else had the 18th-century Enlightenment movement, with its emphasis upon the perfectibility of man and logic, produced other than the horror of the Revolution and the dictator Napoleon? It was time, the Romantics argued, to improve society by removing old, corrupt conventions. Romanticism, basically, involves the following beliefs:

✔ Elevating emotional and intuition to an equal status with reason.

✔ Some crucial human experiences are beyond the rational mind.

✔ The individual and subjectivity are vital.

William Blake

William Blake was a painter, printmaker, and poet who was convinced his poetry far surpassed his art. In the 20th century, it's the art that's considered more important. His most exceptional works are a series of illuminated books, called the *Lambeth Books,* after the suburb of London in which he worked. Started in 1793 doubtless as a reaction to the turmoil of the Revolution, they embody prophecies often of an obscure nature and are accompanied by illuminations — not always linked to the prophetic poems — of alternating visions of horror and beauty.

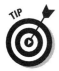

The best place to see Blake's work in America is in the Huntington Library in San Marino, California and the Morgan Library in New York.

Joseph Mallord William Turner

There are few paintings created with the verve, romantic intensity, and the-
atricality equal to those of the great landscapist Joseph Mallord William
Turner. His grand works, most of which are in the Tate Gallery in London, are
noteworthy for their encyclopedic knowledge of nature, their whippingly
energetic lines and forms, their incandescent colors, and their fascination
with human life in all of its manifestations. The best way to appreciate this
genius's efforts is to hole up in some small hotel or bed-sitter near the Tate
and spend a week or two looking at nothing but Turner.

Yet, one visit to London's National Gallery ought to be thrown in for two mar-
velous romantic visions relating to Turner's delight in modern technology.
One is an ode to the fast-fading present, a beauteous rendering, done in 1838,
of the old, and very famous, sailing warship, the *Téméraire,* being hauled off
for scrap in an incredible sunset, *The Fighting Téméraire Tugged to Her Last
Berth To Be Broken Up.*

The second is in praise of the emerging industrial revolution symbolized by a
modern train racing across a bridge with a tiny (and hard-to-see) rabbit dash-
ing to safety ahead of the juggernaut. It's entitled *Rain, Steam, and Speed —
the Great Western Railway* and was painted in 1844.

In the United States, there's a perfect beauty of a canvas, *Rockets and Blue
Lights* (1840), at the superior Sterling and Francine Clark Art Institute in
Williamstown, Massachusetts.

Caspar David Friedrich

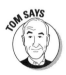

To me, the most romantic of the Romantics is a little-known German painter
of the late 18th and early 19th centuries, Caspar David Friedrich. His moody
landscapes — many of them of the Harz mountains — carry an abundant and
highly fertile series of symbolisms ranging from religious meanings to his
loathing of Napoleon. In America, there are only two small canvases. One is in
the Kimbell Museum in Fort Worth, and the other in the new Getty Museum
(see the Awesome Americas museum guide). His most renowned work, the
quintessence of the Romantic movement to me, is the stunning *Wanderer in
the Mists* (1818) in Kunsthalle (Fine Arts Museum) of Hamburg, Germany (see
Figure 12-2). It shows a man, who, by his clothing and demeanor, seems to be
a combination of philosopher and daredevil mountaineer, standing, his back
to the viewer, on a high promontory looking down into a misty valley sur-
rounded by crags and peaks. What will he do next? It's not too much of a
stretch to imagine this lonely and captivating figure as a symbol of all human-
ity struck by the doubts and anxieties we all have about the future.

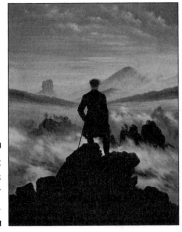

Figure 12-2:
Friederich's
*Wanderer
in the Mists.*

Kunsthalle, Hamburg, Germany/Bridgeman Art Library.
London/SuperStock

Eugène Delacroix

In France, there were two staunch followers of the Romantic movement (who steadfastly reminded people later in their lives that they had no connection with it), Eugène Delacroix and Théodore Géricault. The works of the former are often singled out as the living antithesis to the smooth, correct, and properly-drawn style of Ingres. Yet, Delacroix was just as accomplished a draftsman as Ingres. It was simply that his paintings, unlike those of Ingres, explode with sometimes agonizingly strewn and twisted colors.

My favorite works by this restless genius are in the Louvre. One is the outrageously romantic *Death of Sardanapalus* (1826), which shows the Assyrian king (whom Lord Byron had invented) lolling back on his bed as his city falls to the invading Myrrhans. His minions drag his most precious possessions to be engulfed by fire along with the monarch — shining horses and gorgeous women and great quantities of gold, silver, and valuable spices.

The second painting is the vigorous *Liberty Leading the People on the Barricades* (1830), a dynamic scene of citizens being exhorted to arms by the figure of Liberty, the model for whom was a young working-class woman. Delacroix had witnessed something like it (though presumably the woman wasn't dressed in national colors like the Liberty) during a troubled political situation in Paris. It is a thoroughly romantic and heroic emblem of the struggle for freedom from oppression, and it makes you want to cheer (see Figure 16 of the museum guide color insert).

Théodore Géricault

Théodore Géricault has been called the most compelling French painter of the first half of the 19th century simply because of one remarkable work, his *Raft of the Medusa,* painted in 1819, on view in the Louvre (see Figure 12-3). Mostly self-trained, he gazed for hour after hour in the Louvre (renamed at the time as the Napoleon Museum) at the assembly of paintings by the likes of Rubens, van Dyck, Rembrandt, Titian, and Caravaggio that Napoleon's armies had looted from Flanders and Italy. When Géricault started his master-piece, the public was already weary of the forced pantomime of "Greek" ideal figures all decked out in the archaeologically correct draperies and breast-plates, helmets, and greaves. His monumental canvas (some 12 feet by 20 feet, 3.7 m by 6 m) shocked the public. The subject is an infamous one — the aftermath of a shipwreck that had grievously agitated public opinion three years earlier, the wreck of a government frigate and the shameful abandon-ment of its crew by vessels who could have saved many lives, but didn't.

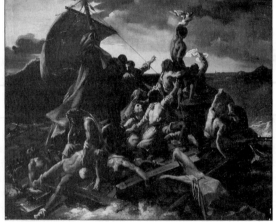

Figure 12-3: Géricault's *Raft of the Medusa.*

Musée des Beaux-Arts, Rouen, France/Lauros-Giraudon, Paris/SuperStock

Géricault has rendered the contemporary tragedy in an almost Michelangelesque style, full of that *terribiltá* for which Michelangelo was so renowned. There are quotations or hints of the horrors reported in depth by newspapers of the day — the outbreaks of mutiny and cannibalism on the abandoned raft and the victims' first, unsuccessful, sighting of a distant rescue vessel. The moment portrayed is the one with the greatest suspense, when one starved member of the survivors climbs the broken mast and waves frantically at a sailing vessel in the far, far distance. Would they be seen? The work is a blockbuster.

Francisco Goya

For me, the greatest artist of the Romantic era and one of the greatest in Western art history is Francisco Goya y Lucientes whose disturbing yet beautiful, sensitive yet awful, troubling yet endearing works embody late Rococo, Romanticism, and, even in the late pieces, Impressionism. He could be as gay and frivolous as a Boucher or Fragonard in his early cartoons for tapestries of games or picnics. He could create religious paintings with a Caravaggesque depth.

His portraits are among the most gripping of history, as the sensational one of 1797 in New York's Hispanic Society demonstrates — this is the stunning image of his love, the Duchess of Alba, pointing down to Goya's name scribbled in the sand at her feet.

His etchings, like the *Caprichos* (1799) or the *Disasters of War* of the early 19th century, are equal to anything produced by Albrecht Dürer or Rembrandt. Of the *Caprichos,* my favorite shows Goya (presumably) appearing — it's number 43 — as a man menaced by looming demons, burying his drooping head in his arms over a desk that bears the warning *The Sleep of Reason Produces Monsters.*

His most universal triumph, I think, is the monumental painting in the Prado, *The Third of May, 1808* (see the main color insert), which Goya painted in 1814. This compelling scene of horror and the glory of human survival against all depredations commemorates the grim ending of the popular uprising in Madrid against the Napoleonic invaders and condemns organized human brutality in a way that stands alone in excellence. (The scene of slaughter captures every detail of a group of hateful men callously, even gleefully, destroying their fellow men.) This is an exceedingly difficult painting to look at for extended periods of time, and it may even lead to nightmares for days after one's first visit. Yet once seen, *The Third of May, 1808* will become an irresistible magnet.

The horrible story does have an optimistic ending, for in the near and far background of this tumultuous canvas we spot guerilla fighters and the people who survive, never to forget.

Chapter 13

Impressionism (The Poetry of the Land and Mankind)

*I*mpressionism can only have been born in sunny France, for in that glorious country, people have always had a passionate love for the landscape and for what the land produces. The French refer constantly to "Dame Nature" and express their reverence for nature. The feeling is quite different from the Italian appreciation for the land and landscape, which is more direct, more like an anatomical drawing. The French look upon their land and paintings of it as having a true soul and a real state of mind basking in the sun of poetry. That is the key to understanding Impressionism.

The Roots of Impressionism

This revolutionary movement, like all art shock waves, didn't start shaking overnight, and the instigators or influencing forces — artists, activities, and ideas — were many and varied. You don't want a postgraduate seminar on the genesis of the style, so here are the root factors that contributed to its birth.

Creative forebears

The painters **Jean-Baptiste Camille Corot** and **Gustave Courbet,** who immediately preceded the Impressionist movement, were passionate about painting outdoors and were dedicated to working in the bright sun and recording, in part, the effects of the sun on the sky, trees, and pastures. They

communicated these thoughts and obsessions to budding Impressionists like **Édouard Manet, Claude Monet,** and **Camille Pissarro.** Corot was the man who urged other artists never to "lose the first fine impression that moved us." And artists like **Johan Barthold Jongkind** and **Eugène Boudin** were creating sparkling scenes of beaches unlike any that had gone on before. Their works were noted and collected by those who would soon "invent" that flickering light that overturned the art world.

Seminal thoughts

Around 1860, for no apparent reason, artists got the itch to work outdoors — the French call it *en pleine-air.* A number of artists, such as Theodore Rousseau, went to Barbizon in the country and produced a striking series of landscapes. In addition, around 1870, virtually all French artists became mesmerized by Japanese prints with their fresh, pastel hues and their simplified patterns; these prints became a strong influence, especially on Édouard Manet.

Political influences

Revolution was in the air, as the turmoil resulting from the proto-communist movement of 1870, called the Commune (which threatened to topple the government and caused riots in the streets), readily shows. Some of the Impressionists gained courage to break from the artistic traditions of the past because of the general feeling of rebellion in the air, and their subject matter and choice of people in their paintings reflect these feelings.

The advent of photography

The fruitful experiments in photography by Nadar were extremely influential for the Impressionists, who were very much taken by the relatively new and intriguing medium. This helps to explain why their compositions with people are so fresh compared to those of the "official" painters preferred by the art establishment.

The impact of science

In the last third of the 19th century, an explosive interest in color theory developed (in which certain emotions were scientifically linked to certain hues), some of which the Impressionist painters found compelling and tried to inject into their work. This was also the time in which the disciplines of psychology and psychiatry were being developed, and the findings of the

early practitioners about the way humans think and react no doubt played a role in the way the Impressionists looked at people and portrayed them.

The art establishment falls

In 19th century France, all aspects of art — from subject matter, to painting materials and technique, to how and what artists should create — was regulated by the powerful French Academy that had come into power in 1661. Deviating from the strict rules meant not being able to show in the annual Salon attended by the elite — from the emperor to every art critic, gallery owner, and collector — and thus no income.

In 1863, the establishment Academy was given a profound shock when a group of maverick artists whose works had been rejected for that year's Salon, including Gustave Courbet and Édouard Manet, mounted their own show, calling it the Salon des Refusés, or the "Show of the Refused." This was the Boston Tea Party of the arts; and in time, the exhibitions of the Impressionists were packed with the people who had been attending the salons, and the Academy's exhibitions had lost their drawing power.

The Key Role of Édouard Manet

In the Salon des Refusés exhibition, one painting in many ways marked the beginning of the Impressionist style and was the banner of the new independent spirit: Manet's *Déjeuner sur l'Herbe* (1863), which depicts two fully clothed, elegant males lolling in a sun-dappled wood with one naked lady and one scantily clad lady. You probably aren't astonished that the critics of the time found the subject bizarre and unseemly, but you will be puzzled to know that what struck the critics as even more hideous — something even approaching moral degradation — were the fragmented colors Manet used to simulate flickering sunlight and his technique of laying paint in broad swaths.

Manet followed this breakthrough with the *Fifer* (1865), which portrays a young soldier playing the piccolo in flat, direct, and primary colors surrounded by a prominent silhouette. It was lambasted as looking like an illustration on a playing card — a mere Jack of Hearts. But it was a major and daring change in the painterly trade. It's farfetched to dub it the genesis of cubism, but there's a hint of this radical artistic style in the painting.

In truth, Manet goes far beyond Impressionism and ranks as one of the most significant artists of all times. He soaked up the old masters, especially Velázquez, and although some of his religious paintings inspired by the old masters can be a bit stuffy, his portraits are magnificent. I urge you, if you go to Paris, to seek out in the Musée d'Orsay, the stunning painting of the nude

courtesan, *Olympia* — the one clothed only in a thin black ribbon around her neck — who looks boldly out at the viewer. His still lifes, particularly the flowers in glass vases, seem to sum up all of nature and, although modest in size, they seem to encompass the universe (see Figure 13-1).

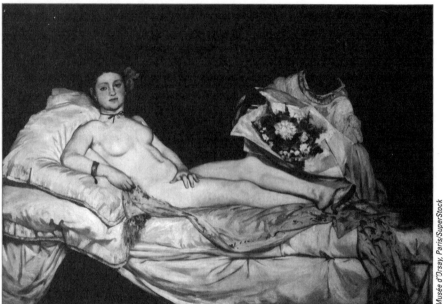

Figure 13-1:
Manet's
Olympia.

Musée d'Orsay, Paris/SuperStock

Claude Monet

If Manet was the artistic spark who fired up the courage of others to break painterly traditions, Monet was the midwife who eased the birth of the special technique for which the movement is known: He perfected that breakup of light and color, that distinct optical mixture in which the colors and brushstrokes of a picture look muddled and out-of-focus up close — but when you step back to the appropriate distance, it all comes together and makes perfect atmospheric sense (the epitome of the Impressionist style).

It was in 1866, at the Seine River resort called Ste.-Addresse, where Monet produced a vibrant canvas that became the first solid step to full-blown Impressionism (see Figure 13-2). It's the lovely image on the terrace with a couple and an elderly gentleman enjoying each other and the spectacle of a sailing regatta. The flowers are abundantly in bloom, and two pennants, one the French flag and the other that of Spain, snap in the brisk wind. (I bought the picture for the Metropolitan Museum in the early 1970s for a mere $1.4 million and was attacked in the press for having paid such a vast sum. Today, the picture would fetch 20 times that amount.)

ART ANECDOTE

Manet's Olympia and Mary Cassatt

Mary Cassatt (an American, and the best woman painter of the Impressionist movement) was influenced by Manet, and she created many gorgeous works, especially of mothers and children. Cassatt was a superior connoisseur and advised the American millionaires Horace and Louisine Havemeyer what to buy. They acquired a racy nude by Courbet for their private collection and were roasted in the New York tabloids, so they quickly gave the picture to the Metropolitan to stop the criticism. Cassatt then urged them to buy Manet's stupendous *Olympia*, that shocking nude courtesan looking out so boldly. Louisine begged her husband to purchase it and give it directly to the museum. He declined, wary of possible flak, which is why the masterpiece is today in the Louvre and not New York City.

The sun is hot and vivid, and an exact time in the morning is marked by the angle of the shadows, which are deep and purplish and mellow. The waves, seen close-up, appear to be nothing but dabs and slaps of the paint brush. When you move back, that signature, impressionistic optical mixture comes into play, and you see real waves whitecap in the breeze. At the correct distance, these and all the painterly elements become nature itself.

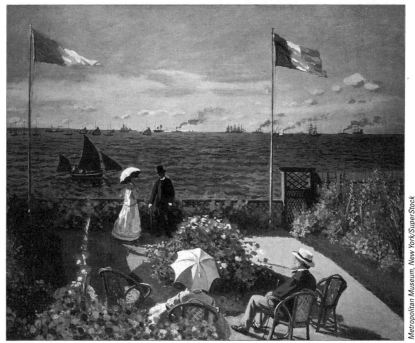

Figure 13-2: Monet's *Terrace à Ste.-Addresse.*

Metropolitan Museum, New York/SuperStock

Faked Impressionists

When the art market had its last explosion of prices and Impressionists fetched tens of millions of dollars, forgers moved in. They worked fast and how they churned out the fakes is entertaining. The fakers, hoping to create "original" works, but not being capable of inventing new subjects, selected details from a host of works and "pasted" them together into a new "Monet." A typical fake had a figure from one Monet, a cow copied from another painting in a museum thousands of miles away, a tree taken from a third, a haystack from a fourth painting, a building from a fifth, and so on. Experts roared with laughter seeing the muddled coming-together of so many famous details painted by Monet over the years.

Monet exhibited this sea change of a painting and was hammered by the critics. He became so despondent that he tried to kill himself and didn't paint an equally daring painting for some years. In 1870, he created his next radical painting, called *Impression: Sunrise.* This delicate scene of a boat at dawn goaded the art critic and satirist Louis Leroy to brand all pictures that focused on shimmering water and flooding light "Impressionism" to mock them.

But the critical gibes and the initial lack of interest on the part of the public had no effect, for Impressionism gained strength and speed, came to full flower in the 1880s and 1890s, and reached a full, late maturity with the large, gorgeous, and free-flowing series of *Water Lilies* by Claude Monet. These paintings were produced at his studio at Giverney, where he painted right through the early 1920s.

The Impressionist "Style"

You need to know that there was no cohesive or lock-step style among the Impressionists, though in general, they all memorialized their appreciation of flickering light, the sun, the outdoors, and the natural — and gave us people who don't pose like ancient Greek gods.

 ✔ **Camille Pissarro** is the pure landscapist of the group, and although his figures can be wooden, the thickness of the rich paint and the sun-drenched atmosphere that the paint carves out is wondrous.

- ✔ **Pierre-Auguste Renoir** was, for most of his output, a second-rate painter, obsessed with sickly-sweet nudes. (He used to boast that he painted with his *bitre,* a low-life French word designating a key member of the male anatomy.) But several of his paintings are divine, such as *Madame Charpentier and her Children* (1878), in the Metropolitan, with its delicious kids and the huge, floppy, rug-like dog. See Figure 13-3.

- ✔ **Edgar Degas** actually hated the Impressionists and worshipped the act of drawing. His light is muted compared to, say, Monet. His portraits are penetrating psychological impressions, and his nudes, which sometimes look like they were seen through a keyhole and rendered with a kind of smoldering resentment, are among the most powerful ever painted. His bronze sculpture ranks along with his paintings and pastels, which, by the way, he mixed in a free, almost lusty, way.

- ✔ **Henri de Toulouse-Lautrec**, the vibrant chronicler of Parisian café life, who worked at the same time as the Impressionists, was never one of them, but was more a Romantic and a gifted illustrator. (See Figure 13-4.)

Figure 13-3:
Madame Charpentier and her Children.

Why is Impressionism so appealing today? It is, no doubt, the single most popular style worldwide. It's sunny and unthreatening, yes, but it's far more. For this style (which, in a sense, is still being practiced today) happens to have produced intriguing images of nature and humanity that help us to understand ourselves. For that reason, Impressionism, which is as important as any of the most historic periods in all of time, will never be forgotten.

Figure 13-4:
Dance at the Moulin Rouge.

Musée d'Orsay, Paris/SuperStock

ART ANECDOTE

Degas bronzes

While Degas was alive, only one of his sculptures was exhibited, the poignant, life-size *Little Dancer,* a 14-year-old ballet dancer wearing an actual ballet costume over the bronze (see the one in the Metropolitan Museum for an example). After his death, in 1917, more than 150 wax models were found in his studio. Critics realized for the first time that the artist was a master of a medium other than painting. Full of life, intimate, technically superb, they constituted a new mode of 19th-century sculpture, being in a real sense part-painting and part-sculpture. Between 1919 and 1932, 74 of the waxes were cast in bronze, each in an edition of 22. They represent ballet dancers stretching and practicing, trotting and rearing horses, and the remarkable *Le Tub (The Bathtub),* which shows a naked woman lying back in a circular bath. One of the more complete sets of the bronzes is in the Metropolitan Museum, and another in the Norton Simon Museum in Pasadena, California.

Chapter 14

Post-Impressionism (Or Better, Pre-Modern)

In This Chapter

▶ The range of post-Impressionist painting

▶ Georges Seurat and Pointillism

▶ Paul Gauguin's decline into bitterness and beauty

▶ The real and the mythical Vincent van Gogh

▶ Paul Cézanne — the father of Modern Art

*W*hat came after Impressionism is called post-Impressionism, a term coined by the English art critic Roger Fry. It was actually not a movement at all, and the term, all too vaguely, signifies works by painters who retained the shimmering effects of light and the outdoors palette but who preferred more formal compositions. Eventually, their achievements would give birth to modern abstraction.

I think the word post-Impressionism should be set aside once and for all since it's almost impossible to shoehorn certain artists into the vague category.

To me, it's more accurate to call the period pre-Modern. The last quarter of the 19th century and the first years of the 20th was a time when artistic experimentation was rampant, and a bewildering number of styles were invented. In that sense, the period is a mirror of contemporary times.

Painting after the Impressionists

The range of painting was cosmic — from the faded Neoclassic stuff the members of the official academy, like William-Adolphe Bouguereau, were still churning out, to **Henri de Toulouse-Lautrec,** who was and was not an Impressionist and who stands alone with a personalized and quirky form of

realism, to **Auguste Renoir** who, in the 1860s, momentarily renounced his impressionistic pyrotechnics and devoted himself to a linearism with extreme emphasis on contours and silhouettes that owes much to Ingres, to **Paul Gauguin's** eccentric brand of oddly colored provincial French scenes, to the tightly drawn, near-mathematical "Pointillist" color theories and applications of **Georges Seurat** and **Paul Signac,** to the shattering expressionistic bombshells of **Vincent van Gogh,** and, finally, to the utterly non-naturalistic paeans to Mother Nature envisioned as best recreated with the "cylinder, sphere, and cone" by the most unlikely painter to achieve what a growing number of art historians are placing in the category of best-in-history, **Paul Cézanne,** who, in 1878, dedicated himself to making "Impressionism something solid and durable like the art of museums."

Georges Seurat

Pointillism started life at the 1884 Salon des Indépendants (meaning, of course, those completely independent of the official Salon, which was still alive, though huffing and puffing). Georges Seurat took the Impressionist practice of applying broken colors to suggest shimmering light and movement to a non-naturalistic extreme. Painstakingly, almost obsessively, Seurat painted tiny dots and thin slashes of contrasting color side by side — thousands upon thousands of them, not only upon the surface of the canvas, but even on their frames — theorizing that by this stark (and highly abstract) system, the hues would meld and merge and create an optical mixture in the eye of the beholder. His somewhat rigid compositions were dictated to a certain extent by theorists who held that the direction and movement of lines — up for happiness and contentment, down for sadness and anxiety — were sure to influence the onlooker.

It works — but not all the time. In fact, when you read Seurat's theories and explanations of individual works or peruse the writings of the color and movement theorists he favored, it's virtually impossible to see any connection with them in his radiant, compelling works. Seurat happened to be a gifted, strict formalist with a rare genius for color who created a unique series of masterpieces that are about as abstract as anything Picasso would subsequently come up with.

His prime works are, in my opinion, the following:

✔ *La Grande Jatte,* or *Sunday Afternoon on the Island of La Grande Jatte* (1884-86), in the Art Institute of Chicago. This is the incomparable image of the crowds of people seeking leisure on the island in the Seine reached by day steamer from Paris. Tightly drawn and painted, the figures seem at first as animated as cardboard cutouts, but after a few moments Seurat's inexplicable magic transforms them into living, breathing souls.

> ✔ The drawing, the *Portrait of the Painter Édmond-François Aman-Jean,* in black chalk at the Metropolitan Museum. Blacks have never been blacker than this, but the stunning drawing has the same "optical mixture" as Seurat's full-color works.
>
> ✔ *Les Poseuses,* or *The Models* (1887-88), in the Barnes Foundation Collection, Merion, Pennsylvania. The magnetic feature of this study of models wearing nothing but knee-stockings is that the very unreal young women become hyper-naturalistic the more one looks at them.

Paul Gauguin

Paul Gauguin was in real life even more fascinating than Anthony Quinn's star turn as the troubled artist in *Lust For Life.* He was born in Paris, fled to Peru with his family after Napoleon III seized power in 1851, at 17 sailed the seven seas for six years, worked as a stockbroker, became intrigued with art through a broker friend, Emile Schuffenecker, himself a painter (and sometime art forger), amassed a fine collection of Impressionists, and started to paint full time when the Paris stock exchange collapsed in 1883. People laughed at his work, and he couldn't earn a dime to support his family of four. Soon he began to study painting under the tutelage of Camille Pissarro who, after Monet, was the most dedicated to the Impressionist style. His early works show little promise, and no buyers were attracted. Gauguin moved to Copenhagen, split with his wife, and returned to Paris in 1885.[5]

From then, his life was a crescendo of increasing bitterness at the world which rejected his art, for he realized that he was producing paintings of unparalleled strength and beauty.

Under the influence of Seurat, he began to experiment with color. He met van Gogh, and that tumultuous friendship came to an end in 1888 in Arles in the south of France after a year. After a journey to Martinique, he was exposed to primitive community living and became obsessed with the colors of the tropical landscape. That experience changed the course of his so-far unpromising career. He dabbled first in a style of painting that emphasized flat areas of color surrounded by black lines — he called it "Cloisonnism" after a medieval enamel technique in which the fired colors were separated by bands of metal. He worked primarily in Brittany, in western France, at a town called Pont-Aven.[5]

By 1891, Gauguin had come to believe that civilization was the cause of barbarism rejuvenation. By this time, his work, which had become remarkably luminous and bold, was a continuing protest against what he thought was the materialism of bourgeois life.[5]

He sailed out to the far Pacific — Tahiti (1891-93, 1895-1901) and the Marqueses Islands (1901-03) — where he painted "natural" men and women. His chief Tahitian work carries the burdensome title of *Where Do We Come From? What Are We? Where Are We Going?* (1879-98). (See Figure 14-1.) Painted while his health deteriorated, it was intended to be a suicide note on a grand scale, but he never succeeded in doing himself in.[5] The giant painting is in the Museum of Fine Arts in Boston. It is one of the great artistic and philosophical statements in all of Western history and is well worth a pilgrimage. Complex, possessing gorgeous colors, a huge idol in yellows and off-greens is set in the middle of a tropical environment surrounded by natives who may or may not symbolize the various stages in life. It's impossible to tell what's happening, but every viewer just knows that this monumental and radiant image sums up the strivings and fears of humanity.

Figure 14-1:
Where Do We Come From? What Are We? Where Are We Going?

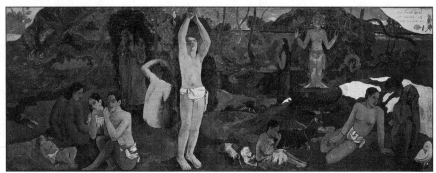

Museum of Fine Arts, Boston, Mass./A.K.G., Berlin/SuperStock

Gauguin's wood carvings of the late period are marvelous — rough yet incredibly sinuous doors, pipes, boxes, and panels — and seeing them all happens to be one of my life's hopes. (I am fairly close to having seen the full roster.)

In the Metropolitan Museum, as part of the Walter Annenberg proposed gift, there's a painting of a *Mother and Daughter* that is direct and moving, with colors that will bowl you over.

Be sure to check our Gaugin's *Tahitian Women* in the museum guide color insert, Figure 20.

Finally, in the Pushkin Museum in Moscow, there are several Tahitian Gauguins that are the very pinnacle of his art, with scenes on a beach where the sands are colored a delicate pink, shaded by emerald green — unreal, perhaps, yet super-real because the colors have been transformed into the hues of coral and the clear blue-green waters of the South Pacific.

Gauguin is one of the forerunners of Modern art and to an extent, even of abstraction, because of the way he successfully balanced the image of nature with an abstracted idea of nature. He rejected the up-to-then given that a

painting had to be a reflection of nature and created new, fresh images that project not only the strength of reality but an even greater strength that emanates from his personal dreams.[5]

Vincent van Gogh

Although the film *Lust For Life* accurately portrays the argumentative end of the disastrous time when Gauguin visited Vincent van Gogh in Arles, where the Dutchman hoped to create a new style of post-Impressionist painting, the movie presents a flawed assessment of much of his life. Contrary to common belief, van Gogh did sell a few paintings during his lifetime; he owned a distinguished collection of paintings; he was considered so eminent that he was forged during his lifetime; he had a number of students (one of whom was Emile Schuffenecker, the stockbroker-artist who had introduced Gauguin to art and who may have faked up a famous van Gogh today in Japan, the *Sunflowers*); and he didn't commit suicide by blasting himself with a shotgun, but fell against it and it went off; and his doctor, Gachet, one of his students, didn't treat him correctly.

He was wild, prone to deep depressions, and did commit himself late in life to a mental asylum at St. Rémy-de-Provence, but it's questionable that he was insane. His forelorn letters to his beloved brother Théo are at times exaggerated expressions of his loneliness and depression.

Although his initial works are awkward and sometimes bumbling, his talent was massive, and from the earliest works known — mostly of somber Dutch scenes of everyday life — to the tortured, flaming landscapes of his last two years, it's clear he was one of the most gifted draftsmen who ever lived. The ink drawings — portraits and especially the landscapes — are as tangible as if each penetrating stroke of the pen were a tiny slice of granite. His touch was as unerring as Rembrandt's and, like Leonardo or Dürer, he instilled universal life into everything he drew or painted.

Van Gogh is the rarest of the rare in that he seems never to have created an unsuccessful or mediocre image, except for the very early fledgling attempts. After that, the Dutch ones are murky and unappealing, but they are acts of genius nonetheless. The fully mature paintings, such as the *Portrait of Postman Roulin* in the Annenberg Collection in New York's Metropolitan Museum, *La Berceuse,* or *Starry Night* (1889) in the Museum of Modern Art (see Figure 14-2), seem to encapsulate all of mankind's most exalted goals. Van Gogh always strived to achieve what he called "consolation for humanity through art." Did he do it!

See Figure 35 of the museum guide color insert for one of his many self portraits.

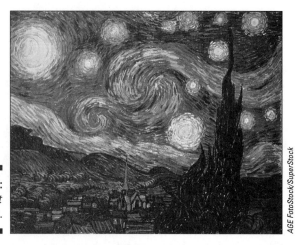

Figure 14-2:
Starry Night
by van Gogh.

Paul Cézanne

The artists who most significantly paved the way to Modern Art all seem to have started off awkwardly, suffering painfully through each early step of the creative process. They were universally looked upon as troublesome eccentrics who would never amount to anything. This was true with Gauguin, van Gogh, and especially Paul Cézanne, who has been called, rightly, the father of Modern Art and Cubism. The reason is that even the radical Impressionists who had broken with the official academy didn't understand their innovations and secretly looked upon their art as inimical.

Cézanne was born in Aix-en-Provence to a wealthy family and received a classical education. His domineering father had charted his son's career in life early — to become a banker-lawyer combination. Cézanne loathed law school and yearned for some kind of artistic vocation, and he was supported in this dream by his mother. He went off to Paris but fled when it became apparent that, technically, he was inferior to his fellow students. He remained in Paris as long as five months only because of the encouragement of the young, up-and-coming writer Emile Zola, who remained a friend for years. He returned to Aix, tried banking, failed, and came back and forth to Paris and Aix many times during 1858 and 1872.[5]

Cézanne met the young Impressionists but never became close to them except for Pissarro who took him under his wing. His violent temper and studied rudeness made him a pariah. His early works are dark, tumultuous, with violent contrasts of light and shadow and broad slathers of paint.[5] The subjects are unconvincing portraits and puzzling and thickly painted historical scenes reminiscent of the boiling drama of Eugéne Delacroix, one of his favorites along with Gustave Courbet.

He gradually soaked up the light colors of the Impressionists but was never interested in the way they tried to capture the feel, look, and aura of nature. Cézanne used to say that all of nature could be distilled to the cylinder, sphere, and cone, and although in his increasingly deft landscapes you can never actually identify those primary shapes, there is a sense of infinite structure in his works wholly lacking in Impressionist paintings.

Cézanne was fascinated with still-life and painted over two hundred in oil or watercolor. At times, such as in *The Black Clock* (1869-71) in the Niarchos collection (see Figure 14-3), the objects — a battered, jet-black table clock, a huge shell with pink interior, and the white drapery — look like elements of landscape like mountain ranges. In others, the feathery patches or horizontal brushstrokes become more dominant than the objects depicted.

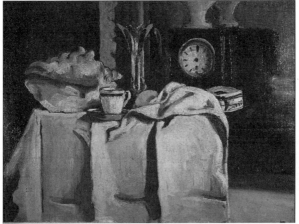

Figure 14-3:
The Black Clock.

Niarcohs Collection, Paris/Bridgeman Art Library, London/SuperStock

In his late watercolors and landscapes, Cézanne, who isolated himself in Aix from 1870 to 1890, developed a magical series of ethereal brushstrokes that look like they're made of delicately colored membranes or dragonfly wings, ever shifting, overlapping and breaking apart and coming back together. Cubism was not far off.

His work was viciously criticized by the art critics during his lifetime, and only the collector Victor Choquet recognized his full genius — he and every young, rebellious artist, for Cézanne was revered by them as the leader to the future, away from the growing stodginess and self-satisfaction of Impressionism.

August Rodin

The pre-Modern period spawned a number of sensational sculptors. The top of the heap was Auguste Rodin (1840-1917), whose work in marble and bronze is bewilderingly varying, sometimes soft and silky as flesh, at others jagged and broken up. His portraits may be the most stellar in Western history. Rodin's finest work, which is monumental, dramatic, puzzling (for no one, not even he, knew what some of the scenes depicted), and forever mysterious is his *Gates of Hell,* commissioned in 1884 but left unfinished on his death. The subjects are loosely taken from Dante's (1265-1321) *Divine Comedy: The Inferno* (1321), but it's hard to pin many of them down. The most indelible images of the 19th and early 20th centuries are to be found on the *Gates of Hell, The Kiss* (1886-98), and *The Thinker* (1879-89). Despite the continuing tendency for art historians to belittle these amazing works, they are triumphant, displaying a profound feeling of antiquity and the shock of what's to come at the same time.

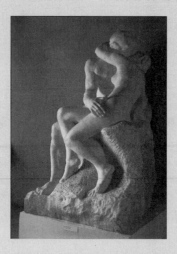

Chapter 15

Modern Art: The Bold, the Beautiful, and the Not-So-Beautiful

- -

In This Chapter

▶ The dominance of Picasso

▶ Modern art and its movements

▶ The real gift of Modern art

- -

*T*he birth of Modern art didn't come in a flash with Pablo Picasso or Georges Braque, the co-inventor of Cubism, suddenly seeing a still-life or figure break down into squares and rectangles colored beige or light silver, surrounded by black lines.

The growth of the Modern style was gradual and was formed by the interaction of many influences. Some of the influencing factors are obvious, such as the late works of Paul Cézanne in which nature became fragmented into adroit references to the cylinder, sphere, and cone. Other influences are somewhat puzzling, such as the works of Henri de Toulouse-Lautrec, Diego Velázquez, and El Greco, all of which Picasso claimed led him to the inevitable simplification of forms.

Simplification seems to have been in the air as the 19th century flowed into the 20th. Literature was becoming downright skeletal, casting aside the florid descriptions of the Victorian era. Gertrude Stein, the wealthy American expatriate from Oakland, California, who would become Picasso's major patron in his early Cubist period, was composing "a rose is a rose is a rose." The mania for the flattened images of Japanese prints was increasing. A new desire to accept as valid art the works of the "primitive" sculptors of Africa was taking hold. In science, Einstein was beginning to come to grips with $E=mc^2$, the utter simplification of all matter in the universe into a lean formula.

Pablo Picasso

Yet Cubism and Modern art weren't either scientific or intellectual; they were visual and came from the eye and mind of one of the greatest geniuses in art history. Pablo Picasso, born in Spain, was a child prodigy who was recognized as such by his art-teacher father, who ably led him along. The small Museo de Picasso in Barcelona is devoted primarily to his early works, which include strikingly realistic renderings of casts of ancient sculpture.

He was a rebel from the start and, as a teenager, began to frequent the Barcelona cafés where intellectuals gathered. He soon went to Paris, the capital of art, and soaked up the works of Manet, Gustave Courbet, and Toulouse-Lautrec, whose sketchy style impressed him greatly. Then it was back to Spain, a return to France, and again back to Spain — all in the years 1899 to 1904.

Before he struck upon Cubism, Picasso went through a prodigious number of styles — realism, caricature, the Blue Period, and the Rose Period. The Blue Period dates from 1901 to 1904 and is characterized by a predominantly blue palette and subjects focusing on outcasts, beggars, and prostitutes. This was when he also produced his first sculptures. The most poignant work of the style is in Cleveland's Museum of Art, *La Vie* (1903), which was created in memory of a great childhood friend, the Spanish poet Casagemas, who had committed suicide. The painting started as a self-portrait, but Picasso's features became those of his lost friend. The composition is stilted, the space compressed, the gestures stiff, and the tones predominantly blue. Another outstanding Blue Period work, of 1903, is in the Metropolitan, *The Blind Man's Meal.* Yet another example, perhaps the most lyrical and mysterious ever, is in the Toledo Museum of Art, the haunting *Woman with a Crow* (1903).

The Rose Period began around 1904 when Picasso's palette brightened, the paintings dominated by pinks and beiges, light blues, and roses. His subjects are *saltimbanques* (circus people), harlequins, and clowns, all of whom seem to be mute and strangely inactive. One of the premier works of this period is in Washington, D.C., the National Gallery's large and extremely beautiful *Family of Saltimbanques* dating to 1905, which portrays a group of circus workers who appear alienated and incapable of communicating with each other, set in a one-dimensional space.

In 1905, Picasso went briefly to Holland, and on his return to Paris, his works took on a classical aura with large male and female figures seen frontally or in distinct profile, almost like early Greek art (see Chapter 5). One of the best of these of 1906 is in the Albright-Knox Gallery in Buffalo, NY, *La Toilette.* Several pieces in this new style were purchased by Gertrude (the art patron and

writer) and her brother, Leo Stein. The other major artist promoted by the Steins during this period was **Henri Matisse,** who had made a sensation in an exhibition of 1905 for works of a most shocking new style, employing garish and dissonant colors. These pieces would be derided by the critics as "Fauvism," a French word for "wild beasts." Picasso was profoundly influenced by Matisse. He was also captivated by the almost cartoonlike works of the self-taught "primitive" French painter **Henri "Le Douanier" Rousseau,** whom he affectionately called "the last ancient Egyptian painter" because his works have a passing similarity to the flat ancient Egyptian paintings.

A masterpiece by Rousseau is in the Museum of Modern Art in New York, his world-famous *Sleeping Gypsy,* with an incredible tiger gazing at the dormant figure with laser-like eyes (see Figure 9 of the museum guide insert).

Picasso discovered ancient Iberian sculpture from Spain, African art (for he haunted the African collections in the Musée d'Ethnographie du Trocadéro — Trocadero Ethnographic Museum in Paris), and Gauguin's sculptures. Slowly, he incorporated the simplified forms he found in these sources into a striking portrait of Gertrude Stein, finished in 1906 and given by her in her will to the Metropolitan Museum. She has a severe masklike face made up of emphatically hewn forms compressed inside a restricted space. (Stein is supposed to have complained, "I don't look at all like that," with Picasso replying, "You will, Gertrude, you will.") This unique portrait comes as a crucial shift from what Picasso saw to what he was thinking and paves the way to Cubism.

Then came the awesome *Les Demoiselles d'Avignon* of 1907, the shaker of the art world (Museum of Modern Art, New York) (see the main color insert and Chapter 20). Picasso was a little afraid of the painting and didn't show it except to a small circle of friends until 1916, long after he had completed his early Cubist pictures. Cubism is essentially the fragmenting of three-dimensional forms into flat areas of pattern and color, overlapping and intertwining so that shapes and parts of the human anatomy are seen from the front and back at the same time. The style was created by Picasso in tandem with his great friend **Georges Braque,** and at times, the works were so alike it was hard for each artist quickly to identify their own. The two were so close for several years that Picasso took to calling Braque, "ma femme" or "my wife," described the relationship as one of two mountaineers roped together, and in some correspondence they refer to each other as "Orville and Wilbur" for they knew how profound their invention of Cubism was.

Every progressive painter, whether French, German, Belgian, or American, soon took up Cubism, and the style became the dominant one of at least the first half of the 20th century. In 1913, in New York, the new style was introduced at an exhibition at the midtown armory — the famous Armory Show — which caused a sensation. Picasso would create a host of Cubist

ART ANECDOTE

Birth of Cubism

The name Cubism comes from an angry art critic, Louis Vauxcelles, who wrote a scathing review in 1908 about Braque. Although Vauxcelles characterized Braque as brave and bold, he noted that Braque's works were so simplified that they were reduced to the point of being mere cubes. (Braque's *Man with a Guitar* is shown here.)

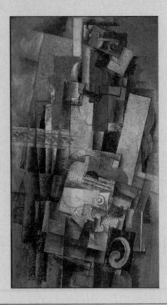

styles throughout his long career. After painting still-lifes that employed lettering, trompe l'oeil effects, color, and textured paint surfaces, in 1912 Picasso produced *Still-Life with Chair-Caning* (see Figure 15-1), in the Picasso Museum in Paris, which is an oval picture that is, in effect, a café table in perspective surrounded by a rope frame — the first *collage,* or a work of art that incorporates preexisting materials or objects as part of the ensemble. Elements glued to the surface contrasting with painted versions of the same material provided a sort of sophisticated double take on the part of the observer. A good example of this, dubbed Synthetic Cubism, is in the Picasso Museum, Paris, the witty *Geometric Composition: The Guitar* (1913). The most accomplished pictures of the fully developed Synthetic Cubist style are two complex and highly colorful works representing musicians (in Philadelphia and the Museum of Modern Art, New York). He produced fascinating theatrical sets and costumes for the Ballet Russe from 1914 on, turned, in the 1920s, to a rich classical style, creating some breathtaking line drawings, dabbled with Surrealism between 1925 and 1935, and returned to Classicism.

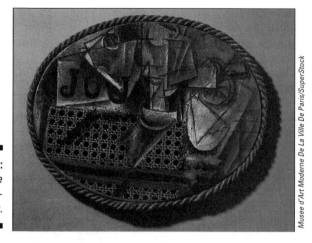

Musee d'Art Moderne De La Ville De Paris/SuperStock

Figure 15-1:
Still-Life with Chair-Caning.

At the outbreak of the Spanish Civil War, Picasso was appointed the director of the Prado. In January, 1937, the Republican government asked him to paint a mural for the Spanish pavilion at the world exposition in Paris. Spurred on by a war atrocity, the total destruction by bombs of the town of Guernica in the Basque country, he painted the renowned oil *Guernica* in monochrome (now in Madrid's Museo Nacional Centro de Arte Reina Sofía.) Something of an enigma in details, there's no doubt that the giant picture (which until the death of Franco was in New York's Museum of Modern Art) expresses a Goya-esque revulsion over the horrors man can wreak upon fellow man. (See Figure 40 in the museum guide color insert.) The center is dominated by a grieving woman and a wounded, screaming horse illuminated, like Goya's *Third of May, 1808* by a harsh light (see the main color insert for Goya's *Third of May, 1808*).

Picasso lived in Paris through the war, producing gloomy paintings in semi-abstract styles, many depicting skulls or flayed animals or a horrifying charnel house. He joined the Communist party after the war and painted two large paintings condemning the United States for its involvement in the Korean War (two frightfully bad paintings about events that never happened — like American participation in germ warfare). He turned enthusiastically to sculpture, pottery, and print-making, and, in his later years, preoccupied himself with a series of mistresses and girlfriends, changing his style to express his love for each one, and, finally, making superb evocations of the works of old masters like Diego Velázquez. Whatever Picasso had a hand in turned out to have an unquenchable spark of utter genius.[5]

The Armory Show paves the way

One of the key moments for the appreciation of Modern art in the United States came with the Armory Show of 1913. This exhibition of modern European and American paintings and sculpture was mounted in New York's drafty 7th Regiment Armory at Park Avenue and 67th Street from February 17 until March 15, 1913. The show traveled to the Art Institute of Chicago and Copley Hall, Boston, ending in May.

It was enormous, presenting some 1300 works, of which two-thirds were by Americans. Yet, it was the first real look at Impressionism, Post-Impressionism, Fauvism, and Cubism. Virtually no German Expressionists were included. European artists ranged from the Neoclassicist Ingres to Post-Impressionists, such as Cézanne, Gauguin, and van Gogh, plus Picasso, Braque, Matisse, Kandinsky, and Marcel Duchamp.

Dadaist Duchamp's flamboyant work *Nude Descending the Staircase* (1912) was the sensation of the show, being equally admired and reviled. The Duchamp was roasted as "an explosion in a shingle factory" and mocked as "The Rude Descending a Staircase (Rush Hour at the Subway)" with a cartoon to accompany the title, and a "staircase descending a nude." It is today in the Philadelphia Museum of Art.

The Armory Show gave birth to unending cartoons parodying abstract painting — the ones with an eye on top of the head and an ear attached to the nose, and so on — and a host of jokes pooh-poohing modern art, which still go on today.

The show garnered a great deal of publicity, and around 300,000 people came to gawk, admire, and scoff. Although the Armory Show wasn't the first exhibition of modern art in the USA, it was unmatched in scope and newsworthiness. Commercial galleries and avid collectors of Modern European art followed in its broad wake, and the show literally transformed the art market in New York. Afterwards, Abby Aldrich Rockefeller and her fellow art lovers decided to organize the Museum of Modern Art, with mostly European works, to defend the new styles and to educate the American public about the legitimacies of abstract art.[15]

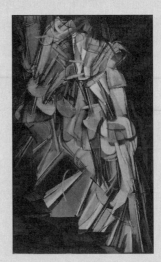

ISMs and Other Styles

Before and after Cubism was invented, a host of styles (or "isms") was spawned. Here are some of the more memorable.

Fauvism

The word was dreamed up by the indefatigable critic Louis Vauxcelles, who saw a show of paintings at the 1905 Parisian Salon d'Automne by the likes of **Henri Matisse** and **André Derain,** in which the landscape and human figures had become a riot of conflicting colors — flesh tones and purple combinations — next to a rather classical and chaste sculpture by Albert Marquet — and wrote "Donatello surrounded by wild beasts." One of the most expressive Matisses of this raging style is in the Copenhagen's Statens Museum for Kunst (State Museum for Art) entitled, *Portrait of Mme Matisse/The Green Line* (1905), the green stripe being a shadow falling on her nose.

See Figure 36 and Figure 37 of the museum guide color insert for Matisse's *Harmony in Red* and *The Dance.*

Die Brücke ("The Bridge")

Die Brücke was a movement founded in Dresden in 1905 and disbanded in Berlin in 1913. A "bridge" to the future of art, this movement initially included **Erich Heckel, Ernst Ludwig Kirchner,** and **Karl Schmidt-Rottluff,** and in 1906 **Emil Nolde** and **Max Pechstein.** Interested in African, Oceanic, and medieval German art, these artists were searching for truth through artistic emotions. This resulted in violent distortions of shapes and anatomies and exceedingly garish, raw, and sometimes brutal colors.

Der Blaue Reiter ("The Blue Rider")

This movement was named after a 1903 painting by the Russian **Wassily Kandinsky,** a painting that depicts a blue naked rider on a blue horse. The work became the logo for a movement he founded in 1911 in Munich with the painter **Franz Marc.** "We both loved blue," Kandinsky explained. "Marc loved horses, I riders." Yet, Kandinsky and Marc were committed artists who wanted to encourage a dialogue between painting, literature, and music for the purpose of "radically widening the bounds of expressive creativity." Kandinsky was to go further and further into pure abstraction and created paintings inspired solely by music or mood. He deserves credit for his vitally important pioneering style of non-objective art. The finest examples of his strong, purely abstract works are in New York's Guggenheim Museum, which

possesses the subtitle of the Museum for Non-Objective Art. It's amusing that Picasso found these non-subjective or objective paintings appalling and commented that no true art should be created without some subject matter. (See Figure 15-2 for an example of Kandinsky.)

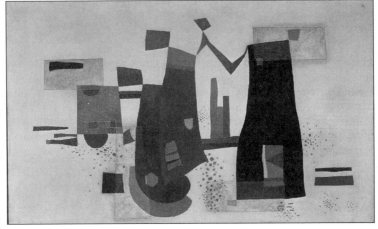

Figure 15-2:
Kandinsky's
Contrast
with
Accompani-
ment.

Solomon R. Guggenheim Museum, new York/ET Archive, London/SuperStock

Futurism

This is an Italian movement related to Cubism, which primarily flourished in Milan from 1909 to 1916. The founder, poet F. T. Marinetti, described what it was all about in a 1909 lecture, "A racing automobile is more beautiful than the *Victory of Samothrace.*" The Futurists also called for the destruction of all art museums. Some fine Futurist artists are **Giacomo Balla** and **Umberto Boccioni.** Figure 15-3 gives an example of Boccioni.

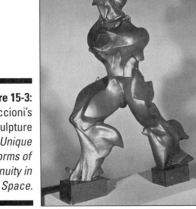

Figure 15-3:
Boccioni's
sculpture
Unique
Forms of
Continuity in
Space.

Mattioli Collection, Milan/Bridgeman Art Library, London/SuperStock

Constructivism

This offshoot of Cubism was born in Russia in the 1920s and is best exemplified in the works of the sculptors who happen to have been brothers, **Naum Gabo** and **Antoine Pevsner.** This, in turn, spurred on Soviet Constructivism, which was associated with the sculptor **Vladimir Tatlin,** who was seeking to create a detached, scientific "culture of machines" to serve the social needs of the day.

Suprematism

In Russia in the teens and twenties, this was a short-lived purist movement — Modernism's first completely abstract paintings style — that did have a limited influence in forming radically non-objective paintings. It was called Suprematism. Its founder was **Kasimir Malevitch,** and he was known for his pared down, utterly pure forms. In the Museum of Modern Art, New York, his landmark work is on view, *White Square on White* (1918), which is simply that, a white square on a white background. He was as much a theoretician as a painter. His works often imparted an underlying political message that, admittedly, is a bit obscure today.

Dadaism

As an art movement, Dada emerged full-blown — and totally crazed — from the blissfully anarchic minds of the art crowd gathered around the Cabaret Voltaire founded in Zurich in 1916. Dadaism swept on to Berlin, Paris, and New York. It was less a new style or technique than a purposefully giddy state of mind, according to its high priest, the Romanian poet Tristan Tzara. Tzara once appeared on stage in a "serious" Dada theatrical event and barked like a dog for a half hour. The name Dada was selected by opening a dictionary and pointing — blindfolded — a pencil to a word that happened to be the French diminutive for "hobbyhorse."

The most flamboyant and gifted practitioner of the Dada movement was the painter and maker of assemblies of various items, **Marcel Duchamp,** who also is famous for his self-styled "ready-mades," works, such as common shovels or a urinal, presented as works of art. His lovely and boisterous painting *The Bride Stripped Bare By Her Bachelors, Even (The Large Glass)* of 1915-23 is one of the gems of the Philadelphia Museum of Art and is a wholeheartedly abstract work (on deliberately broken large glass panes) that simply defies understanding, which is why it is so compelling.

Surrealism

This movement can be looked upon as Dada's French first cousin of art. The artists who practiced the fragmented variety of styles called the Surreal wanted to plumb the riches of the unconscious mind. It all began with French poet Giullaume Apollinaire's nutty playlet *Les Mamelles de Tiresias,* in which the heroine opened her bodice, let fly two balloons, and promptly turned into a man. French writer André Breton defined the movement in his *Surrealist Manifesto* of 1924 as a type of psychic automatism through which artists intended to express, either verbally or in writing, the true functioning of thought. Finding its sources in the subconscious, Surrealism sought to create an art which was symbolic of buried potential. In their work, the Surrealists — Spaniards **Salvador Dalí** and **Joan Miró,** Belgian **René Magritte,** and Germans **Max Ernst** and **Meret Oppenheim** — used "automatic" techniques like rubbing, scratching, and catching candle smoke on a sheet of paper. In 1938, the general hilariousness of the movement culminated in a show in Paris, which was reviewed by a British critic in part as women splashed with mud by a nude actress swathed in chains and a woman in a torn night-dress screaming. The icon of the movement is **Meret Oppenheim's** *Luncheon in Fur* (1936) at the Museum of Modern Art, New York, in which a common tea cup, saucer, and spoon are covered in Chinese gazelle fur.

The Bauhaus

This is the name of the "laboratory" for modern art established in Munich in the 1920s, which tried to apply some of the tenets of Cubism to contemporary interior design, architecture, and art. **Oskar Schlemmer** was one of the painters, as was **Josef Albers,** famous for his pure squares of differing colors, and Hungarians **Laszlo Moholy-Nagy** and **Marcel Breuer,** and Swiss painter **Paul Klee.**

The Bauhaus was established in Weimar in 1919 and then moved to Dessau in 1925, occupying a landmark building in modern architecture designed by **Walter Gropius.** It was closed by the Nazis in 1933. The new Bauhaus was located in Chicago — established by refugee Laszlo Moholy-Nagy in 1937 in what is today the Institute of Design at the Illinois Institute of Technology.

Sezession (Secession)

There were two movements with this name, one German, the other Austrian. The word is German and means, "going away mad — to secede," which is

what the young Austrian artists **Gustave Klimt** and **Egon Schiele** of the late 19th and early 20th centuries started doing when the art establishment wouldn't allow them to show their radical works. Later on, in Germany, there was a second Sezession — this time championed by the expressionists **Max Beckman, Max Pechstein,** and **Emil Nolde.**

Is Modern Art Something of a Joke?

Modern art is, admittedly, rash, confusing, prone to making one suspect that it's all a joke, annoying at times, and forever puzzling as to meaning and significance. Yet, much of it possesses a power and an elegance equal to the greatest earlier movements and styles in Western art. The real gift of Modern art is that it allowed artists, if they wanted, to go far beyond the rather restricted practice of copying a subject faithfully. Pure energy could be expressed. So could mysterious emotion. It takes dedication and lots of work to come to grips with Modern art, but when you have saturated yourself in it, you will, in time, appreciate the explosive genius of Picasso and the infinite calm and serenity of its most illustrious master, who is, in my opinion, Henri Matisse. He once observed that he wanted to create an art that might be so comforting that tired businessmen would readily turn to it for solace. Once you gaze at his triumphant *Red Studio* or *Luxe, Calme et Volupté* in New York's Museum of Modern Art, you'll see that he succeeded.

Photography

I have severely neglected photography, which I believe to be certainly one of the fine arts. (I changed the name of the Prints Department at the Metropolitan to that of Prints and Photographs.) I have done so because there is a book in the Dummies series *(Photography For Dummies)* that deals with the subject specifically and because of space considerations — meaning that from 35,000 B.C. until today, the period from the mid-19th century until now isn't all that big. Very roughly speaking, photography has experienced the following very general periods in the development of its own styles: 1856 to 1867, the early period of experimentation; around the beginning of WW I until the mid-1920s, a time of photographic intensity; 1929 to 1938, when perspective was supreme; from 1952 until the 1990s onward, a period of introspection. Finally, today, photography exhibits the same diversity of styles as other media fine arts.

Chapter 16

Contemporary Art and Its "ISMs" (Not Always So Nice, but Ever Exciting)

• •

• •

*T*he good news about contemporary art is that all styles and modes of expression are now considered to be valid — you can now openly delight in the works of realists (like Andrew Wyeth) and pant publicly over the most minimal hard-edge pieces. By the way, works of art are usually called "pieces" these days. What used to be put down as crafts are slowly and steadily being recognized as the highest of artistic expression — how else to take the grand and glorious glass pieces by the American Dale Chihuly, who has decorated such important buildings as the Vienna Opera and Las Vegas's Bellagio Hotel. All materials from acrylic to *encaustic* (a kind of wax application), feathers, rusted steel, wool, and, yes, even to elephant dung and human blood, are permissible as media. And they do make fascinating pieces.

The Lowdown on Contemporary Art

The bad news about contemporary art is that there's a lot of ugly stuff out there calling itself high art, ghastly junk masquerading as "real art" with few experts willing to blow the whistle on it. Yet the fact is that it's still terribly difficult to tell if one living artist is truly better or more universal than another. It's still very hard — maybe impossible — to predict which artists working today will become the old masters of the future (although I have brashly tried in Chapter 22). Usually, art historians say, "Wait until the next century, and then I can tell you."

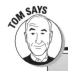

So what's wrong with Norman Rockwell?

In addition to an acceptance of all styles and modes of expression, today there's a refreshing gradual disappearance of art criticism based purely on ideology. Critics and historians are beginning to recognize that styles are simply languages with one no inherently better than another. There are fewer and fewer art critic fights and tantrums defending one style against another. There's also a forgiving, permissive mood currently gaining ground in the art world.

Norman Rockwell (1894-1978), who only a decade ago was considered by most art critics to be a hopelessly mawkish illustrator of little talent and no energy, has recently been touted, even by the curator of 20th century art at New York's Guggenheim Museum (which has the subtitle of The Museum For Non-Objective Art — hardly Norman's forte), as a major artistic force and potent communicator in America from the 1930s through the 1960s. I agree.

Today, anything goes or seems to, and I say, fine. It's far better (and much more fun) for creativity to have an overload of pieces than to be weighed down by the yoke of some pretentious, self-proclaimed Academy or Salon. Think about what I say in Chapter 1: "Art happens when anyone in the world takes any kind of material and fashions it into a deliberate statement." Anything goes and should go.

So, dive into contemporary art and start swimming.

To define all of contemporary art would be like giving individual names to all the stars in the Milky Way. But what follows is a basic primer on the more important schools, style, trends, and tendencies.

Abstract Expressionism

Contemporary art, to some degree, owes (or thinks it owes) a great deal to the Abstract Expressionists. This was the pioneering style — variously slashing and dripping — that started in New York in the late 1940s and remained strong until the late 1950s with an influence lasting to right now. It's also called The New York School and is widely considered to be the most original American style ever to have been created. The reason is that it leaned less heavily on the art of Europe, which has always been, understandably, the genesis of American art.

The term is often applied to artists whose work is not always abstract or not very expressionist. **Willem de Kooning,** dubbed an Abstract Expressionist, made use of many figural motives in his viscerally scary and beautiful visual blasts, such as the female figure and Marilyn Monroe.

Jackson Pollock was the quintessential — maybe the only — Abstract Expressionist and "action painter." His surging, floating, shooting, melting, yielding, charging, attacking, embracing, merging colors — running the gamut from enamel black to mauve and lavender — of his famous so-called drip-and-slash canvases sum up the style. They last and seem to grow in quality, perhaps because they are emblems of the way contemporary people perceive and feel. Pollock's compositions are loaded with contemporary emotion, lightning fast, and delightfully confused. When you really take the time to study his paintings, you'll find you cannot articulate the myriad abstractions. You can only allude to them in the most general terms. This experience of not being able mentally to comprehend forms that the senses innocently get is purely emotional. Samuel Butler once said that life is like learning how to play the violin and having to give concerts at the same time. That is how Pollock painted, as if living and painting were the same. And so he either got it right or blew it, losing himself in monotonous self-indulgence.

The best words I know that have ever been written about Jackson Pollock are those that Paul Richard, the art critic of the *Washington Post,* penned regarding the prime gallery in the last huge retrospective of his finest works of the brief period of the early 1950s. Describing Pollock's method of painting, Richard compared Pollock's activity level while painting drip paintings to that of an enthusiastic, intense dancer and to an orchestra conductor who used a brush instead of a baton. Richard compared Pollock's motions to those of a quarterback making a long pass and a fisherman casting woven nets of color. Pollock's paintings, Richard noted, depicted the energy that Pollock poured into his work integrated with the natural laws of viscosity and gravity.

And don't forget **Clyfford Still, Robert Motherwell, Franz Kline,** and **Richard Pousette-Dart.**

Color Field Painting

Color Field means roughly that the canvas is used for very broad and unarticulated bands or areas of the same color, stacked, or placed adjacent to each other. The Color Field painter **Mark Rothko** was hardly the symbol of the "action painter," which was the late *New Yorker* art critic Harold Rosenberg's way of describing the Abstract Expressionists. Rothko's soft, glowing banners of reds, russets, rusts, and beiges and his incandescent patterns of blues and

blue-blacks were painted with the thoughtfulness of a computer engineer. It just goes to show that in art, labels are about as accurate and meaningful as in any other field.

This is the empty art best exemplified by the canvases of **Barnett Newman**. Nothingness, but of a sensitive and rarified nature.

Pop Art

Another powerful impetus in the formation of today's art is Pop Art. This movement, which devoutly drew upon popular art images from newspapers and TV for its subject matter, followed the extravagant non-objectivity of Abstract Expressionism almost as a relief — for most of the works embrace some kind of realistic subject matter. **Jasper Johns** painted the American flag in various manifestations (see Figure 16-1), even in poetic shades of gray. **Claes Oldenburg** created over-life-sized commonplace things — lipsticks and baseball bats and shuttlecocks (see Kansas City in the U.S. museum guide, the Nelson-Atkins Museum outdoor sculpture). **Andy Warhol,** who was a painter of oddball, yet great, distinction during the years 1962 to 1965 (after which, sadly, he began to believe his own PR and got rotten) idolized Marilyn Monroe and Jackie Onassis. **Roy Lichtenstein** monumentalized common comic strips (Figure 16-2). The message of Pop really was the medium as Canadian cultural analyst Marshal McLuhan wanted it to be — remember "The medium is the message." But Pop artists were — and still are — striving to refresh art with a pungent brand of realism.

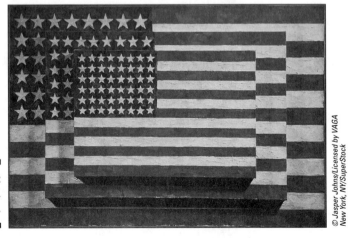

Figure 16-1:
Three Flags,
by Johns.

© Jasper Johns/Licensed by VAGA
New York, NY/SuperStock

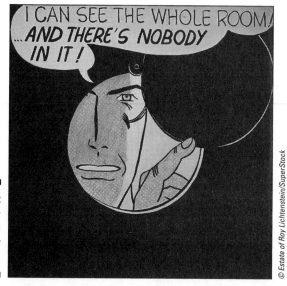

Figure 16-2:
"I can see the whole room...", by Lichtenstein.

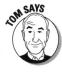

To me, the single finest Pop piece is Andy Warhol's large canvas entitled *Ethel Scull 36 Times* (1963), showing the wife of the late art collector and taxicab mogul of New York in 36 silk screens taken from cheap Broadway penny arcade photo machines she and Warhol ducked in and out of one day. It's now in the Museum of Modern Art (and had been "absolutely" promised to me for the Metropolitan by Mr. and Mrs. Scull). The lovely Ethel Scull is the perfect example of swinging New York City in the 60s and shows herself delightfully gay, knowing, and fully involved in the act of creation.

Abstract Illusionism

This was the label stuck to painters like the American **Frank Stella**. When I was a graduate school student, Frank Stella was an undergraduate in art history, and we became somewhat attached. He spotted a giant king-sized bed box spring in my backyard about to be trashed and asked if he could make a construction. Sure. He did, and it was fantastic, the progenitor of his now justly famous combinations of painting and sculpture. I kick myself in the pants to this day because, when my wife and I moved to New York, we left the grand "piece" in the backyard! (See Figure 16-3 for an example.)

Figure 16-3:
Stella's
Fan #3.

Art Brut

This is a French phrase meaning, simply, raw art. The painter **Jean Dubuffet** summed it up when he proclaimed that his art attempted to bring all disparaged values into the limelight. He also used the term to describe pictures made by children and psychotics and, of course, himself.

Body Art

This movement is linked to 60's Happenings by artists like **Allan Kaprow** and the Fluxus events of **George Maciunas.** As a phrase, body art is often associated with the use — sometimes intended to be deliberately funny and at times destructive and disgusting — of the human body as the prime medium for the art of **Vito Acconci, Chris Burden, Ana Mendieta,** and **Dennis Oppenheim.**

Minimalism

Since the 1960s, artists working in the much-less-is-much-more style have created works that give up all claims to either illusion or raw expression in favor

of an impersonal timelessness. The attitude is, "I have nothing to say, and I am saying it." American minimalists include **Dan Flavin, Donald Judd, Sol Lewitt,** and **Robert Ryman.**

Conceptual Art

This movement started in the late 1960s and involves words — yes, words. The idea is that the idea or the words associated with it alone make the work of art, and the creation in bronze, stone, or paint is merely incidental to the idea. (Check out the Germans **Joseph Beuys** and **Hans Haacke,** and the Americans **John Baldessari** and **Joseph Kosuth.)**

Earthworks

This word designates art made from natural materials selected or imposed in the natural landscape. An example is **Michael Heizer's** *Double Negative* (1969-70), the work that consists of nothing more than scratching out two parallel white lines for a mile or so in the Nevada desert at Mormon Mesa. Other American examples of earth and site projects include **Christo's** now-removed *Running Fence* in Marin and Sonoma counties, California; **Robert Smithson's** spiral jetty at Great Salt Lake, Utah (1970); and **James Turrell's** *Roden Crater Project* (begun 1972).

Hairy Whoism and Chicago Imagism

This movement actually exists and consists of trash "treasures" birthed by artists in Chicago in the late 1960s and 1970s who, for some inexplicable reason, called their group by this strange name. The works by painters **Roger Brown** and **Jim Nutt** can be exceptionally powerful, however.

"True" Art

You may recall the incident a few years ago when two former Soviet Union artists, **Vitaly Komar** and **Alexander Melamid,** painted two "true" pictures in the style that their scientific worldwide poll discovered was what the vast majority of Americans cherished and loathed in art.

The preferred "true" art was embodied in a painting with George Washington taking a stroll along the banks of a gorgeous lake. Lush woods are featured on the left and gorgeous mountains shone in the distance against an azure sky.

Three comely youngsters in neat, modern dress nearby look the other way. There's a pair of pretty deer. The blue sky is streaked with white clouds, and the day is a splendid cool autumn one.

The most-hated style is a hard-edge abstraction festooned with spikey and awkward slices of a red and orange pie that look singularly inedible. It turns out the poll and the resulting paintings were farcical and intended to be. I think it's important to get the word out because the widespread publication of the paintings by the press, which took the event seriously, did have many people thinking that most Americans were philistines about art. They are not.

Neurotic Realism

This current trend was coined by the British advertising whiz and major collector of contemporary art, Charles Saatchi. It is a chaotic style, supposed to portray your everyday apocalyptic nervousness. The witty British art critic of the *London Times,* Richard Cork, recently noted that the style finds no better practitioner than the London-based Japanese sculptor **Tomoko Takahashi.** Her work has been described as nightmarish, a wasteland, futile, and absurd.

Wow! I'd say, maybe it's best to stay clear of neurotic realism.

Transavantgardism

In the late 1980s, some Italian painters, **Sandro Chia, Francesco Clemente,** and **Enzo Cucchi,** swung away from something called Neo-Expressionism, which picked up where Abstract Expressionism left off and was drippier and slashier, and embarked upon a Magical or Hyper Realism, which is what Transavantgardism means — in short, you see, what you see.

Installation Art

Difficult to describe. In principal, it means taking a large interior (the exterior can be part of an installation, too) and loading it with disparate items that evoke complex and multiple associations and thoughts, longings, and moods. It's a huge three-dimensional painting, sculpture, poem, and prose work.

One of the premier artists working in the medium is the American **Ann Hamilton** who was chosen to install a work in the nation's neo-classical pavilion in Venice, which is used every two years for an international art exhibition.

Ms. Hamilton's style is to take a bewildering variety of materials — anything from cut flowers to wool coats, bird carcasses, lumps of soot, decaying bread dough, and horsehair — and arrange them into a purposefully disorganized pile of art. In Venice, for the 1999 show, she placed an enormous veil of water glass in front of the pavilion that both framed and radically obscured the structure's 90-foot length and 18-foot height. Set three yards from the entrance, the steel-and-glass wall distorted the pavilion, making it look something like the other side of a fun-house mirror. Inside, she had some fuchsia-hued powder cascading slowly down the walls. This garish powder piled up on Braille dots Hamilton arranged that spelled out verses relating to human suffering. The powder slowly descended from the top of the gallery walls, and as time passed, the powder built up around the white dots, making them partially visible, yet still frustrating the viewer's ability to read what they say. Muttering softly in the background was Hamilton's whispered rendition of excerpts from Abraham Lincoln's second inaugural address, which deals with curing the wounds caused by slavery. You might not understand it because Ms. Hamilton spelled out the words letter by letter in international alphabet code (alpha, bravo, charlie, delta, and so on).

Hamilton called her piece *Myein,* which comes from the ancient Greek word for mystery and initiation and also refers to an abnormal contraction of the eye's pupil.

"It's the eve of the millennium," Hamilton explained. "I want to bring to the surface the questions we should be asking." Katy Kline, the director of the Bowdoin College Museum of Art in Maine, who chose the work for the Biennale, says, "She invites the viewer into a set of visible and auditory conditions where their entire bodily experience is activated. They are swept into a state of awareness beyond that of the normal viewer. She tries to intrigue the whole body."[14]

It was truly mystifying, perhaps wonderful, and definitely installational.

These, then, are some of the labels associated with the art of today. Hundreds more will be coined, and some of them will be as zany. My final word of advice is to forget the labels, for art that will make the blood rush faster in your veins is beyond labeling and jargon.

Chapter 17

A Look at Art Beyond the Western World

*I*n numbers of souls, tongues, forms of art, spirit and possibly spirituality, the nations beyond the west, in Asia and the Pacific, loom far larger than our relatively small but focused world. The art of the rest of the globe is thrilling, diverse, extremely enigmatic even when you know a lot about it, and virtually impossible to talk about, even in the native languages where the art was produced. But here's a pared-down overview. It might get you started on the twisting and ever-surprising path.

China

The greatest joy about Chinese art is that it is so totally different from the art of the West, and although there are crossovers, these contacts and occasional mergers were superficial. It's futile to compare or contrast Chinese art with that, say, of Roman times or the Renaissance because there's simply no coincidence.

The essence of Chinese art

It's difficult to define the complex essence of Chinese art. But, being ever brash, I'd say that in general, it is far more realistic in style than one would first believe. Landscapes are especially true to nature. Those seemingly off-the-moon scenes of mountains looking like precipitous hairpins crowned by

tufts of half-cut hair happen to be naturalistic. I'll never forget a trip down the Li River on a raft pulled by a tug (the motor launch was on a half-mile cable so one's peace would not be shattered — very Chinese) and my utter astonishment to see these hairpin mountains in the flesh — they were eons ago at the bottom of a sea, now-dry, which explains their bizarre shape. The strange, outer-worldly landscapes depicting them, I suddenly knew, are almost scientifically correct. I urge you to try and spend a couple of days in Guelin for the memorable day-trip on a barge down the Li River. That's the location of these wonderful mountains, and you also can see that Chinese painters weren't creating mountains from their fertile imaginations — just realistically reporting the visual facts.

One of my favorite Chinese landscape paintings is *Early Spring* (1072) by the Song dynasty artist **Gao Xi** (c. 1020-1090). It's in the National Palace Museum, Taipei. Painted with ink on a four-foot-high (1.2 m) silk scroll is a gorgeous misty, forest-filled mountain scene. The brushwork, always beloved to the Chinese, has been applied by the master's signature style in almost infinite degrees of brush pressure and thicknesses of ink. The silhouettes of the rocks are done with a fairly heavy touch while the trees surrounded by fog are rendered with a delicate one. It's uncanny how the treetops gradually disappear almost imperceptibly into the mists while the tree trunks are still vigorously emphasized in stronger ink. These complex ink washes harmonize and express a totality of nature.

Another exceptional example of Chinese nature painting, also in the National Palace Museum, is by the Ming dynasty painter **Wen Zhengming** (active 1470-1559). In this marvelous work, a pine and a cypress grow together at the side of the painting. A dense stone wall fills the background with no space to spare. From a far-away source a cascade of water flows and unifies the composition. The use of the brush is extraordinary, especially because it was done when the artist was 80 years of age.

Worth a trip to China alone is a visit to the unparalleled tomb of Emperor Qin Shi Huangdi (ruled 221-210 B.C.), a dynamic tyrant who unified China and built portions of the Great Wall, The tomb, according to near-contemporary accounts, was intended by the emperor to be a model of his realm during and long after his death. Some 700,000 people were said to have been enslaved to build it. It was protected by ingenious automatic crossbows and rivers of mercury (shades of Hollywood), but the accounts also say that much of the wealth stashed inside was already plundered a century after construction (but wait and see when they finally complete the excavation!).[6]

The excavated portion of the burial complex on the site of of old Xi'an, near the modern city of Lintong in Shaanxi Province is filled with thousands upon thousands of life-size terra-cotta figures of warriors. These unbelievable sculptures were discovered in 1974, and excavations revealed a total of four pits, roughly adjacent to with the emperor's main mausoleum. Three of these

contained an entire small army with everyday equipment, such as horses and chariots. Although the terra-cotta warriors were broken and sometimes totally crushed, the majority could be restored, and they had fallen so that their positions could be established. What is truly stunning about the array (other than the sheer size and awesome numbers of statues) is that the soldiers seem to be portraits. They aren't but seem to be because of the clever manipulation of different hairstyles, mustaches, and beards. These things are unique in all of art. Officers wear caps, display badges of rank, and in some cases wear personal armor. The sharpshooters' garb is of light material suited to mobility. The enlisted men wear knee-length tunics tied with belts over high-collared inner garment or beneath armored jackets. The charioteers wear leggings and caps, and the cavalrymen have short battle vests and boots. Commanders wear fancy battle tunics with armored aprons. The statues are made with coarse clay from nearby Mt. Li. Figures were made one by one — the limbs, heads, and ears were constructed separately, then joined before being fired. The details, such as armor and hairstyles, were individually crafted, which is mind-boggling. Most warriors are posed at attention or in action. Everything, man or beast, was richly painted in various colors, now faded, including shocking green, black, purple, yellow, white, and red. (See Figures 17-1 and 17-2.)[6]

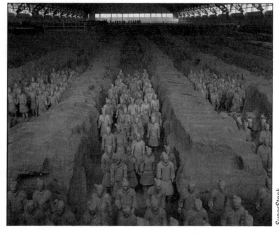

Figure 17-1:
The tomb of
Emperor Qin
Shi Huangdi.

SuperStock

Seeing this burial complex is one of the most exciting archaeological experiences on earth, and you should make every effort to get to China. When I visited pit 1 in 1986, I had dreams about the fabulous contents for weeks — and still do.

I haven't been to mainland China since 1986, so I cannot be of much help guiding you where to go. The Forbidden City in Beijing is under constant renovation. Shanghai, where I saw a fine array of paintings, is also being redone and has opened a splendid art museum.

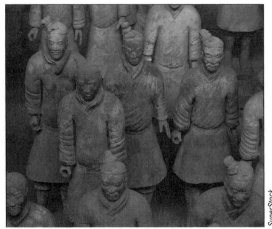

Figure 17-2:
Tomb detail.

SuperStock

Taipei treasures

Arguably the richest museum for Chinese art treasures — and one of the world's wonders as far as art museums go — is the National Palace Museum at Taipei, Taiwan. It exhibits hundreds of items from an inventory of nearly 700,000 treasures from the Imperial Collection, begun in the 10th century. The holdings consist of calligraphy, books and documents, bronzes, porcelains, jades, lacquerware, sculpture, and paintings. All are the absolute top of the line.[9]

One of the brochures at the museum — which offers, by the way, superior guided tours in virtually every language on the globe — primly describes how the place came to be, "Not long after the National Palace Museum was established in 1925, the collection was sent on an odyssey of several thousand miles to avoid the winds of war, before finally settling along with the Republic of China on Taiwan." Which means that while Mao Zedong and his Communist armies were taking province after province in the bitter Civil War after World War II, Chiang Kai-chek, the leader of the opposition Nationalists, formed a special group of soldiers and art historians to grab every work of art from anywhere that these experts deemed important. The group would show up, examine, and seize the best of the best — then thank you very much. The hundreds of thousands of treasures were loaded into boxcars of a special train and continually chugged out of range before a bombardment or territorial takeover. Mao's forces desperately tried to find the train. Countless times the boxcars would escape minutes before the Communist cadres had arrived — hair-raising stories of the close calls abound.[9]

Miraculously, all the objects made it to Taiwan and were deposited in a series of vast underground tunnels cut into the hills immediately behind today's Palace Museum. It hasn't been until fairly recently that a full inventory of the

staggeringly rich holdings has been made. All works on view are on semi-permanent display — every six months or so there's an almost complete switch-over, so the delicate objects won't suffer damage from light and so that, in time, the entire collection can be seen. It will take perhaps a century.[9]

If you are at the museum when the following objects happen to be on view, consider yourself blessed, for they have no equal in Chinese art:

- *Storied Mountains and Dense Forests*, an ink and colored painting on silk by the legendary painter **Chu-jan** of the Tang period (618-907 A.D.). Lyrical and poetic, this landscape also shows off a strikingly observant realism.[9]

- World-renowned Yi ewer dating to the 8th century B.C. This vessel for washing hands in ritual ablutions is supported by four legs in the form of human figures; the handle is a dragon. It is breathtaking.[9]

- Silver cup in the form of a log raft, attributed to the silversmith **Chu Pi-shan** who was active during the Yuan dynasty (1279-1368). This small and delicate silver cup is in the shape of a weathered, old hollow log. One end is smaller than the other and pokes up looking like it was broken off naturally. Sitting casually on the lip of the log is a scholar who raises his head and smiles puckishly. The wind seems to lift his cap and rumple his clothes. His right hand holds a tiny rectangular stone with two Chinese characters incised identifying the individual as Chang Ch'ien who, in the 2nd century, voyaged West seeking the source of the great Yellow River, but, instead, landed in the Milky Way.[9]

- One of the strengths of the massive collection is the jades, and one not to miss (ask if it's on display) is the cabbage carved in the Qing dynasty (1644-1911). The creator has transformed a piece of emerald green and white jadeite into what, at first glance, seems to be a real hunk of cabbage. The semi-translucent leaves look like they might move if you touched them. Look for the grasshoppers partially hidden among the leaves. (See Figure 17-3.)[9]

There's a Museum for Modern and Contemporary Art near the Palace Museum, which is known for its comprehensive exhibitions. Another worthwhile museum in Taipei is the Museum for Decorative Arts, and the staff will be helpful in guiding you to the ceramics workshops that produce excellent reproductions of traditional ceramic wares.

In the United States, there are many excellent collections of Chinese art. Try the Museum of Fine Arts, Boston; the Metropolitian Museum, New York; the Freer Gallery and Sackler Museum of the Smithsonian, Washington, D.C.; the Asian Museum, San Francisco; the Nelson-Atkins Gallery, Kansas City; the Cleveland Museum of Art; and the Art Institute of Chicago.

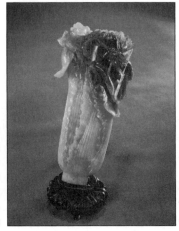

Figure 17-3:
A cabbage
carved in
the Qing
dynasty.

Japan

Japanese art owes a considerable debt to China, but although it shares many characteristics with Chinese art, it stands on its own. If I were to boil Japanese art down to its essence, I'd say that it is ineffably delicate even when depicting subject matter like storms, dragons, or fearsome warriors, and forever subtle and complex even when it looks simplest.

I once bought for the Metropolitan a samurai sword of the 11th or 12th century. In ancient Japan, the swordmakers' art was considered to be on a level with painting and sculpture. I learned that all samurai swords had names, and once the name of this sword was translated for me, I suddenly knew a great deal about Japanese art. The name is *Dew On the Grass*. That's pure poetry, the suggestion of a fresh, pure early morning. It's also a description, for the shape of the blade of the sword and grass are visually similar. Finally, it's a direct and cruel expression of the purpose of such a blade, for when that sword lopped off the head of the samurai's adversary, his blood fell like dew on the grass. Every Japanese work of art contains a similar multiplicity of meaning.

Unbreakable traditions

Through its entire development of thousands of years, Japanese art has always displayed a love of nature and a reverence for natural materials. It has never veered from an excellence in craftsmanship and design. It has forever maintained a deep respect for native artistic tradition. The shrine at Ise near

Nagoya is the classic example of all of this. Constructed of wood in an exacting method of joinery that requires no nails, the shrine has been rebuilt in precisely the same style every twenty years through most of the past 1200 years.

These unbreakable traditions have continued along with irrepressible experimentation and creativity. The result is that Japanese painting, decorative arts, and architecture of the 19th and 20th century are as vital as any art created anywhere else in the world.

The most fabulous places to see Japanese art are Nara and Kyoto, whose architecturally important temples and shrines are filled with major works of sculpture and painting. Nara recommendations would include the *Toshodai-ji* (c. A.D. 795), the *Todai-ji* (8th century A.D.) and especially the *Horyu-ji* (7th-8th century A.D.). While in Kyoto don't-misses include the 14th-century *Kinkaku* (Golden Pavilion) of the Rokuon-ji, the 15th-century *Ginkaku* (Silver Pavilion) of the Jisho-ji and, most famous of all, the 15th-century Zen dry gardens of gravel and rock at the Daitoku-ji and the Ryoan-ji. An hour gazing at the latter will change your life very much for the better.

Kyoto also has a sensational National Museum. One of its most striking paintings is the fascinating, and somewhat grisly *Gaki-zoshi* or *Scroll of the Hungry Ghosts* from the late 12th century. This is one part of the seven-part story of the *gaki* or hungry ghosts. These emaciated non-creatures with skeleton-thin limbs and swollen bellies are invisible to the human eye. They exist in a state of perpetual terrifying thirst and survive only because they lick away at drops of spilled water in temple cemeteries. The artist shows the misery of the gaki. In contrast with the bustling variety of the solid people in front of the temple, the misery of the gaki is depicted by light touches of color. This is breathtaking. Another must-see in the Kyoto National Museum is the simply riveting *Bamboo and Tiger* by **Ogata Korin** (1658-1716), an artist of superb talent. This ink on paper piece shows his legendary sense of what can only be described as humorous friendliness. A tiger sits cozily in front of a bamboo grove, glancing off to one side, like a mischievous kid. Korin's tiger is almost comical. This style has been called in Japanese *giga* or "cartoon style."[7]

It is definitely worth a trip to Nagoya to visit the Tokugawa Museum. This institution preserves the extensive holdings of the Owari branch of the Tokugawa family. No other feudal lords owned holdings that surpassed theirs. This family legacy encompasses the finest imaginable art and a staggering array of heirlooms and furnishings intended for the lord and his household.[7]

Occasionally in Tokyo, the Agency of the Imperial Household exhibits treasures from the imperial collection. If you are in town when one of these shows is on, be sure to go — and go and go.

In the United States, the Packard Collection at the Metropolitan Museum of Art in New York is justly famous. The Freer Collection in Washington, D.C., owns more treasures than you can see in a lifetime. In Los Angeles, there's the stunning collection at the Los Angeles County Museum, and not to be missed are important collections at the Boston Museum of Fine Arts, the Art Institute of Chicago, and the Cleveland Museum of Art.

India and Southeast Asia

One of the few areas of the world I haven't been to is India and Southeast Asia, except for a brief visit to Thailand on the way to China. Therefore, I can hardly call myself an expert on the subject.

Indian aesthetics envision a work of art as having distinct "flavors," meaning artistic attributes — anything from the lovely lines of a sculpture to its smooth finish. And "tasting" or intently observing these "flavors" leads to the appreciation of the piece. But every work can only be tasted according to the intellectual, emotional, and spiritual level of the individual viewer. For example, if you are a devout layperson, it's fine to taste and fall in love with the lines and finish of a particular sculpture. But if you are at a much higher level of spirituality, tasting the sculpture won't benefit you. That's because you're already close to the knowledge of the Godhead, and a sculpture is only a pale reflection of it.

Like you, I have to saturate myself in Indian art. If I were to do so, first off, I'd make a bee-line for the British Museum in London because the institution is fairly brimming with spectacular treasures acquired by the British colonialists. In America, I'd go to the Cleveland Museum of Art, the Los Angeles County Museum, and the Museum of Asian Art in San Francisco.

The best of the best in the Museum of Asian Art are two Khmer (Cambodian) sculptures of the eleventh century that depict, life-size, a male and a female, half-divine, half-royal personages. The statues are carved in loving detail by an artist whose grasp of humanity was as good as any genius of the medium ever born. They are refined and elegant, spiritual to a high degree, full of mystery, and at the same time approachable as real human beings. They've got it all. Just like the best of Indian art. These serene images should be on everyone's list of the top 25 works of art in America.

Islamic Art — Only God Remains

Islam is an Arabic word meaning submission to the will of God and is the religion founded by the prophet Muhammad in A.D. 622 He was born in Mecca and lived principally in Medina in Arabia. The belief in the oneness of God

and obedience to His will forms the basis of Islam. The will of Allah was revealed to Muhammad in the words he wrote in the book called the Koran (Qur'an).[6]

The essential thing to know about Islamic art is that it wasn't about creating unique masterpieces, and it didn't build monuments for the eternal glory of God. Rather, it sought to please man and to make every moment of his life as enjoyable as possible. There is a powerful hedonistic element in Islamic art. Yet it's a hedonism held in check by the awareness that all human things will perish. Islamic art, seen as a whole, offers a curious paradox, for while it lends grace to life's activities, it is created with materials that will disappear, and thus emphasizes Islam's fundamental conviction that only God remains.[6]

Islamic art, like early Christian art, had no visual tradition and grew out a number of existing artistic styles altered by the new faith. But unlike the early Christian movement that deliberately sought to destroy pagan art and architecture, the Muslim conquest wasn't interested in destruction. The attitude was live and let live and assimilate whatever seemed right and decorative. Islamic art in general avoided the representation of the human figure except in strictly secular art. Not a single Koranic passage speaks against representations of living things. It seems that iconoclasm, the ban against human representation, which swept the Byzantine empire at the advent of Islam, also influenced Muslim disinterest in portraying the figure in religious art.[6]

I have listed here some of my favorite periods of Islamic art and what you should look for.

Beginnings — Early Caliphs and the Umayyads (633-750)

The early periods of Islamic art coincide with the Period of the Early Caliphs (633-661) and the Umayyad dynasty (661-750), which was the only one ever to control the entirety of the Islamic world. During these eras, the basic form of Islamic religious architecture, the mosque, was established. Mosques are not "houses of God" but large meeting places where the devout can meet to pray, thereby fulfilling one of Islam's daily obligations. Eventually the *minaret,* or prayer tower, which was first adopted from towers on a ruined ancient Roman structure, replaced the mosque rooftop as a site for calling the faithful to prayer. The minaret also proclaimed the presence of the new faith. Today, it is a minaret-dotted skyline that identifies an Islamic cultural enclave whether in Albania, Turkey, Iran, Pakistan, or Malaysia.[6]

The *minbar* became a necessity for the mosque interior. Originally it had been a chair with several steps used by the Prophet Muhammad to preach. By the way, perhaps the finest minbar to have survived is in Badi Palace Museum in Marrakesh, Morocco. This glorious one, commissioned by the

Sultan Ali Yusuf in 1137, was made in Córdoba, Spain. It's over 12 feet high (3.7 m) and originally consisted of nearly a million diversely-shaped and carved pieces of bone and colored woods — some pieces the size of seeds — shaped as stars, hexagons, scrolling vines, pinecones, blossoms, checkerboards, and Arabic letters.[6]

Two spectacular religious structures were constructed during the early Islamic period. In Jerusalem, the Dome of the Rock (c. 687-91) is the oldest surviving Islamic building and the second most important pilgrimage site for Moslems after the Kaaba in Mecca. Of importance to Jews, Christians, and Moslems, this opulently decorated circular shrine covers a rock believed to mark the site of Adam's creation, the stone upon which Abraham was going to sacrifice his son Isaac, and, most importantly for Moslems, where the Angel Gabriel took Muhammad on his Night Journey into Heaven to meet Allah. The other grandiose structure of the period is the prototypical Great Mosque built in Damascus, c. 715. This is definitely worth a trip to Syria to experience its magnificent spatial proportions and see its lavish mosaic decorations.[6]

From the beginning of Islam, ceramics became an important art form. Because most Islamic societies prohibited the use of human figures for decoration, they primarily used texts from the Koran inscribed in bold calligraphic scripts or introduced intertwining vegetal forms, a type of motif that came to be called *arabesques*. Some of the most stunning Islamic pottery results from the use of rich lustrous glazes that gave the surface of clay objects a metallic, shiny appearance.[6]

Fatimids (909-1171)

A zealous Islamic dynasty, the Fatimids, moved to Egypt from Tunisia, founding the modern city of Cairo. Here is where treasures of Fatimid architecture are to be found. My favorites are the mosques of al-Azhar (started in 970) and especially al-Hakim (c. 1002-03). Every trip to the city should include a stop at this mosque.[6]

In Palermo, Sicily, once a rich center of Islamic art, the extraordinary mid-12th-century ceiling of the Norman King's Cappella Palatina (Palace Chapel) was decorated by Fatimid artists with a stunning array of ornamental vegetal and zoomorphic designs, as well as vigorous scenes of daily life.[6]

Seljuq art (1037-1300)

The Seljuq empire was a confusing succession of dynasties that came to an end with the Mongol invasions of 1220-1260. Centered in modern day Iraq and Iran, its capital was Baghdad. Although renowned for glass and textiles,

Seljuq craftsmen were particularly noteworthy for their metalwork, especially the used of metal inlay. One of the more beautiful examples is in the Metropolitan Museum's fine Islamic Galleries — a bronze ewer from Khorasan in eastern Iran.[6]

Moorish Spain (719-1492)

Invaded from Africa by Muslim armies in 711, almost the entire Iberian peninsula came under Arab domination by 719. Commonly referred to as Moors, these Muslim immigrants from Western Asia and North Africa left a brillant and lasting mark upon modern Spain and Portugal. Córdoba, the capital of the Maghreb or Land of the Western Moslems, became the most important Islamic and Jewish intellectual center of the 9th and 10th century. The Great Mosque (c. 961-76), now the Roman Catholic Cathedral of Córdoba, remains one of the most awesome buildings constructed by the Moors.[6]

The headliner of Moorish art is the Alhambra palace in Granada, Spain. In the 14th century, two successive princes transformed the hilly, fortified site into a fairy-tale residence. Three parts of the palace remain intact. One is the long Court of the Myrtles leading to the huge Hall of Ambassadors. The second the memorable Court of the Lions with its majestic lion fountain in the center. The third is the Generalife, a summer pavilion known for its Islamic style gardens. The Alhambra is one of the rare palaces to have survived from medieval Islamic times. Its decoration is a tour de force. Elaborately decorated ceilings are supported by wispy columns or by thin walls pierced with a profusion of windows — the place is ablaze with light.[6]

The Moorish rule in Spain ended with the 1492 conquest of Granada by Ferdinand II and his Queen Isabel the Catholic. An Islamic style called Mudéjar, however, continued to be seen in architectural decoration throughout the Spanish Empire and in a lustrous surfaced pottery known as Hispano-Moresque ware. One of the better places to see fine examples of the vital designs associated with this ware is in New York's Hispanic Society.[6]

Mamluk art (1250-1517)

The Mamluks managed to hold onto power in Egypt, Palestine, and Syria from 1250 to 1517. During this period, the area emerged as a rich trade center that manufactured and exported some of the finest examples of decorative arts made anywhere in the medieval world. Some of the oldest surviving carpets are Mamluk. One of the finest — of the 16th century — is in the Metropolitan and is 29 feet (8.8 m) long and in matchless condition. Mamluk mosque lamps offer some of the finest examples of medieval glass. Wooden objects made by Mamluk craftsmen are highly ornmented and extremely beautiful.[6]

Ottoman art (1299-1893)

The Ottoman Turks brought about the downfall of the Byzantine Empire and, in 1453 conquered Constantinople, renaming this ancient city Istanbul. Here is where the greatest examples of Ottoman art are to be found. The gems of this Ottoman architectural treasury are the great mosques and *külliyes* (cluster of religious buildings built around each mosque) whose domes and minarets still dominate the Istanbul skyline. My favorites include the Fatih Külliye (1463-70), the Bayezid Mosque (after 1491), the Selim Mosque (1522), the Sehzade külliye (1548), and the Süleyman külliye (ca. 1550). The Sehzade and Süleyman mosques were built by Sinan, the greatest Ottoman architect, whose masterpiece is the Selim Mosque at nearby Edirne (1569-75). These buildings are rigorously conceived so that all architectural elements harmonize to enhance the central dome, symbolic of the redeeming word of Allah and the global connection of Islam. The domes and semi-domes of Ottoman architecture continue to reflect the domical traditions of earlier Islamic architecture, which in turn had been inspired by Istanbul's own Hagia Sophia (Holy Wisdom), the Byzantine church built between 532 and 537 by the Emperor Justinian and then converted into a mosque by the Ottomans.[6]

Another Istanbul Islamic treasure that should be near the top of everyone's itinerary wish list, is the huge palace complex of Topkapi, or correctly, Topkap Saray. Here, 300 years of royal architecture and art are preserved in a seaside setting of elaborate pavilions, halls, and gardens. The collections are staggeringly splendid and opulent beyond belief.

Safavid art (1502-1736)

Architecture and painting were the main artistic accomplishment of the Safavids, a dynasty ruling Iran from the 16th to the mid-18th century. The architectural wonder of this period is Shah Abbas's (reigned 1588-1629) constructions at Isfahan, the capital of Iran from 1598 to 1722. Elegant town planning, lustrous turquoise tiled domes, and sumptuous interiors have made Isfahan one of the wonders of the Islamic world. When you go, be sure to stay at the hotel incorporated into an ancient *caravanserai,* a grandiose series of structures in which the old caravans stopped off for the night.[6]

One of the Safavid works of the most exalted character is a manuscript illuminating the *Shah-nameh* or *Book of Kings* commissioned by King Tahmasp (1524-76). Half of the several hundred miniatures is at Harvard University,is and the other half at the Metropolitan, and they are gems. Their compositions are complex, individual faces appear in crowded masses, and there is a near-miraculous diversity and rendering of details in the landscapes. You'll hardly ever encounter such breathtaking beauty as in these illuminations — differing pages are displayed on a regular basis.[6]

Mughal art (1525-1857)

Baber, a Mongol Islamic monarch from Afghanistan, invaded India and in 1526 founded the Mughal (Mongol) dynasty. The culture of the Mughals was connected to the indigenous Hindu traditions of the Indian subcontinent, as well as Islamic sources in the art of Persia (Iran). Among the many stunning architectural accomplishments of Mughal rule is Fatephur Sikri (1570-1585), the now abandoned capital of Emperor Akbar. Built in only 10 years, it remains singular in scale, design, and in the superb delicacy of its ornamentation. The Taj Mahal at Agra (1631-53) is the finest achievement of the Mughal style. One of the most technically perfect structures in the world, this sublime mausoleum and its gardens were built by Emperor Shah Jahan to commemorate the beauty of his beloved wife.[6]

In Mughal painting a new style emerged around 1567 when a celebrated manuscript *Dastan-e Amir Hamzeh* ("Stories of Amir Hamzeh") was painted (some 200 miniatures remain and are found in most major collections of Indian miniatures, especially at the Freer Gallery of Art in Washington, D.C.). Traditional Persian (Iranian) themes are treated in a monumental way, and the result is an amazing expressive power.[6]

Mughal drawings, particularly those of animals, can be poignantly naturalistic. Muslim images glorifying the female body often display not only an erotic feeling but a penetrating sense of sympathetic humanity as well.[6]

Africa, Oceania, and the Americas

Not too many years ago, the distinguished art of these three enormous segments of the globe was known by the designation, "Primitive," presumably because the people who made them hadn't invented the steam engine and were non-whites, too. The works were shown off primarily in Ethnographical or Natural History Museums even though they were equal to the finest art of any European civilization.

I had the pleasure, when directing the Metropolitan, to acquire a fantastic collection of the art of all three civilizations, which had been assembled by Nelson Rockefeller. What got him going, he told me, was the intolerant advice from a stuffy trustee of the Met when he joined the museum's board and enthusiastically urged the institution to collect African and Pacific Island pieces. The trustee sniffed at the thought of "primitive art" and suggested that Rockefeller collect instead "real" art, meaning Greek and Roman. Rockefeller and I were delighted to have his treasures from Benin, the Sepik River culture of New Guinea, Mexico, and Guatemala, finally displayed cheek-by-jowl with Raphaels and Rembrandts, and, of course, Greek and Roman works. One significant change was made, from The Rockefeller Collection of Primitive Art to the Art of Africa, Oceania, and the Americas, which has now

become the politically correct title for most museum departments collecting arts of these regions. The Metropolitan's department is called the Michael C. Rockefeller Wing to commemorate Rockefeller's son who perished in New Guinea while assembling the Sepik River collection.

Africa

Few sculptures are as robust, eye-catching, profound, and ceaselessly fascinating as those coming from Africa. This sculptural imagery, unlike much of European sculpture, does not depict the world the artist is looking at but, instead, portrays a new kind of reality on its own. African carvers feel they are delivering a being into the world — a new sculpture is often given a name like a newborn babe. The work is not narrative, nor does it seeks to create a feeling of motion or spatial perspective. For example, if the artist wants hair, he'll take real hair and attach it to his sculpture. If movement is desired, the figure is carried in a procession or activated through dance.

African sculptures are never frontal, although they may give that impression at first. They are developed fully in the round and are best viewed from all sides or by walking around them. Unlike European sculptures, they are not made to stand on a pedestal or some flat surface but meant to be carried or to be stuck into the ground. Their creators were unconcerned about whether they'd ever be displayed.

The one characteristic common to all African sculptures is aggressive volume and mass. In every piece, there seems to be an inner mass and energy pressing out towards the viewer. African artists often say they see a sculpture inside the wood and cut away the material to reveal it. This inner volume can be so strong that it can even be seen in naturalistic sculptures like, say, a Fang head where the domed forehead is like a deliberate containment of volume suggesting forcible intellect and overwhelming personality.

There's little systematic about African sculpture, and in the same work, their creators switch from a full three-dimensionality to flat relief carving or incising drawing. They treat the same figure organically and utterly inorganically at the same time. African sculptors are especially adept when it comes to using voids. The space between the legs of a figure of a young woman, for example, might duplicate exactly the shape of her torso, thereby making a negative echo of the positive form. Finally, African work is never symmetrical. A Benin figure, say, will have one arm that's a bit fuller than the other. Like living human beings, African sculptures are given dynamism by subtle irregularities, which can render breathtaking effects.

Perhaps the most famous earlier African art comes from the Kingdom of Benin which was a powerful West African state between the 14th and 17th centuries. A capital was established at Benin City (in modern Nigeria) where an enormous palace came to be erected, and the arts flourished under the

obas, or kings, some of whom appear to have been accomplished artists themselves. The most impressive are life-sized, highly-realistic commemorative heads of royal personages, both male and female, and elaborate square or rectangular reliefs portraying all sorts of ceremonies and historic events, made to hang upon royal ancestral altars or to decorate the palace walls. The ivory-makers made breathtaking portrait head pendants to be worn by the obas, as well as elaborately carved tusks for horns and saltcellars, many of which were exported to Europe through trade with the Portuguese.

The most extraordinary repository of Benin art is in the British Museum. The British conquered Benin City in the late 19th century and made off with thousands of works of art from the palace. Another rich inventory is the Michael C. Rockefeller Collection at the Metropolitan where there is a fine gathering of ceremonial heads from Benin and a neighboring West African kingdom called Ife. One work stands out above all others, an almost perfectly preserved ivory pendant with a captivatingly sensitive portrait of an *iyoba,* or Queen mother; this was worn at the oba's waist. The beautiful carving is on a par with the work of the greatest portrait sculptors of Renaissance Europe, and the magical piece admirably sums up the strength and subtle, power and delicacy of African art. (See the main color insert for a Benin mask.)

Oceania

Oceania refers to the continent of Australia and the island groups in the central and southern Pacific, which are regionally called Melanesia, Micronesia, and Polynesia. As you can imagine, hundreds of styles and traditions existed. What you might not realize is that the sculpture — in general the only material to survive in any quantity — is refined and sophisticated. Most of this sculpture comes from Melanesia and Polynesia.

The greatest variety of sculptural styles is found in Melanesia, especially among the coastal and river peoples of the large island of New Guinea. Works done by the Asmats are the most accomplished. Human figures, often looking like insects, and orderly patterns of hook-shaped decorations appear alone or mixed together in a variety of large or minute works. Countless number of tribes located in the Papua New Guinea areas of the Sepik River, the Maprik Mountains, and along the coast have produced some grandiose sculpture that is world-famous for its inventiveness and dynamism.

The summit of Polynesian sculptural virtuosity was reached by the Maori carvers of New Zealand, who created an abundance of works ranging from minute objects to monumental constructions. The carving style is marked by a strength and confidence, especially in their ambitious decorative designs and delicate surface carving. Figures, which either stand alone or are integrated into highly complex curvilinear patterns, can be both realistic and purely abstract.

One hallmark of this style consists of the sinuous, curving patterns representing tattoos worn by the Maori. When these embellishments are applied to large areas, say, on meetinghouses or canoes, the Maori artist shows a distinct *horror vacui,* an art term meaning that every available space is jammed with decoration.

The most recognized sculptures of Polynesia are the monumental, exaggeratedly elongated heads of volcanic stone found on Easter Island, as shown in Figure 17-4. Theories as to why they were made and what they commemorate abound — almost as many as theories "explaining" the genesis and purpose of the Egyptian Pyramids. Perhaps the people just thought they were beautiful, which they happen to be. Few more moving sights in art exist anywhere than the dozens of these lonely, disembodied heads with their severe faces gazing out to the infinite ocean with sad, expressive eyes.

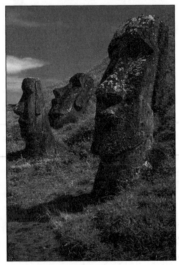

Figure 17-4:
Easter
Island
carvings.

SuperStock

The best places to see Oceanic materials are in Honolulu's Bishop Museum, Chicago's Field Musuem, and the Michael C. Rockefeller Wing at New York's Metropolitan Museum. Young Rockefeller lost his life in New Guinea collecting the world's most extensive group of Asmat Bi'shj poles, decorated canoes, shields, and other paraphernalia.

The Americas

PreColumbian

PreColumbian art is some of the most accomplished ever created. A vast number of cultures and civilizations arose and fell throughout both North and South America, leaving archaeological sites and art objects of staggering

accomplishment and beauty. Again, this is not an area of personal expertise, but PreColumbian art has always commanded my great admiration. One of my favorite examples is the stunning colossal heads, possibly ruler portraits, produced c. 900 to 500 B.C. by the Olmec living along the southern Gulf Coast of Mexico. The most impressive of these huge heads can be see at La Venta Park in Villahermosa, Mexico. I continue to be fascinated by the impressive sculptures and scene-painted pottery produced by the Maya of Mexico, Guatemala, and Honduras during the first millennium A.D. Also stunning are the gold objects produced by the Andean peoples of Colombia, Ecuador, and Peru. In Bogotá, Colombia, Museo del Oro (Gold Museum located in the elegant Banco de la República de Colombia) possesses a staggering collection of more than 33,000 superb works of art in gold (not all are, thankfully, on view at one time).

Among the great Pre Columbian sites, one which should be on everybody's cultural-tourist wish-list is *Chichen Itzá,* located in Mexico's Yucatán peninsula. There are some unforgettable structures and architectural sculpture here. Easily accessible from Mexico City is *Teotihuacán* ("City of the Gods"), famed for its great pyramids that rival those of Giza in Egypt. *Tikal,* one of the most enchanting archaeological sites anywhere, rises out of the rain forest of Guatemala as if the lofty temples, hundreds of feet high, were being thrust upwards by some incredible force. The main structures at *Tikal* appear in a tightly organized square mile of territory, and the closeness of the majestic temples with their precipitous stairs packs a tremendous artistic punch — something very worth seeing. In South America, the not-to-be-missed site is the Inca city of Machu Picchu breathtakingly perched between Andean peaks and lush tropical valleys.

Where to go to see PreColumbian art of the highest stature? In Latin America Mexico City's Museo Nacional de Antropología (National Anthropological Museum) for ancient Mexican art; and for ancient Andean art the Museo de Antropología y Arqueología (Museum of Athropology and Archaeology) and the Museo de la Nación (National Museum) in Lima, Peru. Many museums in the United States have impressive collections, notably the St. Louis Museum of Art, the Dallas Museum of Art, and New York's Metropolitan Museum of Art. Also, the Bliss collection at Dumbarton Oaks in Washington, D.C., has some top-flight pieces housed in an architectural jewel designed by Philip Johnson.

Native American

The field is immense, encompassing the myriad artistic expressions of the original inhabitants of the United States and Canada from prehistoric times to today. Ancient archaeological remains, art from the period of European colonization, as well as objects currently being produced all reveal that Native American artists have an uncanny aesthetic sensibility. Native American art can be a confusing patchwork of hundreds of different styles. Throughout the centuries, some tribes maintained art forms that never melded with those of other tribes. Yet others freely allowed forms to be taken

over and enhanced. For example, when the Navajo came into the Pueblo Southwest, it wasn't long before Navajo weavers — not especially skilled — met the gifted Pueblo weavers, assimilated their skills, and ultimately produced techniques and designs that far surpassed the earlier Pueblo works. Striking artistic differences also existed even when the peoples lived close to each other — the Hopi and Zuni are adjacent, yet the works of each have a distinct style.

The Native American art of the Southwestern United States is the most familiar. Often called *Pueblo art,* it is known for its adherence to traditional art forms, techniques, and symbols. Today, for example, Hopi and Zuni artists still produce imaginative pottery, as well as ceremonial carved and painted cottonwood kachina dolls. The Zuni also remain famous for their intricately worked silver jewelry with distinctive turquoise settings.

The Haida, Tlingit, and Kwakiutl of the United States and Canada produced sculpture of the highest quality from the cedar and spruce growing along the Northwest coast of North America. Especially noteworthy are Haida carvings on the facades of their sacred houses, vivid masks, and utilitarian objects of considerable majesty. The most famous carvings produced by the Haida are so-called "totem poles," which are not religious works, but historical documents to record the social position and wealth of the person who had ordered the pole. A breathtaking collection is brilliantly shown in Vancouver's Anthropology Museum, designed by the renowned Canadian architect Arthur Erickson.

The traditional wooden masks used for dances and social affairs by Arctic peoples are extremely inventive combinations of fantastic and real forms that are unsurpassed in their display of imagination. Some contemporary Eskimo stone carvings, especially those produced by the Inuit, can be brilliant. This is also true of a number of living sculptors, working in whale bone and walrus tusk, whose pieces are equal in expressiveness to any sculptures made anywhere on the globe.

The Plains Native Americans, like many artistically gifted peoples who constantly moved, paid great aesthetic attention to their own personal embellishment, making gorgeous paraphernalia for special occasions. Their splendid feathered headdresses and fringed buckskin clothing look pretty static in museum displays, but in motion, they must have been dazzling.

Part III:
Beginning Your Own Collection

The 5th Wave By Rich Tennant

©RICHTENNANT

"I bought it because I liked the way the play of light and shadow hint at our collective angst in a postindustrial society. And it covers a very large crack in the wall."

In this part . . .

1 let you in on how the professional examines a work of art — ten vital steps that anyone can follow. If you use these steps, you can avoid pitfalls, seldom buying a fake or even plain bad art. I let you in on the proper way to approach art galleries and auction houses. I reveal the truth about "buyer beware." I spell out how to get the proper appraisal and how, if necessary, to get your money back.

Chapter 18

Getting Ready to Collect

● ●

In This Chapter

▶ Using a checklist to examine a work

▶ Knowing the don'ts of collecting

● ●

*E*ssentially, it doesn't matter what type of art you begin collecting with — although I'd recommend you stay away from old masters, ancient Roman art, and Renaissance prints because these are the heights seasoned connoisseurs often find challenging! It doesn't matter if you begin collecting modest things; as you encounter more and more art, you'll lose your taste for the commonplace and find yourself striving for the level just a bit higher.

You might easily say, how can this upper-level professional examination help me, a beginner and not a high-roller? Fact is, all collectors from the most modest up will find this technique invaluable.

Getting Set to Collect

If you want to collect seriously, you need to know how to examine the work of your dreams the right way before signing a check for a few dollars or a few million. All seasoned collectors rely on a checklist to keep them focused. The one I have used since I started buying for the Metropolitan is still employed by many of the curators of the museum who decide what to collect for their various departments. In fact, it is the basis for the official acquisitions form the curators present to the trustees — the stewards over the money who decide how it is to be spent — for acquisitions when they want to add an item to the collections (and you can see a copy of it in Appendix B).

1: Record your first impression

I always record my first, immediate impression of the piece. I don't think; I just react. I try to capture the spirit of my eye's absolutely first, flashing, hundredth-of-a-second impression. I save it and come back to it after I've finished the full examination. This impression can be a couple of words or a phrase, and it's almost better if the words don't make much sense.

For example, when I first sighted the glorious silver gilded and enameled late 14th-century shrine of Queen Elizabeth of Hungary, which shows a magnificent pair of standing golden angels carrying crystal tubes containing relics, I recorded a quick impression. Now a treasure of the Cloisters in New York and a bargain back in 1962 for only $375,000, the shrine inspired me to scribble, "A golden universe! But not too tall." Later, I realized that the original soaring Gothic pitched roof of the resplendent shrine had been replaced by a flat one. Otherwise the object was pure.

And when I first eyed the triumphant painting by Diego Velázquez, the Spanish master of masters of the 17th century, depicting his friend Juan de Pareja, which I got for the Met for a mere $5.4 million dollars (and which is worth at least 10 times that much today), I wrote, "Be careful what I say about him, he's alive and will hear me, but why is he right in the middle of the canvas?" Gibberish? Not after a penetrating scrutiny. For we discovered that an English owner had folded several inches of canvas back instead of cutting them for a frame, and when the canvas was unfolded the young man was suddenly in a bursting, infinite space.

2: Describe the item in writing

I force myself to write a deliberately tedious and pedantic description. This strategy makes me look at the thing from all angles — front, back, and the sides, using my magnifying glass. (By the way, avoid becoming a slave to the magnifying glass or you risk losing the all-important impression of the whole work of the piece.)

Recently I was an expert witness in a court case involving the authenticity of some old master drawings looted from Germany during WW II by the Soviets. One was a world-famous ink drawing of a group of women bathing and being spied upon by a Peeping Tom, done by the incomparable German painter and engraver of the 16th century, Albrecht Dürer. It's known as the *Frauenbad* or the *Women's Bath* and hasn't been seen by many people since the mid-1940s. My first impression was, "not too electric." That was disturbing, because every drawing by the genius Dürer makes you feel as if you've been touched by a cattle prod.

My exhaustive description of the Bath came in handy, for had I not done it, I might not have admitted to myself that a number of details in the piece are mushy. Dürer is never mushy. In his self-portrait drawn at 12 years of age in silverpoint, you can see virtually every pore on his face. In the Bath, the wood grain on the ceiling beams, which in other Dürers is as fine as the engraving on a hundred dollar bill, looks out of focus. The door from which the old voyeur peers at the gorgeous array of naked females doesn't fit correctly onto its hinges, as my magnifying glass examination readily showed. In an arch over a fireplace, the bricks are all the same size and form a bland curve — Dürer wouldn't have been that dull.

Later, when I compared the drawing to a woodcut of the Bath made by one of Dürer's followers and dated two years later, I discovered that all the small errors and awkwardnesses in the master's supposedly original drawing had been corrected, including the wood graining, which was amazingly sharp. Is it logical for the follower to be more accomplished than the master? I soon came to the conclusion that the ink drawing had to be a 16th-century copy of the woodcut, intended to look like an original Dürer, but not by the master at all.

TOM SAYS

How to examine art like a pro

Examine the work of art that you think you may want to own in the best possible physical surroundings — well-lighted and not surrounded by a clutter of other objects that may detract from it. So, when you enter a dealer's shop and suddenly spot something across a crowded room that may be desirable, ask the dealer to put it in a separate room or on its own wall. This can't be done everywhere — the teeming Khan el-Kalili bazaar in Cairo may not be the right place, but give it a try.

I always bring a pocket magnifying glass with at least two powers of magnification and the all-important Swiss Army knife (the one with the scissors and the file).

Plus, I bring a flashlight (for places like the Cairo bazaar where there may not be electricity) and often an ultraviolet lamp, a solvent, and some swabs for a quick cleaning of small areas.

If it's an object or a small sculpture, I watch out for sensitive parts or repaired sections and ask the owner if anything will break when I lift it. I never use cotton gloves — too slippery. Once a jokester (who was also the most distinguished head of Madrid's awesome Academy of Arts) allowed me to pick up a three-foot-wide, two-inch-thick round silver plate made for the 4th-century Christian emperor Theodosius, and it fell apart right at the center onto its pillow. He choked with laughter, and I just choked. I don't know how many heart attacks he engineered by his jest — for the ancient break couldn't be seen.

3: Determine the condition

I next focus in on the condition of the piece that I'm examining. I try to assign dates to the wear — the bumps, bruises, and abrasions. Are they really old or are they phony? A forgery has the burden of having to look ancient when, of course, it's not. When I'm studying a painting, I peer through my magnifying glass for any passages where the artist changed his work or painted over some passage or moved a hand or a head.

Changes, called in art historical jargon *pentimenti,* an Italian word meaning "repentances" and thus an artist's changes, are excellent signs of authenticity. If no such changes exist, that's a problem, for in many cases that means the picture is an exact copy of an original.

If the thing is an antiquity, I look for ancient repairs and ask myself, "Are these really old?" I know that forgers frequently put in phony ancient repairs to make one think that the work must be 5th century B.C. or whatever.

I also analyze the types and layers of corrosion if the work is metal. Every material has an established pattern of corrosion (except gold, which doesn't corrode), and I know what these patterns should look like. In some forgeries the faker simply paints the corrosion on. In forged oil paintings, often the *cracquelure* (the cracking) that comes with age is painted with a single-hair brush or cut with a knife.

4: Figure out how the work was used

Until fairly recent times, even paintings had a specific use — for example, they could be decorations for furniture or even a magical icon intended to cure various ailments. Some paintings show subtle abrasions where the faithful kissed them for a cure. The wear should reflect how the work was used. I use my magnifying glass and scrutinize the wear on hinges or handles or the lips of silver or gold cups. I ask, does this wear show decades of use or is it merely the quick hit of a dentist's drill?

5: Determine the style

My next step is vital — I pin down the style of the work. As I explain in Chapters 4 through 17, every period, every country, and every artist possesses a signature style. Style can be likened to a complex and subtle handwriting or signature. Every style can be dated from its broadest epoch in art history right down to the year of the specific artist's career. Is the style of what I'm looking at identifiable and clearly datable? Is it consistent with the time when the

work is supposed to have been made? Do I detect several styles? If so, why? I ask, "Is this the work of a youthful artist finding his or her way? Or a faker stealing from a number of different works that an artist did at different times in his or her career?"

At this juncture, I choose the one work of art that I've come across in my career that's the most striking example of the artist's best work and in the finest condition. I compare it to the work that I'm thinking of collecting. I always try to have the perfect example brought side by side with the piece of my dreams.

6: Find out where a piece came from

I obtain the pedigree and provenance (where it's been from its birth to now) of the piece, including where and when it was exhibited and who owned it over time. I pore through all the documents as carefully as I do the piece itself. Faked documents are legion. In a recent famous case, forgers slipped into the archives of a great institution and stuffed the files with handwritten references to their fakes.

7: Consult an expert

I ask a qualified expert who has no ax to grind for an opinion. I am never worried about asking dumb questions, either — if it's a sculpture from the Parthenon, why does the Greek god wear a sculpted Rolex watch?

A few museums do have scheduled art clinics where a select group of curators will eyeball the piece and give you an opinion — usually not in writing — of the period, artist, and even condition. Normally, curators are not allowed to indicate values. The system of art clinics is more prevalent in Great Britain than in the U.S.

8: Run some tests

When I have time, I subject the work to a battery of scientific tests. Science can be a great help in figuring out what a work really is, but there's no "black box" you can point at a work that can indicate whether it's real or fake. I have found that all the most accurate measuring and analyzing devices only help to confirm the gut feeling. Forgers read all the up-to-date scientific journals and know how to mimic what should be there if the piece really is old.

Getting to the bottom of it

One curator pal of mine used his Swiss Army knife to file away very gingerly on the surface of the white glaze on a huge terra-cotta relief (and without being caught, for it was at a cocktail reception before a sale). It was laughed at by most experts as a replica of something by the Renaissance sculptor Andrea della Robbia. My friend discovered that below the industrial-looking glaze was another, far more subtle one. He bought the piece for under a thousand dollars, and it turned out to be the original della Robbia worth hundreds of thousands.

It's not feasible to drag the full equipment — X-ray, infrared, spectographic machines, and a few thermoluminescence analyzers — into some gallery or auction house. In the field, I carry with me a flashlight, my magnifying glasses, that Swiss Army knife, a small bottle of xylene, which is a good, mild cleaning fluid, and several swabs. I use the swabs to wipe off a tiny area of discolored varnish to see if the paint surface is disturbed — and I use a portable ultraviolet lamp that, when illuminated on sculpture and porcelain, tells me instantly by a garish purple hue that the work has been recut or filled in.

9: Compare your first impression with what you have found out

Finally, I go back to the split-second impression that I recommend in Step 1 and see if what I've found in my scholarly study conforms to my immediate reaction. I ask the final questions: Does the piece have enduring quality? Does it grow; does it become more captivating for me? Does it penetrate into the very recesses of my heart? Do I ache to possess it? Yes? Then I go for it!

The Don'ts of Collecting Art

My checklist is great for evaluating a work of art that you're examining, but the following list gives you some other general don'ts that you should be aware of.

✔ **Don't buy tired art:** Many works get shipped around the world's auctions until someone who doesn't have any idea of how much the pieces have been flogged eventually buys them. Always get the facts on the recent history of sales, particularly failed sales.

✔ **Don't buy the signature:** Discriminate, discriminate, and discriminate. Be sure to know which works by the artists you're interested in are thought to be more desirable. Remember that every artist made a good, a better, and a best. The name doesn't in the slightest guarantee that every work is equal to another. Works of art aren't new cars — each one has a life of its own with distinct graces and flaws. Usually, a later work is less valuable than one created at the height of an artist's career.

✔ **Don't buy without some research:** Track records count. The new "Michelangelo" had better have been shown in a couple of local shows and received some critical notice. (Bad notice doesn't matter all that much, but silence is fatal.) Find out what the artist fetched at auction if he's ever sold, and compare how the work that you're considering stacks up with the artist's most expensive work.

✔ **Don't ignore condition:** A mint-condition lesser work eventually gains more value than a damaged masterpiece. Be sure that you're getting something as close to the easel as feasible. Never buy without studying a condition report first. Provenance and history matter, too, and can drive up a price.

✔ **Don't be afraid to bargain:** You can expect to work a price down 10 to 15 percent, and most dealers allow payment over time. But do remember that if you become a bargaining bear, dealers may never bother to tell you that they have something fine.

Using your public library and other resources

Your public library will have sufficient art books for research. Go, ask for a library card, and then proceed to the reference cards, books, or computers, and seek the artist's name. The Internet can be valuable, and any of the search machines will quickly find virtually every artist recorded in history. Auction sales catalogues can be helpful, not so much for accurate information about specific works of art, but as a means of discovering the price paid. Do remember that scholars often disagree, and it is wise to find more than one opinion in books.

The goal of collecting

The ideal in collecting, the prime goal, is to find the true original, the single, unique work of art created by a artist. No mere copy — even an original largely retouched or something aggressively cleaned — is worth going for. Of course, in the case of prints, photographs, and sculpture in multiple casts, an "original" may not exist. But even when collecting multiples, there will one print in the series of, say, 200, that is better than the others because of its condition. This is also true with bronze sculptures, for what the artist himself has approved and what has been given his patina is always superior.

Chapter 19

How to Play the Buying Game

*T*he world of art collecting is full of pitfalls, forgeries, fakes, and just plain bad art. How do you avoid being taken? Unfortunately, forgeries aren't the only problems that you face as an art collector. You also need to know where and how to buy legitimate art because you can run into much trouble. And finally, you should always consider which type of art to collect. You may have your heart set on an old master or on an ancient Greek vase, but your chances of collecting in these areas aren't so good.

In this chapter, I show you how to avoid some of the common problems of art collecting.

The Many Faces of Forgeries

Forgeries come in three general categories. One is the straight copy. The straight copy is just that — the forger copies exactly an existing work without making changes. The second is called a pastiche, which is French for "paste-up." With a pastiche, the faker pastes together a mishmash of details copied from several works to give the flavor of the original artist. For example, the faker could combine elements of several paintings in order to make one painting. The third is the truly creative "original" fake. With an original fake, someone creates a work of art in order to pass it off as the work of another artist. Of course, the faker tries to imitate in style and material that which the other artist used.

What's faked the most? The list is varied:

- **PreColumbian pottery:** This type of forgery is common because of the enormous demand for the pieces and increasing penalties for smuggling in South American countries.

- **Greek gold jewelry**: Gold can't be dated, and fakes pass by even the experts — plus the money is good.

- **Ancient Egyptian blue faience (earthenware) animals and scarabs:** Every tourist going to Egypt must have an example or two of this type of work.

- **Paintings by Francesco Guardi, the Venetian 18th-century genius of landscape:** A conservator friend of mine thinks Guardi is still alive because so many of his views of Venice are emerging daily.

- **Salvador Dalí prints:** These prints have exceptional public appeal and are, therefore, faked frequently. In one infamous case, the aging Dalí was induced to sign a thousand blank pieces of paper which, after his death, were filled with images taken from his repertory, but were definitely not by him.

- **Watercolors by the American 20th-century illustrator Maxfield Parrish:** Due to his growing popularity, Parrish's watercolors are often faked.

- **Old master drawings of every period:** This is where the big money can be earned.

- **Chinese porcelains.** I once visited a factory outside of Taipei where glorious vases of all sizes and periods of Chinese history were being manufactured, and each one of the hundreds made each day was hand-painted.

Vermeer or van Meegeren?

When speaking of original fakes, one thinks immediately of van Meegeren, the much-hyped Dutch faker who, during WW II, invented an Italian style that never existed for the brilliant 17th-century Dutch painter Jan Vermeer. The experts were fooled, but not for long — especially since van Meegeren used a paint partly made out of Bakelite, which was invented in the 1920s. Forgeries seldom last beyond a generation or so because, by that time, the style of the forger's own period begins to stand out more prominently than the style he was attempting to fake.

ART ANECDOTE

Master fakery

Has any forger fooled everyone? Perhaps only one: an enterprising Mexican by the name of Brigido Lara from Veracruz who, starting as a teenager, made PreColumbian terra-cottas with a ring of fakers. He was arrested in the early 1980s for smuggling great national treasures of the so-called Veracruz "Classic" style into the United States. But he proved while in prison that he was the maker of the 14th-century terra-cotta masterpiece found in the trunk of his car, and he was freed. Today, he works at the Veracruz Museum — making reproductions for the shop. Had he not been falsely apprehended, Lara might have gotten away with forging not one work or a body of work by an artist, but an entire civilization — because 3,500 and more spectacular terra-cotta sculptures of the so-called Veracruz "Classic" style are all by him or his colleagues.

TOM SAYS

During my years at the Met, I was suckered at least three times, but thankfully not for multi-millions of dollars. In every instance, I was felled because of need, speed, and greed — you know, I simply have to have it, if I don't buy it now my competition will snag it, and getting it will put my name in lights. So play the game relaxed, and you may never get stung. But take heart; every courageous collector buys a fake or two. And one thing is certain: It's far worse to brand a genuine work of art a fake than it is to collect one. If you follow the checklist that I discuss in Chapter 18, the chances of getting stung are minimized.

There is also a category of what I call "near-fakes." These are works which are basically old, but only in part. They have been "restored" in a highly creative manner to make the work seem more attractive or in far better condition than it actually is. Some practitioners of near-fakery will take a mediocre painting of the 17th century, say, scrape off the sky or parts of the foreground, and then paint in (seamlessly with the genuine portions, of course) a glorious cloudy — and better — sky and peasants happily working in the fields in order to increase the selling price.

You may be wondering, "If a fake has fooled so many, isn't it as good as the real thing?" Never! The famous art critic Walter Pach wrote about fakes and their artistic worth in the 1920s, and he's still right. Pach felt that works of art were like living entities, and fakes were like dead objects that might fool their owners temporarily but would never provide lasting pleasure.

One of the misconceptions floating around is that museums are loaded with fakes — some even hanging on the walls — and that the officials stonewall about the scandal. The truth is that a very few forgeries may be on display, but they are being intensely studied by the curators. The obvious phonies are preserved in storage so fledgling curators can learn the tricky nature of such works.

Where to Go to Buy

You may find a Rembrandt etching in a flea market — it's happened — but the chances are equal to winning the Powerball lottery: billions to one. The best place to buy virtually anything is through an art dealer, especially those dealers who have been in business for several generations and whose operations are now run by descendants. And never buy for investment — only for the heart and the soul. For example, only two percent of all contemporary art ever goes up in value, and old masters can flip up and down wildly. Art is, in fact, the worst financial portfolio imaginable.

When you enter that grand art gallery, be advised that some dealers may try to play the snooty game and sniff when you ask bluntly, "Where's the price list?" The majority, though, are as dependent on drop-in business as a fast-food joint, so demand service. Be frank, and you'll get the same treatment.

Don't expect to be treated like a mall customer (who gets an automatic smile and some memorized patter) when you're in an art gallery. Art dealers are in love with their merchandise and deep down they don't really want to part with it. Not that you have to arm wrestle them to allow you to buy, but they do appreciate enthusiasm and a willingness to learn. The best approach is to ask for a lesson.

Knowing What to Ask

Use the following questions to quiz the dealer in the gallery that you've decided to patronize.

- ✔ How can I tell what the condition of this painting really is?
- ✔ When has varnish gotten so dirty that I'll have to have the painting cleaned?
- ✔ Why is this bronze green?
- ✔ How can I — even you — tell if this American early 19th century desk is not completely made up from, say, one authentic drawer?

There's one American furniture dealer, Israel Sacks of New York, who's trained hundreds of budding connoisseurs. After they'd ask such a question, he'd lead them on a merry chase through drawers, joins, inlay, embellishments, and the true nature of handmade nails until some of them could qualify as curators in museums.

Other nitty-gritty questions are:

✔ Do I get a written guarantee of genuineness?

✔ Can I get my money back?

✔ Can't you justify that price — with comparable pieces sold recently?

✔ Will you take 15 percent off that price?

In fact, if a dealer doesn't quote the price, doesn't bargain a little, doesn't hand you a guarantee of genuineness, balks when you ask for a detailed condition report or a solid provenance, and fails to spell out clearly the terms of getting your money back, make for the door. And spread the word around, starting with the Art Dealers Association.

Understanding Dealer-Speak

As you may expect, dealers use a language all their own, and although you may never learn the complete lingo (and don't ever want or need to), you should be aware of a few phrases.

✔ You may be looking at a full-blown work *by* the master — an original work whose origin is clear.

✔ A work whose origin is a bit doubtful is *attributed to* — which means that an expert or group of them agree that it's 60 percent likely to have been created by the master himself.

✔ Farther down the ladder of originality is a work *in the circle of the master,* and that's one done by an artist associated with the master artist, but not one of his pupils.

✔ A step down is a work *in the style of the master,* which is by an artist who lived at the same time.

✔ Another rung down is a work *in the manner of the artist,* or a work created much later that tries to evoke the general style of the master — something to avoid.

✔ At the bottom of the ladder is a work *after the master,* or, in other words, a blatant copy that will be a bargain (and no wonder) because it was probably painted a month ago.

Signature versus quality

Unlike the field of autographs and signed letters or historical documents, the presence or lack of the artist's signature is not as significant as you might think in establishing the importance or value of a work of art. Few things are easier in the faking, near-faking, or restoring game than to add initials or the signature of the artist and a date to a work. In the fine arts, it's the overall quality of the work and its condition that are important, not the signature.

Always ask a dealer just what he or she means by a puzzling phrase and you'll usually get a straight answer.

Taking Your Chances at an Auction

Buying at auction is more of a gamble, and the business, although cleaned up in recent years, is still a let-the-buyer-beware, read-the-small-print operation. Auction houses certainly allow you to examine a work that you're interested in, but far less easily than at an art gallery. The best advice I can give you is to read very carefully the qualifying language printed in the front of every sales catalogue.

Museum professionals never bid themselves at auctions and instead hire representatives to deal with the fury of the bidding, which can at times accelerate to a terrifying pace. I know of one curator who, carried away, bid against himself repeatedly and finally won his prize at a price several thousand dollars above what he could have spent — and all the while the auctioneer desperately tried to stop him.

If you're going to place bids yourself, settle on a final, hard price and never waver. Sit so that the auctioneer can see you. Bid with the paddle or with an articulate voice — no winks or touching the right label of the jacket or some other arcane and confusing gesture. It's okay to ask the auctioneer right in the middle of the fray to split the bid and to indicate to you where the last bid came from. And it's okay to make the auction house prove that the chap on the telephone is or was really on the line.

What to Collect and What to Avoid

If you want to collect art, you must be aware of which types of art lend themselves to collecting. Not all types are equal for the budding collector, and you'd be surprised to know what you should hesitate to collect — and what you should go for.

What to Look Into or Avoid

- **Posters:** This somewhat overlooked, affordable field has some chance of modest price appreciation. Yet posters are multiples, and the frightening load of modern replicas that exist is pretty hard to detect.

- **Old masters:** Not many of these works are around, and the available ones are often in poor condition. Many auction houses refuse to hand out authenticity warranties on works produced before 1870.

- **Drawings:** Even great works are still relatively cheap. But on the downside, drawings are fragile and forgery is rampant. Drawings are super-sensitive to direct sunlight, and most damage can't be repaired. Overrestoration is standard, and many blemished drawings are bleached, giving them an unpleasing, bone-dry white look.

- **Prints:** Many great artists made prints, which are readily available at fair prices. Nonetheless, a legion of phonies is floating around out there.

- **Antiquities:** Never buy antiquities. Because of stringent export laws, they have, for the most part, been illegally smuggled out of their country of origin and can snap back to bite you. Plus, forgeries abound.

- **Contemporary art:** This means living artists, whereas Modern art is generally understood to be the period from 1900 until the 1960s, although each art historian will have a different take on the definition. At least you know that you're not getting a fake, but the most minuscule percentage of living artists will be remembered in a decade. Yet, so what? You aren't buying art as a hedge, so purchase what you love and buy plenty of it.

- **Crafts:** By crafts I don't mean the sort of things you see at booths in the mall: pink bunny rabbits or portly pigs painted on weathered boards that say "Welcome to our home," but artistically inventive textiles, jewelry, glass, and pottery. I always recommend crafts most highly. The prices are right — and the creators are dedicated (in general) to making honest and solid pieces, the manufacture of which is normally impeccable, making such pieces last for centuries. I'm sure that in a few decades, pieces slightly looked down on today as "mere crafts" will be considered the fine and expressive art of our times. It's a basic rule of mine to buy in fields that are ignored, misunderstood, or reviled by the official critics, and crafts is the most glaring example of such treatment.

Condition, condition, condition

The goal is to collect absolutely original pieces, but, of course, in certain instances (such as posters, prints, photographs, and sculptures that were cast in series), you are going to be dealing with a piece that is technically not an original, but in its context is as valid. Use common sense and know that the 25th print in a series of 30 is better than the 12th in a series of 500, and the 4th cast of a bronze sculpture out of 10 is more desirable than the first out of 3,000, but that condition, condition, and condition have precedence over virtually all considerations.

Part IV:
The Part of Tens

The 5th Wave By Rich Tennant

Whoa~Dwayne!
Nice bear!

CHAINSAW
ART EXHIB

In this part . . .

1 isolate the greatest works of art and tell you why
they're the greatest. I also select the ten most interest-
ing artists who ever lived and explain why they are so
captivating. You will probably recognize a few names
already — but there are a few artists you may never have
heard of but will cherish from the moment you see one of
their great works. I also present my list of the artists I think
will last through another millennium. Finally, I let you in on
how to tell if your child has artistic talent — for the future
of art is always with the very young.

Chapter 20

The Greatest Works of Western Civilization

*O*ne early morning on a beautiful day not long ago, I retraced my life as an art lover — from 1951 — and wrote down the works that when I first encountered them bowled me over visually and emotionally. These are the ones that changed my life, the ones I believe to be the pinnacles of quality and artistic strength, the hallmarks of unalloyed genius.

My list was in the hundreds, but here I make the cut to 15 that happen to be primarily Western and more or less easy to see. I look upon them as friends, works I continually revisit because no matter how many times I gaze at them, I find something new and inspirational.

King Tut's Golden Mask

The find of the tomb of King Tutankhamun in November, 1922, with its nearly 5,000 works of art, caused a sensation. And today, visitors to the galleries that are loaded with the goods are still enthralled by the beauty and state of preservation of these pieces, which were made in the 14th century B.C. (See the main color insert.)

I shall never forget how I felt, as the organizer of the exhibition throughout the United States of some of Tut's works of art, when I personally lifted the golden mask that covered the mummy's face and touched it. I actually kissed it on the lips and didn't fall victim to the famous curse.

This gold and lapis lazuli mask is the most evocative and smashing work of decorative art that's survived antiquity. It is perfect in execution and condition. Artistically, the mask ranks among the top portraits ever created — the gorgeous youth (he was 14 or so when he died) is portrayed as a king, a god, and a vulnerable teenager. If you gaze at this magnificent piece, you can't help but be moved by the strength, as well as the sensitivity, of the visage.[16]

The Sculptures of the Parthenon

Only a handful of Greek originals made it through wars, neglect, and the zeal of the early Christians to eradicate all marks of paganism, but even if every single Greek sculpture had survived, the finest by far would be the sculptures of the Parthenon. These noble stones, exhibited in the British Museum and in Athens, resonate with that which is most noble and civilized in human nature. They strike you as being the very heart of our civilization. They are carved with a delicacy that has never been equaled, and they also possess an astonishing sense of vitality and movement — from the Athenian citizens on parade, to the gods and goddesses with their draperies that ripple like fresh waters, to the horses that prance so realistically in the procession. (See the main color insert.)

The daring reliefs of the frieze, which are only inches thick, nonetheless give you the feeling of infinite depth. The monumental figures that were inserted into the tympanums are all carved fully in the round, but no one at that time would have seen their backs. You must keep in mind that these white stones were originally vividly painted — the hair was of varying colors, including bright red, and the eyes sparkling blue.

The master of works in the Parthenon, the principal temple to Athena on the Acropolis, was Phidias, who probably didn't carve the sculptures himself but who directed the complex works. Taken as a whole, these sculptures are a staggering achievement, and seeing them is equal to any of the greatest artistic experiences.

The bulk of the frieze and pediment sculptures are in the imposing Duveen Gallery of the British Museum; they were obtained in the early 19th century by Lord Elgin in a deal with the Turkish rulers of Greece. Today, a controversy still rages about whether the stones should be returned to Greece, and you can imagine what the British say to that. A few sections of the frieze are on display in the small Acropolis Museum in Athens.[16]

The Scythian Gold Pectoral

The most lauded artist of the Hellenistic Age (that of Alexander the Great) was his court sculptor Lysippus. Unfortunately, not a work by him has made it through the ages to us. But there is one piece dating to around the time of Alexander that even the great Lysippus would have looked upon with envy.

The piece is a large gold necklace made by an anonymous Greek artist in the 5th century B.C. for a prince of the fierce Scythians, nomads who roamed the Russian steppes from the 9th to the 3rd centuries B.C., and who were so friendly that they were known to toast victories drinking from the skulls of defeated foes.

In three bands of this massive gold chest piece, the artist has contrasted scenes from the home life of the tribe with wild, symbolic struggles between the horse (which was the symbol of the Scythian way of life) and mythical griffins. Calves and foals suckle away — because the animals are only about an inch tall, the details are mind-boggling. A dog pursues a rabbit. Two grasshoppers peer at each other, fascinated. In the center, two Scythian warriors busy themselves with sewing a sheepskin shirt. The realism is so vivid that you can almost imagine yourself enthralled, sitting next to these soldiers and watching their work on some late fall evening.[16]

This work is in the Historical Museum in Kiev in the Ukraine — not, admittedly, a very amusing place to visit these days. The necklace that sits in the glass case on the main floor of the Historical Museum is a fake — a reproduction intended to foil any thieves who may visit. So be firm and demand to see the original in the vault downstairs, and by golly, the guards will show it to you.

Nicholas of Verdun's Enameled Altar

To many people, medieval art consists of stiff, somewhat primitive, and relentlessly serious religious sculptures — truly something out of the dark ages. You may be somewhat astonished to learn that the art from the middle

of the 12th century to around 1200 was about as experimental and highly-charged as that of the dawn of modern painting or even the Renaissance. Artists made fanciful experimentations with the human figure, and there isn't a period in art that possesses equal energy.

If I were to choose one work that sums up the vividness and heat of this rich period, it would be the 27 enormous gold and enamel plaques made by the genius Nicholas of Verdun, which he completed in 1181 for the altar of the monastic church of Klosterneuberg (a little north of Vienna).

Eighteen Old Testament enamels, glowing like roaring fires, are set in bands above and below nine New Testament scenes. The Old Testament subjects were chosen to prefigure and parallel those of the New. Nicholas's drawing is as good as Picasso's; the colors sparkle, and the gold is so hot you feel that if water fell on its surface, steam would be produced. The condition — and condition in art is of prime importance — is flawless.

Each plaque, which is shaped like a little chapel with a domed roof, is surrounded by an elegant inscription in Latin telling you what the subject is. Some plaques are simply dynamite — Jonah stuffed into the mouth of a shark-like whale, Samson slaying a fierce lion, and the explosive resurrection of Christ (who slams out of his stone coffin like a rocket).

Vienna is perhaps the greatest city in all of Europe for art treasures (see Vienna in the Europe museum guide) with its incomparable Kunsthistorisches, the Treasury, and the superb drawings collection called the Albertina. But a visit to the art of this city would be gravely impaired if the side trip (about 20 kilometers) to Klosterneuberg for Nicholas's stunning enamels were not made.

Giotto's Arena Chapel

This Italian genius gave birth to modern painting in the early 14th century (1305-06) by breaking the lovely, but rather stiff, Byzantine style. He gave his figures bulk and movement and expression. The pinnacle of his art can be seen in the frescoes in the Scrovegni Chapel in Padua, the so-called Arena Chapel (because it was built on the site of a Roman arena).

These frescoes portray scenes from the life of the Virgin and the life of Christ as a continuous narrative, with the Last Judgment as a climax. They also include vivid representations of the Vices and Virtues.

These paintings may be the single greatest work of art from Christian civilization. Their emotional content is so profound that tears come to the eyes of many viewers.

The finest of the cycle is perhaps *The Lamentation,* where Mary holds her dead son on her lap in a way that expresses infinite human grief. (See the main color insert for this work.)[16]

You may wonder why the frescoes are in such perfect condition. First, they weren't hit in the WW II bombing of Padua, and second, fresco is perhaps the most hardy of painting techniques because paint is applied to sections of wet plaster, where it soaks in about two inches and hardens, becoming a thick shell that virtually nothing can erode. It's possible to remove — millimeter by millimeter — thin sections of a fresco to obtain not only images as fresh as when the paint was applied, but also, several layers down, even the preliminary drawing the artist first placed to guide him.

The Ghent Altarpiece by Jan van Eyck

This altar of 20 diversely-shaped oil panels is set into a frame measuring 15 feet by 11 feet (4.6 m by 3.4 m) and was created between 1425 and 1432 by Jan van Eyck and possibly his brother Hubert. The major parts depict the Adoration of the Mystic Lamb, God the Father, the Virgin Mary, John the Baptist, and Adam and Eve, plus a host of other subjects. The altar has 12 panels on the inside and eight on the outside that can be seen only when the altar is closed like a book. Many of the outer panels show figures painted in a charming way, as if they were carved in the most lustrous alabaster.[16] (See the main color insert.)

The painting is world famous for its monumental conception and the consummate, almost microscopic, care with which every detail has been rendered. The realism is literally breathtaking. No other work even comes close to this one in its intense and unblemished portrayal of materials.

From the hundreds of jewels and pearls in the huge bejeweled crown worn by God the Father to the hairs on the fleece of the Mystic Lamb, everything seems to have been painted with a single-hair brush.[16] The colors of crimson, azure, soft emerald, gold, and silver look as if they came from melted down gems. The color shock is almost frightening.

Jan van Eyck literally transforms base materials into divine substances. But the truly wondrous thing is that this zealot for details did not permit his avid fascination in the tiny to diminish the overall grandeur or the powerful feelings of spirituality, devotion, and piety he wanted to achieve and did.

This great altar resides in a special chamber in the Cathedral of Saint-Bavo in Ghent, Belgium. Although the location is far more spacious than the chapel where the altar was placed for decades, be advised that tourists mob the chamber, and it is best to be mentally prepared for a wait — which is definitely worth it. The rest of the cathedral is intriguing.

Leonardo's "Mona Lisa"

Although my favorite Leonardo is the stunning young woman holding the ermine in the Czartoryski Museum in Krakow (and she may be the most beautiful woman ever depicted by any artist), I admit that the *Mona Lisa* (1503-1506) is a staggeringly captivating masterpiece.

I had the pleasure of seeing her very close up when she was in New York in the early 1960s at the Metropolitan Museum. I worked in the medieval department, and the picture was displayed every morning in the grandest of our galleries. I never failed to pay long homage when I came to work.

The portrait looks so fresh, even revolutionary in its directness and sense of the now — it's almost as modern as a brilliant photograph. Although some observers fall for her profound sense of mystery, I find the young lady compelling and, almost shockingly, alive.

Michelangelo's "David"

What a genius! So many of mankind's greatest works issued forth from his chisel or brush or pen! He always executed works that were charged with electricity and that will endure forever in our hearts. I choose the *David* of 1504 over all his other works, however, even over the Sistine Ceiling, despite the majesty of that enormous cycle of frescoes. The reason is that sculpture was what Michelangelo did best. (See the main color insert for a great view.)

Everything about the *David* is stupendous — the concept, the execution, and the courage of Michelangelo in attacking the hunk of marble directly and winning over its weaknesses. (The block had been abandoned for a generation because of a dangerous flaw.) There is no equal to the godlike anatomy of the body, the dynamic turn of his head, the anxiety in his eyes and furrowed youthful brow, his casual stance that disguises his fear, the alertness of the eyes, the impressive curly mass of his hair, and the subtle yet powerful muscles, ready to whip into action against the killer Goliath who had chopped up into pieces all of the Israelites previously sent into battle.

This sculpture sums up the ideal of both humankind and divinity and is full with what Michelangelo's contemporaries called *terribilità,* or the awesomeness of an overpowering nude figure.[16]

The Accademia, where the sculpture was moved centuries ago for protection, is a relatively uncrowded place to visit, because many people think the copy of the David standing outdoors in the Belvedere (a gorgeous plaza with a view of Florence) is the original.

The Isenheim Altarpiece by Mathias Grünewald

The most emotionally charged religious painting in the world is the one Matthias Grünewald created in the early 16th century for the monastery church of the Order of St. Anthony at Isenheim, in Alsace, France. It now hangs in the Musée Unterlinden (or Civic Museum), in Colmar, France.

This remarkable work, more than 20 feet (6.1 m) in length, has on one side the Crucifixion with a Lamentation and on the other three wings a concert by a group of angels, the Madonna and Child flanked by the Resurrection, and the Annunciation, the episode where Mary is told that she'll bear the Christ child by the Angel of the Lord. The body of Christ on the cross is horrifying, for it is covered with a most ugly series of lacerations and what appear to be marks of some dreadful disease. A disease it is — and one which had no cure in the 16th century. The Order of St. Anthony took care of dying syphilis patients, and the Christ was depicted like one of the suffering patients. But in the Resurrection, the figure of Christ has been totally cleansed of the disease and is surrounded by an enormous golden halo.[16]

There are few more powerful and satisfying works in all Christendom, and you leave the gallery in which the altar now resides deeply moved.

El Greco's "Burial of Count Orgaz"

After the Ghent Altar, the most beautifully crafted religious picture of all time is, I believe, this tremendous oil by El Greco.

This grandiose painting, which measures an impressive 16 feet by 10 feet (4.9 m by 3.1 m), was completed in 1586 and depicts the mystical events that occurred at the burial of a local hero, Count Orgaz, who died in the early 14th century. When Count Orgaz was interred by the Cardinal and a host of clerics, suddenly his friends and mourners witnessed with amazement the heavens erupting with images of Christ, the Virgin, and St. John, surrounded by platoons of saints and angels.

El Greco has managed to capture that miraculous event along with the mortals who attended the burial.

Some of the passages of paint shimmer and dance with an earthly and unearthly glow that has no match in art. Some of the details, especially of the flamboyant ecclesiastical garments, are little masterpieces on their own, for the clothing is decorated by El Greco's painted embroideries, which are pure marvels. The garments are so brilliant that they come at you like shooting stars.

This triumphant work, in which the supernatural is made human by contact with the splendidly human, came into being because of a successful lawsuit. Count Orgaz had promised a fortune to the parish of Santo Tomé in Toledo; and after his death, the officials of the town of Orgaz ignored his wishes — for over two centuries. The humble priest of Santo Tomé, a certain Father Nuñez, sued for back payments. He won the case in 1569, decided to decorate the small chapel in honor of Count Orgaz, and unerringly chose El Greco to depict the miracle that had immortalized the nobleman.

The small church of Santo Tomé in Toledo, Spain, seems to be jammed with tourists even during the winter months, so be patient. A visit may sound unpleasant, but it isn't, for a surprising number of souls can fit into the chapel where the work is hanging in solitary splendor. It's peaceful on even the most crowded day, and you can't hear a rustle because people are so moved by the thunderous spectacle. See Chapter 9, Figure 9-5, for a look at this painting.[16]

Diego Velázquez's "Las Meninas"

This is a blast — an enchanted fragment of a living environment, in tight restraint in parts and almost recklessly undisciplined in others, which has been mysteriously transported through time and space. It's uncanny. The large painting — 12 feet by 9 feet (3.7 m by 2.7 m) — shows the Infanta Margarita at three or so years old, surrounded by her ladies-in-waiting, her mastiff , and a "house dwarf," with the painter himself putting the last touches onto the canvas we are looking at and have entered, in a sense. King Philip IV and his queen, Mariana of Austria, who have just stepped into the studio by chance it appears, are reflected in a mirror at the long end of the chamber, and a well-dressed courtier stands on the stairs in a bright doorway giving a startling depth perspective to the amazing environment.

The greatness of this picture is that it captures an instant and makes it infinite. It has been painted in a breathtaking technique — the effect is atmospheric, full of natural light, a monument to the terribly difficult act of painting. This has it all. The dignity of officialdom, the tenderness of humanity, the laughter of a child, and a sense of joy unmatched in all of art. Housed in the Prado, its recent cleaning has given it a double zap.[16]

Rembrandt's "Return of the Prodigal Son"

Who's the finest painter of all time? Leonardo, Piero della Francesca, Rubens, Velázquez, Picasso, Rembrandt? Any one or all depending upon the work, I suppose. But if I were to have to select one, it would be the brooding, painterly genius Rembrandt van Rijn. If I were given a six-by-six inch fragment taken from any one of his late works, I would feel fortunate, for in only inches, Rembrandt painted the cosmos. Or at least that's how his work strikes me.

It's hard to choose my favorite Rembrandt, but the *Return of the Prodigal Son* in the Hermitage of St. Petersburg has to be the one. The painting is high drama and at the same time the very epitome of Christian belief in its portrayal of compassion and forgiveness. Many scholars believe it's unfinished, but I'm not sure of that, for it looks virtually polished to me. It's cold — the elderly patriarch is wearing a heavy shawl — and I sense that the shaven (probably from prison and lice) prodigal is shivering, although he's probably putting on an act. But it doesn't matter because all is — and should be — forgiven. Take a look at Figure 10-4 in Chapter 10 to see this extraordinary work.[16]

Francisco Goya's "The Third of May, 1808"

When it comes to both the soft and the grippingly harsh, no painter can equal Goya. He is the most observant and gutsy painter of all time.

Tops in his career is the huge canvas, *The Third of May, 1808* (located in the Prado in Madrid), which commemorates the ending of the people's uprising against the Napoleonic French invasion of the Spanish captial, Madrid. The scene of slaughter captures every nuance of a group of hateful men callously, even gleefully, destroying their fellow men. The futile gesture of the peasant in the highlighted center with his arms stretched out to the sky — a reference to Christ on the cross — symbolizes all mankind being terrorized. The soldiers firing point-blank into the mass of stricken humanity have invisible faces, and their back packs indicate that they will make a swift, panicked escape. This is simply a part of their soldier's uniform. But in the background, we see a friar, guerillas, and the masses watching, never to forget or to forgive. (See the main color insert.)[16]

Pierre-Auguste Renoir's "Luncheon of the Boating Party"

Of the many glories of Impressionism (see Chapter 13), this large, sunny, and ebullient work may be the tops. Renoir's captivating portrait of a congregation of young beauties and eager athletes, at the moment they have just polished off a great French meal with copious wine, seems larger than life. (See the main color insert.)

Populated with five gorgeous young women, one holding possibly the cutest puppy ever painted, and nine of the handsomest of men, it bubbles with fun, celebration, and a heady late-summer heated sensuality. The large painting —

5 feet by 6 feet (1.5 m by 1.8 m) — sums up every happy moment of that fortunate age of placidity, called the Belle Epoque, that existed in France just before the dawn of the 20th century.[16]

The work was painted, presumably mostly out-of-doors, in 1881 at Argenteuil near Paris and today stands alone in Washington's Phillips Gallery. Although the Phillips has a very exciting collection, indeed, with a host of terrific late Georges Braques, it's worth the cab fare to dash up there and be bowled over by this amazing work — it makes the clouds of the sky and your mind vanish.

Picasso's "Les Demoiselles d'Avignon"

In 1907, Pablo Picasso exploded into a fury of creativity that produced an unpleasant, somewhat evil, and yet beautiful image of humanity that changed the course of art forever. This is the huge *Les Demoiselles d'Avignon* (now in the Museum of Modern Art in New York), which was named after a brothel in Barcelona by the Surrealist painter and poet (or writer) Max Jacob. (See the main color insert.) The faces of the women, one of whom seems to be squatting on a bidet, are African masks. The bodies are flat slathers of clashing colors. A more abstract denunciation of humanity can't be imagined. The painting is — face it — ugly. Yet, you can see it hundreds of times and still be astounded by its freshness and audacity.

The art significance of this chaotic, repellent, magnetic, and lyrical painting is that from this point onward, great art didn't have to be aesthetically right or nice.[16]

Chapter 21

The Ten Most Interesting Artists (And Why)

● ●

In This Chapter

▶ Leonardo da Vinci

▶ Albrecht Dürer

▶ Pablo Picasso

▶ Francisco Goya

▶ Diego Velázquez

▶ Caravaggio

▶ Rubens

▶ Rembrandt

▶ Michelangelo

▶ Lysippus

● ●

Leonardo da Vinci (1452-1519)

*W*ho wouldn't want to meet Leonardo da Vinci and chat with him — sometimes off the record? I find him the most intriguing and enduring genius of the fine arts. He surpassed every artist known throughout history not because of his innovations, because he truly didn't make any or very few, anyway, but because of his blessed technique and his amazing portrayal of the life zest of all living creatures, animals as well as human beings.

His drawings of horses, many as sinuous and lazy as cats, and his caricatures of mankind are priceless and all but unique. His studies of waves and the effects of winds upon clouds have never been equaled, even by the most advanced renderings of modern technology. Leonardo's great contribution to the arts may be that he softened science, making it a slave to aesthetics and beauty.

If I were to pose questions to him, I'd ask:

- Who really is the Mona Lisa?

- Why did you find it so difficult to finish so many canvases?

- Was it necessary to experiment with the paint in *The Last Supper* so that even in your lifetime the colors started to fade and paint chips were found daily on the floor beneath the masterpiece? (Which is true. The work today is nothing but a shadow of the original general outline.)

- Do you consider the *Battle of Anghiari,* which was initiated in the Palazzo Pubblico in Florence and was not completed (and the fragments of which were demolished), your finest achievement?

- Did you hate Michelangelo?

- Did you love Albrecht Dürer?

- Are those oil studies of drapery forgeries of recent times?

- Who is the divinely beautiful young woman in your portrait the *Woman Holding the Ermine?*

The *Woman Holding the Ermine* is in a little-known European museum, the Czartoryski in Krakow, Poland. It's oil on wood, dates around 1483-90 and, to me, is second only to the *Mona Lisa* in beauty, character, and eternal fascination. The current art historical thinking has it that she's a young Italian noblewoman. But I wonder.

Around the head of this heavenly looking young woman, who gently holds a vicious ermine with bared teeth, is a barely visible veil. This was the sign in the 16th century for the evil Poppea, wife of the loathesome emperor Nero. The more one looks at this act of painterly super-genius (I once stood before it for four hours without moving), the more one thinks one can see an awesome corrupting evil underneath that glistening surface beauty. I'd like to find out from Leonardo if I'm right. Also, the background of the painting is jet black, something totally familiar with Northern Renaissance artists like Albrecht Dürer, never Italians and especially Leonardo, who with every other work managed to show a window with lush landscape. Was the work done to render honor to Dürer?

Albrecht Dürer (1471-1528)

It was early on in my training as a professional art historian when I encountered a reproduction of a silverpoint drawing of himself by Dürer when he was but 12 or 13 years of age. It dates to 1485. I was overwhelmed by the combination of two utterly different elements — its precision and lack of precision. The lines that make up the gossamer hair of the youth, for example, look like they'd been made using a high-powered magnifying glass, which, of

course, they hadn't. But the overall impression of the preadolescent is one of slightly hesitant vulnerability, that layering of doubts all adolescents have. I was awed that a kid at such a young age could portray himself so perfectly yet so awkwardly in a totally human manner.

Later on, after I had studied the man's works, I realized that although he was arrogant and knew he was the equal to any artist of all history, Dürer, nonetheless, never got rid of his doubts about himself. His motto was "As I can." Arrogant? Perhaps. Especially when one looks at the unparalleled marvels of paintings to which the motto is attached. Yet maybe he wasn't arrogant. Because even in those perfect creations there are passages of hesitation and clear painterly doubt. Dürer's genius is that he was so good that he didn't have to hide the tiny flaws. He didn't have to fake it by sheer technique. He felt it was vital in his art never to draw the human figure in perfect proportion, but to paint the proportions as they appear to us in the real world, which are always somewhat warped because of the constant motion of the human body and our skewed point of view. That's why his figures are always so charged with mysterious vitality, I think.

Dürer traveled to Italy twice in his lifetime and made some watercolors of his experiences, particularly in the mountainous region of the north. They are heart-stopping they're so cracklingly energetic. He kept a kind of diary and once laughingly described what it was like to stay overnight in an inn that had, for the dozens of travelers, one enormous bed in which everyone slept. One hundred and fourteen people could be booked into this bed. The price of the overnight depended on where you were situated in that vast piece of furniture and how much square footage you took up. As for the aroma? Don't ask.

It was on the second visit to Italy when he may have encountered Leonardo, and if such a meeting took place, it's likely that the two incomparable geniuses compared notes and styles and techniques. That's when Leonardo could have painted his woman with an ermine in his honor.

Dürer was a visionary connoisseur, too, and when the dazzling feathered shields and headdresses given by Montezuma to Cortez arrived at the court of Charles V, he immediately proclaimed them equal to any works of art created in the western world. He was right — they can be seen in Vienna in the Museum für Völkerkunde (Museum of Folk Art) and should not be missed.

What makes Dürer so interesting is that he took considerable pleasure in successfully communicating with the common man. In the 16th century, clear, rapid, and blunt storytelling in art was not looked upon as a major weakness (which it is today). His exceptional engravings, like the frightening *Knight, Death and the Devil* (in which both Death and the Devil make all Hollywood vampires and monsters ever thrown on the screen look like kindergarten images) or the poignantly powerful *Melancholia* with the most beautiful — and saddest-looking — woman ever portrayed, were literally devoured by the common man who had little book learning and zero art history. Dürer's

engraved Passions of Christ were collected avidly, even by those with meager incomes. These are dramatic, thrilling, small-scale blockbusters that elicit disbelief, shock, and horror as Christ is led inevitably to slaughter. They were so popular in their time that forgers seized the opportunity to fake them (for bargain prices, of course). Maximilian I, King of Germany and Holy Roman Emperor, Dürer's steadfast patron who was memorialized by the artist, passed the first known law to severely punish fakers of the splendid master. The emperor shouldn't have bothered because the fakes are devoid of life.

I have had the opportunity to hold in my hands several drawings by the master — the most exalted being his study of hands in the Robert Lehman collection at the Metropolitan. Once I picked up the delicate sheet and brought it to my eyes, it was as if some hidden, almost electrical force, shot from the surface of the page. I had to hold my breath. That was years ago, and there are times when suddenly, when I bring that splendid drawing back in my visual memory, I feel that zap. I am convinced that the works of such geniuses as Dürer all possess an inner force.

Pablo Picasso (1881-1973)

(Picasso, like Dürer, was also super ego. Because of his massive talent.)

My favorite story about this legendary genius was told to me several years ago by an acquaintance who had spent years trying to meet the elderly master in St. Paul de Vence in the south of France. He'd sent Picasso letter after letter and had heard nothing, when suddenly he got an invitation. Just inside the door, my friend was taken aback to see a mound of unopened letters stacked from the floor almost to the ceiling, and he spotted his letters nestling in the pile like objects in an archaeological mound. The Grand Master escorted him into a spacious library where there were hundreds of books, every one devoted to Picasso. Nonplussed, he asked the "maitre" which book he admired the most. Picasso swept his hand across an edition of 30 or more volumes by a Japanese author. Did Picasso understand Japanese? Not a word. This was the largest number of books in any language.

Picasso was devastatingly charming, intelligent, and entertaining, with coal-black eyes that soaked up every nuance of human emotion and visual presence. He was so animated it seemed he was plugged into an electric socket, and he never forgot an anecdote or a line of what his eyes had latched onto.

When around 1911 or 1912 Picasso created Cubism with his dear friend and colleague Georges Braque, the pair would refer to each other as "Orville and Wilbur," knowing that their visual revolution was every bit as profound as the first flight. That revolution began with the mighty painting now in New York's Museum of Modern Art, *Les Demoiselles d'Aviginon* (shown in the main color

insert), perhaps named after a brothel in Barcelona (but possibly no more mysterious than an imaginative recreation of an old photograph showing a group of African women sitting by the side of the road). Picasso's irrepressible inventiveness allowed him to seize upon any subject, whether an old photograph, a common still-life, or the piece of caning from a chair, and transform it into a divine act of painting and *collage* (bits of paper and chair caning and wood or other materials pasted on the canvas and connected by paint). Cubism, essentially, allowed him to fragment everything he was looking at, chop the elements up, and shift them around. A woman's face could have an eye where the eye always is and the other on the back of her head or have hair shooting from below the eyes or a pelvis made of a series of intensely colored oval lines — anything that seemed a fascinating and never-before-imagined combination. Cubism's basic process is rooted in all of art. What landscape painter has not moved a cloud, even mountains, around? What still-life painter has not exaggerated or diminished the fruit or flowers before his eyes? Or what portrait painter hasn't made significant alterations in facial anatomy? Of course, no painter ever created with Picasso's untrammeled freedom. Picasso was not so much the quintessential rebel as he was the very symbol of artistic freedom.

Picasso doted upon the real subject and, in fact, had to have it. When asked what he thought about pure abstraction, nonobjective art, of the kind Wassily Kandinsky created in Germany in the 1920s, he remarked that, to him, it was inconceivable to work without a recognizable subject.

Was he playing with the public in coming up with Cubism or his other more complex styles of fragmenting, rebuilding, shifting, and pasting of elements? Of course not. He was playing with the compositional possibilities of everything in the world around him and making a new, exciting universe. That is his genius.

Francisco Goya (1746-1828)

As the German philosopher Frederick Nietzsche put it, "We have Art that we may not perish from Truth." To me, no artist brought forth the raw and unvarnished truth in such a brilliant way as the Spaniard Franscico Goya who worked in from the mid-18th century until his death in 1828. I look upon him as the man who laid the foundations for Modern art in much the same way as Giotto was the spark who first ignited the flame of the High Renaissance.

Goya was a child prodigy who could draw like an angel at a very young age and whose unique personality is literally embedded into every line he drew, every passage of paint he laid down on canvas. He was a master of styles, innovative, brisk, and unerring. Early on, Goya painted cartoons in oil to be used for charming tapestries, and these are ebullient, sunny, and full of fun.

Towards the end of his life, when afflicted by deafness, he painted dark, almost jet black paintings of tremendous power, showing the Greek god Saturn devouring his children alive. These Goya hung in his dining room.

He was deeply shocked by the unspeakable ravages caused by the Napoleonic armies invading Spain, and his extensive series of etchings and engravings entitled the *Horrors of War* are lasting images of man's brutality to his fellow man.

Like Picasso, Goya painted a bewildering variety of moods and subjects, almost switching back and forth at will between the sweet and the sad, the joyful and the downright terrifying. He could depict his mistress, the raven-haired noble Countess of Alba, both clothed and naked, as one of the most fetching women of history.

And he could give us the frightening *Third of May, 1808,* which commemorates the grim ending of the people's uprising in Madrid in 1808, a monument to the agonies of war throughout time. (See the main color insert for this work.)

His gentleness was legendary, and it shows in his exceptional and moving self-portrait he painted as a gesture of thanks to the physician who nursed him back to life after a life-threatening illness. This is in the Minneapolis Museum of Fine Arts and is worth a detour.

It is always something of a mystery to me how certain artists can take a pen or a pencil or the engraved or etched line and transform it into human life. A nest of black scrawls by Francisco Goya seems to be able to breathe and speak because it is so vital.

Diego Velázquez (1599-1660)

We all know this 17th-century genius as the creator of the fabulous *Las Meninas* in the Prado, that incomparable portrait of the Infanta with her handmaidens and fuzzy mastiff, her house dwarf and her parents, the King and Queen of Spain, reflected in a far-off mirror with Velázquez shown painting away, pleased as punch with the grand decoration the king has just bestowed upon him. (See Figure 39 in the museum guide color insert for this work.)

Or his moving *Surrender of Breda* (1634-35), which symbolizes the gentility of a benign conqueror. Or his stunning, gorgeous nude Venus in London's National Gallery, who gazes at us coyly by looking into a mirror held up by a cupid. Or his poignant dwarfs. Or the languid, small landscapes completed when he was staying at the Villa Medici in Rome.

Or the snappingly lifelike *Juan de Pareja,* the portrait of his Moorish companion (one of the heights of the Metropolitan Museum's holdings) that he dashed off to impress the Italians before he won the commission to paint Pope Innocent. See Figure 6 in the museum guide color insert.

And that breathtaking image of imperious and suspicious papal grandeur itself, Pope Innocent X (1650), which is the gem of the private museum in Rome, the Palazzo Doria-Pamphili and which should be close to the top of anyone's art list when traveling to the Eternal City.

To me, Velázquez is intriguing for something else. He was one of the finest connoisseurs who ever lived, and the fruits of his impeccable eye are the best of the grandest Italian paintings in the Prado. Velázquez was sent by King Philip two times to Italy, the second excursion around 1650, to gather up an art collection for the royal household. Velázquez reportedly spent two million in gold, today a fortune that's virtually impossible to imagine as to purchasing power, and bought some of the top Titians, Veroneses, and Tintorettos that have survived. Because of Velázquez, the Prado is one of the premier museums on the globe.

Michelangelo Merisi da Caravaggio (1573-1610)

The rebellious artists — even the crazy, foulmouthed, dirty, disheveled, and impolite ones — are the most interesting. Why? We expect the bohemian stuff of the artist. And none was more of the above than the 16th century Roman innovator "supremo," Caravaggio. In the late 16th century, Caravaggio changed painting forever by rendering his subjects in a microscopically realistic manner while treating the light and shade around them as violently contrasting virtual hot spotlights and deep, brooding, and theatrical shadows.

He was revered and hated for his aggressive, in-your-face paintings. Loathed by the establishment painters who were shackled to a glossy, proper, lifeless sort of classicism. Revered by the younger generation of all Europe, for his influence spread like wildfire throughout Italy up to France, Holland, and west to Spain.

His subject matter astounded and rankled. He could create one Madonna of ineffable sweetness and another who holds a squalling Christ Child and slouches against a doorway looking astonishingly like a woman of the streets (which the model certainly was). He could paint the youthful John the Baptist looking like a touched-by-God athlete and greasy, androgynous young street punks surrounded by the odor of sex-for-sale. His one surviving still-life, in the Ambrosiana Museum in Milan, is a world-beater, expressing the stages of life of mankind by the subtle states of freshness and decay on the fruit and

vine leaves. His works seem to have been composed after scads of preparatory drawings, yet, oddly, not a single drawing by Caravaggio has ever surfaced.

His most exceptional works are in Rome near the Piazza Navona where he was born and lived most of his life. The most exalted are the three oils of the life of St. Matthew in the Contarelli Chapel in the church of San Luigi dei Francesi (St. Louis of the French), behind the Piazza Navona, including the *Calling of St. Matthew* (shown in the main color insert). In this painting, Christ enters a dim hall where a group of men are counting money or gambling and, in a blazing shaft of light, stretches out his hand in a gesture Caravaggio no doubt took from God's creation of Adam in the Sistine Chapel. He points at Matthew — "follow me." The future saint seems to duck the calling, "Who me?" Yet in his face is both the joy of meeting his redeemer and sorrow prefiguring his impending martyrdom. Matthew's horrible death at the hands of swordsmen is magnificently depicted in the huge painting across from the *Calling*. The blood of the martyr is like deep Chinese red lacquer.

Caravaggio's girlfriend was a certain prostitute, Lena (as Caravaggio described her in one of his many court appearances for hoodlum behavior, 'Lena, who stands on her feet [or soliciting] in the Navona' — "Lena chi sta in piede nella Piazza"). Lena posed as the Virgin Mary for the stunning *Madonna of the Pilgrims* in the church of San Agostino around the corner from San Luigi dei Francesi. The art critics of the time found that objectionable, but even more, the fact that the feet of the male and female peasants kneeling before Lena-the-Madonna are dirty.

Caravaggio had a pathological temper. He lost a tennis match in the Piazza Navona, jumped over the net, and brained his opponent. He fled Rome and went on the lam through Sicily and eventually to Malta where he painted like an angel (if you ever get to Malta, Carvaggio's enormous *Decapitation of John the Baptist* will strike you, correctly, as one of the finest paintings ever painted). In the Louvre, there's another Maltese work, the stark and powerful portrait of the head of the Knights of Malta, one Wignancourt.

Eventually, Caravaggio received a papal pardon for the murder and returned to Rome, disembarking at Porto Ercole. There, stranger-than-fiction, he was arrested and cast into jail. The police thought he was someone else. When he was released days later, he had a high fever and, in a delirium, ran down the beach, trying to chase the sailing vessel departing Porto Ercole with a group of his paintings. He died the next day without the pardon and without the paintings, which have never shown up again.

Peter Paul Rubens (1577-1640)

I would love to have known this Flemish painter who is getting to be one of my favorites. The reason is that he was exceptionally intelligent and prided himself on his diplomatic skills — he was Ambassador to Spain — and his writing abilities as much as his fine arts talents which were prodigious. I happen to feel his landscapes are among the best ever created, and his lightning-fast oil studies are more accomplished and full of more verve than 99 percent of the finished works by any artist in the upper ranks.

Rubens was something of a charming knave, too, and appears to have been involved — just for the fun of it — in "restoring" (totally reworking, actually) a group of copies of Italian master paintings that were damaged in a storm when they were being transported from Italy to Spain to become part of the collections of the wealthy Duke of Lerma. Rubens wrote that he didn't want the works to be fiddled around with by incompetent Spanish painters and so he took on the restoration work himself. He wryly notes that the good Duke never seemed to get it that he actually received copies instead of originals. I have seen Rubens' own copies of Titians in the Madrid collection of the late Duke of Alba and can attest to his flawless technique.

In my view, no artist in history has painted women more gloriously. Sure, there are routine jokes about his plump and variscosed-veined goddesses and nymphs, but once you recognize that Rubens was glorifying the ideal feminine form of the particular moment of the 17th century, you will see the intensity and utter love with which they've been done.

Rembrandt van Rijn (1606-1669)

I have always believed that the behavior, personality, and actions of artists have little to do with the beauty of their creations. Caravaggio is an emblem to it; so is Rembrandt.

He was a petty crook, a grifter, a skirt-chaser, and a liar both to others and to himself. He stole from his wife's inheritance to line his pockets and carried out a series of small-time scams, all of which are completely at odds with the majesty of his images.

His self-portraits show us a tragic lump of aging flesh, reddened by excess, but a lump with sad and sympathetic eyes, a facial expression of great poignancy, and a demeanor of the heights of human dignity. He was no doubt acting, putting on a con, but he did it well, and his images are unforgettable.

His religious works — especially the crucifixions and the two passion etching series — would make it seem that Rembrandt was a profoundly devout man. From what we know, this seems unlikely.

It simply doesn't matter that a grifter and part-time con artist just happens to be one of the three giants of all art. And similarly it doesn't mean much that a contemporary artist is not the most upstanding example of humanity around.

Michelangelo Buonarroti (1475-1564)

Many times in art history, there have been attempts to make the truly devout and humanitarian Michelangelo something of a crook.

One of his earliest biographers spins the tale that he forged old master drawings when a student and aged them craftily by stuffing them for the right amount of time into a smoky chimney in the studio where he was being trained.

There are other tales of Michelangelo sculpting a number of Roman fakes, from the head of a faun to a sleeping cupid, the former of which Lorenzo de Medici discovered while puttering around in his garden — the 14-year-old Michelangelo had supposedly buried it for the lord to find and be impressed and hire him. The only problem with these stories is that the bronze Sleeping Cupid is impossibly weak for this master of sculptural strength. And the Faun is a piece of jelly, having nothing to do with the master since it's a forgery cooked up by a contemporary French faker.

Of course, Michelangelo's twisted nose is said to have been broken in a vicious fight with a fellow artist who Michelangelo envied. Yet, it's hard to imagine the creator of the David or the Sistine Chapel envying anyone. It's a fact that Michelangelo and Raphael didn't get along and that Michelangelo had a short temper, but he had every right to explode, especially weighed down by the mental and physical exertion of completing the Sistine ceiling.

He has left us writings describing the agony along with the ecstasy, the head-aching pain of lying on his back for hours, muscles tense and painful from cramps, the constant inflammation of his eyes from the paint dribbling onto his face, his arms wooden from the strain of holding the brushes just so. Certainly, Michelangelo's short fuse blew. Whose wouldn't have? Especially with Pope Sixtus IV hanging around, badgering him to finish the work in St. Peter's. The pontiff, although not as picky as Rex Harrison in the rather fine film with Charlton Heston playing a convincing Michelangelo, must have been a tempting target for the master's wrath.

Little known about the Sistine is the fact that Michelangelo was learning on the job while he painted the enormous and infinitely complex works. Scholars have been able to learn how long it took him to paint the first large rectangular panel and the last. In fresco painting (in Italian, "fresco" means fresh), the artist applies his paint into fresh plaster, which is applied to the ceiling in an amount that can be completed in a day (in Italian a *giornata*, literally "a day"), for the plaster cannot be allowed to dry out.

Turn to Figure 30 in the museum guide color insert to see a detail of his work.

The first section Michelangelo tackled, the *Flood,* took him 39 days. One can actually see through binoculars the separate sections of the plaster. The last scene he painted, *God the Father Dividing Light and Darkness,* the first in the Genesis cycle, which is about the same size as the *Flood,* took him four days.

He remained a pure Christian until the end of his days, never boasted about his genius, never looked down on his fellow men, and was perhaps the single finest artist in the history of the Western world.

Lysippus (Flourished 4th Century B.C.)

The sculptor mentioned most times by ancient Greek writers as the greatest of them all, outstripping even Phidias, who engineered the sculptures of the Parthenon, was Lysippus. He worked in the 4th century B.C. and was known for his landmark innovations.

He introduced subtle, truly human proportions into sculpture. It was said that Lysippus showed man as he seemed to be, not as he was. He imbued his subjects with the impression of thought. He invented an implied yet vivid movement that took one's breath away.

He was the court sculptor of Alexander the Great and created for his lord, the world-conqueror, a famous portrait of him gazing up to heaven as if he were a god about to join the pantheon of the traditional Greek gods. It was an image that literally stopped the ancients in their tracks when they saw it. His bronzes of athletes scraping oil from their glistening bodies were the talk of the ancient world. His sculptures of women made men swoon with desire.

Of course, not a single one of his listed works has made it through time, and all we have are pale Roman copies that may or may not be reflective of Lysippus' works, plus some scratched and worn impressions on tiny coins.

My dream, when I was an archaeologist and a museum director, was to find a statue that fitted every particular by Lysippus and was beyond doubt an original. Naturally, it never happened. And it's highly unlikely that any original work by the unequalled master is likely ever to surface. But then again, far stranger things have happened in the history of archaeology. Who knows what sunken Roman vessel somewhere or what hidden, underground cache contains a Lysippus bronze with perfectly gilded hair and glowing, silvered eyes?

Chapter 22

Ten Artists Worth Watching

In This Chapter

▶ Discovering some of today's great artists

*W*ho alive today will gain the heights of universal art history? Who will stand side by side with the giants? Is there living today a Michelangelo or Pablo Picasso? If so, who are they?

Nothing is more hazardous than predicting who among today's artists are bound to become the old masters of the future. It's easy for the professional to determine where, for example, a newly unearthed Greek statue fits into the rest of classical art or where a recently discovered Gothic Virgin and Child ranks in comparison to all the others surviving. But to say where a living artist fits in? All but impossible. The pros always say the only way to tell if a living artist is going to make it big is to wait 150 years and see.

Wonderful. But there are ways to measure future greatness and lasting quality. Simply put, they are: originality, numbers, and publicity. If the artist creates a style or subject matter that has never, or seldom, been seen before, then even if it's somewhat disconcerting, it has a good chance to endure. If the works set the tongues wagging madly, there's probably something to the art, and time will usually allow the strength of it to last. If an artist is massively prolific and his or her works appear all over the place and are published widely, then there's a decent chance for immortality. It is a given in art history that if an artist receives extraordinary plaudits in his or her own time, even if the reputation fades during the inevitable rise and fall of fashion, that artist will eventually gain or regain the heights. Sheer genius of technique also stands a chance for making it into the history books.

Here's my short list of those living artists who are the prime. Maybe you should buy one of them now so your grandchildren can dangle their wills before the covetous eyes of the biggest museums in the land, and be wined and dined for the rest of their lives at the homes of wealthy museum trustees.

Mark di Suvero (b. 1933)

Mark di Suvero is the premier sculptor of his generation and possibly the finest of the second half of the 20th century. He's bold, experimental, free and mysterious, harmonic, and earthy. The works are huge, witty, energetic, and timeless. Di Suvero has "painted" the American way with steel, scrap, and wood.

Gary Simmons (b. 1964)

Gary Simmons is the most powerful social commentator in art of his generation. At the 1993 Whitney biennial, he shocked and moved visitors with a profoundly fierce piece in which eight pairs of gold-plated sneakers were placed in a police lineup wall. Simmons can be lyrical, too, as his stunning "erasure drawings," as he calls them, attest.

Helen Frankenthaler (b. 1928)

Helen Frankenthaler is a member of the New York School of abstract expressionism (see Chapter 16 for that "ism") and has managed to tame and enhance that often-wild style. To look at one of her pieces on canvas or paper is to be calmed and put into a peaceful frame of mind. She has brought a needed longevity and purpose — even a dignity — to the tumult of the New York School.

Andrew Wyeth (b. 1917)

I pick Andrew Wyeth not in the least because he happens to have written the foreword to this book and likes me. He's a major creative force, even though the more snobbish (and unseeing) art critics dismiss him. His creations are observant, independent, quixotic, romantic, and never "merely real." The large watercolor *Whale Rib,* painted in 1993, is an uncannily perceived picture and a deeply emotional and dramatic one. It possesses a host of delicious, "false" surrealistic touches.

Frank Stella (b. 1936)

The veteran Frank Stella's work has never been better than right now. I've watched his work throughout my career (and as a graduate student at Princeton, where I knew him, I even allowed him to use a huge box spring of a discarded bed for a piece — which, stupidly, I left in my backyard when I had to move). He's progressed from gorgeous, spare, pinstriped paintings of the late 50s, so remote and poetic and bereft of trickery, to a trendy welter of charming, 3-D, and colored paint and sculpture pastiches. But some recent sculpture is marvelously hard, uncompromising, and powerful. They are like giant, gnarled hunks of some petrified forest of the imagination.

Anselm Kiefer (b. 1945)

The German painter-sculptor Anselm Kiefer paints moving large canvases in which hints of the horrifying railroad-track environment of holocaust camps are lifted into the high realm of magnificently sensitive compassion and even beauty by means of the plain genius of paint. His finest work is a mammoth glass and lead sculpture in the St. Louis Art Museum entitled *Broken Vase,* which is a contemporary *Gate of Hell,* as forceful and unforgettable as Rodin's.

Wayne Thiebaud (b. 1920)

The San Francisco painter Wayne Thiebaud is great primarily, I think, because he defies being categorized. He was once mistakenly branded a Pop School painter. Thiebaud is a painterly magician who transforms the most banal objects — mens' cravats, round cakes, or candy apples — into adventurous combinations of the real, the abstract, and the mysterious. His landscapes of San Francisco, created with his typical surges of painterly bravado, are dizzifying, cruel, and dramatic impressions of the famous city as unnerving as the first shocks of an earthquake.

Robert Rauschenberg (b. 1925)

Few living artists have the breadth, the raw intensity, and the gentleness of the painter, sculptor, and printmaker Robert Rauschenberg. His 1953 *Bed,* part painting and part pasted-up coverlet, pillow, and sheets, is a dynamic portrayal of the just-awakened state of mind that we all have experienced one time or the other: a state of turmoil, anxiety, sleeplessness, doubt, and irrepressible hope.

Jenny Saville (b. 1970)

Jenny Saville is an Englishwoman who doesn't paint your standard "beauty queens." But she's superior. Her enormous oils of fatty, sometimes bloated, naked women, some of them covered with strange writings, evoke the universal images of Great Mother Earth reminiscent of the Venus of Willendorf (see Chapter 4). Her works can be upsetting, even ugly, but they are as sensitive as Renaissance pieces. I look upon them as truthful and gripping representations of humanity — ungussied, unairbrushed, uncosmeticized. Sensational.

Dale Chihuly (b. 1941)

The American glassmaker, Dale Chihuly is looked upon by many in the art world as a craftsman, but since I look upon crafts as fine art, I include this virtuoso of glass among those artists who will be remembered hundreds of years from now. His monumental, soft, sinuous, colorful silicate explosions of energy and joy are unmatched throughout the entire history of the making of glass.

TIP

Losing and gaining favor

Art of any style is going to be loved and ignored, lauded and forgotten — but the stuff with character and guts will always snap back into favor. A lucid example is the American artist of the 19th century who worked principally abroad, John Singer Sargent. In his own day, he was praised fulsomely and condemned roundly. He could create poetic scenes of Venice, luscious landscapes, and penetrating studies of human beings and at the same time could crank out the most fawning portraits of the insipid upper classes in a kind of slick, pseudo-Impressionistic style. His star has waxed and waned (mostly waned) but today, art experts see the scope and grandeur of Sargent's efforts and no longer snipe at him for either being too much a copier of Impressionism or simply a failed practitioner or nothing but a big hatchwork of brushstrokes.

Chapter 23

How to Tell if Your Child Has Artistic Genius and Then What to Do

*J*ust ten last words . . .

- ✔ Art is for enjoyment, fun, the lifting of your spirits.

- ✔ Reading about art is okay, but looking at it is the only way to get to appreciate it.

- ✔ Look at 10 works of art each day and your life will change for the better.

- ✔ Art and politics never mix.

- ✔ Art is not utilitarian.

- ✔ Forget about art as an investment. Maybe in 50 years the prices of your works will be higher than when you bought them, probably not, but so what?

- ✔ Collect living artists. That way you'll never buy a fake. You'll also gain great satisfaction in knowing you're supporting a cause not usually known for its economic well-being.

- ✔ Every work of art, except for those finished yesterday, have changed from the original appearance.

- ✔ A reproduction is always a pale reflection of the original.

- ✔ Be sure to watch what kind of art your children are creating. One — or more — could have that super touch.

Does My Child Have an Artistic Spark?

One of the most frequent questions I'm asked is, can I tell if my young child has an artistic spark like, say, Picasso?

There are certain indications of possible artistic talent in children between four and six years, and here are some of them, based on the experiences of artists who did turn out to be uncommonly skilled, ranging from Albrecht Dürer to Andrew Wyeth.

- ✔ An interest, almost an obsession, to draw or paint in as realistic a manner as possible. While the other kids are slathering away with their paints in a delightfully free manner, the truly talented child will diligently make drawings that try to capture the reality of the subject.

- ✔ Many times the child will express frustration at his or her inability to get it right. But, invariably, the work gets more and more recognizable, sometimes only after dozens upon dozens of drawings are completed. Even if the works aren't "magic realist" efforts, you'll see how much more attention that child pays to recording visually the specific details. Often, although the overall subject isn't that real, small details will be almost shockingly true to life.

- ✔ One sign of talent is that the eyes of the gifted young person will move with lightning speed from the subject to the drawing or painting.

- ✔ The gifted youngster will sometimes be able to draw very swiftly and come up with a likeness of the subject without apparently bothering to look at it very much.

- ✔ The gifted child will rapidly try out every artistic material in sight and might get annoying demanding more and more. Be sure to give everything from watercolor to acrylics to the youngster.

- ✔ He or she will insist upon creating works with a story line.

Now, what to do if you suspect that your child does have an unusual ability for art? One thing and one alone, and that is, get out of the way.

Never ask the child to paint this or that, never set up a still-life and ask the child to paint it. Let the child be completely free, allow full experimentation, give the youngster every opportunity to experiment with yet another artistic material. Be careful not to say too much about the results. Refrain from too much praise. Avoid talking about what you think may be an unusual talent with friends in the presence of the child. Act with the child as if the perhaps-astonishing works are a normal activity. Then, once the child knows that he or she can paint or draw anything without it becoming a big deal, it's time to get that invaluable second opinion from a professional artist or teacher.

Part V:
Appendixes

The 5th Wave By Rich Tennant

"His style isn't really surreal, although his prices are."

In this part . . .

1 show you how to speak artspeak, in case you really want to give it a try. In addition, I include a copy of a form I developed at the Metropolitan Museum of Art to help guide the purchase of art. Finally, I provide a list of artists mentioned in the book along with the dates of their lives so that you can put them into historical context.

Appendix A

Artspeak Unmasked

● ●

*A*rtspeak is today's arcane, jumbled, confusing way of writing about fine art preferred by many academics, curators, and a few art critics in which you will understand every word but have no idea what whole sentences or entire paragraphs mean.

If I were to give you a description of the flowering of artistic styles from the caves to today, I might begin this way:

Initiating around 28,000 B.C., as a result of the existence of a pure hunting environment, an animistic expression developed, linked to wish-fulfillment of hoped-for prey, which gradually died out when agrarian impulses became evident. The art of this hunter-seeker period is aggressively naturalistic, yet seldom realistic, and at times even idealistic, in that prime specimens were portrayed that may never have existed but in the creators' imaginations.

And follow with:

Egyptian art, a logical extension of pictographic interests and associated pragmatic necessities, was deliberately constrained from change in order to mirror the pace of the Nilotic cycle and to maintain the strength of religious belief and the orderliness of the pharaonic succession. The Heb-sed ceremony of the early middle Old Kingdom at Sakkara, in which the Pharaoh was figuratively judged and killed in order that a young successor's magic might renew the land, was, in fact, played out throughout ancient Egyptian history, if symbolically.

Or pop to:

Baroque early style is marked by a steady appearance of sweeping diagonals of force within overall compositions along with the contrappostic entanglement of figures and anatomical parts within single figures . . .

And conclude with:

"Modern" art can either be utilized to describe that which is strictly historical or employed to single out what is new and unarguably contemporary — living as opposed to seeming to be alive, as far as influence is concerned.

I think you get the point. Enough!

Appendix B

The Professional's Checklist on How to Buy Art

• •

*H*ere's the form I crafted for professional curators at the Metropolitan Museum to follow when pushing a work for purchase.

RECOMMENDED PURCHASE BLANK FOR THE METROPOLITAN MUSEUM OF ART

TO THE DIRECTOR AND THE ACQUISITIONS COMMITTEE:

Cc: Vice Director for Curational and Educational Affairs (2 copies of Curator's Report) Registrar (this blank only) Secretary (this blank only)

I recommend the purchase of the object(s) fully described in the attached report and briefly captioned below.

Classification_____

Artist, title, date

Vendor: Recommended loan class:

Price:

Additional Expenses:

Transportation _____ Insurance _____

Sender to pay _____ Sender to pay _____

M.M.A. to pay _____ M.M.A. to pay _____

Installation _____ Restoration _____

Other

Recommendation approved: Submitted by:

_____ _____

Director Curator of _____

Date: _____

FOR USE OF SECRETARY'S OFFICE ONLY

ACTION BY ACQUISITIONS COMMITTEE To be charged against income from
the (authorized) _____ fund 19____

Purchase (not authorized)_____

Authorized at $ _____

Reported to Board _____

Reported to _____

Secured for $ _____

Acquisitions Committee _____

Purchase Authorization no._____

Accession no. _____

RECOMMENDED PURCHASE-CURATOR'S REPORT

Classification

Attach at least one photograph of the object(s) to the Director's and Vice
Director's copies.

 I. Name the title, artist, nationality or school, period, material, dimensions
 in inches and centimeters.

 II. Full description of the object. Provide a complete visual account, includ-
 ing the description of all parts. Transcribe any inscriptions, describe
 marks and mention any added attachments or missing parts, etc.

 III. Describe the condition of the piece, indicating any repairs and attempt a
 prognosis for future condition. Name the results obtained from scientific
 investigations, whether of microscopy, chemical tests, X-ray, infra-red,
 ultra-violet, spectrographic analysis, thermoluminescence, etc.

IV. State the function of the piece, and whether anything about the object indicates its function as part of a greater whole or as an independent work.

V. Describe the iconography of the object. Does it follow traditional iconography, or is there something unusual in its iconography?

VI. Stylistic considerations.

A. State briefly your initial reaction to the object.

B. Describe the style and relate the style of the piece to the appropriate artist, school, period, etc.

C. Discuss and illustrate the two or three pieces that make the best stylistic comparisons with this piece. Indicate what distinctive qualities this piece has in relation to them in terms of style, technique, condition, documentation, etc.

D. Provide a list of all relevant works of art, whether copies, variants, or other closely similar compositions, pointing out the relationship to each work named.

VII. State how the work of art complements the existing Museum collections or how it fills a gap.

VIII. Explain your plans for exhibiting and publishing the piece.

IX. Give the history of the piece, all known provenance, with traditional documentation, when available. Include any hearsay evidence or traditional provenance, with source.

X. Give any significant archeological information.

XI. List all published references, pointing out those of greatest importance. Also any expert advice sought or volunteered from outside the Museum.

XII. Give the resume of your reasons for deciding to recommend the piece, being candid as to its strengths and weaknesses, its rarity of quality, technique, type, etc. Mention any problem outstanding that could affect the decision to buy.

XIII. Tell how long you have known of the piece and give a history of negotiations.

XIV. If possible, give recent market prices for comparable works of art.

XV. Financial considerations.

A. If the object is to be purchased, state the price _____

B. State the name of the fund, if you recommend that a specific fund be used.

C. If the object is to be acquired by exchange, specify M.M.A. object(s) involved, including accession number(s), valuation and status of de-accessioning.

D. Specify any anticipated additional expenses.

Transportation _____ Insurance _____

Sender to pay _____ Sender to pay _____

M.M.A. to pay _____ M.M.A. to pay _____

Installation_____ Restoration_____

Other_____

 E. State any conditions attached to the purchase. State chance for bargaining.

Appendix C

Art Chronology

Artist	Born	Died	Artist	Born	Died
Acconci, Vito	1940	—	Brown, Roger	1941	—
Albers, Josef	1888	1976	Brueghel, Pieter (the Elder)	1525	1569
Alberti, Leon Battista	1407	1472	Brunelleschi, Filippo	1377	1446
Apollinaire, Giullaume	1880	1918	Buoninsegna, Duccio di	?	1319
Baldessari, John	1931	—	Burden, Chris	1946	—
Balla, Giacomo	1871	1958	Campin, Robert	1378	1444
Beckman, Max	1884	1950	Canaletto (Giovanni Antonio Canal)	1697	1768
Bellotto, Bernardo	1720	1780	Canova, Antonio	1757	1822
Bernini, Gian Lorenzo	1598	1680	Caravaggio	1571	1610
Beuys, Joseph	1921	1986	Cassatt, Mary	1845	1926
Blake, William	1757	1827	Cellini, Benevenuto	1500	1571
Boccioni, Umberto	1882	1916	Cézanne, Paul	1839	1906
Bondone, Giotto di	1266	1337	Chardin, Jean-Baptiste-Simèon	1699	1779
Bosch, Hieronymus	1450	1516	Chia, Sandro	1946	—
Botticelli, Sandro	1445	1510	Christo	1935	—
Boucher, François	1703	1770	Christus, Petrus	1410	1472
Bouts, Dirck	1415	1475	Chihuly, Dale	1941	—
Braque, Georges	1882	1963	Cimabue, Giovanni	1240	1302
Breton, André	1896	1966	Clemente, Francesco	1952	—
Breuer, Marcel	1902	1981	Clodion	1738	1814
Bronzino, Agnolo di Cosimo	1503	1572			

Artist	Born	Died
Copley, John Singleton	1738	1815
Corot, Jean Baptiste Camille	1796	1875
Correggio, Antonio Allegri da	1494	1534
Courbet, Gustave	1819	1877
Cucchi, Enzo	1950	—
Dalí, Salvador	1904	1989
David, Jacques-Louis	1748	1825
Degas, Edgar	1834	1917
Delacroix, Eugene	1798	1863
Derain, André	1880	1954
Donatello	1384	1466
Dubuffet, Jean	1901	1985
Duchamp, Marcel	1887	1968
Dürer, Albrecht	1471	1528
El Greco	1547	1614
Ernst, Max	1891	1976
Eyck, Jan van	1390	1441
Falconet, Etienne-Maurice	1716	1791
Fiorentino, Rosso	1495	1540
Flavin, Dan	1933	—
Fragonard, Jean-Honoré	1732	1806
Francesca, Piero della	1420	1492
Frankenthaler, Helen	1928	—
Friedrich, Caspar David	1774	1840
Gabo, Naum	1890	1977
Gainsborough, Thomas	1727	1788
Gauguin, Paul	1848	1903

Artist	Born	Died
Géricault, Théodore	1791	1824
Ghiberti, Lorenzo	1381	1455
Giorgione	1477	1510
Gislebertus	12th century	
Goes, Hugo van der	1440	1482
Goujon, Jean	1510	1568
Goya, Francisco	1746	1828
Greuze, Jean-Baptiste	1725	1805
Gropius, Walter	1883	1969
Grünewald, Matthias	1480	1528
Guardi, Francesco	1712	1793
Gunther, Ignaz	1725	1775
Haacke, Hans	1936	—
Hamilton, Ann	1956	—
Heckel, Erich	1883	1970
Heizer, Michael	1944	—
Hogarth, William	1697	1764
Holbein, Hans (the Younger)	1497	1543
Honthorst, Gerard	1590	1656
Hugo	12th century	
Ingres, Jean-Auguste-Dominique	1780	1867
Johns, Jasper	1930	—
Judd, Donald	1928	1994
Kandinsky, Wassily	1866	1944
Kaprow, Allan	1927	—
Kiefer, Anselm	1945	—
Kirchner, Ernst Ludwig	1880	1938

Artist	Born	Died	Artist	Born	Died
Klein, Yves	1928	1962	Moholy-Nagy, Laszlo	1895	1946
Klimt, Gustave	1862	1918	Monet, Claude	1840	1926
Kline, Franz	1910	1962	Motherwell, Robert	1915	1991
Komar, Vitaly	1943	—	Neumann, Johann Balthasar	1687	1753
Kooning, Willem de	1904	1997			
Kosuth, Joseph	1945	—	Newman, Barnett	1905	1970
La Tour, Georges de	1593	1652	Nicholas of Verdun	12th c. B.C.	
La Tour, Maurice Quentin de	1704	1788	Nolde, Emil	1867	1956
			Nutt, Jim	1938	—
Le Vau, Charles	1612	1670	Oldenburg, Claes	1929	—
Leonardo da Vinci	1452	1519	Oppenheim, Dennis	1938	—
Lewitt, Sol	1928	—	Oppenheim, Meret	1913	1985
Lichtenstein, Roy	1923	1997	Palladio, Andrea	1508	1580
Liotard, Jean-Etienne	1702	1789	Parmigianino	1503	1540
Lorenzetti, Pietro	1280	1348	Pechstein, Max	1881	1955
Lysippos	4th c. B.C.		Pevsner, Antoine	1886	1962
Maciunas, George	1931	1978	Phidias	5th c. B.C.	
Magritte, René	1898	1967	Piazzetta, Giovanni Battista	1682	1754
Malevitch, Kasimir	1878	1935			
Manet, Edouard	1832	1883	Picasso, Pablo	1881	1973
Mantegna, Andrea	1431	1506	Pisano, Andrea	1290	1348
Marc, Franz	1880	1916	Pisano, Nicola	1220	1278
Marinetti, F.T.	1876	1944	Pisarro, Camille	1830	1903
Martini, Simone	1285	1344	Pollock, Jackson	1912	1956
Masaccio	1401	1428	Pontormo, Jacopo da	1494	1557
Matisse, Henri	1869	1954	Pousette-Dart, Richard	1916	1992
Melamis, Alexander	1945	—	Poussin, Nicholas	1594	1665
Mendieta, Ana	1948	1985	Praxiteles	4th c. B.C.	
Michelangelo Buonarroti	1474	1564	Primaticcio	1504	1570
Miró, Joan	1893	1983	Puget, Pierre	1620	1694

Artist	Born	Died
Raphael	1483	1520
Rauschenberg, Robert	1925	—
Rembrandt van Rijn	1606	1669
Renoir, Pierre-Auguste	1841	1919
Revere, Paul	1735	1818
Ribera, José de	1591	1652
Riemenschneider, Tilman	1460	1531
Rockwell, Norman	1894	1978
Rodin, Auguste	1840	1917
Rothko, Mark	1903	1973
Rousseau, Henri	1844	1910
Rubens, Peter Paul	1577	1640
Ryman, Robert	1930	—
Saville, Jenny	1977	—
Schiele, Egon	1890	1918
Schlemmer, Oskar	1888	1972
Schmidt-Rottluff, Karl	1884	1976
Seurat, Georges	1859	1891
Simmons, Gary	1964	—
Sluter, Claus	1340	1406
Smithson, Robert	1938	1973
Stella, Frank	1936	—
Still, Clyfford	1904	1980
Stoss, Viet	1447	1533

Artist	Born	Died
Suvero, Mark di	1933	—
Tatlin, Vladimir	1885	1953
Thiebaud, Wayne	1920	—
Tiepolo, Giovanni Battista	1696	1754
Tintoretto, Jacopo Robusti	1518	1594
Titian Vecellio	1490	1576
Toulouse-Lautrec, Henri de	1864	1901
Turner, Joseph Mallord William	1775	1851
Turrell, James	1943	—
Tzara, Tristan	1886	1963
van Gogh, Vincent	1853	1890
Vasari, Giorgio	1511	1574
Velázquez, Diego	1599	1660
Vermeer, Jan	1632	1675
Veronese, Paolo Cagliari	1528	1588
Warhol, Andy	1930	1987
Watteau, Jean-Antonie	1684	1721
Weyden, Rogier van der	1400	1464
Wyeth, Andrew	1917	—
Zurbaran, Francisco de	1598	1664

The Essential Guide to the World's Top Art Cities and Centers

In this part . . .

In this special part, I begin with the Americas and single out the top cities, identifying the prime pieces in each museum. Then it's on to cities in Europe and the rest of the world — paying heed to the works that you simply cannot miss. This part has its very own color insert so that you can get a good look at some of the works I mention.

Remember that this part can't cover everything. Instead, I concentrate most on the museums and sites I personally have visited. This way I can recommend where to go and what to see for the best artistic experiences.

The Awesome Americas

*W*hen it comes to art, the United States is neck and neck with Europe. The reasons are the collecting zeal of wealthy art lovers in the late 19th and early 20th centuries, but even more because of our enormous wealth acquired after World War II and a tax deal in effect until the mid 1980s that allowed donors hefty deductions for giving art to museums. America swept through the international art market in the postwar period and displayed the treasures in burgeoning museums.

We have it all. Not ancient Egypt, nor Babylon, nor Rome, nor Vienna under the Hapsburgs, not even Paris under Napoleon accumulated more art nor showed it off better than the U.S. Hardly a single decade of any civilization on earth is not represented by a worthy piece. The range is staggering — gold, bronzes, and marbles of the Greeks, Achamenian daggers, Baroque arquebuses, Art Deco settees, old masters by the hoard, tons of Rodins, enough Limoges soup tureens to feed an army, whole interiors and exteriors of homes and palaces and churches, an entire Egyptian temple, thousands of baseball playing cards and wine labels in the Metropolitan's Burdick Ephemera collection, Impressionists by the hundreds, enough Fabergé eggs to fill a chicken coop, a "13th" century silver bejeweled finger reliquary (alas, fake), and one fur-lined coffee cup with saucer.

UNITED STATES

Arizona

Now that an expansion has been completed, the **Heard Museum** in Phoenix is a desirable visit. The museum's holdings comprise the Heard family's collection, begun in 1895. The showcases brim with Zuni turquoise and silver, Navajo blankets, Pima baskets, Santa Clara blackware, Apache and Kiowa beadwork — and the late Sen. Barry Goldwater's incomparable collection of Hopi *kachina* (now called *katsina*) dolls.

Arkansas

The **Arkansas Art Center** in Little Rock is one of the more surprising museums in the land. It is devoted only to works on paper and has been collecting drawings both of old master category and wildly contemporary for decades — longer, in fact, than when the trendy thing became drawings and before the prices rocketed. It's hard to tell you what to look for, because the permanent collection (fabulous shows are mounted several times a year) is somewhat fragile and can't be shown for lengthy periods of time. The good thing about this small, plucky institution is that its founders and leading lights decided to collect what they could afford — long before the drawings collecting rage and so, even now, when drawing prices sometimes seem like major Impressionists, the drawings dealers, who remember the old day when Little Rock was a rare and faithful client, still steer great things Little Rock's way. Don't miss this one.

California

California started slowly as an art repository, but in the past several decades has surged forward.

Los Angeles Area

J. Paul Getty Museum at the Getty Center

The **Getty** (www.getty.edu/museum) is not so much a museum as the imaginative recreation of some Italian Renaissance hill town conceived by the renowned American architect Richard Meier and completed recently for a mere $1.3 billion. There are many restrictions on visitations, and it would be well to phone the Getty Center information service for the details before going. Cars must be booked well in advance for garage space, for example. There will be likely be long lines to enter and for access to shops and cafeterias once you get inside.

The new Getty museum is the classic conclusion of a war between the architect and the art in which the architect won. The massive, emphatically rusticated fort-like travertine facades broken up by Meier's signature bone-white squares and balconies loom imposingly among splendid formal gardens, ranging from flowers to cacti. The views of Los Angeles from multiple grand porches are spectacular, and although the "Hollywood" sign can't be seen, these vistas are the best ever of the sprawling metropolis.

The galleries of the four pavilions — north, south, east, and west plus a separate building for special exhibitions — making up the museum proper (the sizeable peripheral structures house Getty administration and conservation studios) are surprisingly small, lighted in a rather haphazard way, and lacking any flow from one series of chambers to another. To get to the art, one must walk up and down steep industrially designed stairways and from building to building in a fairly exhausting tour — mostly on hard marble floors. The experience is a bit daunting. By the way, the old Getty Museum in Malibu, built to mimic an ancient Roman Villa near Pompeii, is closed for extensive renovations and will open again exclusively for the somewhat hit-and-miss antiquities collections in which there are thumping master-works and some forgeries, some of the latter being courageously identified as such.

The quality of the works in the Getty Center is, sadly, just below the top rank, despite the serious attempt by the overwhelmingly wealthy institution to secure old masters and treasures from the ancient world. The problem essentially is that the Getty received its billions at the moment when the well springs of old master art had dried up. And J. Paul Getty, the oil magnate, demanded that no works dating after around 1900 enter the collections (except for photographs). Thus, there is a slight feeling of time suspended and lack of vitality.

Here's my pick of the not-to-be-missed works.

- The panel showing avid net fishermen in a lagoon of Venice by the grand master of the 15th century, Vittorio Carpaccio — this is an amazingly deft work (*Fishermen in a Venetian Lagoon,* 1490-1500) bought by J. Paul Getty himself.

- One of the surprising gems of the entire Getty holdings is the recently acquired (for $36 million) Rembrandt's early mythological landscape showing the *Abduction of Europa by Jupiter Disguised as a Bull* (1636). What's astonishing is not only the fine condition (not always the case with Rembrandt) but the romantic and effervescent reflections in the turbulent waters around the bull of the pastel-colored raiments of Europa and her shore-bound handmaidens. It's clear Rembrandt was throwing down a challenge to Titian whose magnificent *Rape of Europa* is in the Isabella Stewart Gardner museum in Boston. The owner had the Rembrandt on loan to the Metropolitan for years and on his death tried desperately to win it raising $25 million. But the Getty easily topped that.

- By far the finest gallery in the four pavilions is the appropriately dim one devoted to delicate pastels of the 18th and 19th centuries. The largest — and arguably the best — pastel ever created is displayed in a gorgeous curlicued gilded wooden 18th century frame on the central wall. It's a portrait of an arrogant French aristocrat *Gabriel Bernard de Rieux* (c. 1720) by the pastel master Maurice Quentin de la Tour. This is the full blast of the *ancien régime,* and it alone is worth the long trip and the waits. There's another marvelous — smaller and clearly middle class — 18th-century pastel by the second accomplished master of the medium, the Swiss Jean-Etienne Liotard. This is a captivating portrait of a delightful 7-year-old, *Maria Frederike van Reede-Athlone,* dating to around 1755. There is also a triumphant pastel by Edgar Degas, *Waiting* (1882), showing a young, anxious girl in a ballet dress waiting for an audition, presumably, with her nervous mother seated beside her.

- The grand, crisp, and shining Venetian cityscape by the incomparable 18th century Bernardo Bellotto, *View of the Grand Canal Santa Maria del Salute and the Dogana from Campo S. Maria Zobenigo* (1740). This is surely one of the finest Venetian paintings in America.

- The small but highly romantic landscape by the German 19th-century Romantic par-excellence, Casper David Friedrich. It's entitled *A Walk at Dusk* (1830-35) and is only one of two Friedrichs in the entire United States, the other being in the Kimbell Museum in Fort Worth, Texas.

- The sprightly Edouard Manet, the portrait of *Albert Cahen d'Anvers* (1881).

- A moody and powerful dark blue night scene by the Norwegian expressionist Edvard Munch, the *Starry Night* (1893).

✔ The famous, very expensive ($54 million) Vincent van Gogh *Irises* (1889), which evokes a Japanese painted screen is here and is a lovely visual concerto. (See the museum guide color insert Figure 1.)

Los Angeles County Museum of Art (LACMA)

The **Los Angeles County Museum of Art** (www.lacma.org) is not one of the gems of the United States, neither for the architecture nor for the collections (except one stunning exception). The museum seems almost a sad and partially wrecked vehicle sitting in a no-man's-land near the La Brea tar pits of L.A., abandoned by donor after donor who promised the museum goodies beyond imagining and then reneged. Will danglers, as the type is known in the museum profession, like Norton Simon and Armand Hammer, pledged all, but went their own ways.

Yet there is one reason to go to LACMA, and that's the majestic Japanese collection housed in a structure that, in a sense, turns its back on the rest of the muddled museum complex. This was designed by a pupil of Frank Lloyd Wright, Bruce Goff. It's a perfect horror on the outside, but, inside, it's one of the most peaceful, serene, and successful museums in the country.

The collections of porcelain, wood carvings, lacquer and screens, scrolls, and painted fans changes frequently, which is good. When I went recently, I found most beguiling the following:

✔ Twelve earthenware plates illustrating the delights of the months, by Ogata Kenzan, who worked from 1663 until 1743.

✔ A pair of six panel ink and colored screens on gold paper depicting the Willow Bridge on the Uji River. It is of the famous Momoyama period of 1572-1615. You'll adore the moon looking like a 3-D gold lozenge hanging there in the golden sky.

✔ A huge screen comprising six panels decorated with ink and colors on gold of the mid-17th century depicting a series of battles in the Gempei wars of 1180-85 during which the powerful Heike clan was wiped out. In this unbelievable wide-screen rendering, don't miss the drowning of the boy emperor Antoku by his nurse in top of second panel from left.

The Museum of Contemporary Art (MOCA)

Designed by the flamboyant Japanese architect Izosaki (who has said — seriously — that the canon of proportions for his structure was Marilyn Monroe), the **Museum of Contemporary Art** (www.artcommotion.com/Issue2/moca/) has assembled a premier bunch of modern and contemporary works. All the usual suspects of abstract art can be found with top-flight examples — Mark Rothko, Jackson Pollock, Robert Rauschenberg, Franz Kline, and Claes Oldenburg. All the same, there's something a bit déjà vu about the works. More exciting — as far as architecture and works are concerned — is the branch of MOCA housed in a former police garage. The space is luminous and big, big, big, so the massive contemporary works show off to their finest. The place is dedicated mostly to temporary exhibitions — especially Installation Art (see Chapter 16 for an overview of this type of art).

Orange County Museum of Art

The **Orange County Museum of Art** is a showcase for the avant-garde and the experimental — a visit will probably blast your eyes in a good way.

Museum of Art, Santa Barbara

In Santa Barbara's **Museum of Art,** you will be entranced at the small but lofty collection that is super-rich in drawings, American painting, and Greek and Roman art. This may be second best after the Norton Simon in quality.

Norton Simon Museum, Pasadena

To many experts, the **Norton Simon** (www.nortonsimon.org) is the best collection of European paintings in the state, and the Huntington still has the finest English pictures — many much better than those anywhere in the world. For the Norton Simon, the following are truly world class (the museum has its own peculiar schedule, so call):

- The Venetian Jacopo Bassano's 16th-century *Flight Into Egypt,* with the most exuberant and glorious angel ever painted in the century of angels.
- Goya's *Saint Jerome* (1798). Raw and ferocious and magnificent.
- Henri Rousseau's *Exotic Landscape* (1910). Heated and overpowering.
- Any of the many paintings and sculptures by the caustic and bitter genius, Edgar Degas.
- Claude Monet's *Autumn Seascape* (1866). Cold and windy and wonderful.

Be warned of two fake or overly restored pictures that the museum refuses to acknowledge. The fake is the Rembrandt, *Portrait of the Artist's Son, Titus*. The Titus is 20th century, for infrared photographs show completely non-Rembrandt brushstrokes and a host of errors. Simon repeatedly bid against himself at auction, desperately trying to be able to pay more for his Rembrandt than the Metropolitan had done for the famous *Aristotle* — the MMA having paid $2.3 million and Simon stopping at $2.25 million. The painting repainted-for-cash is the large *Resurrection* (around 1455) by the Northern Renaissance painter Dirck Bouts. Described by the first director of London's National Gallery in the early 19th century as a heavily damaged painting, it was repainted and tarted up in the 1950s or so.

The Huntington Library, Art Collections, and Botanical Gardens (San Marino)

The **Huntington Library** (www.huntington.org) is in San Marino, California, and means more than books or even art, for the gardens are peerless, and the domestic architecture is superior. The pictures to see are *Pinkie* (1794) by Thomas Lawrence and *The Blue Boy* (c. 1770) by Thomas Gainsborough, which is simply one of the most penetrating human studies in all of Western art

(see Chapter 11, Figure 11-7). Be sure not to miss the Virginia Steele Scott Gallery of American Art, with the fine Eakins and exceptional study of a mother and child on a divinely rumpled bed, by the Philadelphian Mary Cassatt.

San Diego Area

Timken Museum of Art

In San Diego, California, the surprise is the little known, tiny **Timken Art Gallery** associated with the San Diego Museum of Art (www.sddt.com/sdma.html/), which shows only about 50 works at any time. Fantastic are the Northern Renaissance master Petrus Christus' huge *Death of the Virgin* (c. 1455-600); Pieter Brueghel's *Parable of the Sower* (1557), equal to anything in Vienna; the 16th-century Italian master of eerie light; Girolamo Savoldo's *Temptation of Saint Anthony* (c. 1535-38); and a Cézanne flower study, which surpasses almost everything else by him (*Flowers in a Glass Vase*, c. 1872-73). The art museum has the finest still-life painted by the grand still-life creator, the Spanish genius Sánchez Cotán, and a smashing Canaletto, *The Molo from the Bacino of San Marco.*

Museum of Contemporary Art (La Jolla)

Finally, in nearby La Jolla, you may enjoy the shocking works of right now in the **Museum of Contemporary Art** (www.mcasd.org). And the views over the Pacific Ocean are breathtaking.

San Francisco Area

The San Francisco area is getting its art act together. The two competing museums, the **C** and the **de Young** have merged (www.thinker.org). **The Legion of Honor** is known for some superb French paintings of the 18th and 19th centuries (look for Jean-Honoré Fragonard's dreamy *La Résistance Inutile* (1770) — the Useless Defense — in which a pretty young thing bats away at her approaching and welcome seducer with a feather pillow). The de Young is renowned for American art; don't fail to see Thomas Moran's *Grand Canyon with Rainbow* (1912).

San Francisco Museum of Modern Art

The grand new **Museum of Modern Art** (www.sfmoma.org), in downtown San Francisco, has a growing coterie of modern works and has one of the best Sam Francis works existing. You may find the pre-drip Jackson Pollock *Guardians of the Secret* (1943) tangled and completely enthralling.

Asian Art Museum of San Francisco, the Avery Brundage Collection

The adjacent **Asian Art Museum** (www.asianart.org), incorporating the Avery Brundage collection, is famous for fabulous Oriental sculptures (the *Khmer Devi* and *Shiva* of the 11th century are among the top ten pieces in all of America).

The **University Art Museum** in Berkeley is a mecca for modern and contemporary, especially the 49 paintings the abstract painter Hans Hoffmann gave.

Colorado

The **Denver Art Museum** (www.denverartmuseum.org) is about to get its second legs with some promising major gifts of old masters. But until the gifts come in, you can enjoy some great Native American art, especially Northwest Indian painted wooden sculpture. For PreColumbian sculpture, the museum gets very high marks.

Connecticut

Hartford's **Wadsworth Atheneum** (www.hartnet.org/~wadsworth) is the first art museum founded in America, and although in recent years it has been neglected by the community, it has some smashing paintings collected by an eccentric and visionary director, Charles "Chick" Austin. The legendary collector and money-man J. P. Morgan (who boosted the Met to international prominence in the early decades of the 20th century) gave some of his favorite decorative arts, ranging from Early Christian bronzes to dazzling French ceramics, to the Wadsworth — and they, alone, are worth the visit.

The landmark paintings are:

- An exceptional, large (5 by 6 feet, 1.5 by 1.8 m) work of 1490 by the Florentine Early Renaissance painter, Piero di Cosimo (rare as can be), depicting the strange scene of five gorgeous nymphs finding the young Vulcan, who would become the chief weapon-maker of the Olympian gods.

- A genuine early Caravaggio showing, in a striking night scene, a matineé idol of an angel tenderly holding St. Francis of Assisi in a religious trance (*The Ecstasy of St. Francis* — 1595-1602).

- The finest painting in America by the Baroque Spanish painter Francisco de Zurbaran, his masterpiece *Saint Serapion* (1623), showing the monk, bound to a tree, at the precise moment of expiring. The off-white, slightly yellowish monk's garb with its vivid handling of the drapery, contrasting with the graying face of the noble martyr, constitute two of the most skilled passages of paint in the entire 17th century.

Don't miss the New Haven's **Yale University Center for British Art,** donated largely by the late Paul Mellon, for the superb examples of British painting of the 18th and 19th centuries.

District of Columbia

Washington, D.C.

The National Gallery of Art

There's a platoon of museums in town with more than 7,000 works from every civilization. I shall single out 18 utterly unmissable works from the **National Gallery of Art** (www.nga.gov/).

- Jan van Eyck's *Annunciation,* made between 1434 and 1436. In this painting, God, truly, is alive in the details, especially the brocaded mantle of the Angel — so perfect, the painting is a miracle.

- Pablo Picasso's *Family of Saltimbanques* (1905). Sums up the human condition in the 20th century — mankind wandering, curiously at odds with nature, isolated in a strange wasteland, waiting for some message that may never come. By the way, a saltimbanque is a circus performer.

- Raphael's *Saint George and the Dragon* (c. 1506). Tiny, in mint condition, the Saint George has action, bravado, theatrics, and an almost overpowering fluidity and grace.

- El Greco's *Laocoön and his Sons* (c. 1610). The painting, with its amazing view of Toledo in the background, is at once ancient, Christian, and Freudian in feeling. (See Chapter 9, Figure 9-6.)

- The English painter John Constable's *Wivenhoe Park* (1816). One of the most serene landscapes of the gifted 18th century. Count the birds.

- Albrecht Dürer's riveting *Madonna and Child* (1505).

- Louis Le Nain's, *A French Interior* (1645), which is a masterpiece, by this creator of everday scenes of workers and peasants.

- Leonardo da Vinci's early portrait of *Ginevra de' Benci* (1474). Otherworldly, intense, the young woman is a Renaissance icon who looks beyond us to some private world. I vote this as the second most important old master in America. See the museum guide color insert Figure 2.

Hirshhorn Museum

The **Hirshhorn Museum** (www.si.edu/organiza/museums/hirsh/start.htm) is the flamboyant, large round doughnut on the mall, designed by the late Edward Durrell Stone and accepted for the nation by President Lyndon Johnson.

- Mark di Suvero's *Isis* (1978), outdoors. Huge, witty, impolite, incongruous, and made out of scrap materials, this is grand theater. The junk-metal creature, as bizarre as the Sphinx, stares out at you through eyes made from hawser ports.

- Richard Pousette-Dart's immense and complex abstraction called the *Cavernous Earth With 27 Folds of Opaqueness* (1961-64).

- Francis Bacon's *Triptych* (1967). Raw, arrogantly beautiful, and thankfully, inexplicable.

Freer Gallery

- In the Freer Gallery (www.si.edu/asia), devoted to Asian art, check out the *Peacock Room,* flamboyantly decorated in blue and gold by James McNeill Whistler, whom the museum's founder, the Detroit industrialist Charles Lang Freer, saw as the link between the esthetics of East and West.

- A Japanese screen in the Freer collection. *Dragons and Clouds* by Rimpa Sotatsu (Momoyama-Edo period of the early 17th century). The dragons are the storm: their claws and whiskers make up the lightning, and their undulating bodies become the scudding clouds of the fierce squalls.

Other remarkable works

- ✔ The collection of PreColumbian art in the Dumbarton Oaks Museum.

- ✔ Pierre Auguste Renoir's lovely *Luncheon of the Boating Party* (1881), in the Phillips Collection. (See the main color insert for a full view.)

- ✔ Frederic Church's stupendous landscape, *Aurora Borealis* (1865), in the National Museum of American Art.

Illinois

Chicago

Chicago has some legendarily rich museums. The imposing neo-classical Art Institute is, I think, America's second most illustrious. For antiquities, the Oriental Institute is grand — be sure to spend some time there.

Art Institute of Chicago

Here are the bell-ringers at the **Art Institute** (www.artic.edu):

- ✔ El Greco's large, perfectly preserved *Assumption of the Virgin* (1577), which is like a heavenly choir singing a sweet hymn. The legendary American Impressionist painter Mary Cassat persuaded the Institute to buy it, and luckily, they did. (See the museum guide color insert Figure 3.)

- ✔ Georges Seurat's lofty pointillist work, *Sunday Afternoon on the Grande Jatte* (1884–86), showing a host of diverse Parisians enjoying the park, is probably the most successful Post-Impressionist picture ever. The thousands of painted dots come together into a grand and airy visual scheme when you step back to the proper distance.

- ✔ Claude Monet. The Institute has 33 of them given by Mrs. Potter Palmer, and all are prime.

- ✔ Grant Wood's crafty and solidly painted *American Gothic* (1930).

Terra Museum

The **Terra Museum,** on North Michigan Avenue, is devoted to American painting and, although small, has some fine paintings.

- ✔ One painting is the sensitive and dramatic portrait of George Washington (1823) — the so-called Porthole portrait, because of its unique shape — by Rembrandt Peale.

- ✔ Another of the highest quality is Samuel F. B. Morse's *Gallery of the Louvre* (1831).

- ✔ The Maine painter Marsden Hartley is represented by a strong abstract work entitled *Number 50* (1933), with a compelling mixture of orange and yellow teepees and a horse.

Oriental Institute Museum

The **Oriental Institute** (www.oi.uchicago.edu/OI/MUS/OI_Museum.html) has recently reopened its brimming Egyptian galleries after years of reconstruction. The collection of Egyptian antiquities is one of the most comprehensive in the country. The newly restored main gallery is dominated by a colossal statue of Tutankhamun. The nearly 18-foot (5.5 m) quartzite pharaoh, the largest Egyptian statue in the Western Hemisphere, is about 3,320 years old, and is one of two excavated by an Oriental Institute team in 1930 at Medinet Habu in Luxor.

Indiana

The **Indianapolis Museum of Art** (www.ima-art.org) is one of the finer museums in the land. The strengths are in old masters, Chinese and African art, the prints, drawings, and watercolors by J. M. W. Turner, and the works of French Pointillist Georges Seurat and his followers. In 1998, in a stunning coup, the museum acquired 17 paintings and 84 prints by Gauguin and his Pont-Aven followers. The paintings, valued at about $30 million, were given by and purchased from Samuel Josefowitz, a retired Swiss businessman, with the help of a $20 million challenge grant from the Lilly Endowment, an Indianapolis philanthropy. The newly-gained pieces make Indianapolis a key regional center for late 19th century French art.

Maryland

Baltimore

Two museums are in town, and one possesses what may be the best art in the country. One is the somewhat stodgy-looking neo-classical Museum of Fine Art, and the other the funky-looking Walters Art Gallery downtown.

Baltimore Museum of Art

The overall collection of the **Baltimore Museum of Art** (www.artbma.org) is not memorable except for the truly magnificent works by Pablo Picasso and Henri Matisse, collected and donated by the Cone sisters. A drop-in should be made just for these. You'll also be intrigued by the miniature rooms made by Henry Kupjack.

The Walters Art Gallery

In my opinion, the **Walters Art Gallery** (www.thewalters.org) is, piece-for-piece, the best art museum in the entire United States. Collector Henry Walters began to collect early and got it all from Greek and Roman beauties, Renaissance, and Medieval treasures, old masters, and spectacular furniture plus Oriental wonders. The works are in unmatched condition, so much so that the art professionals come to the Walters to see what's best before spending any money.

A list of the most exciting works:

- The limestone *Madonna and Child,* by a Burgundian (France) painter of the 15th century — lyrical.

- The Flemish painter Peter Paul Rubens was an avid collector, and one of his prizes, which he memorialized in a drawing, is a late antique Roman (4th century) vase with the leering face of a satyr.

- A rare bronze by the 16th-century Fleming, Adrian de Vries, of a wild and sensual dancing faun.

- Three small, intense canvases by the 18th-century Frenchman François Boucher. Second-rate Bouchers abound in America, but these, with their tight drawing and thick layers of confident paint, are genuine and super.

- The remarkable furniture — both Italian of the late Renaissance and French of the 18th century. Of the latter there's a mouthwatering model in wax, wood, and paper for a jewel cabinet given by Louis XV to mark the wedding of the ill-fated Louis XVI and Marie Antoinette. The finished product is gone, but this "dollhouse" number will have you whistling in admiration.

- The Treasury Room is worth walking across the continent to see (figuratively speaking!). Incomparable worldwide are the French 18th-century porcelains — if you've never been a fan of Sèvres or Meissen porcelain, the Walters selection will make you understand why the French and German nobles and royals of yore swooned for these little figurines and elegant dining accouterments.

Every foot of the way through the Treasury, your eye will be attracted by yet another crowning achievement. The best of the lot is exceedingly rare — a ceremonial cup with a rearing horse, by the master of European early 18th-century jewelwork, Johann Melchior Dinglinger. This radiant object was made for Augustus the Strong, Elector of Saxony and King of Poland. The motif is the crown of Poland set on a red cushion in shimmering enamel, decorated with the Polish Order of the White Eagle. There was never a rider on the dynamic horse, for an unseen, spiritual, and royal presence is sufficient.

There are so many knockouts here! Among the host of unbelievable things, do not miss the intense perfection and drama of the gold medallion, depicting Scaramouche, designed by Georges Tonnellier, a French gem carver who lived from 1858 to 1937. Or the moving white chalcedony miniature memorial to the tragic Titanic. Or, for the Russian 19th-century jeweler Fabergé, the Rose Trellis egg depicting Gatchina Palace and the blocky, strong rhinoceros in jasper, which may be the finest Fabergé animal of all. Finally, gaze at the group of 19th-century Italian miniature mosaics.

The pick of the European paintings serves to underline that Henry Walters' eye was historically deft.

- One of the greatest portraitists of history was the 16th-century Florentine Jacopo da Pontormo, and here his *Portrait of Maria Salviati with little Giulia de' Medici* (1537) is prime.

✔ Jean Auguste-Dominique Ingres painted several pictures depicting the well-known episode in which Ulysses, confronting the fierce Sphinx, tries to guess the answer to the famous riddle — what walks on four legs, two legs, and finally three (if you got it — man, as a baby, adult, and elderly person on a cane — you were saved from becoming an instant lunch). This is the slickest version that exist. (c. 1808).

✔ Édouard Manet's *At the Cafe* (1879), a portrait of the interior of the dashing Cabaret de Reichshoffen on the Boulevard Rochechouart, where the avant-garde met. The painting was both highly praised and roundly condemned when shown in 1880. Today, we wonder why it was attacked.

✔ The Giambattista Tiepolo, *Scipio Africanus* — dating around 1720 — is both grand and pristine, with the master's usual incomparable rendering of colors.

✔ Finally, for American paintings, there's a small but stunning Frederick Edwin Church, *Morning in the Tropics* (1858), that may start you humming.

Massachusetts

Boston Area

Boston has some of the hottest museums and the best works of art in the nation. You have the Museum of Fine Arts, and attached to Harvard (Cambridge), the Fogg, the Busch-Reisinger, and the Sackler, plus the Isabella Stewart Gardner — and don't forget the Contemporary Museum and the Museum for Bad Art.

Museum of Fine Arts (MFA)

The **Museum of Fine Arts** (www.mfa.org/home.htm) is a sprawling building, the most recent addition to which was designed by the famed I. M. Pei and includes a decent restaurant and an art shopping center. Here are some highlights:

✔ The Oriental collections are thought to be the best in the nation. Their richness is in part explained because of the active trade with China and Japan by early Boston merchants.

✔ The best classical Greek fake in America is also on display — the so-called Boston Throne, which has recently been proven to be a forgery made in the 19th century in Rome.

✔ One of the most important Early Christian pieces ever unearthed is a large marble bust of St. Paul with eerie, wide-open, fervent eyes of prayer, dating to the early 4th century, coming from the church bearing his name in Corinth, Greece. (I found it for the Met when I was junior curator and was denied the purchase, so I called a competitor in Boston who snapped it up and discovered what it was. Ouch!)

✔ Donatello's low-relief sculpture of *The Madonna in the Clouds* (1425-35). He was one of the greatest artists of the Early Renaissance, and his works are rare outside of Italy. This enraptured work has a real punch in the contrast between the weighty Madonna and the diaphanous clouds on which she sits.

- Pierre-Auguste Renoir's *Dance at Bougival* (1883) — a delight.

- Claude Monet's *Woman in a Japanese Embroidered Dress* (1876). It's almost as if the lady is dancing with the embroidered Kabuki player.

- Paul Gauguin's triumphant masterpiece — *Where Do We Come From? What Are We? Where Are We Going?* (1897) — his monumental, lush, and provocative ode to all life, which he intended to be his suicide note (his attempt failed). Maybe the most significant painting from 1800 up to the *Demoiselles d'Avignon* by Picasso. It is the image of all of mankind (see Chapter 14, Figure 14-1).

- John Singleton Copley's unforgettable portrait of the patriot and silversmith *Paul Revere* (1768) — direct, no-nonsense, are strictly American.

- John Singer Sargent's life-size, miraculously rendered, shadowy interior of the Paris apartment of the Bostonian Edward D. Boit with the four beautiful young daughters (1882). The ladies wear exquisite white pinafores. Feast your eyes on the sweet toddler in foreground. On the right side, a Chinese urn as tall as the eldest daughter glistens like a lighthouse.

Isabella Stewart Gardner Museum

There is a host of great Italian pictures of the 15th and 16th centuries in the **Isabella Stewart Gardner Museum** (www.boston.com/gardner). But the knockout is Titian's large *Rape of Europa* (1559-62), which is soft, silky, sensual, painted with what seems to be the colors of distilled rainbows, and in superior condition. Jupiter, disguising himself as a snow-white bull, has captured Europa and swims away as her handmaidens weep and moan on shore. Europa shows some concern, but Titian has portrayed her as being on the edge of acceptance, and even more. I vote this painting to be the single finest old master in the United States.

The Fogg Museum

The **Fogg Museum,** (www.artmuseums.harvard.edu/Fogg_Pages/FoggMain.html), which is in an hospitable old house, is open to visitors other than Harvard students and has a grand collection of Impressionists and a great Picasso drawings collection. Another majestic series is the series of terra-cottas by the 17th-century Italian genius Gianlorenzo Bernini, which makes the finest representation of the work of this Olympian sculptor anywhere in America. Ask for them, although most may be hidden away owing to space, which is hard to come by at the tiny Fogg.

Another striking series of works is in the 300 gifts from donor Lois Orswell — including 43 sculptures by David Smith, called by some the greatest American abstract sculptor of the 20th century. She also donated paintings by Willem de Kooning, Arshile Gorky, Paul Klee, and Franz Kline. Kline's *High Street* is now the centerpiece of the new installation of 20th-century American painting.

Arthur M. Sackler Museum at Harvard University

The **Arthur M. Sackler Museum** (www.artmuseums.harvard.edu/Sackler_Pages/SacklerMain.html) is adjacent to the Fogg and has a bountiful collection of Oriental pieces and European drawings. The temporary shows are stellar.

The Busch-Reisinger Museum at Harvard University

The **Busch-Reisinger** (www.artmuseums.harvard.edu/Busch_Pages/BuschMain.html) is devoted to German art from medieval to modern times. The best sculptures are the late medieval ones.

You'll be overwhelmed by a great work by the German Expressionist Max Beckmann on loan from the Fogg (another gift by Lois Orswell). It is a grim and disturbing 1941-42 triptych titled *The Actors,* which shows the artist as a king stabbing a dagger into his heart.

Museum of Bad Art

Boston is also the home of the **Museum of Bad Art** (www.glyphs.com/moba/) — seriously. The museum, housed in the locker-room-like basement of the community theater in the Boston suburb of Dedham, is devoted to art too awful to be ignored. Its frequently visited Web site will show you more truly wretched art than you'll ever want to see.

Michigan

Here are some things at the **Detroit Institute of Arts** (www.dia.org) — which is the fifth-largest fine arts museum in the U.S. — that you'll want to see.

- The 27 fresco panels entitled *Detroit Industry,* painted in 1932, are Diego Rivera's best U.S. frescoes, and actually among the best he ever painted.
- Pieter Brueghel's *The Wedding Dance* (c. 1566).
- *Nocturne in Black and Gold: The Falling Rocket* (c. 1875), by James Abbott McNeill Whistler, is a textbook image — forerunner of abstract painting, as well as a fascinating example of relation of artist to the critic.
- Don't miss *Judith and Her Maidservant with the Head of Holofernes* (c. 1625), by Artemisia Gentileschi. This is one of the most important pre-19th century works by an "old-master" woman artist in the U.S. Continually reproduced in art history surveys and books on women in art.
- *The Jewish Cemetery* (c. 1655-60), by Jacob Isaaksz van Ruisdael. Reproduced in many standard histories of art. Major allegory of Protestant Netherlands that uses landscape to relate religious views.
- *Selene and Endymion* (c. 1628), by Nicolas Poussin. An outstanding Poussin.
- *The Nightmare* (1781), by the Swiss Henry Fuseli. One of the great Romantic images — again, repetitively reproduced.

Also, the American collection at Detroit is very famous — it was here that the Archives of American Art was first organized.

Minnesota

The **Minneapolis Institute of Arts** (www.artsmia.org) is a traditional "bank-architecture" building with a Roman flair and acres of polished marble floors. Recently, 22 new Oriental galleries have been opened, which alone are worth the visit.

✔ The stars of the Chinese ensembles are a lofty 17th-century reception hall from a Ming mansion and an 18th-century scholar's study with an adjoining rock garden. Both were brought from China and painstakingly reassembled.

✔ For European paintings, don't miss a superior work by the talented English painter of the 18th century, Joseph Wright of Derby, *Cottage on Fire* (1787) — one of the best fires ever painted. And a deeply moving work of feathery beauty, reeking with love and respect by Francisco Goya, *Self-Portrait with Dr. Arrieta* (1820), given to his physician, who literally saved the painter's life (he lived for another eight years).

The **Walker Art Center** (also in Minneapolis), known for its great exhibitions, has a fine permanent collection, and its sculpture garden is thought by many to be the second best in America (after New York's Museum of Modern Art).

✔ See Claes Oldenburg's *Spoonbridge and Cherry* (1988), which is a bold combination of realistic forms, inflated hugely in size and with some startlingly sensitive detailing. Oldenburg has said that all he cares about is stimulating meaning.

✔ *The Bronze Horse* (1988) by Deborah Butterfield, also in the garden, is a delightful, half-abstract and half-realistic image. She's one of the country's finer contemporary artists.

✔ The most striking painting is the German Expressionist Franz Marc's imposing work, *Large Blue Horses* (1911) — stark but gentle at the same time.

Missouri

Kansas City

Two first-rate museums are here, the Nelson-Atkins (www.nelson-atkins.org/) and Kemper Museum of Contemporary Art (www.kemperart.org/). The former is a generalized collection in a magnificent Beaux-Arts style building with great strengths in Oriental art. The latter, housed in a postmodern structure of inviting hospitality, is given over to the contemporary, primarily with changing exhibitions.

At the **Nelson-Atkins,** the postwar director of the Nelson-Atkins, Larry Sickman, was an Oriental specialist who served in Japan in the occupying army and who bartered and bought hundreds of Chinese and Japanese masterpieces from Japanese collectors, mostly using American cigarettes as currency. The numerous glories of the Oriental collections are thanks to Sickman and the generous donors he attracted. Prime among them are the following:

✔ The drop-dead beautiful, large wooden painted and gilded sculpture of the Bodhisattva of the *Water and Moon,* (11th-12th century), which may be the most breathtaking Chinese sculpture in the country.

✔ The ten large terra-cotta statues of the funeral cortege, including several fabulous camels from the estate of Joyce Hall and members of her family — most spectacular, T'ang (ca. A.D. 700-750).

✔ An incredible treasure of paintings shown in a special climate and light-controlled gallery. Dozens of gems. For one, don't miss the painted handscroll painted in grays and black (ink and a bit of color on silk), representing *Fishing in a Mountain Stream* (mid-11th century), which is America's finest Chinese painting. The mountains will never leave your memory.

In the old master category, you will delight in the excellent *Saint John the Baptist* (1604) by Caravaggio, which is equal to the best of the artist in Rome or Vienna.

For French 19th century, there are some knockouts. These include a gorgeous Monet of the *Boulevard des Capucines* (1873) and a startlingly vivid little study for his *Bathing Place, Asnières* (1883), by Georges Seurat.

The American paintings are extraordinary here. Especially the works of the 19th-century painter George Caleb Bingham (*Canvassing for a Vote,* done in 1852, with its smarmy, ever-smiling politician is a classic). One of the top works by Thomas Hart Benton, the fire-eating, outspoken, so-called "regional" painter who worked his life in Missouri, is here — the shocking *Persephone* (1938), in which a horny old farmer sneaks a look at the very naked modern Persephone.

For contemporary sculpture, you won't be able to miss a series of mammoth shuttlecocks, done in 1994, by the American Pop Art sculptor Claes Oldenburg, which punctuate the grand green terraces. Oldenburg is known for inflating ordinary objects. The effect is not so much that you're looking at gigantesque shuttlecocks, but that a tiny museum building has been dumped in the middle of a normal-size badminton court and that any moment a hand will remove the birdies so the game can go on.

Saint Louis

The architecture of the **Saint Louis Art Museum** (www.slam.org) is half and half neo-classical and modern and works very well. The interior is one of the best organized in the country, and the restaurant is one of the few that rises above standard museum fare.

The collections are broad — a mini-Metropolitan — and you'll see examples from Egyptian times to today. The greatest strength is in the paintings of the German Expressionist school (see Chapter 15 for details), given by the May family, and which are unparalleled in the nation.

✔ Feast your eyes on masterworks by the likes of Emile Nolde, Max Beckmann, and Ludwig Kirchner. The Surrealists are hot, too, and the Belgian Paul Delvaux is well represented. There are, in addition, some topnotch works by the 20th century Frenchman Henri Matisse.

✔ For contemporary, what is perhaps the most powerful work by the dynamic German Anselm Kiefer is here. It's called *The Broken Vessel* (1990) and is a huge and profoundly moving assemblage of lead forms and broken glass, which evokes Rodin's *Gate of Hell* and captures the horrors of the so-called Kristallnacht when, in November, 1938, the Nazis smashed all the windows in Jewish shops and offices.

> ↙ You'll find some superior American paintings of the 19th century, in particular, those by George Caleb Bingham.

New York

Buffalo

Buffalo and the **Albright-Knox Art Gallery** (www.albrightknox.org) should be on everyone's list to see, for it's an overwhelming art experience. Small, intimate, and seductive, the museum has one of the most thumping modern and contemporary collections in the world. You hear the names and you'll hope — but until you go and see the specific examples, you'd never guess the staggering quality of the Gauguin, the Juan Miró, the Matisse, the large and serene canvases by the late American Abstract Expressionist Clifford Still. The chairman of the board of trustees for some years was Seymour "Shorty" Knox, who happened not only to come from a very wealthy upstate New York family, but who possessed probably the most refined "eye" in the world when it came to assessing art. "Shorty" also possessed a steely desire to acquire, acquire, and acquire — not in numbers but in excellence. And he certainly did. Do yourself a favor and go to the divine Albright-Knox gallery.

Corning

The newly expanded **Corning Museum of Glass** (www.cmog.org), associated with the Steuben glassworks, is even better today than it has ever been. That's hard to believe, for the place is one of the gems of the United States. The museum collects and exhibits only glass — *only.* You wouldn't imagine that glass would loom as such a major art possibility. But it does. There are something like 300,000 pieces in the comprehensive collection (but I promise you, you don't have to see them all). The glass ranges from Roman times, with an openwork, membrane-thin miracle of a work to the finest examples of the 20th century. This is not a specialist place — it is a grandiose, highly professional, and devastatingly beautiful art experience. See it, for sure.

New York

The city may be the richest cultural metropolis on earth. Millions of works spanning 50 centuries are housed in 36 museums. Can you examine this wealth? Sure. Most of it is on view, but any attempt to pick your way piece by piece would lead to cultural shock. Besides, who would want to? Only 15 percent of the treasures is worth a glance, and merely .0006 percent is the kind of thing that makes you shiver with delight. You can see the goose-bump ones in a week or a lifetime, which I'd recommend. It has been done in two days, followed by hospitalization.

The American Museum of Natural History

The **American Museum of Natural History** (www.amnh.org) is mishmash of architecture dominated on the main facade by a huge and frightfully dated equestrian statue of Teddy Roosevelt as superhero. Art? You thought the place had only dinos and rocks and animal dioramas? Art does exist in abundance, and some of

it is of the highest caliber, too — what used to be called "primitive art." The pick of the pick is from the Northwest Indians, especially the delicate Tsimshian masks or the Haida carvings in black slate, as if velvet had been molded and petrified.

Or the nubby Tlingit textiles or the heart-throbbing, intricately carved Kwakiutl wooden sculptures of humans and mystical beasts. They are from never-never land but as real as we are. (See the museum guide color insert Figure 4.)

The Brooklyn Museum

The architecture of the **Brooklyn Museum** (www.brooklynart.org/) suggests nothing more than a work in progress, with its original neoclassical staircase brutally amputated. But, at least you don't have to climb a hundred stairs. Brooklyn is always being touted as America's second finest museum, which it's not; but nonetheless, it possesses some terrific gems.

Some American paintings are choice. I'd highly recommend Albert Bierstadt's grand _Storm in the Rocky Mountains_ (1866), Mother Nature putting on a blaster of a show with a thunderous, blue-black hammerhead of a storm crackling over the soaring peaks.

The late Egyptian antiquities are heralded throughout the world.

The Frick Collection

The **Frick** (www.frick.org) is another neoclassical wealthy-man's architecture. This one has a kind of French twist, is supple and delicate and, inside, a real pleasure, especially the fountained courtyard where concerts are held. The ambiance will make you feel like a billionaire. It's the private museum attached to the home of the steel magnate and robber baron Henry Clay Frick, now opened to the public (except for children under 16). Some think that it's the best collection of Old Master paintings in town — and although that's saying too much, there are some world-class pieces. These alone are worth the visit.

- Rembrandt's penetrating _Self-Portrait_ (1658), in which he paints himself as an aging wreck with a fighting spirit, stands in the top three of all his works.

- _The Polish Rider_ (c. 1655) may or may not be by Rembrandt (scholars are arguing about whether it is), but it's an enthralling bit of mysterious drama. Here we see an unbelievably attractive young man riding into town. Who is he? Mr. Nice? Or an advance scout for an army of marauding Scythians who will invade and slaughter everyone? Or maybe the Devil himself? Not by Rembrandt? Come on! Who else?

- The fabled Venetian 15th-century Giovanni Bellini's crisp portrayal of the brooding _Saint Francis in Ecstasy_ (c. 1485).

- Titian's incomparable early 16th-century essay in realism, _Man in a Red Cap_ (c. 1516). Can you believe the intensity of the silver topknot on the sword?

- Jan Vermeer's mouthwatering _Officer and Laughing Girl_ (1655-60). This, I believe, is the best Vermeer in the nation.

- Jean Honoré Fragonard's exuberant four pictures from a series entitled _The Progress of Love_ (1790-91), made for royal mistress and arts patron Madame du Barry. Check out how love — or whatever — makes out.

Guggenheim Museum

The roundabout beige concrete structure of the **Guggenheim** (www.guggenheim.org), finished in the 1960s, is New York's only Frank Lloyd Wright building and, except for the near-impossibility of showing flat pictures on its curved walls, it is sensational, especially the gracious circular skylight. I always view the collection or special exhibition from the top down because it's easier to walk down the inclined corridor. (I've always dreamed of wearing roller blades.) I attended the fancy opening in the 1960s, and when the donor Harry Guggenheim asked my witty father-in-law (who was wearing a cane) how he liked the place, he smiled and said, "Simply staggering, Harry."

Although the Guggenheim started with the intent that it would house only non-objective art, the collections contain some fabulous Impressionism and Post-Impressionism "old masters." The bulk is, however, gems illustrating the chief European avant-garde movements — Cubism, Surrealism, Futurism, and the like. Don't miss:

- ✔ Van Gogh's vividly drawn *Roadway with Underpass* (1887). Look at those painterly forms — they're so strong that they look like they are carved out of paint.

- ✔ Paul Cezanne's near-perfect *Portrait of a Man with Crossed Arms* (c. 1899). I think that this is one of the top three portraits in all New York — and there are plenty!

- ✔ Pierre Bonnard's *Dining Room on the Garden* (1934-1935), an energetic helter-skelter kaleidoscope of brilliant colors.

- ✔ Picasso's masterpiece, *Woman Ironing* (1904), with her rigid arm pressing cruelly down on her hand, a symbol perhaps of 20th-century masochism.

- ✔ Picasso's Cubist melody in gray, beige, black, and silver-green, entitled *Bottles and Glasses* (1911-1912). This is, for me, the best example of Cubism there is and is easy to understand.

- ✔ The Guggenheim owns an enormous collection of the paintings of the first non-objective artist, Wassily Kandinsky. Ask if his super *various actions*, painted in August of 1941, is on view. It's a dance of biomorphic shapes in red, yellow, orange, green, and gray, all cavorting (or whatever) on a soft green background.

The Hispanic Society

The white marble and travertine building of the **Hispanic Society** (www.hispanicsociety.org) is Neoclassical and superb. The place is isolated way up there on Broadway and 158th street, and it's New York's secret museum. If you have the guts to enter the messy neighborhood, you'll revel in several "ne plus ultras," or "nothing better than."

One is Francisco Goya's saucy portrait of his black-maned supposed lover, the Duchess of Alba (1795), who points at the name "Goya" etched in sand at her feet. In several glass cases covered with fabric you can pull aside are some of Goya's most wondrous drawings. You'll also see several impeccable paintings by Diego Velázquez and the finest collection of Hispano-Moresque pottery in America, glistening with incandescent rusts and blues.

The Metropolitan Museum of Art (MMA)

The facade architecture on Fifth Avenue of the **Metropolitan Museum** (www.metmuseum.org) is a combo of an ancient Roman Bath and a pair of flanking bank buildings. The ends and the back are delightful silvery, glass modern additions of the 70s and 80s. Inside, the feeling is warm and hospitable.

Probably the best way to see the Met is to nibble at it for 20 minutes a day, every day of the year, looking at only two or three sublime works. Only, that might take until Y3K. So, come at the opening bell, remain the whole day, and gorge on the art of all mankind. The restaurants are okay — as museum restaurants go — so you don't have to leave the building. Go first to the mall-sized store and select postcards of what you want to see and show them to the guards whenever you lose your bearings. (See Chapter 3 on how to visit a museum.)

The MMA has an admissions system I helped to create. It's called, "pay-what-you-wish-but-you-must-pay-something." The museum suggests a fairly substantial fee, but you can personally decide what you want to give for yourself and your family and sashay right in. A penny is legal, but that's a little too little.

Here's my chronological "tour de force" of the pick of the 29 curatorial departments, which cover a mere 50,000 years. You don't really need to follow it, for if you do you'll have to walk back and forth, up and down through the 14-acre building, but at least it's a way to get a handle on the enormous scope of the holdings. The Met is said to have three million pieces, which is probably an exaggeration (the real number must be somewhere in the 300,000 range — but that's plenty).

Egypt

Every work is on display in a series of chronological primary galleries with explanatory labels in good, clean English, and the secondary material is exhibited nearby — totaling something like 5,000 pieces in all. If I were to chose the hottest items to sum up the magic and mystery of Pharoanic art, which was all about representing the world and saving it for eternity, I'd pick the reassembled tomb of Peri-Nebi at the entrance, the gallery with the ensemble of models of ships, a brewery, and a flax-spinning factory made 3,000 years ago in the Old Kingdom for the afterlife of one Meketra (see Cairo in the museum guide). They look as if they'd been made yesterday. Then, for a hint of the spirit of ancient Egyptian architecture, pop your head inside the massive glass gallery housing the 1st century A.D. Temple of Dendur, situated east-west — just as it once was on the Nile riverbank.

Ancient Near East

Don't miss the royal Assyrian reliefs of the 9th century B.C., depicting muscular, yet delicate, winged bulls. They are from the Iranian palace of King Ashurnasirpal II at old Nimrud.

Greek and Roman Art

The cream of the galleries has just been reopened, so ask the guards where things are (and flash any postcards you may have purchased for directions). The best pieces are the stately, archaic (7th-6th century B.C.) marble stela (a tomb marker) with a sphinx on top; the huge terra-cotta Krater of 510 B.C., decorated by the

painter Euphronios, showing the hero Sarpedon being carried from the battlefield by Sleep and Death (the spectacular drawing makes it one of the finest Greek objects in existence); and, on the ground floor, the charming series of Roman wall paintings, including a captivating bedroom.

Early Christian and Byzantine art

Noteworthy are the 7th-century silver plates with the story of King David — the fresh, classical-revival style shows how inaccurate is the term "Dark Ages." Seek out also the dark-gray-silver top-heavy Chalice of Antioch that John D. Rockefeller Jr. bought, thinking it might be the chalice used in the Last Supper — it isn't; it's Syrian of the 5th-6th century.

In the Medieval Hall, the soaring metal choir screen dates to the 15th-16th centuries and came from the cathedral of Valladolid. The best piece in the gallery is the stone seated Madonna and Child of the late 14th century from Polignac, a Burgundian (Southeastern France) masterpiece.

In the medieval Treasury to the north, there's a welter of superior pieces. Significant are the postage stamp-sized 12th-century golden reliquary locket of St. Thomas à Becket — the only one of its kind — (which I bought as a young curator in a 57th Street gallery for less than $1,000, because the dealer didn't know what it was) and the magnificent 14th-century jewel and enamel pendant with St. Catherine of Alexandria holding her wheel of martyrdom.

The Cloisters, way up town in Fort Tryon Park, is a museum of the Met devoted to medieval art. The building is a combination of modern construction looking like medieval Carcassonne in France and authentic sections of Romanesque and Gothic monasteries, chapels, and cloisters brought over from Europe and assembled in this charming "museum of ambiance." The best pieces are: the 12th-century ivory cross from Bury St. Edmunds, which is one of the triumphs of the Romanesque age, the fabulous Unicorn tapestries of the 15th century, and the beautiful illuminated manuscript, the early 15th-century Belles Heures of the Duke of Berry (see Chapter 6 for the International style and the Limbourg brothers). Best of all is the atmosphere of the place. Springtime when the trees are blossoming is the time to go.

The Lehman Pavilion

These precious galleries recreate part of the private museum built by financier Robert Lehman and show a selection of his incomparable old masters and drawings. The best picks are: Ingres's portrait of the *Countess de Broglie,* with her shimmering blue satin dress (19th century), and Giovanni di Paolo's *Expulsion of Adam and Eve from the Garden of Eden* (mid-1400s). Among the drawings, Leonardo da Vinci's *Bear* and Albrecht Dürer's *Self-Portrait* — if they happen to be on view — for drawings are susceptible to ultraviolet rays and must be kept hidden for most of the year.

Arms and Armor — Near the Medieval Treasury

Armor is decorative arts, and the ornate parade armor, shields, and richly decorated helmets prove it. Don't miss the Japanese armor, which used organic materials to deflect arrows and slings and was probably more effective than steel.

Musical Instruments

Just above the arms and armor galleries, a number of fascinating instruments from all over the world are shown in a series of beautiful galleries. Every one of the instruments can be played (some are used for special concerts). The more intriguing are made from precious metals, glass, and porcelain. The instruments of the Northwest Indians — especially the Haida and Tlingit peoples — are gripping.

The Costume Institute

Clothing is also fine art. The galleries usually present a temporary and fascinating show.

Islamic art

These galleries are amongst the freshest in the place. Do not miss the pages from the illuminated manuscript of the *Sha-Nameh* of King Tamasp, which feature breathtakingly detailed paintings of the sophisticated 16th-century Mughal court (see Chapter 17) and are among the most sophisticated works of art ever made.

"Primitive Art" in the Michael C. Rockefeller Wing

Seek out the stunningly realistic 17th-century Benin bronzes, the majestic 16th-century ivory Benin mask of a Lord (his headdress consists of the troops he's hired to protect him), and the mammoth Pacific Islands Asmat ritual poles from New Guinea.

Oriental art

The collection of Chinese and Japanese art is considered one of the better ones in the nation. The thrillers are the monumental Chinese sculptures in the Sackler Gallery, the David Packard collection of Japanese paintings, and anything from the C. C. Wang collection of Chinese paintings.

European Decorative Arts

The art is housed in literally dozens of superb galleries and courtyards, donated by such wealthy donors as Henry Kravis and Milton and Carole Petrie, and includes thousands of goodies of furniture, porcelain, silver, gold, textiles, tapestries, period rooms, and sculpture. Not to be missed are:

- The Wrightsman French period rooms of the 18th century
- The English Croome Court and Lansdowne rooms
- The 15th-century Italian room from Gubbio, with amazing wood inlays
- The 15th-century Blumenthal Patio from Spain

Exhibited there is a stunning small marble sculpture (depicting a faun climbing a tree) carved by the incomparable 17th-century Italian Baroque master, Gianlorenzo Bernini, who made it when he was just 16. (It came up for sale for $2,500 as a work by an unknown 18th-century sculptor, but because of a mail strike, I didn't get that catalogue. I was able to snag the sculpture later — when it had been discovered as a Bernini — for a mere $750,000. Sometimes getting is more important than price.)

European Paintings

It's best to view these numerous galleries in the early afternoon — the light is a bit more favorable. The old masters are in the central part of the Met, and the

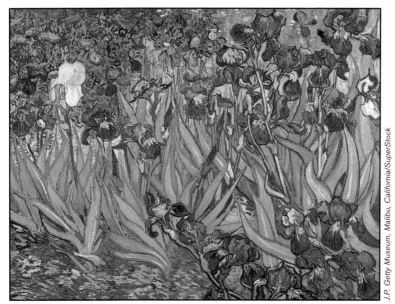

1) Van Gogh: *Irises*

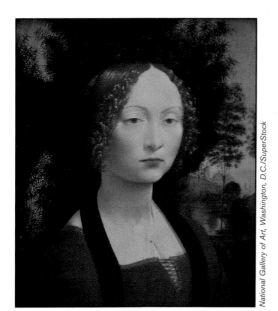

2) Leonardo da Vinci: *Ginevra de' Benci*

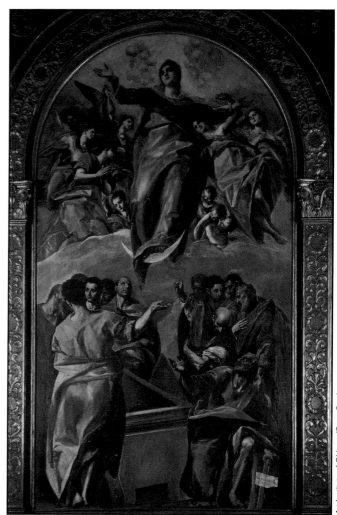

3) El Greco: *Assumption of the Virgin*

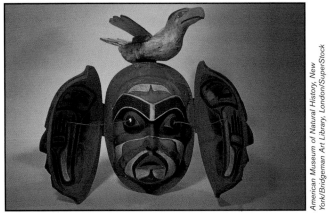

4) Kwakiutl revelation mask

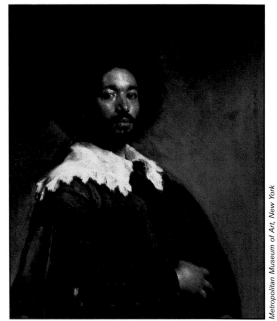

6) Velázquez: *Juan de Pareja*

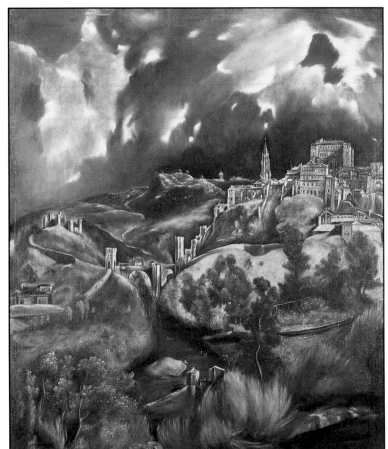

5) El Greco: *View of Toledo*

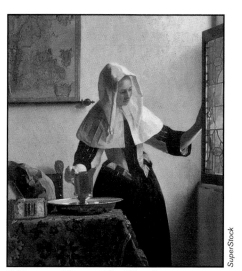

7) Vermeer: *Woman with a Water Jug*

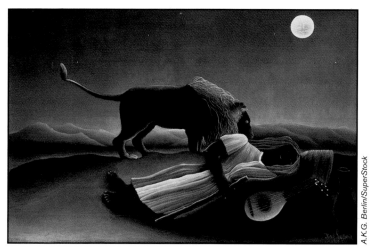

8) Rousseau: *Sleeping Gypsy*

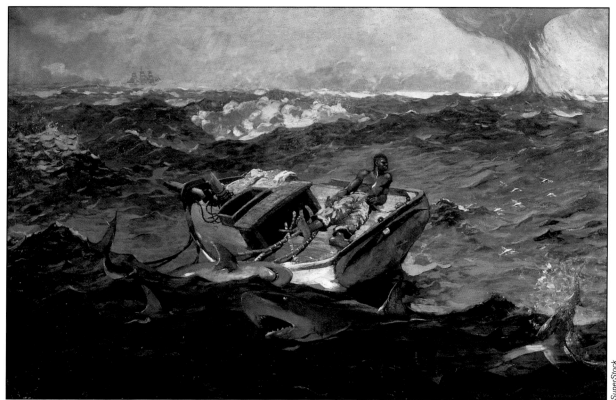

9) Homer: *The Gulf Stream*

10) Eakins: *The Gross Clinic*

11) Georges de la Tour: *The Cheat with the Ace of Clubs*

12) Brueghel: *The Peasants' Wedding*

13) Mantegna: *The Calvary*

14) Raphael: *Baldassare Castiglione*

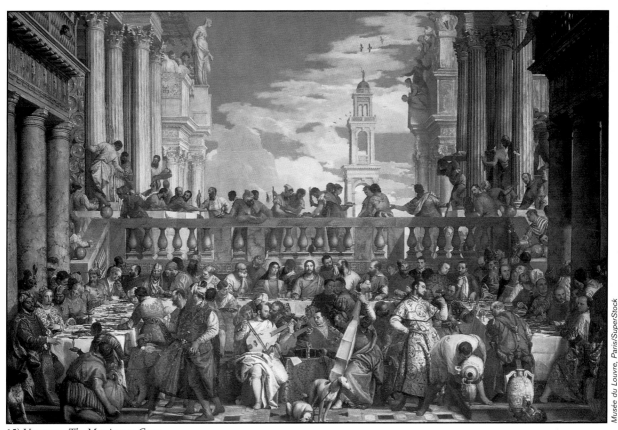

15) Veronese: *The Marriage at Cana*

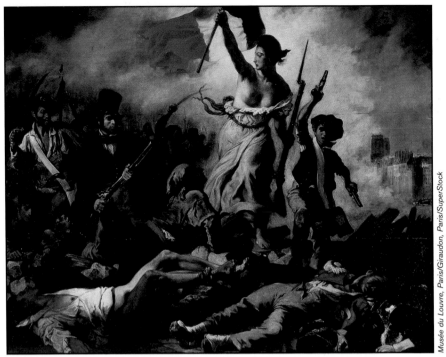

16) Delacroix: *Liberty Leading the People*

17) Puget: *Milo of Crotona*

18) Rubens: *Landing at Marseilles*

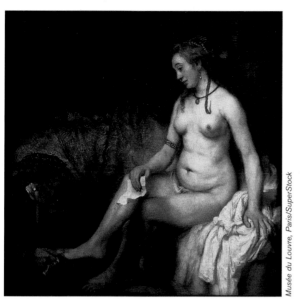

19) Rembrandt: *Bathsheba at Her Bath*

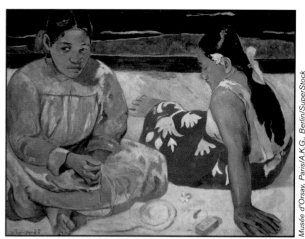

20) Gaugin: *Tahitian Women*

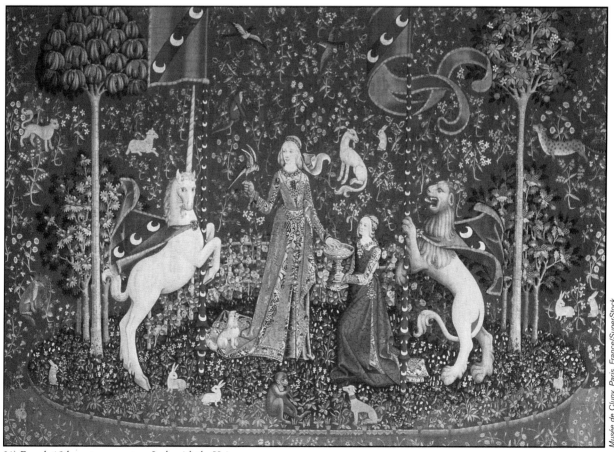

21) French 15th-century tapestry: *Lady with the Unicorn*

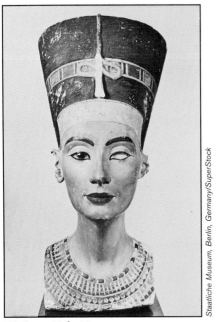

22) Queen Nefertiti

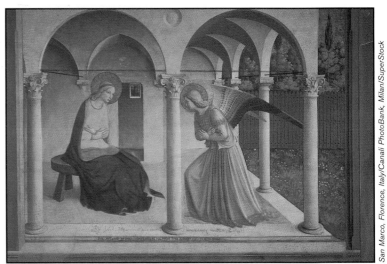

24) Fra Angelico: Annunciation fresco

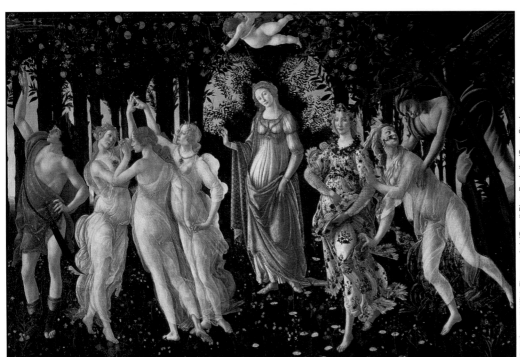

23) Boticelli: *La Primavera*

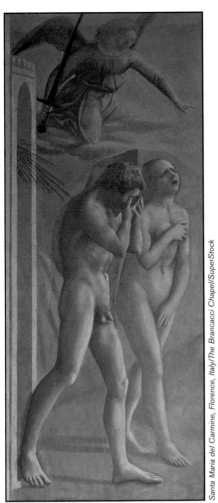

25) Massacio: *Expulsion of Adam and Eve from the Garden of Eden*

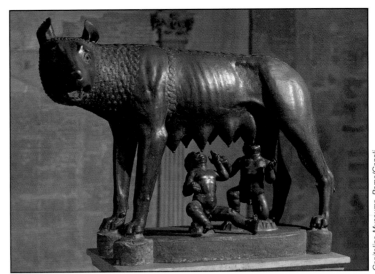

27) 7th-century B.C. Etruscan bronze

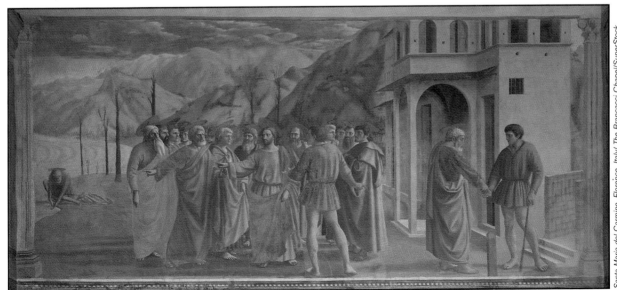

26) Massacio: *Payment of the Tribute Money*

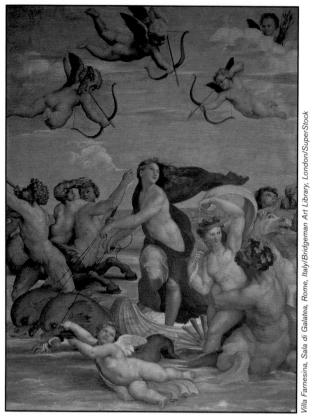

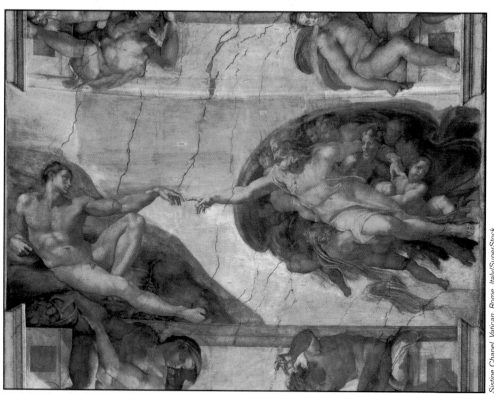

29) Raphael: *Galatea*

Villa Farnesina, Sala di Galatea, Rome, Italy/Bridgeman Art Library, London/SuperStock

28) Raphael: *Deposition of Christ*

Galleria Borghese, Rome, Italy/Fratelli Alinari/SuperStock

30) Michelangelo: Sistine Ceiling, *Creation of Adam*

Sistine Chapel, Vatican, Rome, Italy/SuperStock

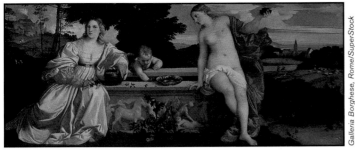

31) Titian: *Sacred and Profane Love*

32) Carpaccio: *The Courtesans*

33) Rembrandt: *Day Watch*

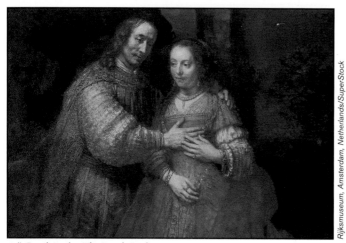

34) Rembrandt: *The Jewish Bride*

35) Van Gogh: *Self-Portrait with Hat*

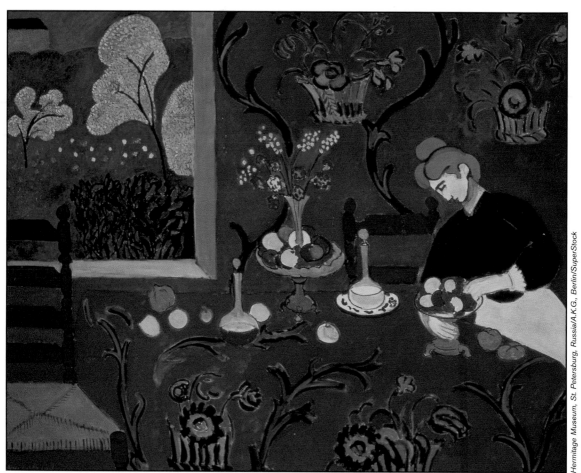

36) Matisse: *Harmony in Red*

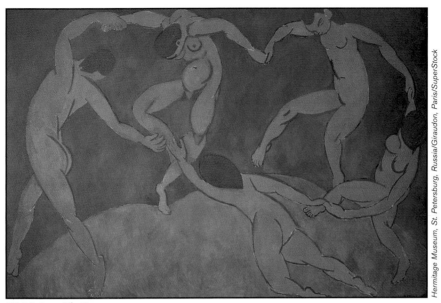

37) Matisse: *The Danse*

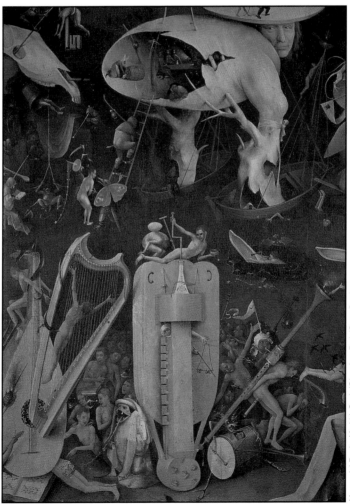

38) Bosch: Detail from *Garden of Earthly Delights*

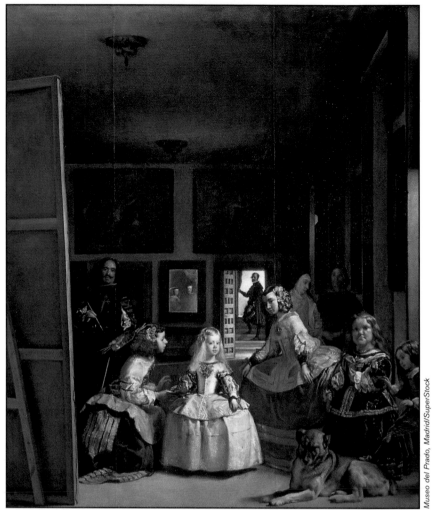

39) Velázquez: *Las Meninas*

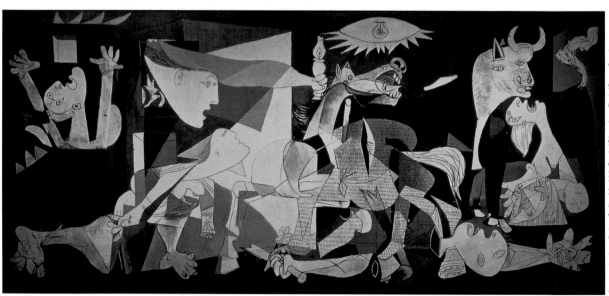

40) Picasso: *Guernica*

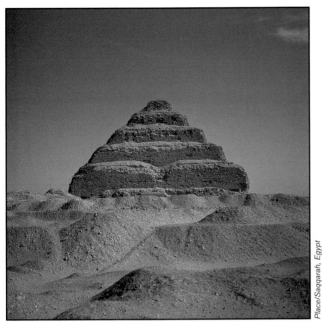

41) The Stepped Pyramid at Saqqara

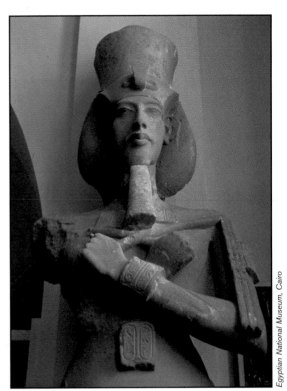

43) The Pharaoh Akhenaten

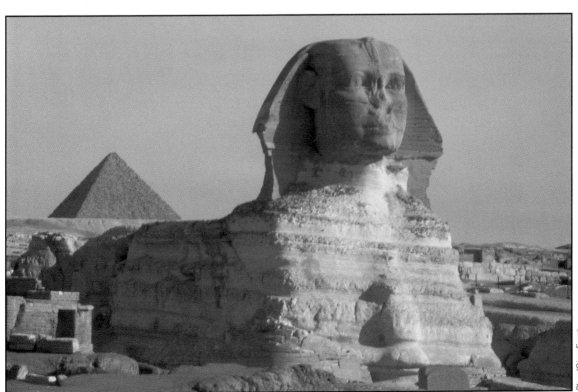

42) The Sphinx

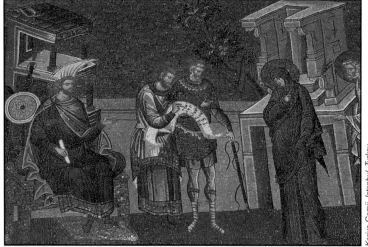

Kariye Camii, Istanbul, Turkey

44) Joseph and Mary Enrolled for taxation,
from the Chora Monastery

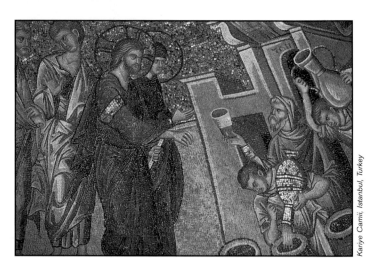

Kariye Camii, Istanbul, Turkey

45) The Miracle at Cana, from the Chroa Monastery

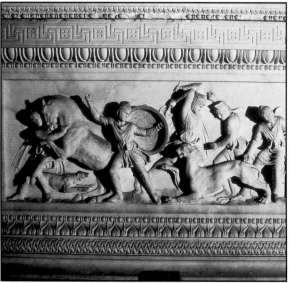

Archaeological Museum, Istanbul, Turkey

46) Detail from the Alexander Sarcophagus

Impressionists and Post-Impressionists in the Rockefeller Wing in the south end. Pay special attention to:

- The early Flemish pictures, especially the Jan van Eyck diptych, with *The Crucifixion and Last Judgment* (this comes close to the *Ghent Altarpiece* on my list of the best art of the world, described in Chapter 20).

- Early Italian masterpieces, such as Sandro Botticelli — his impressively detailed *Last Communion of St. Jerome* (c. 1490) being one of the museum's top paintings.

- The 17th-century French canvas by Georges de La Tour, showing a newly rich country bumpkin being fleeced by Gypsies (c. 1630).

- The world-famous *View of Toledo* (c. 1597) by El Greco (see Chapter 20 for his greatest work and the museum guide color insert Figure 5).

- The portrait of *Juan de Pareja* (1648), by the 17th-century Spanish genius of geniuses, Diego Velázquez (which I purchased for only $5.4 million in 1970). (See Chapter 20 for the expanded story of this painting and the museum guide color insert Figure 6.)

- The array of Flemish and Dutch paintings, especially Pieter Brueghel the Elder — his magnificent *Harvesters, Autumn* (1565) — Jan Steen, Frans Hals, and Jan Vermeer's glowing *Woman with a Water Jug* (1664-65). See the museum guide color insert Figure 7.

- Above all, the Rembrandts, which compete with what Holland has to offer, in particular, the famous *Aristotle Contemplating the Bust of Homer* (1653).

Rich, too, is the Met's hoard of 18th-century French and Italian masters, such as Watteau, Boucher, Tiepolo, and Canaletto. A standout is Jean Antoine Watteau's *Mezzetin,* or guitar player (1718-19).

Come after dinner to see the 19th-century pictures, which are the most popular works in the museum. The Goyas are superior, but even more striking are the paintings by Gustave Courbet (his *Woman with a Parrot* is typically sexy), Renoir, Monet, van Gogh, Gauguin (his great *Ia Orana Maria,* "I hail thee, Mary," of 1891 is here), Cézanne, and especially Édouard Manet (because the influential 19th-century Met patrons Horace and Louisine Havemeyer went crazy over him). The Impressionists that will live forever in your memory are:

- Manet's *Boating* (1874), which is as fresh as the sun on a clear spring morning.

- Claude Monet's Impressionist ground-breaker, *Terrace à Ste.-Adresse* (1867) — illustrated in Chapter 13 — with light so intense that it looks hacked out of a huge prism.

- Pierre-Auguste Renoir's warm family portrait (with fuzzy dog), *Madame Charpentier and Her Children* (1878), shown in Chapter 13.

- Edgar Degas' haunting *Woman with Chrysanthemums* (1865).

Be sure to ask where Walter Annenberg's collection of Impressionists is hanging because there are some beauties, including a magnificent Gauguin of two women and a Cézanne landscape of *Mt. Estaque* that's as good as the master achieved.

American paintings, sculpture, and decorative arts

The huge collection is divided into two basic sections. One is in the American Wing, with its memorable series of period rooms, including an intact music room designed by Frank Lloyd Wright. In addition, you can find decorative arts, including a fine selection of lean Shaker furniture. A number of galleries are set aside for paintings. I think the best pictures are:

- Thomas Cole's peacefully cosmic *The Oxbow of the Connecticut River* (1836).

- Edwin Church's grandiose *Heart of the Andes* (1859).

- George Caleb Bingham's crystalline *Fur Traders Descending the Missouri* (c. 1845), with its bear cub sitting on the bow like a magical figurehead.

- Thomas Eakins' stunning portrait of *Max Schmitt in a Single Scull* (1871).

- John Singer Sargent's *Madame X* (1884); she's the imperious lady with the impossibly-pointed nose.

- Winslow Homer's canvas of high drama and deep sadness, *The Gulf Stream* (1899), showing the lonely, young black youth adrift and soon to perish in a raging sea with waterspouts all around. The red streams in the water aren't gobs of blood but the commonplace sargasso seaweed that runs for countless miles through the gulf stream. (See the museum guide color insert Figure 8.)

- Jackson Pollock's gnarled, drip-and-splash painting *Autumn Rhythm* (1948), in which, under the splashes and drippings, are well-disguised human figures. Can you spot them? (See also Chapter 16 for more on Pollock.)

There are also numerous paintings in the South West wing (the Lila Acheson Wallace Wing) of European and American 20th century, but generally the specialized museums devoted to these artists, like the Modern and the Guggenheim, have better examples.

The Morgan Library

The **Morgan Library's** (www.morganlibrary.org) structure is a typical "bank" building so beloved by the 19th century hyper-rich and is rather amusing. Don't bother to visit the Morgan unless the special exhibition is compelling — and the place does have some stunning drawing and prints shows. Some superior works of art are here, especially Byzantine enamels and perhaps the best surviving Carolingian (9th century) golden bookcover, called the *Lindau Bookcover,* but the installation, frozen forever in the way the old financier arranged it in his library, makes it impossible for the common man to see anything.

The Museum of Modern Art (MOMA)

The architecture of the **Museum of Modern Art** (www.moma.org) is haphazard, which is odd because some of the bigger names had a go at the extensions. The inner garden is the best feature. The galleries, even after the most recent massive construction, are rather cramped.

MOMA is one of the greatest museums on earth, combining old masters of modern art (works under 100 years old) with shocking contemporary art — exemplifying all styles from dreamy surrealism, stark social realism,

conceptual art, and what you may call "beyond belief." If I had an hour in MOMA, here's what I'd focus on:

- The "Douanier" Rousseau's *Sleeping Gypsy* (1897). Rousseau, a self-taught "primitive," was a favorite of Picasso, who called him the "last ancient Egyptian painter." This picture has to go on the list of the world's most enthralling, if only for the magical, dreamlike concept of the subject and the penetrating eyes of that beast. See the museum guide color insert Figure 9.

- Picasso's *Les Demoiselles d'Avignon* (1907) — the work that opened Pandora's box of artistic abstraction. 1907 was a long time ago, but this still shocks. (See Chapter 15 for more details, and the main color insert has a great view.)

- Picasso's monumental and blindingly colorful *Three Musicians* (1921), which is the "Sistine Ceiling" of Synthetic Cubist paintings. Picasso has transformed human beings into dotted and swathed blocks and trapezoids — and why not? — for a genius like him, everything and anything is permissible. Plus, he could pull it off. (See Chapter 15.)

- Henri Matisse's *Red Studio* (1916) and his *The Dance* and *Piano Lesson* (1911) — unforgettable symphonies of color and form. The Frenchman once said he wanted to paint pictures that would soothe tired businessmen, and in these he achieved monumental peace and harmony.

- Salvador Dalí's *Persistence of Memory* (1931). Yes, those famous limp watches. Dalí, who was quite mad and liked being mad, said he was painting the "camembert of time." But this isn't cheesy.

- The late Britisher Francis Bacon's menacing *Dog and his Pope* (1953), which was inspired by Velazquez's *Innocent X*. Bacon is the most skillful painter of beautiful, horrible subjects in history.

- The American abstract painter Stuart Davis's *Visa* (1951), with the word "Champion" emblazoned overhead like a shouted slogan. Davis started painting in the abstract style after being struck by the upside-down shapes in the Sunday comics his kids were gazing at on the kitchen floor. Which proves that no one will ever know what will excite an artist's fancy.

- Robert Motherwell's whiplash of black and white, the *Elegy to the Spanish Republic* (1965-67). This is a powerful pattern, which says absolutely nothing about the 1930s Spanish civil war; but that doesn't matter, for pure form, as we know, can be legitimate art.

- Jasper Johns' mesmerizing *Flag* (1945-55), which takes Old Glory and lauds it poetically in soft whites and beiges.

- Andrew Wyeth's *Christina's World* (1948), the most popular painting in the place, is a triumph of unromantic and coldhearted realism, showing the crippled Christina Olsen crawling across the field below her house in Cushing, Maine.

- Of the exceptional sculptures, don't fail to see Constantin Brancusi's lyrical golden *Bird in Space* (1928).

The New York Historical Society

The building is a second-rate neoclassical job, the interior is jumbled, and most of the collections are mediocre. There is one memorable treasure, a great series of

John James Audubon's prints of North American birds. The best has got to be number 27, the weird and wonderful *Anhingas*.

The Whitney Museum of American Art

The building devoted to American art in splendid black-gray marble (to be sure, it's marble), leaning moodily over Madison Avenue, the **Whitney Museum** (www.whitney.org) is by the famous architect Marcel Breuer and is pleasant and intimate inside. There are some fantastic pieces:

- Joseph Stella's bright and clanging *Brooklyn Bridge* (1939), which captures the architectural grandeur of this "eighth wonder of the world."
- Edward Hopper's lovely hymn to loneliness, *Early Sunday Morning* (1930). The total absence of people on the rose-red Brooklyn street somehow imbues the work with an overpowering human spirit.
- Jackson Pollock's scintillating, romantic *Number 27,* 1950, which is a breathtaking drip-and-splash potpourri of yellow, pink, gold, lavender, and silver and may convert you to appreciate a painting which has no content except the very act of painting.
- Alexander Calder's tense, supple, and elegant *Circus* (1926), in which dozens of acrobatic figures twisted cunningly out of copper wire make you hear the calliope ripple.

North Carolina

The **Museum of Fine Arts** (www2.ncsu.edu/NCMA/) in Raleigh, North Carolina, is one of the premier smaller museums in the land. In the old master category, see Jan Brueghel the Younger's 1596 work on copper, *Harbor Scene with St. Paul's Departure from Caesarea,* a triumph of a seascape and religious picture combined, deftly painted in atmospheric blues and purples with amazing details.

Ohio

Cleveland

The **Museum of Art** (www.cma.oh.org) is a grab bag of architectural elements of no architectural significance guarded over by an impressive statue of Rodin's *The Thinker* (1880). The interior has been treated with grace and elegance; the collections are exceptional because local industrialists of the 19th and early 20th centuries poured money into the institution's endowments, and a series of directors (especially William Milliken of several decades ago) and Sherman Lee bought voraciously. At recent count, there are 30,000 pieces in all fields spread over 50 centuries of art history. The Oriental collections are considered by experts to be up there in America's top five, especially for Indian art.

Here's a brief list of what you should not miss.

- The early medieval portable altar and ceremonial crosses in gold, silver, and enamels made for Countess Gertrude of Holland and Count Liudolf Brunon around 1040 — part of the so-called Guelph Treasure.

- Don't miss the unique series of late Roman marble sculptures (4th century) from Antioch, showing in half size a man and wife and various miracles, especially Jonah being thrown up by the whale.

- Also, Vincent van Gogh's *Poplars at Saint-Remy* (around 1889). Van Gogh painted the canvas when he had begun to experience seizures.

- For Modern European paintings, see in particular Picasso's *La Vie* (1903), which shows in varying shades of blue (this is a great work of his blue period, in fact) two nude loving couples in a darkening room. Brooding and emotional.

- One American painting is a standout — the cruel and grisly George Bellows boxing scene, *Stag Night at Sharkey's* (1909).

- For contemporary painting, the German Anselm Kiefer's *Landscape* (1989), with references to the railroad tracks leading to Auschwitz.

- Finally, after a two-year reinstallation project, one of the country's foremost collections of medieval and Renaissance armor is back on view. Nearly 300 of the museum's finest pieces sparkle inside custom-made cases lined in a lavish burgundy fabric. The pride of the array is the Field Armor for Man and Horse of around 1575, flanked by 17 full suits of armor.

Oberlin

The **Allen Memorial Art Museum** at Oberlin College (www.oberlin.edu/ ~allenart) possesses 11,000 works and is one of the most comprehensive amongst university institutions. One work I regard as amongst the top 10 old masters in America — it's *Saint Sebastian Tended by Saint Irene* (c. 1625) by the Dutch master Hendrick Terbrugghen. Unsurpassed is the striking close-up scale and vital immediacy of the figures set into an eerie, evening light.[1]

Toledo

The **Art Museum** (www.toledomuseum.org/) is splendid, and the architecture is modest, pleasing, and hospitable. The museum includes a wing by the impetuous American Frank Gehry that works exceedingly well. The museum doesn't try to be an encyclopedia of art. And although there are some fine medieval pieces and some superior European decorative arts and spectacular glass collections (for this city is the home of the Libby Glass Co.), the paintings are the crème de la crème.

- One of the most beautiful items by Picasso in America, as good as a Botticelli portrait, is his blue period, gently graceful, evocative, and haunting *Woman with a Crow* (1904). You'll never forget this stunning image.

- The Peter Paul Rubens, *Three Magi*. This 17th-century painting is easily the best by Rubens in the nation. It is something of a headache for the Metropolitan. When it was offered for purchase back in the late 1950s, one trustee, thinking it too good to be true, rejected it. The renowned director of Toledo, Otto Wittman, instantly snagged it. The brush strokes are spectacularly feathery, and it is undeniable that the Magi is totally by Rubens — a fairly unusual phenomenon with the great master because he was so sought after that he encouraged a bustling studio with dozens of assistants, and all works were signed as if created solely by Rubens.

Oklahoma

The **Thomas Gilcrease Museum** (www.gilcrease.org) in Tulsa, Oklahoma, is one of the premier institutions in the land and is renowned around the world for its exceptional collection of Indian works of art and Western and American painting. This one is worth a thousand mile journey to visit.

The museum has several paintings it considers its banner pieces, and they are worth the trip alone.

- Thomas Eakins, of Philadelphia, is generally considered the nation's master of masters, and his grand portrait, created in 1895 of Frank Hamilton Cushing, the Smithsonian's expert on the Zuni Indians, is second only to the *Gross Clinic* (see "Philadelphia," later in this chapter). The picture shows Cushing as if he were in a Zuni "kiva," a sacred underground sanctuary. The exotic, Indian paraphernalia, surprisingly, is Cushing's invention and had nothing to do with the Zuni.

- Winslow Homer's late pictures are his triumphs, where he combined his acute drawing with a lofty impressionism. The *Watching the Breakers* (1891) depicts the crushing power of the northern ocean's waves crashing on the rocky coast of Maine with bystanders in awe — as you will be from the power of the picture.

- James Abbott McNeil Whistler was roundly condemned for his poetic and luminous studies of the evening and night. Today, gazing at his placid masterpiece, *Nocturne* (1866), it's difficult to see why his critics got so upset. But that's art; just wait a hundred years or so, and the shocks will be acts of painterly genius.

- Charles Russell, sometimes put down as just a western painter, was far more than that. His colors and structure, his sense of irony and wit combined with high painterly skills make him a preeminent artist.

- Gilcrease's work, *Meat's Not Meat, 'til It's In the Pan,* painted in 1915, shows all his prodigious and amusing talents.

- Thomas Moran is one of the most sublime painters in American history — because of his accurate and extraordinarily dramatic landscapes of Yellowstone, the area that became a federal park. *The Shoshone Falls, Snake, Idaho,* a huge 6 by 12 foot (1.8 x 3.7 m) canvas, shows this incomparable waterfall in utmost glory. As Moran observed about these mammoth falls — Niagara drops 225 feet in 25 miles and the Shoshone 500 feet in four miles — wow! What a grand painting!

Pennsylvania

Philadelphia

TAKE A LOOK

The museums are fabulous and are often bypassed because of the city's proximity to New York and Washington. Visit the Museum of Art in the overpowering neo-Greek structure, the Pennsylvania Academy of Fine Arts, the Barnes Collection at Bryn Athyn, and, if there's time, the Jefferson Medical College for the finest single

American painting of the 19th century, Thomas Eakins' slightly frightening *The Gross Clinic* (1875), depicting vividly an operation. (See the museum guide color insert Figure 10.)

Philadephia Museum of Art

In the **Museum of Art** (www.philamuseum.org), the following are of highest interest:

- The tiny but impeccable 15th-century oil depicting Saint Francis, by the Flemish master of masters, Jan van Eyck. (See Chapter 20 for details on his Ghent Altarpiece.)

- The radiant *Crucifixion with Virgin and Saint John* (around 1450), by the Flemish painter Rogier van der Weyden. No drapery has been painted in a more vivid, crackling way. (See Chapter 5 for a style discussion on him and his contemporaries.)

- The monumental glass and painted object by Marcel Duchamp, the high priest of the Dada movement (see Chapter 15 for the explanation of Dada) — his *Bride Stripped Bare by Her Bachelors, Even,* created between 1915 and 1923. This odd composite strongly influenced scores of modern American artists.

University of Pennsylvania Museum of Archeology and Anthropology

In this museum is displayed one of the most thrilling archaeological works in the country — the contents of the Royal Tombs of Ur (ancient Iraq) dating to 2650-2550 B.C. Feast your eyes on such beauties as the gold and lapis lazuli bull-headed lyre and the gorgeous sculpture of the *Ram in the Thicket* and, finally, Lady Pu-abi's amazing headdress and jewelry.

Pennsylvania Academy of Fine Arts

This grand old institution devoted to American painters and sculptors is going through much-needed renovations and rethinkings. There is a pleasing hoard of American works from Gilbert Stuart, Charles Willson Peale, and superior works by 19th century sculptors, especially the works of William Rush. Be sure to find out what show is currently on view in the special exhibition galleries.

Texas

Austin

The **Blanton Museum** at the University of Texas in Austin has acquired a one-of-a-kind collection of more than 700 European paintings and drawings comprising the world-famous Suida-Manning collection. The collection includes works from the Renaissance through the Rococo period and by old masters such as Rubens, Poussin, Claude Lorrain, and Correggio. One of the top works is a glowing landscape with a religious theme by the Italian Baroque master Giovanni Guercino, *Landscape with Tobias and the Angel.* Overnight, the Blanton has become a true art mecca for those interested in the broad span of European painting — seen at a high level.

Dallas

The **Dallas Museum of Art** is a small, growing, thoroughly delightful environment put together by the architect Edward Barnes. The main corridor is flamboyantly decorated with one of those ubiquitous Claes Oldenburg inflations, this one being a museum special commission in 1983, a huge spike attached to a thick reddish-brown rope, five inches across, of gigantesque proportions — which makes one think about scale and the meaning of art.

The strength of the institution lies in a series of five period rooms that donors Wendy and Emery Reves gave, which replicate the chambers of their gracious Côte d'Azur villa, La Pausa. The Impressionists are prime — Degas' gripping pastel, *Concert after the Ballet* (1879), Vincent van Gogh's *Sheaves of Wheat,* painted in his last year, 1890, and a pair of sparkling Renoir portraits of his lady friend Lise (1866-68). Be warned that because the ambiance reproduces a private abode, the works are sometimes not all that easy to see.

Don't miss the incredible, large painting by the American Frederick Church, *The Icebergs* (1861), in the museum's collection, which is a monument to the Romantic period and which summed up all the frightening forces of nature puny man had to contend with and be humbled by.

Dallas also correctly boasts a fine wing devoted to PreColumbian art and a recently installed sculpture garden containing many gems from the Nasher collection.

Fort Worth

Look for two of the most interesting examples of contemporary or post World War II museum architecture here, which number amongst the top five in the country.

The Amon Carter Museum

The **Amon Carter Museum** (www.cartermuseum.org), a virtual icon of the glass architecture and spare detailing of the early 1960s by Philip Johnson, is devoted to Western art. There are many masterworks, and one is a Frederick Remington painting, which is one of his best, if not the best, his *Dash for the Timber* (1889), in which seven wild and woolly cowboys are whipping their horses into the woods away from the Indians. Charles Russell, the famed Western painter, is represented here extremely well, and don't fail to gaze at his lavender and peach extravaganza, *The Wild Horse Hunters* (1913), with the melee of riders and horses dashing around the jagged canyon. American painting is another strength, and the cap of the collection may be Thomas Eakins' *Swimming* or *Swimming Hole* (1885), the very image of young, confident America. For Impressionists — American, that is — see *Idle Hours* (1894), by William Merritt Chase.

Kimbell Art Museum

The **Kimbell** (www.kimbellart.org) is one of the younger museums in the land — 1972 — and it may be the finest. This small and almost perfect museum, in the form of six, four, and six cohesive vaulted halls, has been singled out by numerous experts the finest small-scale museum in America. The jewel-box architecture is by Louis Kahn and has been praised as the best museum structure in the world because of its discreet and harmonic exterior and its luxurious, glowing interior.

The policy statement of 1972 called for the gathering together of works of the highest possible aesthetic quality.

Because of the limited size of the building (no additions can be made), the collections are small in numbers and size. But the works — ranging from ancient Egyptian to Mayan and Aztec, African, Japanese, Chinese, and European — are absolutely mind-boggling; and because every one is prime, it's virtually impossible to pick the best.

- ✔ Diminutive seated PreColumbian woman of 1500 B.C. from Xochipala with a most engaging smile.

- ✔ Hanging Japanese scroll depicting a raging waterfall and delightful playing monkeys (1872), by Shibata Zeshin.

- ✔ The Italian late-13th-century master Duccio's glowing tempera *The Raising of Lazarus* (1308-1311), which once adorned the painted base of the world-renowned Maestà altarpiece of the cathedral of Siena. (See the museum guide section on Italy.)

- ✔ Fra Angelico's small square panel *Saint James Freeing Hermogenes* (around 1430), which was a part of a larger, unidentified altarpiece. The blues of the saint's clothing contrast spectacularly with the sparkling crimson garb of the magician who has been captured by the very devils (horrid and beautiful) who cringe behind the sorcerer.

- ✔ Ercole Roberti's tiny masterpiece of emotion (and the rendering of drapery), *Brutus and Portia,* of the late 15th century — she has wounded herself to show her trustworthiness to her dour husband, who was the main conspirator against Julius Caesar.

- ✔ A fine painting by the 16th-century father of *tenebrism* (sharp contrasts of light and dark), Michelangelo da Caravaggio, *The Cardsharps* (c. 1594), depicting a naive lad being fleeced.

- ✔ Georges de La Tour's radiant and witty canvas *The Cheat with the Ace of Clubs* (1630), perhaps influenced by Caravaggio's *The Cardsharps.* See the museum guide color insert Figure 11.

- ✔ Terra-cotta sculpture of *The River Rhine* (1765), signed and dated by the late 18th-century French sculptor Clodion (Claude Michel.)

- ✔ Jean-Antoine Watteau's tiny (8 by 9 inches, 20 x 23 cm) oil depicting in joyful style five charming children, entitled *Happy Age! Golden Age!* (1716).

- ✔ One of the best by the Spanish modern painter Joan Miró, his amusing study of *Heriberto Casany* (1918) with the painting of his car hanging on the wall.

Houston

The **Menil Collection** (www.menil.org) is in a building by Renzo Piano and is particularly elegant. The collection, put together by the late of John de Menil, is an ambitious and, at times, rather quirky, modern, and contemporary collection

that many experts believe is the most exciting in the United States. Two pieces are very well known: *The Chapel* painted by Mark Rothko and *The Obelisk* by the Abstract Expressionist Barnett Newman.

Virginia

The **Virginia Museum of Fine Art** (dit1.state.va.us/vmfa/index.html) in Richmond, Virginia, is extraordinary for the sporting art given by arts patron supreme Paul Mellon and for modern and contemporary paintings.

Wyoming

The **Buffalo Bill Historical Center** (www.bbhc.org/gall_exhib.htm) in Cody, Wyoming, is truly spectacular. Along with the Gilcrease in Tulsa and the Amon Carter in Fort Worth, it is full of marvelous works by such artists as Frederick Remington, Thomas Moran, and the magnificent painter of Native Americans, George Catlin.

CANADA

Montreal

The **Musée des Beaux-Arts de Montréal** (Montreal Museum of Fine Arts — www.mbam.qc.ca/index.html) is a fabulous institution with a near-encyclopedic collection, which includes outstanding examples of painting, graphic, furniture, textiles, sculpture, and the decorative arts. Plus, it owns one of North America's finest collections of Eskimo prints and carvings and Northwest Coast Native American art of the highest caliber. The museum is one of the earliest in the hemisphere, founded in 1847 as the Montreal Society of Artists.[8]

The collections of old masters have a surprising breadth and level of quality, from the Flemish northern Renaissance master Hans Memling, to El Greco and Nicolas Poussin, Rembrandt, Canaletto, and Gianbattista Tiepolo.[8]

The Impressionists and Post-Impressionists are represented by excellent works. The collections of early 20th-century art are knockouts, with prime pieces by Picasso, Matisse, and Salvador Dalí.[8]

The Montreal Museum, too, has a rich collection of Canadian art, and by looking at it, you can chart the course of Canadian history from the struggling colony of 17th-century France to today. The progress of Canadian painting into modernism unfolds through a series of major works. Native works make up a major part of the museum's richness — sculpture and graphics, by the top Inuit artists, portray the lifestyles and legends of the people of the Far North.[8]

This is a truly all-inclusive museum, and it possesses an incredibly rich collection of contemporary works in all of today's complex styles. In fact, few museums in the Western world are as pleasingly comprehensive.

Ottawa

One of the premier art museums in the world is the awesome **National Gallery of Canada** in Ottawa (`national.gallery.ca`), which, thanks to a superb staff over a long period of time, especially the former director Jean Boggs, and the support of an enlightened government, has assembled a host of top-flight collections. These range from the arts of the Middle Ages and pre-Renaissance Italian paintings to tough and invigorating pieces by contemporary artists, plus fabulous holdings of works by the Inuit, the Eskimos from Cape Dorset and Baffin Island.

Here's my list of hits:

- The Renaissance master Piero di Cosimo's *Vulcan and Aeolus,* of around 1485. A compelling image of an ancient Greek myth.

- The German painter of fantasy, Hans Baldung Grien's *Eve, the Serpent and Death,* around 1510. The figure of death is magnetically horrifying, and the serpent with his leering face and oily skin is worth the price of admission.

- For the Baroque (see Chapter 10 for Baroque info), cherish a rare marble bust by the Italian genius Gian Lorenzo Bernini, his portrait of *Pope Urban VIII,* dated 1623.

- Two grand works by the Flemish 17th-century marvel Peter Paul Rubens, *The Entombment of Christ* (1612-1614) and a very rare — and dreamy — landscape, *The Storm.* His landscapes can be sublime — this sure is.

- One of the top Rembrandts is here, the moving image of a Jewish woman, entitled *Heroine from the Old Testament,* of 1632. This virtually sums up his penetrating humanism.

- The collection of Impressionists and Post-Impressionists is breathtaking, with a bunch of beautiful Degas and a late landscape by Paul Cézanne, *Forest,* painted between 1902 and 1904, in which you can almost see Cubism in the way the landscape elements are achieved by slashing panels of brilliant colors and abstracted shapes.

- Ottawa would also be a fine place to start saturating yourself in the art of Southeast Asia, particularly by viewing the comprehensive collection of Indian art assembled by a legendary art dealer, Nasli M. Heeramaneck.

Ottawa also boasts a key collection of Canadian artists' works — from the early Québec religious sculpture to the most contemporary and avant-garde creators. Nowhere else will you be able to get such a full overview. Canadian artists, especially the Group of Seven, artists with a determined nationalistic outlook who banded together in 1912 to concentrate on the natural beauties of Canada, are shown by splendid examples.

The Group of Seven — Lawren S. Harris, J.E.H. MacDonald, Arthur Lismer, Frederick Varley, Frank Johnston, Franklin Carmichael, and A.Y. Jackson — believed that Canadian art "must grow and flower in the land before the country would be a real home for its people." The 1920 exhibition of the Group marked an important moment in Canadian art, showing art that embodied the conviction that Canadian art had to be inspired solely by Canada itself. They and their followers were supremely successful and captured the spirit of a whole country in a way that has seldom been equalled.

Another memorable set of holdings in this memorable museum is the Inuit art created from the 1950s until today.

The galleries devoted to the 20th century are strong. All the important European and American movements are represented with banner works. One of Jackson Pollock's key works of his best period is here, the tempestuous drip painting of 1950 entitled, simply, *No. 29*.

Toronto

The city is a gracious, sophisticated one, very much in love with the fine arts, and should be one every art lover lists as worth a detour. There are dozens of high-powered art dealers — especially the contemporary — and two museums are world class.

The first is the **Royal Ontario Museum** (The "ROM" — www.rom.on.ca), where the massive collections of Chinese art rank in the top five, outside of China and Taiwan.

The second is the **Art Gallery of Toronto Ontario** (the "AGO" — www.ago.on.ca), which is rightfully proud of its sculptures by the 20th-century English master, Henry Moore.

Vancouver

The **Vancouver Art Gallery** (www.vanartgallery.bc.ca) is the largest Canadian art museum west of Toronto and the fourth largest in Canada. It resides in a landmark building in the center of the beautiful city and is a handsome mini-art-encyclopedia.

LATIN AMERICA

Brazil

In **São Paulo,** many people consider the **Museu de Arte de São Paulo,** or MASP (São Paulo Museum of Art), to be the best all-around collection of European 19th- and 20th-century masters in all of South America. I have never had the opportunity to see it in person, but every time I spot a painting on loan from the museum to some special exhibition, I have always been struck by the high quality and excellent condition of the work. If you are in São Paulo in the autumn of odd-numbered years, don't miss the Bienal (Biennial), one of the most important exhibitions of contemporary international art in the world.

Mexico

Art has always played a major part in the everyday lives of the Mexican people, and the art museums in the country are justifiably proud institutions that preserve and exhibit the cultural heritage of the land to the highest level of professionalism. They can be objects of considerable beauty themselves.

In fact, one of the most gracious architectural and artistic environments in the world — buildings and surrounding grounds that are on par with such modern beauties as Frank Gehry's new titanium museum in Bilbao in Spain, which shows off modern art from the Guggenheim in New York, and the Kimbell Museum in Fort Worth — is the series of elegant structures in **Mexico City,** in Chapultepec Park, making up the peaceful **Museo Nacional de Antropología** (National Museum of Anthropology).

The name has always been a bit off-putting to me since the place is filled with some of the most accomplished art ever created. Although there are anthropological displays, the art reigns supreme.

The vast museum, opened in 1964, was designed by Mexican architect Pedro Ramírez Vázquez. You approach the entrance up a flight of broad stairs, flanked by myriad small waterfalls and gardens, which at once prepare you for the aesthetic experiences within. The entrance looks out on a large courtyard around which the museum is built. The courtyard is dominated by a lofty round column with waters cascading down its entire length.

On the main floor is an incomparable exhibition of PreColumbian Mexican art. The large numbers of galleries on the second floor are devoted to exceptional displays of Mexican folk art, which is often related to its Mesoamerican antecedents below.

The other exceptional PreColumbian museum in Mexico City is the **Museo de Templo Mayor** (Museum of the Great Temple), with all the discoveries made in excavating the Great Temple of the Aztecs. Located in the center of colonial Mexico City, formerly the Aztec Tenochtitlán, this site and its museum are like being in Rome or Athens, where the continuity of many layers of history can be experienced together. The PreColumbian enthusiast should not overlook **Anahuacalli,** a museum built by the painter Diego Rivera to house his collection of PreColumbian art, which is second only in importance to the one in the Anthropology Museum.

If you think you will be moved by art from the colonial period (I have never been, although it does have its qualities), visit the **Museo Franz Mayer,** fittingly housed in magnificently restored 18th-century hospital. The **Museo Nacional de Arte Virreinato** (National Museum of the Viceregal Period) is outside of Mexico City in Tepotzotlán. Using the overwhelming late Baroque environment of an 18th-century Jesuit College and Church, this is one of the colonial jewels of Latin America.

Mexico City has a number of Museums devoted to modern and contemporary art like the **Museo Nacional de Arte** and the **Museo Arte Moderno.** One of the more intriguing is the **Museo de Arte de Carrillo Gil.** The museum contains the fine collection achieved by Dr. Carrillo Gil during his lifetime (1899-1974) and includes works of some of the most important modern Mexican masters, such as José Clemente Orozco, David Alfaro Siqueiros, and Diego Rivera. It has also become an important center for exhibitions of "cutting-edge" contemporary art. Frida Kahlo (she was the surrealist wife of Diego Rivera, whose works are much touted these days) fans will want to visit the **Frida Kahlo Museum** in Coyoacán, the studios of Frida and her husband in San Angel, and finally the newly opened **Museo Dolores Olmedo,** a restored colonial hacienda in Xochimilco, which has at least half of Frida's paintings.

Peru

The **Museo de Antropología y Arquelogía** (Museum and of Anthropology and Archaeology) and the Museo de la Nación (National Museum) in **Lima** can not be missed. They both have breathtaking collections of masterpieces from all periods of PreColumbian Peruvian art. Lima also abounds in many small museums of PreColumbian art where one can see extraordinary private collections. My favorite is the fabulous museum of PreColumbian Peruvian pottery called the **Museo Arqueológico Rafael Larco Herrera** (Rafael Larco Herrera Archaeology Museum). Like Bogotá, Colombia, Lima boasts an incomparable **Museo del Oro** (Gold Museum) where one can see dazzling examples of ancient Peruvian metal artistry.

Venezuela

Caracas is truly an "art-city" and three fine museums grace it, the **Museo de Bellas Artes** (Fine Arts Museum), devoted to European art from the Middle Ages to modern times, contemporary European and North American painting and sculpture with a particular emphasis upon manifestations of the Cubist style, and a small, but fine collection of Egyptian antiquities. The **Galería de Arte Nacional** (National Gallery), housing works from every period of Venezualan history, includes a fascinating collection of local 19th- and 20th-century artists. And an exciting and sometimes shocking museum devoted to contemporary art called the **Museo de Arte Contemporáneo de Caracas, Sofía Imber** (Caracas Museum of Contemporary Art, Sofía Imber).

Europe (All That's Worth a Detour)

*E*urope is awash in museums of all sizes, ranging from one room to thousands of galleries, historic homes and palaces, and grand exhibition halls, which have no permanent collections but which put on such dazzling temporary shows that it's wise to keep watch on upcoming schedules. My favorite small museum was the desk of the mayor in the town hall of the Sicilian village of Caltaniseto. That's where a lovely Greek original bronze youth of the 5th century B.C. was kept. Visitors asked the mayor or his secretary, and the piece was placed on the desk for a hands-on examination.

My guide cannot deal with every "desk" museum in Europe or even some of the more illustrious ones. I take you to the ones I know intimately, which happen to be the larger (and more confusing) museums with comprehensive collections. For example, I dwell upon the great Kunsthistorisches in Vienna, which is curiously not all that well known and is jammed with a huge number of items from all civilizations. I skimp, for example, on the museums of Athens, barely listing them and their general holdings because 99 percent of the works are ancient Greek or Byzantine and because the local museum folks have done a fine job of pointing out what's worthy of a long look.

One way to look at great European art museums is as if they are individual people with their own personalities. The British Museum is a fusty colonialist who sequestered everything in sight and brought it home to gloat over it. The National Gallery in London is a member of the House of Lords who has only recently recognized the masses. The Prado is a Spanish grandee with brittle, even cruel taste who'd rather have it all to himself. The Louvre is a conqueror in war who seized thousands of art goodies as spoils of war and pridefully shows them off in a series of magnificent palaces. The Uffizi is an aging, self-absorbed Medici princess reveling in Italy's former grandeur and suffers tourists not very well.

Austria

Vienna

Vienna is loaded because the Hapsburg family, who ruled the empire from virtually the late 13th century until 1918, was blessed with the best taste on earth and spent like a gambler on the finest art. The city is, in my opinion, a museum paradise and the single richest art city in Europe — Paris being just a shade less loaded with treasures.

Kunsthistorisches Museum

Think of the art museum in Vienna as the wealthiest old geezer on the globe. It is called the **Kunsthistorisches Museum** (pronounced koonsthistorishess, meaning, simply, Art History Museum.) It is spread throughout seven buildings in the city,

the hours are erratic, there are few guidebooks in English, and the lighting tends to be a work in progress, so sunny days (which are unfortunately rare in Vienna) are preferable.

Here's the classic tour of the very best of this incomparable trove. Start at nine at the Naturhistorisches Museum (Natural History Museum), which is opposite the Kunsthistorisches, and go to Room XI to see what is probably the earliest and possibly the most universal work in history, the 4-inch-tall (10 cm) *Venus of Willendorf,* in stone colored a reddish ochre which dates to roughly 28,000 B.C. (see Chapter 4 for an illustration). This sensuous and powerful image of Mother Earth is cosmic and proves that the greatest art of any time was created with a consummate skill and that its message will endure forever. (If you can't find it or the place is being renovated, buy a postcard and brandish it at a guard.)

Then go across to the Kunsthistorisches, and in the halls marked I through XV, plus a host of unnumbered side galleries you'll find what I believe is the world's best collection of Western paintings.

- **Hall I:** The Italian Renaissance. Correggio's *Jupiter and Io* (c. 1532), in which Jupiter thunders down from Mount Olympus in the shape of a storm cloud and embraces the gorgeous nymph.

 Nearby, off in a side room, there's Andrea Mantegna's *Saint Sebastian* (c. 1460) which superbly sums up the Italian Renaissance, which exulted in antiquity and man's physical perfection. The inscription, in Greek, states "This, I, Andrea painted."

- **Hall II:** Few galleries in the world can match this — for there are 19 grand Titians, that awesome Venetian master of color and writhing, flickering paint surfaces. Look especially at his portrait of Isabelle d'Este (1534-36) and the juicy, lush Danae who's having a great time with Jupiter who, this time, has disguised himself as an ardent shower of gold dust.

 In the side gallery is a delectable painting by Titian's teacher, Giovanni Bellini, *A Young Woman at Her Toilet,* and in the next chamber, a work by one of the most important artists of all time, the Venetian master Giorgione. This is his enigmatic and moving *Three Philosophers* (1508-10), which may portray the three Magi, but who knows?

- **Hall III:** Venice's 16th century prime master of ripe color and satisfying figures, Paolo Veronese, is represented by a swell *Lucretia* and an awe-inspiring *Anointing of David.*

- **Hall IV:** Here, you'll bump into 24 illustrious works by the 16th century Venetian Tintoretto — all are great, and one is sublime: the *Susannah and the Elders.* The silhouette of the nude female body has never been drawn with greater sensuality and throbbing energy.

- **Hall V:** The Italian 17th century. Here is the monumental *Madonna of the Rosaries,* by that Roman innovator who "invented" *tenebrism,* meaning sharp light and dark contrasts, Michelangelo Merisi da Caravaggio. Nearby is one of the most perfect paintings of the 17th century, the Italian Orazio Gentileschi's *Rest on the Flight into Egypt.* The pastel colors move from blue to golden orange like a magical sunset, and the gaze of the Christ Child forms an unbreakable bond with the viewer.

✔ **Side room off Hall VII:** Here, in the midst of the Italian galleries, you'll be surprised to bump into eight magnificent works by the ace of the 17th century, the Spaniard Diego Velázquez. But the Hapsburgs, being the royal family of Spain, did have the opportunity to acquire fine Spanish pictures. Don't miss the portrait of the little girl Margarita Teresa with her blue robe and fur muff.

✔ **Skip Halls VI and VII,** for the Italians here are boring. Instead, rush to the side galleries to feast your eyes on the top-notch Venetians of the 18th century, especially Canaletto's *La Dogana* and Gianbattista Tiepolo's radiant *The Post Boat,* in which colors look like melted-down precious stones.

✔ **Halls VIII through XV:** Here you'll find the cream of the Dutch, Flemish, German, and Swiss masters, plus a few fine works by English painters as well.

In Hall VIII are two jewel-like works by the Flemish painter Rogier van der Weyden, which are as fine as anything on earth. But even better is the Flemish Renaissance master Hugo van der Goes's diptych depicting *The Temptation of Adam and Eve* and *The Deposition* (1467), each panel only eight by six inches. The crafty, humanoid snake in the former is worth the visit.

✔ **Hall X:** This, to me, is the high point of this exceptional museum, for it contains 12 smashing works by Pieter Breughel the Elder of the 16th century. These paintings are amongst the most poignant, hilarious, cruel, invigorating, humble, lofty, poetic, scientific, and downright mad images of humanity ever created.

The three best are usually called *Hunters in the Snow* or *Return of the Hunters* (1565), *The Peasants' Wedding* (c. 1565), a raucous affair in which everyone has the best time in his or her life (see Figure 12 in the museum guide color insert), and the *Christ Carrying of the Cross* (1564). The painting with dozens and dozens of games being played throughout a village square and streets is here — some people try to count how many, and their number always is at odds with another's guess.

In the side galleries, there is amazing material, including two premier works by that universal genius of Germany's 16th century, Albrecht Dürer. One is *The All-Saints Altarpiece* (1511); the other his captivating *Portrait of a Young Venetian* (1505). For realism, nothing surpasses Dürer.

Another side chamber contains 15 beauties by the German Lucas Cranach, including some ebullient stag hunts and a few sensuous Eves, some of whom wear nothing but curious wide-brimmed hats. And yet another side chamber is the home of a dozen superior Hans Holbeins, the German master of the 16th century, who was so beloved in England that he traveled there to make hundreds of gripping portraits of swells in the court of Henry VIII.

✔ **Halls XIII and XIV:** No two galleries on earth are stuffed with as many diverse or heady paintings by the Flemish genius Peter Paul Rubens. Don't miss his *Stormy Landscape* (c. 1620) or the sexy portrait of his wife just emerging from the bath, *Helene in a Fur Coat* (after 1635), which he entitled the *Little Fur,* and which was the only painting she kept after he died.

The side chambers to Hall XIV contain two blockbusters. One is a self-portrait by Rembrandt done in 1652, in which the artist shows himself as a handsome fellow, thumbs hooked into his belt, looking confidently at the world. This image is not just Rembrandt, but all of humanity presented with great dignity and a hint of frailty. The second picture is Dutchman Jan Vermeer's *Allegory of Painting* (c. 1666), simultaneously daring, flamboyant, and delicate.

The paintings are but half of the treasures in the mighty Kunsthistorishes. On the Main Floor are displayed the museum's stupendous collection of sculptures and decorative arts. Skip the Egyptian and Greek and Roman material (which is half-hearted) and go to the German, Italian, and French decorative arts. It's easy to get lost here since the halls and the individual works (not the glass cases) are numbered. Here are my picks.

✔ **Hall XXXVI:** #2316, the immense rock-crystal dish made in Italy during the late 12th century, which may be Arabic work.

✔ **Hall XXIX:** #s 2705, 2711, and 2714 — three fabulous, late 17th century blown and twisted glass figurines, representing characters from the Italian "commedia del'arte" or the delightfully clownish lowlife theater so popular at the time.

✔ **Hall XXVII:** Feast your eyes on Italian Renaissance goldsmith Benvenuto Cellini's unbelievable golden *Saltcellar* (1543) for King Francis I (see the main color insert for a view). The earthy woman is Earth; her partner, Water. They obviously adore each other. This is a universe of butter-colored impressionistically shimmering gold highlighted with vibrant splashes of shimmering blue, red, and green enamel.

✔ **Hall XIX:** Although the objects may already be installed back in the Schatzkammer (German for "Treasury"), check the gallery for a selection of objects from the Treasury. Pay special attention to #1, the Imperial Crown of the late 10th century, the series of grand church textiles of the 16th and 17th centuries, and one tiny, charming piece that is easy to miss, a gold and enamel brooch of the 15th century depicting a young dandy and his sweetheart.

✔ **Hall XV:** This may be the best object in the place. A grand onyx cameo carved around A.D. 10 for the Emperor Augustus, called the Gemma Augustea. This huge black and snow white gem shows in flawless manner the godlike emperor seated amongst various gods basking in his many military victories. It is breathtaking. (See Chapter 5 for an illustration.)

The Schönnbrunn Schloss

The Schönnbrunn of the 17th and 18th centuries is an enormous palace, roughly equivalent to Versailles in France, with dozens of period rooms, not all of which are really authentic to the periods. Make this quick.

The Belvedere Gallery

The Belvedere Gallery is notable for the wild Austrian painters Gustave Klimt, who painted works that seem inlaid with gold, and the expressionist Egon Schiele, whose male and female nudes are — exceedingly naked.

France

Paris

Vienna may have a slight edge on Paris when it comes to range and high quality of artistic masterpieces, but the shining city is the wonder of the world when it comes to showing them off. That's because of all those great works seized in war shown to perfection in the triple whammy — the Louvre, the Musée d'Orsay, and the Pompidou Center.

The Louvre

The entrance of the **Louvre** (`mistral.culture.fr/louvre`) is down through I.M. Pei's great glass pyramid in the center of the Cour Napoléon (one of five by the way); the enormous spaces (the Louvre is some four times the size of New York's Metropolitan Museum) are organized into a U-shaped entity encompassing a series of royal palaces in which the millions of works are very roughly in chronological order. To the right is the Denon Wing — the "Old Louvre," which has Egyptian, Greek, and Roman (including some sculptures from the Parthenon and the famous *Winged Victory*), Michelangelo's *Bound Slaves,* and the Grand Gallery of paintings. Straight ahead are both the Sully Wing and the wing that confines the Carrée Court, housing a spectacular series of old master paintings, including Peter Paul Rubens' *Medici Cycle.* To the left is the "New Louvre," or the Richelieu Wing, with over 1,200 French sculptures laid out in two magnificent glass-enclosed courtyards, the ancient Assyrian sculptures from Khorsabad in an enclosed court of their own, Islamic treasures, a ravishing display of decorative arts from early Byzantine times to the Rococo (18th century), and 15th- and some stunning 16th-century Northern Renaissance paintings.

About the only amenity the Louvre doesn't have is a hotel. In the well-lighted caverns excavated beneath the Place du Carrousel, you can find no less than 25 restaurants ranging from gourmet to fast-fast-food and dozens of shops selling everything from books and postcards (here is the largest selection anywhere in the world) to casts, neckties, couture fashion, CDs, and videotapes.

Numerous galleries are still being redone, so navigating the Louvre is like going down the Mississippi — you always encounter obstacles that weren't there last week.

Not to be missed in the Denon and Sully Wings are the following:

- ✔ Michelangelo's *Bound Slaves* (c. 1513), in marble for the unfinished tomb of Pope Julius II.

- ✔ Van Dyck's *Charles I at the Hunt* (1635), the most regal portrait ever.

- ✔ Rubens' enchanting wife, *The Fair Hélène Fourment.*

- ✔ Andrea Mantegna's tiny painting, *The Calvary* (1457-60), so lively and precious that its effervescent colors look like they are glued to the surface of a flat diamond. (See Figure 13 in the museum guide color insert.)

- ✔ Paolo Uccello's *The Battle of San Romano* (c. 1455). The quintessential Renaissance battle painting obsessed with perspective.

✔ Cimabue's *Virgin and Angels,* of the 13th century. He moves the Byzantine stiff style into real humanity, yet keeping intact the feeling of sacred unchanging dogma, too.

✔ Antoine Watteau's profoundly moving clown, *Gilles* (1717).

✔ Leonardo da Vinci, *Mona Lisa* (c. 1503-1506), which can be seen despite the throngs and the thick glass and which is even better than any reproduction and what one's imagination may lead one to expect.

✔ Raphael Sanzio, the portrait of *Baldassare Castiglione* (1514-15), the Renaissance man, all-knowing and supremely confident. (See Figure 14 in the museum guide color insert.)

✔ Paolo Veronese's immense canvas of *The Marriage at Cana* (1571), with the most intriguing bit players ever painted, ranging from cats and dogs to servants and musicians. A few years ago, when moving the huge canvas, it ripped right down the middle, but the deft restoration, has returned the wide-screen painting to its full glory. (See Figure 15 in the museum guide color insert.)

✔ Titian's striking portrait of the unknown handsomest man of history, *Man with a Glove* (c. 1510).

✔ Georges de La Tour of the early 17th century, *The Cardsharps* and *Mary Magdalene.* The infinite mystery of sharp contrasts of light and dark.

✔ Frans Hals, the roistering *Bohemian Girl* (1666).

✔ Eugene Delacroix's dramatic and uplifting *Liberty Leading the People* (1830). (See Figure 16 in the museum guide color insert.)

✔ Theodore Gericault's cosmic drama of the *Raft of the Medusa* (1818-1819).

✔ Jean-Auguste-Dominique Ingres' *The Bather* (1808).

✔ Jacques-Louis David's aristocratic portrait of *Mme Recamier* (1800).

✔ Sculpted metopes from the Parthenon c. 440 B.C.

And in the New Louvre, you can find the following goodies:

Sculptures

The Marly Court

✔ *The Horses of Marly* (1745) by Guillaume Coustou — energy and nobility combined.

✔ The slender 13th-century door sculpture of King Solomon and the Queen of Sheba — splendid Gothic fantasy.

✔ The imposing, 14th-century life-size statues of Charles V and Jeanne de Bourbon.

✔ The dynamic *Tomb of the Sénéchal de Bourgogne, Philippe Pot* (1493) with its eight hooded, weeping mourners.

✔ Jean Goujon's classical-style reliefs for the *Fountain of the Innocents* (1548-1549) — the ancient Greeks produced nothing finer.

The Puget Court

- ✔ The huge four bronze *Captives* by Martin Desjardins (17th century), which once surrounded a monument to Louis XVth.

- ✔ Pierre Puget's marble *Milo of Crotona* (1671-1682), a breathtaking horror story of the intrepid strongman and hunter, Milo. He tried to split a tree trunk with his bare hands and got caught. Along came a lion . . . (See Figure 17 in the museum guide color insert.)

- ✔ The wall of 18th century stucco reliefs by Clodion (Claude Michel) — too bad these angels never lived.

- ✔ The poetic little tomb for the heart of Comte Charpentier (1781), by Jean-Antoine Houdon.

Decorative Arts

- ✔ The grand ivory in high relief of the 6th-century Byzantine Emperor on a charger demolishing his enemies.

- ✔ The most noble 12th century eagle in silver gilt and *porphyry* (a special type of purple marble found only in Egypt), made for the famous Abbot Suger who built St. Denis, where the kings of France are buried. Suger helped create the Gothic style.

- ✔ The *Virgin and Child* (c. 1339) in gilded silver owned by the queen of taste, Jeanne d'Evreux, one of the pinnacles of Gothic art.

- ✔ The expansive, vigorous, 12 tapestries of the Hunt made for Emperor Maximilian I in the 16th century.

- ✔ The Treasure of the Order of Sainte-Esprit (16th-17th centuries) — silver, embroideries, and tapestries all of surpassing beauty, which are displayed for the first time in centuries.

- ✔ The Chamber of Madame Recamier (late 18th-early19th) in which the bed alone is worth the price of admission. Take a tour, too, of the lavishly decorated apartments of Napoleon III.

French paintings

- ✔ The gorgeous linen altar frontal painted entirely in grays with scenes from the Passion (1385) called the Parement from Narbonne.

- ✔ The large painting on wood, showing the dead Christ on the Virgin's lap — in art history called a *pietá* — by Enguerrand Quarton (early 15th century) from Villeneuve-les-Avignon.

- ✔ All 38 paintings by the French genius of the 17th century, Nicholas Poussin, and especially his *Four Seasons*.

Northern paintings

- ✔ Jan van Eyck's dazzling *Madonna with Chancellor Rolin* (1432). If you can't make it to the *Ghent Altar* (see Chapter 20), this will do.

- ✔ Peter Paul Rubens's *Medici Cycle* of 24 gigantic canvases (1622-1625), created for Marie de Medici showing, à la Hollywood, the life and times of the queen and her husband Henry IV. The best is the one showing her arrival at Marseilles with a bunch of wet, gleaming mermaids cheering her on. See Figure 18 in the museum guide color insert.

✔ Rembrandt's *Bathsheba Reading David's Love Letter* (1654) is one of his most poignant works. (See Figure 19 in the museum guide color insert.)

Ancient Near Eastern (Oriental) Antiquities

✔ The awesome and potent sandstone Akkadian period stela of Naram, *Sin defeating his Mesopotamian enemies* (c. 2254-2218 B.C.)

The Assyrian Khorsabad Court

Everything in sight here (c. 721-706 BC) is unparalleled. Pay homage to the enormous "hero" statue (holding a lion in the crook of his elbow as if it were a kitten) and the monumental bulls.

Islamic Galleries

Don't miss the lavish silk-and-silver "kilim" or ritual napkin and the de Mantes carpet with astonishingly intricate hunting scenes.

Musée d'Orsay

The **Musée d'Orsay** (www.musee-orsay.fr) is the "modern-as-all-heck" museum for 19th-century art, constructed in the interior of a former railroad station on the Left Bank. Although the decor is a bit self-indulgent, it's outfitted with all the most modern museum hardware and is exciting to visit, especially for some Impressionists and post-Impressionist knockouts.

✔ **Edouard Manet:** Especially the one that caused so much brouhaha and may have given birth to Impressionism, his *Déjeuner sur l'Herbe* (Luncheon on the Grass — 1863) with its daring juxtaposition of two nude (or almost nude) women and two clothed men. And his in-your-face, sexy *Olympia* (1862-1863), with the enchanting courtesan (wearing nothing but a thin black ribbon around her neck and two bedroom slippers) looking boldly out at you. (See Chapter 13 to find out why it didn't make it to the Metropolitan Museum of Art.)

✔ **Claude Monet:** The sun-dappled *Women with Parasols in the Garden,* dating to 1869, which was one of the artist's most ambitious early works.

✔ **Vincent van Gogh:** The brimming gallery has a half dozen wonderful paintings, especially *Arles Station* (1890).

✔ **Paul Gauguin:** There is a host of his works from the earliest period until the Tahitian times, but, sadly, the decor gets seriously in the way — all those little brass columns. (See Figure 20 in the museum guide color insert.)

✔ **Paul Cézanne:** The d'Orsay is the repository of some of the genius's most powerful works, in particular, his moving portrait of his father.

The d'Orsay is also the "Fort Knox" for works by Gustave Courbet and Millet, and the former's stupendous *Studio of a Painter: A Real Allegory Summarizing My Seven Years of Life as an Artist* (1854-55), which, even if you don't have any idea what's going on (I don't), is a compelling masterpiece.

Amusing to look at are the numerous overstuffed works by the academics, whom the Impressionists toppled, a handful of which are not too shabby, especially those by painters Bougereau and Gérôme.

Beaubourg Centre Georges Pompidou (The Pompidou Museum)

The architecture of the **Beaubourg** (www.cnac-gp.fr/musee), devoted to Modern and Contemporary — which has been wryly described as an inside-out job because of all the utility ducts festooned on the exterior — caused a sensation when it opened two decades ago. From the start, the prime attraction was the grand escalator that shot you up on the exterior for stunning views of Paris. I went to the opening and was excited by the daring architectural forms and dismayed by the shoddy construction. (The huge glass panes didn't fit, and half-inch spaces allowed the wind to whistle through the galleries.) That's why the place shut down for complete rebuilding so soon after opening.

When the Pompidou opens its doors again, don't miss the following:

- ✔ Henri Matisse's *Le Luxe I* (1907), showing two handmaidens preparing their naked goddess for some mysterious rite.

- ✔ Fernande Leger's *Composition with Two Parrots* (1935-1939).

- ✔ Amedeo Modigliani's *Woman's Head* (1912). This is a virtual blockbuster, a dour and sublimely powerful square cinder-block-size limestone head which looks like it's 20 tons of solid plutonium. This creature, her baleful physiognomy rudely scratched out on the stone, looks like something that's crawled out of some prehistoric stone, an archetypal goddess who, if you add water, will grow to her full 50 feet and will rule the world after unleashing all sorts of horrifying ills, plagues, rituals, and cults.

- ✔ Hopefully, the Pompidou curators will recreate the mesmerizingly contemplative room containing three large 1961 paintings by the Spanish Surrealist, Joan Miró, and a mobile by the American modernist Alexander Calder. It's luxurious, peaceful, and infinitely serene — the closest thing to it is one of Raphael's frescoed "Stanze" in the Vatican — yet with a sense of humor.

 The paintings — *Blue I*, *Blue II*, and *Blue III*, all of 1961 — have soft, pulsating surfaces of a startling blue that rivals the primest cuts of lapis lazuli ever sliced off the mother lode. The Calder is painted that distinctive red-red-orange that may have the color of the artist's blood, for all I know. It's made up of 13 gently fluttering typically Calder amoebic "leaves," which form a serene canopy over the settee. The mobile is like a guardian protecting the Mirós or a lover who whispers poetry at the paintings — for Calder's red lozenges are almost identical in shape to the red and black shapes in the Mirós. The artists couldn't have planned these works as an ensemble — could they? No. But now they have.

 In *Blue I,* a thin black line, like some vigilant nanny, firmly keeps a crowd of black and red forms apart. In *Blue II,* there's a red upright "male" thunderbolt form that herds a harem of black forms off the right. And in *Blue III,* a pencil-thin black line has attached itself to a red form, and together they are about to put the make on the black shape below. Art should sometimes be fun.

- ✔ Joseph Beuys' felt-covered grand piano, *Infiltration-Homogen for Grand Piano* (1966), a powerful example of this influential artist's sculptural expressionism. Only Beuys would have thought of a felt-covered piano decorated with a Red Cross — or so superbly rendered the provocative idea.

Musée de Trocadero

For those who may be interested in a museum of casts made before acid rain devoured the surfaces of France's prime architectural elements, don't fail to make a quick visit to the Musée de Trocadero. Full-scale plaster casts of such astounding masterworks as the main portal of Chartres Cathedral will knock your eyes out.

The Musée de Cluny

The **Cluny** is the somewhat tattered remains of a convent and is devoted to medieval art (which one also finds in abundance in the Louvre).

The six Lady with the Unicorn tapestries, some of the most fabulous late medieval tapestries surviving, were made around the mid-15th century. They depict one of the most beautiful women who ever lived, in the guise of the five senses. The French inscription woven into the tapestries, "A Mon Seul Désir" is "To My Sole Desire." The style is called *millefleurs* (a thousand flowers), and there are plenty of varieties plus a bevy of attractive animals including a shining silvery white unicorn that could be subdued only by a true Virgin. (See Figure 21 in the museum guide color insert.)

The Petit Palais

The **Petit Palais** is known mostly for its temporary exhibitions. There's one work that's worth a detour. It's by Gustave Courbet, the 19th century maverick, revolutionary, and realist, who is represented by a striking, large, and provocative painting — two naked models sleeping together fully entwined, called *His Models* (1862).

Musée de l'Orangerie

Extraordinary in the **Orangerie** are Claude Monet's 20th century "grandes decorations," which is what he called his 18-foot-long (5.5 m) canvases depicting *Water Lilies.* The gallery is suppose to open in 2000, but, being France, you never know, so check.

Musée Picasso (Picasso Museum)

The **Picasso Museum** is housed in the Hôtel Salé, an elegant 17th century mansion in the historic Marais district. This vast collection of paintings, sculpture, and furniture the French government eventually wrested from the Picasso estate (he died without a will, apparently on purpose to confound the art bureaucrats). The collection is not the finest, but some super treasures do exist among them.

Germany

Berlin

Berlin is likely the city that's most heavily under construction at present, and seeing its art treasures for next half decade or more will be challenging. Museums are being renovated, moved around, or the contents of one being taken to another. Here's what I would single out as the prime works of the German capitol — the trouble is, you have to find them whether in their old or new homes when you arrive.

The most flamboyant and awe-inspiring work surviving from Hellenistic times is the *Altar of Pergamon* (c. 166-156 B.C.), made up of nearly a half-acre of sculptures in a long rectangular frieze on an immense altar atop a lofty flight of stairs, portraying the struggle to the death between the Greek gods and the giants for control of the universe. All the heros won — Zeus, Hera, Apollo, Ares, and Aphrodite.

They then threw mankind into a continual state of anxiety by their mischief.

The altar has been recreated in a gallery about the size of a football stadium in the old antiquities museum on what is known as the "Museum Island," which contains several museums, all pockmarked with the bullets and shells of the siege of Berlin by the Soviets in the waning days of World War II. As one approaches the figures, they seem almost to come alive. The sculptors of the altar, which dates to roughly 160 B.C., emphasized struggle, agony, wounds, and death. Although it sounds like just the work not to see, the ensemble and individual panels of the evolving scene are exceptionally moving and impressive. One panel of the dozens is especially poignant — that in which the vigorous figure of Victory, wings fully extended, gives an ugly, bellowing giant the *coup-de-grace* (final blow).

The old masters in the painting gallery of Berlin are worthwhile, although not up to the quality of those in Dresden (later in this chapter).

The picture once considered to be the cream of the cream, Rembrandt's *Man in a Golden Helmet,* has recently been determined to be a clever fake. But there are high points, and they are to be found among the northern Renaissance masters like Pieter Breughel, Hugo van der Goes, and Dirck Bouts.

The single finest painting in Berlin — in fact, one of the tops in the Western world — is the large canvas by the ultra-genius of the 18th century, Jean-Antoine Watteau — *The Signboard of Gersaint* (c. 1721). This depicts in the most lively manner, richly dressed noble ladies and gentlemen visiting an art gallery with a splendid array of paintings hanging on the walls and a series of crates being opened, revealing more treasures. The story has it that this grand oil was actually a mundane sign Watteau painted for an art dealer friend and it actually hung outside over the gallery. Probably not for long, if it ever hung out-of-doors, for the condition is mint. The work hangs in the sprawling Charlottenburg Palace. It is, to me, the essence of the French 18th century.

Egyptian antiquities are the real pride of the jumbled, brooding, and forever sad city of Berlin, in which the never-fading odor of the Third Reich seems to pervade everything. The tiny Egyptian museum in the suburb called Dahlem (to be moved sometime into a gigantesque new institution) is the home of the lovely bust of Queen Nefertiti — this is the one you see constantly in posters and reproductions, the one in which the slender-necked beauty gazes out at you with a quartz eye that radiates affection and the imperiousness of godhood (see Figure 22 in the museum guide color insert). Equally compelling are a series of captivating small sculptures of the queen and her king, Ikhnaten, the probably daft pharaoh who created the first monotheism in history for the sun god Aten. Ikhnaten is portrayed almost in caricature with sloppy loose lips and a bulging potbelly. This is not a cartoonist's jab at the crazy monarch, but the official style demanded by the court for unknown reasons (see also Chapter 5).

One sculpture showing the children jumping all over the royal parents is as delightful as a family snapshot — dating, of course, to 2100 B.C.

The museum for modern and contemporary art is a shining, virtually all-glass structure designed by the renowned 20th century architect Mies van der Rohe (he coined the phrase, "less is more" to describe the spareness of modern glass cube design). You'll find the usual panoply of moderns and living artists all hanging on interior walls with the windows heavily curtained against the ill effects of the sun. Van der Rohe had originally designed the structure as the headquarters of a rum company in Cuba before Castro, and when the dictator came to power, Mies sold the plans to Germany where they were used for this rather awkward museum.

Cologne (Köln)

I would recommend Cologne and its rich **Walraff-Richartz Museum,** particularly the Peter Ludwig Wing which houses the best-on-earth collection of modern and contemporary American painters, especially Pop Art.

Dresden

Dresden is the principal art city in the new Germany after Munich. The Electors of Saxony, who determined who the monarchs of the empire would be, were avid art collectors.

The city is exceptionally rich in art but is even sadder than Berlin because of the traces of the Allied firebombing, which seriously damaged all but a few of the more precious monuments. The great cathedral, to which thousands ran in panic and perished in the horrific fire, has been left as a ruin and a mass grave. The grandiose palaces that house a variety of museums — the **Gemäldegalerie** (Picture Gallery) and galleries called the Green Vaults — have been extensively restored. The works of art had all been sent into deep caves for protection and then, as war booty, to the Soviet Union, from where they were returned in excellent condition.

I'd make a beeline for the following:

- There's a splendid small antique Greek stone sculpture of a dancing woman who throws herself back in abandon, created by one of the greats of the late 5th century B.C., a man named Scopas, who was renowned in ancient times for having "invented" emotions.

- Of the old masters, I believe the finest treasure is Raphael Sanzio's monumental *Sistine Madonna* (1513), which has at its base two of the cutest angels ever painted — which, despite having been used for countless greeting cards, are fresh and appropriately mischievous.

- The Gemäldegalerie is especially rich in works by French painters and *pastelists* (artists who worked in pastels) of the 18th century.

- One, whose works are particularly profuse, is the Swiss master Jean-Etienne Liotard. His glowing work depicting a beautiful servant girl bringing some lucky person morning chocolate is one of the most striking images of the entire epoch. Indeed, when one sees here the abundance of works of the French masters of the 18th century, who depicted the daily goings-on of the larger-than-expected middle class, you get a completely different impression of the times, which we tend to believe were a constant struggle between awesomely wealthy aristocrats and poor peasants without a crust of bread.

- The Green Vaults contain decorative arts of unexcelled quality. The best of the best are the dazzling large-scale pieces of jewelry and carved semi-precious stones by the likes of the 16th- and 17th-century German craftsmen as Jamnitzer and Dinglinger. There's one expansive frivolity made out of a dozen gems, pearls, silver, and gold showing a kind of late Renaissance circus with hundreds of tiny animals, trainers, and spectators, which simply has no parallel.

Munich

Thanks to the aristocratic Wittelsbach family, who ruled Munich from 1180 until 1918, this center of Bavaria possesses more key art museums than any other city of its size in the world (some 30). This is the clan of Mad King Ludwig, who constructed stage-set castles like Neuschwanstein which eventually became the model for today's stage-set at Disneyland in Orlando.

Here's my pick of the "musts" of the 30 museums and the top works in each.

Alte Pinakothek (Old Picture Gallery)

The cream of the city is the paintings gallery for old masters. It's called the **Alte Pinakothek,** simply "old picture gallery." There are some world-class knockouts here. Especially rich are the pre-Renaissance Flemish works, those by the second greatest artist of Western civilization, Albrecht Dürer (12 of them), and stunnners by Peter Paul Rubens. And before you lunge into the galleries with the Dürers, ogle one teeming beauty by the German Renaissance painter Albrecht Altdorfer, his *Alexander the Great Defeating Darius at Issus* (1529). Packed into this ebullient picture, measuring six by four feet (1.8 m by 1.2 m), are literally thousands of fighters of all kinds, ranging from men and horses to elephants. It's a miniaturist's tour-de-force — but one on a grand scale.

Of the Dürers, catch his two huge paintings on black backgrounds depicting St. John the Evangelist, St. Peter, St. Mark, and St. Paul, and his gripping *Self-Portrait* (1500), in which he has portrayed himself looking rather like a combination of God Almighty and Christ (see the main color insert for the self-portrait).

There's a heady Leonardo da Vinci in here, the early and overwhelmingly refined *Madonna and Child* (c. 1478). By the way, don't overlook the marvelous, very late Titian (painted when he was in his late eighties), the *Crowning with Thorns* (c. 1570), probably the second best work of his entire long career.

For Rubens, there's hardly a better place on earth. Several galleries are devoted to his works, and these are most noteworthy: both the large and the small *Last Judgment*, the explosive *Rape of Leucippus's Daughters* (c. 1616-17), the portrait of Rubens with his first wife Isabella, and another enchanting image of his second wife, Hélène Fourment, and, finally, a magnificent landscape, with perhaps the most vivid rainbow ever painted *(Landscape with Rainbow)*, at least during the golden age of the 17th century.

Neue Pinakothek (New Picture Gallery)

The Wittelsbachs disdained "modern art" and never went in for Impressionists; and so for those, the pickings are meager. But in the **Neue Pinakothek,** there are memorable works by Goya and the German Romantic master Caspar David Friedrich, a fine and brooding moonlit *Landscape in Mist.* As you walk out the doors, don't fail to glance at Jacques-Louis David's sublime and silvery portrait of the *Marquise de Sorcy de Thélusson.*

Schatzkammer der Residenz (Residence Treasure Chamber)

The Residenz, a grandiose series of Wittelsbach palaces, has hundreds of rooms, and you could immerse yourself here for days. You don't have to if you go immediately to the crowning works of art and revel in them alone. They are to be found in the Schatzkammer, a German tongue-twister for Treasury. Here, do not pass by without a long glance at the Saint George Reliquary of the 16th century, encrusted with enamels and jewels of such fabulous manufacture that it surpasses even the most ambitious Fabergé pieces. The fantastic gold objects are arranged in chronological order, and the best are at the beginning.

Glyptothek (Marble Museum)

In the museum called the Glyptothek, or "museum of marbles," you can find sculptures dating from around 450 B.C., from the two pediments of the Greek Temple of Aphaia at Aegina, and they are almost as good as those that adorned the Temple of Zeus at Olympia (see Chapter 4). Another piece is the late Hellenistic (2nd century B.C.) marble of a *Satyr Sleeping* — he's lolling back in a most suggestive way, so be warned.

Staatliche Antikensammlungen (State Antique Collection)

There's a small museum for Greek and Roman art called the **Stattliche Antikensammlungen,** and here there are some spectacular pieces, the top of which are the gorgeous and emotional Greek vases of the 6th century B.C. showing Achilles stabbing Penthesilea, the queen of the Amazons to death, as she, expiring, looks lovingly into his eyes very close up.

Bayerisches Nationalmuseum (Bavarian National Museum)

Munich is also the home of the finest decorative arts museum in Germany, the **Bayerisches Nationalmuseum.** The place is chock-a-block full of everything from sculpture to porcelains, bronzes, and silver and gold. The wood sculptures by Gregor Erhart and Tilmann Riemenschneider are superb. So are the Meissen porcelains and the carved ivory figures by the master Georg Petel of the 16th and 17th century.

Galerie Moderner Kunst (Gallery of Modern Art)

Modern art is only halfway represented — Hitler called it all "degenerate" and got rid of it. But the **Galerie Moderner Kunst** (Modern Art Gallery) does have some recently acquired German Expressionists like Nolde and Beckmann that compare with top-flight works elsewhere.

Greece

Athens

National Archeological Museum

This is exceptional and probably the only museum you will have to see to gain a better understanding of Greek art and the art of the Minoan and Mycenaen civilization. Two things are paramount — one is the large bronze Poseidon or Zeus throwing a thunderbolt of the 5th century B.C. (shown in Chapter 5). And the other, far earlier, perhaps as early as the 7th century B.C., is the gold *Vapphio Cup* with scenes of bull chases.

Acropolis Museum

The **Acropolis Museum** is notable for a series of exceptionally fine female statues of the 6th century B.C. called *koré* and fragments from the Parthenon *frieze,* or the long low relief that was placed high on the walls behind the columns on the side of the temple. The major parts of this frieze are in London's National Gallery.

Other museums of note are the **Byzantine Museum**, the **Museum of Cycladic and Ancient Greek Art,** and the **Benaki Museum.**

Ireland

Dublin

Dublin has a pleasant group of old masters.

National Museum

At the **National Museum,** you can find treasures of Celtic art, notable for fabulous gold necklaces called *torques* and the so-called "Brooch of Tara," an oversized, probably ceremonial pin to keep ritual regalia fastened together.

Trinity College Library

The Library of Trinity College, Dublin, for the miraculous 9th-century *Book of Kells,* which is so intricate and minute that it would seem the illuminators painted the pages with their complex initials with a high-powered microscope which, of course, didn't exist in this early medieval time. The legend is that angels illuminated the Book of Kells — and once you see you might agree. See Chapter 6.

Italy

A recurring art historical game is: If you were to be exiled to one country in the world, where you would choose to go for the richest possible lifetime of art? Colorful arguments break out over which would, indeed, be the better place of exile — the land more loaded with the widest imaginable array of art treasures — France or Italy? To me, Italy wins hands down, if only because of the all-encompassing foundation of profound antiquity. But Italy can be frustrating for the art lover. So many museums, monuments, and churches (the majority of Italy's most outstanding treasures are in churches) are right now under sweeping restoration. This is especially true of Rome, where a major effort is being made to refurbish the entire city. A host of monuments are covered with scaffolding and green plastic webbing. Plus, Italy is accustomed to strikes by museum workers (not that this is totally unknown in France), and the monument or museum you came to see may be closed. If so, I advise what the Italians do — it's summed up in the phrase "dolce far niente" — meaning roughly, have a sweet time just doing nothing and go see something else.

Naturally, as with every country listed in this introductory guide to the best of the best, not every important museum, monument, or city in Italy is mentioned. In fact, I take you to just three, Florence, Rome, and Venice. But, at least, this pared-down list will get you going sufficiently so that you can carry out my process of saturation on your own.

Florence

Having lived in Rome, I've been an "Eternal City man" and looked upon Florence as, well, slightly provincial. But the more experienced a connoisseur I've become, the more I have shifted my admiration to Florence and am convinced that she possesses a richer treasury of artistic wonders than even Rome.

The best way to see Florence is to learn Italian, pick up a copy of the Touring Club of Italy's guidebook to the city, start at the Duomo (the Cathedral), and radiate out on foot until your eyes and feet give out.

Or read the following abbreviated insiders' art guide.

The shape of the city is roughly a circle, with the main sector on the north side of the Arno River (including such goodies as the Baptistery, the Palazzo Vecchio, and the Uffizi), and in the southern half, such marvels as the Carmine, Santa Felicitá, and the Pitti Palace. The center of this triumphant artistic circle is the Duomo. So start there.

Florence is walkable, and though the hills to the south are steep, hoofing it is good for the soul and the physique.

Baptistery of Florence

The **Baptistery** in front of the Duomo has traces of its 4th-century childhood, but they're hidden in the foundations. The outer fabric dates from the 11th to the 15th century, and the four prime things to see are, inside, the radiant 13th-14th-century mosaics in the cupola representing the life of St. John, plus a theatrical Last Judgment — and on the outside, the three bronze doors which are totally captivating.

The three bronze portals, in backwards chronological order, follow.

TAKE A LOOK

 ✔ The eastern portal was christened by no less than Michelangelo as the *Gates of Paradise* (1425-1452), created by Lorenzo Ghiberti. The gates have 10 rectangular bronze, gilded panels with scenes, from the Old Testament, of heartstopping beauty surrounded by a wonderful series of diminutive heads peering quizzically at you. This portal, the very symbol of the Early Renaissance, shows an extraordinary mastery of the human figure, perspective, naturalism, and humanism, all delivered with a deep religious fervor. See the main color insert.

 ✔ The north door, also by Ghiberti, dates to 1403-1424 and represents New Testament scenes — the Annunciation to the Pentecost. The style of this exceptional work is more Late Gothic than Renaissance and shows a sinuous, idealized, somewhat incorporeal figure style. Ghiberti won the commission in a 1402 contest among six famous sculptors, including Brunelleschi, who became one of the leading architects of the Early Renaissance (see also Chapter 7).

 ✔ On the south, the door created by Andrea Pisano in 1330, with the life of St. John, is High Gothic in style. So, you can walk leisurely from High Gothic to Late Gothic to the full-blown Renaissance made by the most accomplished artists of history.

Duomo (Cathedral of Florence)

The **Duomo,** with its ornate colored-stone decoration and upwards-thrusting finials, looks like the purest Italian Gothic 14th-century style but actually dates to the late 19th. The grand octagonal cupola, with its distinctive lantern dominating the city, is by the genius architect Filippo Brunelleschi and dates to the 14th-15th centuries. The soaring Campanile (bell tower) was started by Giotto in 1334 and completed by Andrea Pisano some 20 years later.

The interior of this splendid church is loaded with art, but three pieces are, to me, the most fascinating. Chief among them is the rough-hewn marble *Pietà,* by Michelangelo (c. 1553), which he sculpted for a church in Rome and which he didn't like, despite its raw power. It was completed by a student. The second work is a huge painted equestrian portrait, mostly in grays, of the English mercenary John Hawkwood, who led the Florentine army in the late 14th century. It's on the gallery above the left nave, and it's by the Renaissance master Paolo Uccello (dated 1436). The third work is nearby in the gallery and is another enormous equestrian portrait — this by the early Renaissance artist Andrea del Castagno dating to 1456, in grays, of a soldier-for-hire, Niccolò da Tolentino. The paintings were both originally *frescoes* (pigments painted on a fresh layer of plaster, which soaks up the colors) transferred to canvas and replaced. What few art historians know (except you, now) is that these two masterworks were fully restored in the 17th century (and possibly extensively repainted) and put on canvas by the Bolognese painter Guido Reni, a painter known for rather sweet religious works. An acquaintance of mine researching 19th-century Italian battles found the invoices for Reni's work misfiled in the archives of Florence and told me the secret. They're still grand.

Museo dell'Opera del Duomo

What you shouldn't miss is the museum of the works of the cathedral (**Museo dell'Opera del Duomo**) directly behind the cathedral. Over the door, there's a 16th century bust of Cosimo de' Medici who "made" the Renaissance city. Inside, are sculptures that rival any in Italy and are so convenient to see.

- Ten reliefs from Luca della Robbia's luxuriant Cantoria or singers balcony (1431-1438). The principal subject matter is Psalm 60, but the unforgettable features are the group of singing and dancing *putti* — little angels who are depicted in the freshest, most vivacious manner. You'll want to sing out, too.

- On the opposite wall, dating to the same time, is the *Cantoria,* by the most gifted genius of the early Renaissance, Donatello. Whereas Luca's angels are incomparably sweet, Donatello's are both sweet and ignited by the spark of a divine power, and they sing out as if possessed by divine powers (see Chapter 6).

- The wooden, late sculpture of *Mary Magdalene* (1435-55), by Donatello, originally in the Baptistery but moved after the disastrous flood of the 1960s. She is portrayed as a crone, withered, twisted, possibly diseased (she was a prostitute), her face a desert of wrinkles but nonetheless utterly radiant with faith. This alone — plus Michelangelo's *David* and the *Sistine Ceiling* — are worth going all the way to Italy to see.

- The 16 enormous, weatherworn stone sculptures once adorned the bell-tower and are interesting examples of works transitioning from Late Gothic to Early Renaissance — essentially from smooth, silky, and weightless people, to people of heft, muscle, and bone.

Orsanmichele

A sublime example of the Gothic style is inside the small church of **Orsanmichele** (literally Saint Michael's in the "Orto", or "place"), which is south of the Duomo on the via Calzaiuoli. It's Andrea Orcagna's amazing marble tabernacle in *intarsia*

(or elaborate colored marble inlay work), illustrating the Life of the Virgin (1349-59). Also, don't miss the mandatory sculptures adorning the exterior by Donatello, Ghiberti, Nanno di Banco, and Verrochio.

Palazzo Vecchio

The center of town is the Piazza della Signoria and the imposing, almost defiant Palazzo Vecchio with its world-famous tower. The *David* is a mere copy of the masterwork in the Accademia, so don't get excited yet. The *Judith and Holofernes* (c. 1455) is by Donatello. And the steroidy and somewhat ugly *Hercules Lifting Cacus* is by the 16th-century sculptor Baccio Bandinelli (the man who completed the famous *Laocoön* in the Vatican (see Chapter 5).

The high point of the Piazza is the porch to the right, the Loggia dei Lanzi, in which is housed an act of sculptural perfection, the goldsmith Benvenuto Cellini's *Perseus* (1500-1571), a harmonious, delicate, and awesomely potent portrayal of the hero holding aloft the ragged head of Medusa, her hair snarling with live snakes. As you no doubt know, looking at it will turn you to stone, so take care.

Note: Cellini's *Perseus,* which I say is in the Loggia dei Lanzi, has been moved inside the Uffizi itself (where no one will be able to see it because of the huge crowds — the new Uffizi, with its Bonacorsi collection galleries, is extremely difficult to see because of the often two-hour wait to get in).

I suppose a visit inside the labyrinth of rooms of the Palazzo Vecchio is worthwhile, but I admit to going there only once, and I remember but one work, in the niche in the center of the Hall of Audiences: Michelangelo's stirring, athletic statue of *Victory.*

Galleria degli Uffizi (Uffizi Gallery)

If you can make it into the newly-renovated **Uffizi** (`www.musa.uffizi.firenze.it`) because of crowds (or because the guards happen not to be on strike that day), you could spend most of your life there. But what follows is the pick-of-the-pick of this chauvinistic museum for Italian art. Luckily, the Uffizi has been renovated, and it is the most stunning example of how Italy is seeking to renovate its state museums.

The museum now boasts a bookshop, a coatroom, an elegant café, a multimedia information center, and an electronic ticketing service for advance reservations, promising to reduce the legendary long lines outside the museum.

For what art historians call the *Ducento* ("two hundred" or the 13th century, namely 1200-1299):

- Duccio's cracklingly gorgeous *Madonna Enthroned with Christ and Angels* (1285). It was painted for the chapel the Rucellai family built in S. Maria Novella and is usually called the *Rucellai Madonna.* Colorful as a handful of melted gemstones, it is also famous for its energetic drawing style.

- Cimabue's *Madonna in Majesty* (1280-85), which through its human vitality (despite the still slightly stiff formula), literally gave birth to modern Italian painting, so different from the flat, dry, and lifeless Byzantine works.

For the *Trecento* ("three hundred" or 14th century, 1300-1399):

✔ Giotto's great altarpiece depicting *The Madonna Enthroned with Christ Child, Angels and Saints* (1310). This is another giant step in art, for Giotto has created a stunning sense of bulk and presence in his figures (see Chapter 7).

For the Early Renaissance, the Uffizi is home to a hoard of incomparable paintings, and I single out the "to-die-for" ones.

✔ Paolo Uccello's thumping third piece of a three-part series of canvases (London's National Gallery and the Louvre own the two other pieces) depicting the mercenary Niccolò da Tolentino's victory over the Sienese in the *Battle of San Romano* (1456). This demonstrates all the elements the Early Renaissance artists were obsessed by — perspective, action, the human figure, and struggle.

✔ Piero della Francesca may have been, after Donatello, the mightiest of the Early Renaissance immortals (he is to me, anyway), and here there is a treasury of his works of the 15th century, all displaying his unique fruity and rich colors, his exceptional observation of faces, and his signature dreamy, almost mystical, feeling. Revel in the *Portraits of Duke of Urbino Federico di Montefeltro and Wife Battista Sforza* (1472-73). The stark profiles mimic Roman medals, but the crystal-clear, vivid atmosphere and stunning perspective are pure Piero. On the back, there's a breathtaking scene of the allegorical triumph of the power couple.

TAKE A LOOK

✔ Few artists can come close to the drawing and color skills of Sandro Botticelli, whose career went (I simplify) from the lushness of sensuality to the dark, dour asceticism of religious fundamentalism. The lush period is magnificently exemplified by two grand paintings, *The Birth of Venus* (c. 1480) and the verdant and sexy *Primavera (Spring)* of 1477-78 (see Figure 23 in the museum guide color insert). The eye-catching *Pallas Athena and the Centaur* (c. 1482) shows the goddess Athena picking up a rebellious centaur by a lock of hair and seems to be in splendid condition, but is actually a wreck cleverly reconstituted in modern times — I know, because I've seen it in its stripped condition. One can never be too sure about the physical state of old masters. (A standard art historical observation has it that every old master has two beings — the original and the one the restorers have crafted over the years.)

✔ One of the few non-Italian works in the Uffizi is sublime, the Flemish painter Hugo van der Goes' great altar *triptych* (three-paneled painting) called *The Portinari Altar* (1474-76) because it was commissioned by Tommaso Portinari who was the Medici moneyman in Bruges, Flanders (Belgium). The monumental altar depicts the Adoration of the Shepherds, and every figure is a revelation from the serene Virgin, to the real-life baby Christ, to the angels with their radiant wings, to the gnarled shepherds, and, finally, to the gorgeous portraits of the Portinari family (see Chapter 8).

The High Renaissance is marvelously represented in the Uffizi.

✔ Don't leave without having a penetrating look at Leonardo da Vinci's early *Adoration of the Magi* (1481-82), with one of the most captivating angels ever painted.

✔ Michelangelo painted the round picture (a "tondo" in Italian) depicting *The Holy Family* in 1504 to celebrate the wedding of Agnolo Doni and Maddalena Strozzi, and it is a divine combination of paint and sculpture.

✔ These days, Raphael is looked upon as a secondary talent behind Leonardo and Michelangelo, falsely I think. A long look at his wondrous study in human psychology will make you a believer that he's up there with the other giants. The painting is the portrait of *Pope Leo X with Cardinals Giulio de' Medici and Luigi de' Rossi* (1518), finished not long before his death. All sorts of emotions and states of mind are portrayed in the most classically harmonious composition imaginable.

The Uffizi is a literal Fort Knox of Mannerist artists (see Chapter 9 for Mannerism) — works by Jacopo Pontormo, Parmigianino, and Agnolo Bronzino; but frankly, they are better represented in various churches elsewhere.

Bargello Museum

The **Bargello Museum** is almost as rich in sculptures as the Uffizi is wealthy in paintings, and the following is a list of the ultimate pieces.

✔ Michelangelo's lifesize marble, *Drunken Bacchus* (1497), his first large sculpture. The figure is mean, frightening, and represents magnificently the darker side of mankind, man about to explode in a rage.

✔ Giovanni da Bologna's celebrated *Mercury* (c. 1564-80) or "Flowers By Wire" as it's known to art historians who remember the advertisements by the American flower shop by direct order that used this image as its logo. It's slick, sophisticated, and daring, but still fresh, despite its longtime use as a corporate symbol that still crops up today.

✔ Donatello's forceful marble representing the young *Saint George* (c. 1415-1417) who looks out at the world with a vivid stare (a bronze copy is now in the niche of Orsanmichele).

✔ Donatello's superior bronze *David* (c. 1430) is the first bronze male nude of the Renaissance. It emphasizes the adolescence of the "patron saint" of Florence in a most acute way. He looks relaxed, but he's tense as a coiled spring.

✔ The bronze plaque created by Lorenzo Ghiberti — *Sacrifice of Isaac* (1402) — which won him the commission to create his first of two doors of the Baptistery.

✔ On the second floor, Andrea Verrocchio's *David* (1476) in bronze, showing yet a different Old Testament hero, this time after the smashing victory, casually awaiting the plaudits of his people.

Santa Croce

To the east of the Piazza della Signoria near the Arno is the great church of **Santa Croce** (the Holy Cross), and inside are two chapels of world-renown, the Peruzzi and the Bardi, both decorated in the early Trecento (14th century) with glowing frescoes by that father of modern painting, Giotto di Bondone. Giotto, by the way, was something of a tycoon — he cornered the market on pigs' bristles and was a major hairbrush manufacturer. To the northeast on the via Buonarroti is a

museum in the house Michelangelo bought for his nephew and which now exhibits some of his excellent works, including a number of clay sketches for sculpture and a famous relief of 1492 depicting the *Battle of the Centaurs.*

Hospital of the Innocents

You'll not want to miss the charming and colorful terra-cotta reliefs by Andrea della Robbia on the facade of the **Hospital of the Innocents,** dating to the late 15th century.

Archaeological Museum

As you wander northeast from the Duomo on one of your walking tours, you may want to know that in the bulging **Archaeological Museum,** just behind the hospital, there is the single finest work of Etruscan Art ever, a bronze sculpture of the 5th century B.C., the *Chimera*, an inventive mythical beast being a combination of a lion and a serpent — it's truly breathtaking. Also in this museum is the huge, early Greek vase called the *François Vase,* illustrated in every art history book with its 6th century B.C. scenes done in strong, primitive stick-figure drawing.

Accademia

Not too far from the Archaeological Museum is one of the highest treats of the city, the **Accademia** (Academy), where Michelangelo's *David* (1501-04) resides. To me, the *David* may be the single finest work created by Western civilization, so far at least. What I have always found so stirring about the young man who is portrayed just before launching his sling is that he is obviously a slightly awkward and distinctly anxious adolescent who's not at all sure he's going to make it. The perfection of every single inch of this looming work (it's 12 and a half feet tall, 4.09 m) is beyond belief.

Convent of San Marco Museum

Not far away is the **Convent of San Marco** and its museum, in which there are dozens upon dozens of paintings by the brilliant 15th-century master Fra Angelico. (See Figure 24 in the museum guide color insert for a sample.) I have always thought, however, there might be slightly too much of a good thing.

Cenacolo of S. Apollonia

One of the works Florence is most famous for can be seen in what is known as the **Cenacolo of S. Apollonia** (or refectory) — the powerful fresco *The Last Supper,* painted by Andrea del Castagno in 1450, in which the figures appear as strong as sculpture.

San Lorenzo

Another treasure-laden church is a few hundred yards northwest of the Duomo, **San Lorenzo,** in the bowels of which are its 4th-century beginnings — the main fabric of the mid-15th century is by Brunelleschi. For Donatello, this is the tops, especially his two pulpits in the main nave with their near-expressionistic bronze

reliefs. The Old Sacristy possesses a body of painted stucco, terra-cotta, and bronzes by Donatello, one of which depicts the Holy Martyrs and is fresh — and a bit scary, too.

The **Laurentian Library** is a splendid architectural work by Michelangelo, and in the Medici Chapel (in the New Sacristy), there are his majestic and profoundly moving sculptures for the Medici tombs. For that of Lorenzo the Magnificent, he carved the seated image in deep meditation. Nearby are the moody, elegiac marbles representing *Dawn and Dusk*. For the resting place of Giuliano, Michelangelo cast that prince as an alert, super-active pragmatist and created the theatrical images of *Night and Day* as outspoken statements rather than quiet poetry.

S. Maria del Carmine

On the south side of the River (to be approached, of course, over the Ponte Vecchio with its bustle of shops) are some extraordinary works. Chief among them are the frescoes in the Brancacci Chapel of the church of **S. Maria del Carmine,** by the groundbreaking genius of Western painting, Tommaso di ser Giovanni Masaccio (1401-1429), who transformed art as fundamentally as Giotto had done a century before. In his frescoes of the *Life of Saint Peter* and *Original Sin,* Masaccio invented human figures with a wide variety of emotions — this for the first time — who seem capable of moving in real space. Masaccio belongs amongst the top innovators of all of art history.

Of the many scenes arranged in two horizontal bands flanking an altar, two will knock your eyes out and will make you think more deeply about the human condition. One is *The Expulsion of Adam and Eve from the Garden of Eden* and the other is *The Payment of the Tribute Money* (see Figure 25 and Figure 26 in the museum guide color insert). Eve is shown shrieking in desperation, and Adam shrinks himself into the smallest possible shape — it's wonderful drama. In the *Tribute,* Christ is shown with the Apostles before the gates of a city as if in an ancient Greek frieze (see also Chapter 7).

Santa Felicitá

Just across the Ponte Vecchio to the left is the often-overlooked church of **Santa Felicitá,** where Jacopo Pontormo's startling *Entombment of Christ* stands over the high altar. This is the epitome of the Mannerist style with strangely distorted figures gazing out with burning eyes, all painted in dissonant, yet gorgeous colors like lavender and puce. It sounds weird and it is — but it's good weird, full of energy, heart, and artistic freedom.

Galleria Palatina, Palazzo Pitti

The hulking **Pitti Palace** (the delightful Boboli Gardens lay behind) is jammed with thousands of works of art of all kinds, much of it inconsequential. Top-notch are a bunch of Titians, especially his *Portrait of a Gentleman* (usually called, for no reason, the *Englishman*), several grand pictures by the Fleming Peter Paul Rubens, especially his vast *Consequences of War,* and some knockouts by Raphael Sanzio.

Raphael's glowing, sweet (yet not saccharine) round oil, the so-called *Madonna of the "Seggiola"* (1515), is one of the highest artistic moments of the entire Renaissance and all of art-rich Florence. ("Seggiola" means "chair.")

Rome

An American tourist once asked Bernard Berenson, the crusty super-connoisseur of the early 20th century, how much time to set aside to see Rome. "Fifty-seven years," was his tart reply. Yet, if you're brutally selective and go courageously on your own, you can see the artistic best of Rome in three days or, better, a week.

Rome came into the world in 753 B.C. as 2 villages on the Palatine and Capitoline hills, and over the centuries it expanded to 11. The original feeling of neighborhoods remains undimmed today, and the best way to savor the city aesthetically is "village" by "village," devoting to each a half day — or half a lifetime. In the Eternal City, museums house a small part of the artistic inventory, and you can find most art in churches and palaces.

Note: Be sure to check out the Timeline of the Eternal City of Rome at the end of this section.

The Village of the Campidoglio

This highest hill was the spiritual heart of pagan Rome, the site of her finest temples. Climb Michelangelo's steps (the Cordonata) past the Egyptian sphinxes and the Roman trophies at the top and enter the magnificent piazza. The stark brick church high on the left is S. Maria in Aracoeli (Mary's of the Altar of Heaven). To the left, in Michelangelo's wondrous piazza, is his Palazzo Nuovo (New Palace) containing the **Capitoline Museum.** To the right is the **Palazzo dei Conservatori** (Palace of the Conservators). The Senate is straight ahead with the ancient Roman statue of Father Tiber lolling back. The equestrian bronze in the center is a copy of the gilded statue of prissy Marcus Aurelius (the original is in the Capitoline — see the timeline). The Capitoline is the world's first museum and contains a hodgepodge of antiquities, including one room with the busts of all 65 emperors. Memorable works are the polished image of the *Dying Gaul,* swooning like a movie star (see the Timeline of the Eternal City of Rome) and the enormous green bronze head of steel-eyed emperor Constantine.

In the grand court of the Conservatori, don't miss the unworldly marble remains of Constantine (see the Timeline of the Eternal City of Rome). Upstairs, in the confusing labyrinth of exhibition rooms, is a powerful altarpiece painted in the 17th century by Guercino — of Saint Petronilla — which blasts forth like an angels' choir and has blues that will impress you. The other paintings are unimpressive.

In the Sala della Lupa (Hall of the Wolf) is the abstract but weirdly realistic 7th-century B.C. bronze Etruscan image of the She-Wolf. (See Figure 27 in the museum guide color insert.)

You can trudge into the Forum or gaze down on its ruins from the balcony in back of the Senate building. The view is poetic. I have always been moved by the three slender columns of the Temple of Castor and Pollux, the serene round Temple of Vesta in the middle of the Forum, and the looming three arches of the basilica or market of Constantine. At the far end of the Forum is the jewel box Arch of Titus.

Art under wraps

Because of the Jubilee Year 2000, proclaimed by the Pope, much of Rome is shrouded by plastic or closed for restoration, and I recommend that you ask your travel agent or the hotel concierge very specifically what is closed or almost inaccessible. (Many recent travel articles or Web sites do not mention the extent of the work.) Here's a partial list of what is closed or covered, which may be finished by the time this publication comes out, or more likely, which may not have been completed on schedule:

- The interior of Il Gesu church is almost totally wrapped in renovation plastic.

- The Baths of Diocletian are closed until the end of the year.

- St. Peter's is open, but much of the facade and the marvelous statues high over it are obscured by scaffolding.

- The court of the Castel Sant'Angelo is under plastic, and Bernini's famous *Angels* are not on view.

- Michelangelo's glorious marble statue of Moses in the church of St. Peter in Chains (S. Pietro in Vincoli) has been placed in a box and is very difficult to see.

- The Arch of Constantine and the Roman Forum are both mostly hidden by scaffolding or cranes.

- In the Borghese Gallery, just redone after decades, many rooms are being redone and are sealed off.

- In the Sistine Chapel, the ceiling is viewable, but the paintings on the walls are covered with scaffolding.

- The Museo delle Terme — which houses a grand antiquities collection — is closed as are the adjacent ancient baths.

- The Colosseum is ringed by scaffolding.

- Parts of the interior of the Pantheon are under restoration.

- The interior of the church of S. Maria Maggiore is largely under wraps — although the 13th-century apse mosaic is visible.

- The Trevi Fountain was restored in 1994, but the principal street leading to it is a mess.

Nearby is the church of **Santa Francesca Romana,** with the most hypnotic early Christian painting of the Madonna that's survived, dating to the 6th century. (See the Timeline of the Eternal City of Rome.)

Looming over this village is the eternally white (the marble will never mellow) wedding-cake memorial to King Victor Emmanuel, a perfect example of 19th-century architectural bombast. The views across Rome from its deserted porticoes are, however, fabulous.

The traffic-choked Piazza Venezia is the home of the Venetian-style Palazzo Venezia, where Mussolini used to harangue the people from the central sole balcony. It's a bedraggled museum, enlivened by two objects of great character, the grandest Gothic silver cross ever and a stunning ivory box of the Carolingian age (see the Timeline of the Eternal City of Rome).

Enter into the **Forum of Trajan** for his storyboard Column, in which the history of a victorious war is carved in newsreel form on its upward-winding frieze (see Chapter 5 for an illustration). The ancient structures in the seldom-visited upper part of Trajan's forum are astonishingly well preserved.

Finally, plunge into the teeming streets and piazza around the Theater of Marcellus and pass by the delicate brick Portico of Octavia built in honor of Augustus' mother. Augustus boasted that he'd started his reign when the city was built of brick and left her in radiant marble.

The Village of the Pantheon

Begin with the church of **Il Gesu** on the Via del Plebiscito, for it's the perfect example of the full-blown didactic Jesuit style and marvel at the volcanic ceiling frescoes by Baciccia and Andrea Pozzo, both of the late 17th century (see also Chapter 10). In the Piazza del Collegio Romano, you can find one of Rome's most captivating museums, the private Doria Pamphili, which is open certain days a week and is home to incredible works by Caravaggio (his lyrical *Rest on the Flight into Egypt*), Guido Reni, and Diego Velázquez, whose amazing portrait of *Pope Innocent X* is here (see the Timeline of the Eternal City of Rome).

Amble along Via di Plebiscito and pop into the Baroque church of **S. Maria Sopra Minerva** (literally "Mary's above the temple of Minerva") to glance at the only work Michelangelo failed at, an awkward marble *Christ Carrying the Cross*.

In the piazza behind "Minerva," you can enjoy the svelte little elephant carrying the Egyptian obelisk, by Bernini, which illustrates Pope Alexander's prime dictum inscribed on the base in Latin, "It takes a robust intelligence to sustain a solid wisdom."

The highlight of this "village" is the illustrious **Pantheon** itself (see the Timeline of the Eternal City of Rome) — which, after the Parthenon, is the most exciting antique survival. The light from the open *oculus* (or eye) in the center of the vault gives the interior a feeling of infinite calm. The luminous disc changes shape every second as it seems to crawl around the pavement.

The focus of this village is the oblong **Piazza Navona,** which takes its shape from an ancient amphitheater, sections of which appear behind glass. Bernini's grand *Four Rivers Fountain* is a drama in stone and surging water. The rebellious 16th-century painter Caravaggio caroused in and around the piazza and left some masterworks in two nearby churches. One is the three oils of the life of St. Matthew in the Contarelli Chapel in the church of **San Luigi dei Francesi** (St. Louis of the French) including the *Calling of Matthew* (1602) (see the Timeline of the Eternal City of Rome) and the spine-chilling *Martyrdom*. His girlfriend, the local prostitute Lena, posed for the stunning *Madonna of the Pilgrims,* now in the church of **San Agostino,** where you'll find a superior Renaissance work by Jacopo Sansovino depicting in marble the *Virgin and Child,* which looks like a classical Greek statue (see the Timeline of the Eternal City of Rome).

The Village of the Piazza di Spagna

Noteworthy for its elegant shopping along the Via Condotti and the must-see Baroque Spanish steps. The best way to make your walking tour (very hilly) is to start walking up the Via Sistina merging into the Via di Quattro Fontane.

Of interest is the Palazzo Barberini, which houses the **National Gallery** and Raphael's enigmatic portrait of his mistress *La Fornarina*, which a late friend of mine, a super connoisseur, Federic Zeri, insisted is a 19th century fake, made possibly by Ingres — see for yourself. On the crossing of Via diQuattro Fontane and the Via Quirinale is the dazzling small super-Baroque church by Borromini, the tiny **San Carlo alle Quattro Fontane** (Saint Carlo at the Four Fountains). Proceed along the Via Quirinales and the seat of Roman government, the Quirinal Palace, is on the right. There are two Roman museum wonders down the Via XXIV Maggiore (May 24th), open sporadically. One is the private palace — **Pallavicini-Rospigliosi** — with Sandro Botticelli's spectacularly haunting image of a melancholic young woman, *La Derelitta.* The other is the **Torlonia Collection** with some superb Roman antiquities.

Plunge down to the overblown but impressive 17th century Fontana di Trevi and toss your coin to guarantee a repeat visit.

At the far northern end of this neighborhood, along the Via del Corso, is the serene Piazza del Popolo, ornamented by the twin late Renaissance churches of **S. Maria dei Miracoli** (Mary of the Miracles) and **S. Maria di Montesanto.** To the right of the grand arch that leads you to the famous antique street leading north from Rome is **S. Maria del Popolo** in which there are two masterpieces by Caravaggio — a must is *The Conversion of Saul* (1601) — and several blockbuster sculptures by Bernini.

The Village of the Aventine

Up on the heights overlooking the barren Circus Maximus. Of special interest is the 5th-century Early Christian church of **S. Sabina,** with a virtually intact nave with columns plundered from pagan structures and an intact wooden door of the 5th century (see the Timeline of the Eternal City of Rome). Don't miss the ebullient church of **S. Maria del Priorato,** designed by Piranesi for the Knights of Malta in the 18th century. Through the keyhole in the massive bronze gates of this church, one can see as if spotlighted the dome of triumphant St. Peter's. In this quarter is the immense Baths of Caracalla (used for operas in the summer — *Aida* with real camels and elephants), which accommodated 1600 bathers and had as many libraries as exercise rooms.

The Village of the Coliseum

The neighborhood is small and hilly with sights ranging from the awesome **Coliseum** to the many-layered underground church of S. Clemente to the rolling parkland of the Oppian Hill and one of Michelangelo's major works.

The imposing Coliseum was dedicated by emperor Titus in A.D. 80 with 100-day-long celebrations, including all sorts of outrageous gladiatorial games and a sea battle with 200 galleys. The arena, where only a few Christians were martyred, was in antiquity not called the Coliseum. That name was attached to a colossal statue of Nero, the site of which is the square marked on the ground near the arch of Constantine. In medieval times, because the statue was long gone, people thought the name for something colossal must be the amphitheater.

One of the most intriguing "time-machine" churches is **San Clemente,** where the Irish priests speak a most animated Italian. There is a smashing 12th-century apse mosaic, rare 15th-century murals by Masolino, and 40 feet down in priceless excavations, several earlier churches and an abundance of pagan remains including a

section of the great sewer, called in Latin the Cloaca Maxima, and a Mithraeum, a sanctuary for the worship of the eastern deity Mithra, which rivalled early Christianity for drawing power, with its perfectly preserved and spooky dining room.

The final walk in this village should be up the Oppian Hill to the beautiful 5th-century church of **S. Pietro in Vincoli** (Peter in chains) where Michelangelo's sublime *Moses* (1515) is placed (see the Timeline of the Eternal City of Rome).

The Village of S. Giovanni in Laterano

Two incredible churches are here — **S. Giovanni di Paolo** and **Giovanni in Laterano.** The former is found up the Clivo di Scauro (an ancient Etruscan name) and was started in the 4th century. The plaza, in front of the 12th-century facade, is graceful, and inside the church are remains of a large Roman house with two floors virtually intact.

The immense church and adjoining Baptistery of S. Giovanni in Laterano was begun by Constantine, and underneath the 17th-century stucco and marble facing, much of the original brick construction survives. The architect Borromini kept the two-aisled Constantinian fabric and made 12 grandiose niches out of the simple row of columns. The statues and the two facades are 18th century. Look up and enjoy Pirro Ligorio's gilded and painted 16th-century ceiling festooned with Papal arms — it's the finest in Rome.

This "borgo" possesses three seldom-visited, yet striking ancient buildings, which blew the minds of art lovers in the 16th century.

✔ One is the **Basilica Sotterranea** (underground basilica), near the Porta Maggiore, devoted to some mystical cult and decorated with the best stucco reliefs that have made it from antiquity. (Get your concierge to book a visit through the Superintendent of the Archaeology of Rome.)

✔ The second is something called the **Ipogeo degli Aureli on the Via di Giovanni Geolitti** and has spectacular stucco reliefs and frescoes combining Christian and Gnostic episodes. (Permits can be gotten from the office of the secretariat of the Ponteficia Commissione di Archaeologia Christiana — the Papal Commission for Christian Archaeology — at Via Napoleone III.)

✔ Third is the gutted remains of the little round 4th-century **Temple of Minerva Medica,** down the same street, which was renowned in ancient times for extraordinary healing powers.

The Village of Santa Maria Maggiore

Three incomparable churches are Santa Maria Maggiore, S. Pudenziana, and S. Prassede. **Santa Maria Maggiore** is on the heights of the Esquiline Hill and was started in the 4th century after a rare snowstorm when the Pope saw the outlines of the church in the snow. Inside are a series of 36 exceptional 5th-century mosaics of the Old Testament (see the Timeline of the Eternal City of Rome) and a contemporaneous, massive, triumphal arch leading into the apse, showing Jerusalem and Bethlehem. The ceiling is laden with the first gold to be shipped back from the New World.

S. Pudenziana, on the Via C. Balbo, may be the oldest church in Rome, started in the 2nd century by Senator Pudente, a personal friend of St. Peter's. The apse has a stupendous 4th-century mosaic of Christ Enthroned, which should not be missed.

Charlemagne was crowned in Rome in A.D. 800 and memorialized his becoming Holy Roman Emperor by erecting a dozen churches all modeled after Constantine's basilica hall-style churches. The best is **S. Prassede,** on Via Giovanni Lanza, whose apse mosaic is a "copy" of SS. Cosma e Damiano — seeing both will be a fascinating exercise in stylistic comparison. Don't miss the tiny chapel of S. Zeno in **S. Prassede** built in A.D. 822 with Byzantine golden mosaics so vivid they seem to be on fire.

The Village of the Piazze della Repubblica

This Piazza was the grandest open space built in Rome before the Fascists widened some of the boulevards. The fountain, with its busty 20th-century naked Naiads, or water nymphs, was considered scandalous (and they still are).

The curving brick facade opposite is that of Michelangelo's **Santa Maria degli Angeli** — (Mary of the Angels) built right into part of the ancient Baths of Diocletian. Nearby is the newly-opened antiquities museum in the **Palazzo Massimo,** containing incomparable treasures, such as the 5th-century Greek *Ludovisi Throne* that wasn't a throne but the head of a sacred well (see the Timeline of the Eternal City of Rome) and the astonishing punched-out bronze Boxer, one of ancient Rome's most dramatic works of art of the first century B.C.

In the crowded church of **Santa Maria della Vittoria** (Mary of Victory) — near the ugly Moses Fountain, whose creator passed away from the popular criticism of his bloated statue — is the divine sculpture by Gianlorenzo Bernini, showing Saint Teresa gripped in a reverie which looks fleshly, but it definitely one of spiritual nature (see the Timeline of the Eternal City of Rome).

It's a long walk up the Via Veneto into the Villa Borghese park, but it's beautiful, and the park contains Rome's most spectacular museum, the recently-restored **Borghese Gallery.** Everything is solid gold. The smashers are: Titian's *Sacred and Profane Love* (c. 1515), Figure 31 in the museum color insert; Raphael's ultra-graceful *Deposition* (1507) (see Figure 28 in the museum guide color insert), and his sinuous *Madonna Holding the Unicorn;* Carvaggio's frightening *David with the Head of Goliath* (1599); Tintoretto's lissome *Io;* Bernini's unbelievable sculpture of *Daphne* (1622-25), whose perfect, glistening body is turning into a tree; and, finally, Antonia Canova's world-class *Pauline Borghese* (1804-8) (see the Timeline of the Eternal City of Rome).

After closing for a year for repairs, the late 19th-century wing of Rome's **National Modern Art Gallery** reopened in 1999. The year before, the modern art museum also unveiled a restored wing devoted to early-19th-century art as well as a chic restaurant with terrace dining overlooking the Villa Borghese.

The Village of Trastevere (literally, across the Tiber)

This, the most Roman of the "villages" with medieval twisting streets, is best approached via the Ponte Fabricio bridge of 62 B.C., leading to the Isola Tiberina (which was thought for centuries to be a submerged Roman ship) and thence over the Ponte Cestio to the shore of Trastevere on the riva Veiente, from where the Etruscans tried to wipe out the Romans in the 6th century B.C. but failed.

Don't miss the church of **Santa Cecilia** on the Via di S. Michele, with its marvelous 9th-century mosaic of Christ on a sparkling ground of red and azure and Pietro Cavallini's *Last Judgment* (1293) in the convent choir, a Gothic Italian masterpiece.

On the way to the grandiose church of S. Maria in Trastevere, pop in to gaze at one sculpture by Bernini that's often overlooked, the *Blessed Ludovica Albertoni,* in a state of sensual mysticism (see the Timeline of the Eternal City of Rome).

Santa Maria in Trastevere was begun in the 3rd century and has been added to ceaselessly ever since. The facade is 12th century, and the mosaics on the outside 13th century. The portico has a host of intriguing inscriptions, including one from a Roman slave. The ornate 17th-century ceiling is by the painter Domenichino. The palace to the left of the church is that of **S. Callisto,** and inside is a tiny gem of a 12th-century church with its own little courtyard.

North a little way from S. Maria on the Via della Lungara is the remarkable **Villa Farnesina,** a great example of High Renaissance architecture designed by Baldassare Peruzzi and decorated with ravishing frescoes by Raphael and others — the high point being his *Galatea* (c. 1512) (see Figure 29 in the museum guide color insert).

After the Farnesina, take a cab up the Janiculum Hill and go to the church of **S. Pietro in Montorio** (Peter in the Mountain) — and there be dumbstruck by Bramante's Tempietto in the courtyard, a matchless Renaissance chapel in a perfect circle symbolizing the universe and holy innocence. This ornate underground chapel has a hole in the very center, where St. Peter is thought to have been crucified (see also Chapter 7).

The Village of the Farnese Palace (Palazzo Farnese)

The plazas and streets surrounding the Palazzo are amongst the most intriguing of Rome. Start a walking tour at the square called the Largo Argentini, where extensive ruins of four republican temples stand, and amble along the Via del Corso to **S. Andrea della Valle,** which is a Baroque beauty by Carlo Rainaldi. The **Palazzo della Cancelleria** (1485) is the best early Renaissance building in the city and has a breathtaking staircase by Donato Bramante. A stroll back on the Via del Monserrato will lead into the Campo dei Fiori with fabulous open-air flower markets and the imposing **Palazzo Farnese** — the current seat of the French embassy. Inside is a fabulous fresco cycle — the *Triumph of Love* (1595-1605) — by Annibale Carracci, an early 17th-century contemporary of the revolutionary Caravaggio. Nearby is the Palazzo Spada with a striking perspective designed by Borromini, who squashed a row of Doric columns into a space of 28 feet (8.5 m), making it look three times longer. The statue at the end of this perspective trickery looks like a colossus, but it's less than three feet (.9 m) high.

The Village-City of the Vatican

The most exciting way to approach the splendid **Vatican** "city" (www.christus-rex.org/www1/vaticano/0-Musei.html) is on foot, like a humble pilgrim, across the Ponte Sant'Angelo, with its ten angels, two of which are Bernini copies (the two glorious originals are in the church of **S. Andrea delle Fratte** — Andrew of the Brothers).

The Vatican is one of the few places in Rome where legend and fact are one. The site was Nero's gardens, where Constantine the Great built an enormous basilica — Peter was buried under the crossing. The beautiful old church was torn down in the 16th century to make way for the present St. Peter's. The facade is by Carlo Maderna, the great dome by Michelangelo, and the welcoming arms of the curving portico are by Gianlorenzo Bernini.

This is, no doubt, the greatest church in Christendom. The awesomely huge interior is about the same as Constantine's church, but a host of visual tricks makes it seem superhuman in scale — for example, the holy water fonts are vastly oversized so that only when you dip your hand do you realize the overwhelming scale of the place. Bernini's Baldacchino, the massive canopy over the high altar with its twisting bronze columns, soars six stories. The mosaics in the nave — copies of famous paintings — are three times normal size.

It is impossible to count the incomparable works of art in the church, but stellar are:

- Michelangelo's sweet *Pieta* (1499).
- Bernini's *Throne of St. Peter* (1657-66) held aloft by four church fathers (and inside of which is hidden an ivory throne dating to Charlemagne's time, around A.D. 800).
- Antonio Pollaiuolo's bronze tomb effigy of *Innocent VIII* (see the Timeline of the Eternal City of Rome) in the small museum in the heart of the church.
- The unique Early Christian marble sarcophagus of Junius Bassus, a wealthy Christian of the 4th century (see Chapter 5).

The palaces and museums in the Vatican contain 1,400 halls, rooms, and chapels plus 20 courtyards loaded down with literally tens of thousands of works. The best of these are:

- The colossal bronze pinecone, the *Pina,* that adorned Constantine's church, which is now in the Belvedere Court (see also Chapter 7).
- The marble *Laocoön* (see the Timeline of the Eternal City of Rome).
- The *Belvedere Torso* (see the Timeline of the Eternal City of Rome) in the **Museo Pio-Clementino.**
- The RV-sized purple marble sarcophagi for Constantine's mother and daughter (see the Timeline of the Eternal City of Rome).
- In the **Museo Chiaramonti,** the giant marble portrait of emperor *Augustus* that once stood at the Prima Porta (principal gate) of ancient Rome.
- In the **Museo Gregoriano-Etrusco,** the contents of an Etruscan tomb of the 7th century B.C.

✔ In the Pinacotheca, Raphael's soaring *Transfiguration* (see the Timeline of the Eternal City of Rome).

✔ Leonardo's unfinished *St. Jerome.*

✔ For some surprises, the **Museo Missionario-Etnologico,** with treasures from all over the Catholic world and the excellent collection of modern religious pictures in the new paintings galleries.

✔ The work of works are, of course, Michelangelo's **Sistine Ceiling** (1508-12) and *Last Judgment,* which are revelations after the splendid cleaning (see Figure 30 in the museum guide color insert).

Timeline of the Eternal City of Rome

Rome — the name comes from a very ancient word "Ruma" for river — was, according to legend, founded on April 21, 753 B.C. It is artistically the richest city in the Western world. Sometimes called the Eternal City, Rome is a time machine. Fourteen feet down, all over town, lies antiquity. Dig out a cellar, and you'll find a foundation stone laid in imperial times; enter a church crypt and you're in pagan times. Antiquity goes straight up, too, for what grand Renaissance or Baroque church or palace is not built from pagan remains?

Here's a convenient timeline to accompany the tour of Rome's "villages," works of art of surpassing quality you won't want to miss.

Prehistory: Wall vestiges of the 10th-9th century B.C. can be seen on the Palatine Hill off the Forum near the Temple of Cybele.

7th B.C.: In the Etruscan Museum of the Villa Giulia, a pair of gold bracelets with representations (in granulated gold filigree so minute it looks like dust) of cats, chimeras, and sphinxes.

6th B.C.: Also in the Villa Giulia, a knockout life-size sculpture couple in terra-cotta — called *I Sposi,* or the married couple. Elegant, confident, amused, clearly in love, they cuddle up together on their banquet couch facing death and eternity with an insouciant smile.

In the Conservatori Museum on the Capitoline — in a gallery named the Sala della Lupa (hall of the wolf) — is a life-sized and breathtaking She-Wolf of Etruscan origin (little Romulus and Remus in bronze sucking away are "improvements" of the 16th century).

5th B.C.: The marble *Ludovisi Throne* in the Palazzo Massimo is one of the finest Greek originals to have survived. Graceful and devout, Aphrodite is lifted by her acolytes from a well.

4th B.C.: Nothing of merit has survived.

3rd B.C.: A wonderful fresco found in the 16th century, showing a young couple surrounded by friends, is entitled *The Aldobrandini Wedding,* for the family who owned it after its discovery. It is in the antique collections of the Vatican Museums and is the best preserved of all ancient paintings.

2nd B.C.: In the Vatican antiquities museum, there's the muscular nude torso of Hercules, lacking head, arms and legs, called the *Belvedere Torso,* and it's signed by the Hellenistic artist Apollonius — magnificent.

1st B.C.: *Ara Pacis Augustea,* the altar of peace, installed by emperor Augustus and now on display near his tomb, has a stunning series of realistic sculptures in marble with vivid representations of Augustus, his cortege, and the personification of the fertile Earth.

1st A.D.: The marble statue, in the Vatican antiquities museum, of Laocoön and his two sons being suffocated by a huge serpent. Hair-raisingly good theater, despite much 16th-century restoration.

The reliefs on the Arch of Titus at the entrance to the Forum showing the booty taken from the great Temple of Jerusalem, including the mammoth seven-branch candlestick.

An especially moving statue is the glistening, café-au-lait colored marble of the *Dying Gaul,* that unforgettable image of the long-haired, naked warrior expiring from a wound in the chest. It's on the second floor of the Capitoline Museum, which is the world's oldest.

2nd A.D.: The Pantheon, erected in durable concrete, brick, and marble by Emperor Hadrian around 125 A.D., is the most perfect antique structure that's survived. Although its acres of marble sheathing and great solid bronze beams in the interior were stripped by builders in the 17th century, the portico, the massive bronze doors, and the extraordinary dome with its circular opening are intact. There is nothing like looking up the 142 feet (43 m) to that open "oculus," or eye to heaven, for the building seems to have captured the sun in full flight. When it rains, the drops evaporate before reaching the ground.

In the Capitoline Museum, on the ground floor in swell modern surroundings and very well lighted, you'll find the bronze and gilded statue of the Emperor Marcus Aurelius on his doughty horse. It survived medieval vandals because it was thought to be Constantine, thus Christian, not pagan. This was for centuries in the middle of Michelangelo's great plaza in the Campidiglio, and Roman legend has it that once the last speck of gilding falls from this statue, either Rome will fall or the Last Judgment will descend upon us.

3rd A.D.: There is a series of incomparable mosaics said to have been commissioned by Helena, the mother of Emperor Constantine, in a round tomb structure near the church of Santa Costanza, which depict one of the earliest symbols of Christianity, *putti, or* fat little babies, crushing grapes for wine. Here, there is also the most authentic of the Christian catacombs.

4th A.D.: There is a host of grand things, but two associated with Constantine (who allowed Christianity to be worshipped) are the most exceptional. One is fragments of his humongous 38-foot-tall seated statue — a marble head, an arm, part of one leg, a foot, and a hand — in the courtyard of the Palazzo dei Conservatori on the Capitoline Hill. This awesome face stares heavenward with a pair of the coldest eyes ever sculpted.

The second is the pair of huge porphyry sarcophagi, made out of deep purple marble from a mountain in Egypt, which today has disappeared, for Constantina, the emperor's daughter, and Helena, his mother. They're in the Vatican and are carved with the most beautiful ripe vines and acanthus.

In perfect state is the sensational mosaic in S. Pudenziana (Village of Santa Maria Maggiore) of a robust Christ flanked by the Apostles, one of the treasures of Early Christian art.

Of course, there are the stubby, rather inept sculptures on the Arch of Constantine, which is decorated with far more sculptures of the times of earlier emperors (see Chapter 6).

5th A.D.: The remarkably well preserved pair of cypress doors inside the church of Santa Sabina are carved with a series of Old Testament scenes, which are believed to prefigure episodes in the life of Christ. The church is on the Aventine Hill.

In the early Christian church of Santa Maria Maggiore, there are (above the giant columns of the nave) 36 brilliant mosaics depicting scenes from the first five books of the Old Testament and an epic mosaiced triumphal arch just before the apse.

6th A.D.: In the Forum, there's the church of Santa Francesca Romana with a truly singular painting of the Virgin and Child, which dates to the 5th-6th century and which was found beneath a 12th-century work. Mary's looming white face is as pure as an egg, and her hypnotic eyes pierce to one's very soul. This is one work that should not be missed in Rome and is unknown to all but the most discriminating experts.

7th A.D.: The best work is a delicate mosaic showing Saint Agnes in the apse of the church of St. Agnes Outside-the-Walls in pure flat Byzantine abstract style and in perfect condition. The saint, carrying the sword signifying martyrdom, floats for eternity on a ground of thousands of golden mosaic pieces.

8th A.D.: In the lower church of San Clemente near the Coliseum, there's a stark and powerful mosaic of the Madonna and Child transformed into pure, abstract religious dogma.

(continued)

9th A.D.: Emperor Charlemagne in the 9th century copied the architecture and art of the time of Constantine in his attempt to recreate ancient Rome of the Golden Christian age. In his Early Christian church of S. Prassede, there's a tiny chapel devoted to St. Zeno, adorned with exceedingly rare and mind-boggling mosaics.

In the overly stuffed museum in the Palazzo Venezia, there's a gorgeous ivory inlaid casket from Terracina. Get the postcard; it's worth it.

10th A.D.: In the lower church of San Clemente, a fresco of *Christ Triumphant* that is a rich and startling emblem of this century from which very few works have survived from anywhere.

11th A.D.: Only one work of this century in all of Rome — it's an enigmatic white marble reliquary in the third niche on the left in the church of S. Maria del Priorato that's an early medieval recreation of a ancient Roman funerary urn.

12th A.D.: A Romanesque marvel is the huge apse mosaic in the church of S. Maria in Trastevere, depicting the twin holy cities of God and imposing figures of Christ and the Virgin.

13th A.D.: The High Gothic is sparsely represented, but one of the few works is grandiose. It's in the gracious cloister of the church of San Giovanni in Laterano and is the boundlessly diverse and energetic architectural carvings by the master Vassalletto and his sons.

The looming Torre delle Milizie above Trajan's Forum is a wonderful monument of the period and was once thought to be the place where Nero fiddled while Rome burned.

14th A.D.: In the church of S. Maria Maggiore, where I singled out those exceptional Early Christian mosaics, there's a grand mosaic in the vault of the apse representing the Triumph of the Virgin. It is so stunning it looks like an Imax movie.

In that rambling museum in the Palazzo Venezia, there's the finest surviving silver cross of the Gothic epoch, dated to 1344, the Orsini Cross.

15th A.D.: The finest piece is in the small museum inside St. Peters itself, the bronze tomb monument of Sixtus IV, by the Florentine Antonio Pollaiuolo, with its impressive image of the pontiff lying in his sacred robes, surrounded by high-relief church fathers.

A close second is the gripping marble sculpture of the seated Virgin in the church of S. Agostino, just off the Piazza Navona, by Jacopo Sansovino, which could easily be the goddess Athena it's so classical in style.

16th A.D.: The Sistine Chapel Ceiling. Especially now that is has been cleaned to its original explosion of colors (any concerns that the frescoes were damaged by the cleaning are unfounded, for I was up there on the scaffold when the last piece was being cleaned and saw how effective and non-damaging the process was).

The fresco by Raphael Sanzio depicting the story of the nymph *Galatea* (Figure 29 in the museum guide color insert) in the seldom-seen Farnesina in Trastevere. And Raphael's frescoes in the Vatican — the Stanze as they are called, one of which depicts the Burning of the Borgo and the other created in a dazzling classical evocation the Disputà or meeting of the ancient philosophers.

His monumental painting of the *Transfiguration* in the Vatican Museum is not bad, either. For a look at early Raphael, there's his graceful and spiritually moving oil in the Borghese Gallery, *The Deposition* (Figure 28 in the museum guide color insert). Finally, for yet another triumph, his divine *Four Sibyls* in the church of Santa Maria della Pace near the Piazza Navona — above the arch in the first chapel on the right.

The thunderously powerful, huge marble of *Moses* by Michelangelo in the refectory of the church of S. Pietro in Vincolo is, to me, his best marble after the *David* in Florence. It shows the patriarch at the moment when, upon returning with the tablets of the Ten Commandments, he spots, to his disgust, the Israelites worshipping the golden calf. His oncoming temper will make the parting of the Red Sea look like calm waters.

One of the Venetian genius Titian's masterpieces is in the Borghese Gallery, his *Sacred and Profane Love;* one beautiful woman is clothed, and one nude — which is which? (Hint: naked seems to have been sacred.) See Figure 31 in the museum guide color insert.

17th A.D.: Rome is above all a 17th-century city, so any attempt to winnow down to a precious few the treasures of this super-age of art is a bit risky. But if you have a few days in the Eternal City, here's what not to miss:

Anything by Caravaggio and especially the paintings of St. Matthew in the church of S. Luigi dei Francesi near the Piazza Navona.

Anything by Gianlorenzo Bernini, the master of the Roman century of centuries and particularly the *Four Rivers Fountain* in the Piazza Navona, the huge bronze Baldacchino in St. Peter's over the high altar, the great bronze *Throne of St. Peter*, being held aloft by the evangelists in the apse of St. Peter's, *St. Teresa in Ecstasy* in the church of Santa Maria della Vittoria, and finally, the fantastic sculpture of the blessed Ludovica Albertoni in a state of sensual mysticism and blissful shock in the church of S. Francesco a Ripa in Trastevere. (And all of his dynamic sculptures in the refurbished Borghese Gallery.)

Diego Velázquez's best portrait, *Pope Innocent X,* is in Rome in the private (open to the public on certain days) museum in the Palazzo Doria Pamphili near the Collegio Romano.

18th A.D.: Curiously, Rome isn't all that rich in works of this century, having exhausted its money and artistic resources in the years before. Yet there's one that's thrilling — the entire church on the Aventine Hill, S. Maria del Priorato, which is a triumph of bone-white, Neoclassical decoration with a decided sense of humor — seriously. Designed by Piranesi.

19th A.D.: The best of the best, and it's in the fabulous (recently reopened) Borghese Gallery — the sensational marble effigy of *Paulina Borghese* by the greatest master of the neoclassic period, Antonio Canova. She's arrogant, gorgeous, and outrageous and is portrayed in all her comely decadence as a make-believe empress of ancient Rome.

20th A.D.: Expect little in the modern vein, for, after all, Rome is the quintessential ancient time machine. One is a piece of antic architecture, which you'll spot coming and going to and from the airport, the Mussolini-period, somewhat ridiculous, yet weirdly surreal square "Coliseum" out at the R.U.R. Note that out at R.U.R., there is also something you might get a kick out of — it's in the Museo della Civiltá — a 660-square-foot plaster model of ancient Rome at its heyday. This will help get a handle on where the ancient fragments of monuments were situated.

In the heart of town, my favorite 20th-century work is the *Fountain of the Naiads* (or water nymphs) in the Piazza della Repubblica, with the sexy water-splashed belle époque nude ladies. They are all the same woman, one shocking and gorgeous Vittoria Placidi, whom the sculptor Mario Rutelli loved and immortalized in 1901.

Venice

Venice has always generated inflated descriptions — from those who became addicted to the city to those who found it wet, dirty, and supremely arrogant. I happen to be one of the addicted. I look forward breathlessly to the trip on the swift boat from the airport, when the enchanted pile of odd-shaped domes and fairy-tale towers suddenly looms from the poetic mist. I can't wait to walk for hours along the narrow alleys, getting lost on purpose so as to emphasize how far away the contemporary world is. My favorite time is between Christmas and New Years because that's when the sun looks like it's being filtered through silver mesh, and at night only a small percentage of the windows is lighted, adding to the mystery. I once rented a small motorboat (the rental is near the railroad station and all you need is your driver's license) and spent several unbelievable days putt-putting through every canal immense or three-feet wide. I found street lights, traffic cops, speed limits, one-way signs, and an amazing population of everyday Venetians delivering groceries, refrigerators, and computers and TV sets to the inhabitants. I'd spot a nice restaurant along some narrow "rio," tie up, and

dine. I've even gone specially during "aqua alta" (high water) for the thrill of walking in the Piazza (no Venetian calls it Piazza San Marco, but the Piazza, and piazzas are called *campos* in Venice) on wooden platforms or wearing fishing waders and buying something in a shop where the water is three feet deep and the shopkeepers don't pay any heed.

"My" Venice is to be found in the twisting streets and alleys, in the backwaters, in the unique light and fog, in the deteriorating, beautiful colored stones, that make the entire city look like some gigantesque mosaic, in the gilding that's going yellow, in bronze that's corroded to dark green, in the flotsam and jetsam bobbing about in the waters, and, yes, even in the dank smells. I go for the atmosphere and only give a passing glance at the art that, although exalted, is, to me, secondary to the overall atmosphere.

Art abounds in Venice. But it is distinctly and gloriously provincial in nature. The wealthy Venetians of the high times of the 16th and 18th centuries didn't actually swoon to have foreign artists come rushing in to pick up the abundant commissions. So for painters, expect the likes of Vivarini, Bellini, Carpaccio, Giorgione, Titian, Veronese, Tintoretto, Canaletto, Guardi, Tiepolo, and Piazetta. For sculptors, expect works by Bartolomeo Bon, Tullio Lombardi, and Antonio Bregno.

The Cathedral of San Marco

In the **Cathedral of San Marco,** here's my list of the art to glance at.

- The cathedral of San Marco dates principally to the 13th century and is in many ways a fake. Those ancient Roman and early Christian sculptures on the façade, for example, are forgeries of the 13th century — the reason is that the Venetians wanted their cathedral to look as old as any in Rome.

- The mosaics representing Genesis in the ceiling of the domes of the main entrance porch, which are 13th century but which copy a famous (and now destroyed) early Christian illuminated manuscript of the 5th century.

- The famous bronze, gilded four horses stolen from Constantinople in the victory (and pillaging) of 1206 — very probably Greek of the Hellenistic period of the 4th century and maybe even by the genius Lysippus. The originals are way, way upstairs in a small gallery.

- The so-called *Pala d'Oro,* behind the main altar. This exceptional gold and enameled work, encrusted with precious stones, was originally made in Constantinople in the 10th century and was added to in the 13th and completed in 1342. Stunning are the Byzantine cloisonné enamels.

The best way to approach the ornate church is not from the Piazza but from the south, which was the way foreigners first saw it and were overwhelmed, presumably, by the rich array of trophies stolen in the 13th century — things like the two freestanding pillars, which are Syrian of the 6th century. Embedded into the corner of the church is the strange 4th-century *porphyry* (purple marble) which may represent the Tetrarchs (Emperor Diocletian and his co-rulers) embracing each other in a suffocating embrace of fealty and fear.

Gallerie dell'Accademia (Academy Gallery)

The **Accademia** (the Academy of Art) boasts the most complete collection of Venetian paintings on earth, and frankly, there are more than you'll ever care to see. I always drop in to see four old friends while on some walking tour.

- ✔ Vittore Carpaccio's monumental *St. Ursula Cycle* (1475-95). The most "Venetian" of painters is the Renaissance master, Vittore Carpaccio.

- ✔ Giorgione's precious and utterly incomprehensible delight, *Tempest* (1507), which shows a soldier with a woman nursing a baby under a tempestuous sky. (See Chapter 7, Figure 7-8.)

- ✔ The massive canvas *Feast in the House of Levi* (1573) by Paolo Veronese, recently restored and radiant. This immense work started off as a Last Supper, but the Inquisition objected to the downscale details, such as the company of dogs, dwarfs, and drunks (plus the curious 15 instead of 13 participants), and Veronese didn't alter anything except the name, which made the masterwork acceptable to the religious curmudgeons.

- ✔ Canaletto's *Capriccio of a Colonnade* (1756), which he presented to the Academy when he was made a member.

Correr Museum

The most "Venetian" of painters is the Renaissance master, Vittore Carpaccio. A canvas of captivating quality, mistitled *The Courtesans,* of the late 15th century, is in the **Correr Museum** (see Figure 32 in the museum guide color insert). It shows a number of severely made-up and acerbic-looking Venetian women seated indolently on a roof terrace (which are typical to the city and which can be seen everywhere today). These two charmless ladies are probably the upper-class wealthy of the time. This is a stunning look inside a private dwelling of the 15th century.

Scuola di San Giorgio degli Schiavoni

Carpaccio's endearing paintings in the **Scuola di San Giorgio degli Schiavoni** are the sole works to remain in their original building. "Schiavoni" is old Venetian dialect for Slavs, meaning the Dalmatian merchants who were active as traders since the mid-15th century.

They built a small "school" and commissioned Carpaccio to paint, in 1502-08, scenes from the lives of various Dalmatian saints — Sts. George, Tryphon, and Jerome. The two most exceptional are the hair-raising *St. George Killing the Dragon* and *St. Augustine in His Study.* The dragon is loathsome, as the sickening body parts in his lair attest. St. Augustine, shown in his cluttered studio, no doubt a faithful recreation of a Venetian scholar's workplace, has just witnessed a minor miracle — a light has burst forth, and a voice has just given the news of the death of St. Jerome. Augustine picks up his pen to compose a letter. The charming little dog seems transfixed by the event. The shelves are laden with marvelous accouterments and offer up a series of incomparable still-lifes.

The Doges' Palace

A visit to the **Doges' Palace** is, I suppose, a must, although the tours often make me want to cross the Bridge of Sighs into the prison, I'm so bored. If you must, there are some decent — and exceedingly large — works of art.

- The *Scala dei Giganti* (Staircase of the Giants), with the imposing sculptures by Jacopo Sansovino (1567) of Mars and Neptune, symbols of Venice's powers on land and sea.
- In the Anticollegio (antechamber of the Cabinet Hall), there's a spectacular picture by Paolo Veronese, *The Rape of Europa* (1580).
- In the Sala del Collegio (Hall of the Cabinet), Veronese painted the glorious ceiling (ca. 1575), representing *Venice Enthroned.*

Frari Church

In the grandiose Gothic church of the Frari (church of the Franciscans), there are two extraordinary masterpieces by Giovanni Bellini and Titian, both of which have recently been beautifully cleaned.

- Over the altar in the Sacristy, commissioned by the powerful Pesaro family, is Bellini's *Madonna and Child with Saints Nicholas, Peter, Benedict, and Mark,* dating to 1488. Henry James (an American writer) was struck dumb and wrotethat it seemed to be painted with molten gems and was as solemn as it was gorgeous"
- The Titian depicting *The Assumption of the Virgin* (1516-18) hangs in the chancel and is explosive — the Virgin sweeps upwards, from where the apostles stand in awe, to the heavens like some divine rocket.

Church of Giovanni e Paolo

After Saint Mark's, the most popular square is that in front of the Gothic church of **Giovanni e Paolo** (Zanipolo, in Venetian dialect) and the Scuola Grande di San Marco. Here is where you'll find Andrea Verrocchio's powerful monumental bronze equestrian portrait of the mercenary Bartolomeo Colleoni, who thought he'd get his monument in the Piazza, but the wily Venetians placed him in the campo near the school of Saint Mark's. Everything about this compelling statue is perfect — from the serene head of the marvelous horse to the twisted, almost infuriated grimace of the general-for-hire.

Scuola Grande dei Carmine

Of all the superb Venetian artists, my pick of the most intriguing is that 18th-century master of frescoes, light, and scintillating colors, Giovanni Battista Tiepolo. He is fabulously represented in his sensuous and vivid ceiling in the **Scuola Grande dei Carmine** (School of the Carmelite Order), the *St. Simon Stock Receiving the Scapular from the Virgin Mary* (1744). To see this will be the cap of any art tour of the enchanting, poetic, ever-baffling and wondrous city of Venice.

TIP

Scuola Grande di San Rocco

The **Scuola Grande di San Rocco** school houses the largest collection of the largest Tintorettos on earth, representing the life of Christ; and frankly, size doesn't help.

Peggy Guggenheim Museum

The New York Guggenhiem Museum has a branch in Venice, the home of Peggy Guggenhiem, legendary art collector. There are some fascinating works by all sorts of modern artists, but, unfortunately, many are not in prime condition. It's worth a quick drop-in but, to me, has always been somewhat jarring in this city, which is the perfect museum in itself.

Netherlands, The

Amsterdam

The Rijksmuseum

The **Rijksmuseum** (www.inform.nl/rijksmuseum/index.htm) roughly translates to the National or State Museum, and it is compelling. Don't expect the world view or an encyclopedia of painting, for this is the place for the Dutch School of the 16th and 17th centuries.

In my opinion, the top five works are four by Rembrandt and one by Jan Vermeer:

 - Rembrandt's *Day Watch* (1642) (before extensive cleaning, once commonly known as the *Night Watch*), which, in an enormous canvas the size of some theatrical stage, portrays one of the more popular marching societies and band of good fellows that abounded in the city in the 17th century. The painting was slashed a couple of decades ago by a vandal, which explains why the security is so heavy. Despite the grievous damage, the work still possesses all that force of life for which Rembrandt is so well known. (See Figure 33 in the museum guide color insert.)

 - The *Anatomy Lesson of Dr. Nicolaes Tulp* (1632) manages to enliven what is basically a group portrait of the doctor taking students through an autopsy into an audacious study of the varying states of the human mind.

 - *The Jewish Bride* (c. 1665) is, along with his poignant *Bathesheba Reading David's Letter* in the Louvre, Rembrandt's most penetrating image of human affection. Simple, unaffected, and painted with dazzling purity, the man and woman are the archetype of devotion (see Figure 34 in the museum guide color insert).

 - *The Woman at the Open Half Door.* The glory of Rembrandt is his uncanny and possibly unique ability to take what is almost a commonplace subject and imbue it with a sense of the infinite and with a feeling of super-humanity.

 - Jan Vermeer's *Village Street* (1657-58) is but a tiny geographical slice of the world at large, but it is laden with the light of the cosmos. What is especially wondrous about this little work is not only the perfection of the details but also how the artist has not allowed these details to overwhelm the overall sense of timelessness.

Van Gogh Museum

One of the richest artistic experiences in Europe comes from a visit to the **Van Gogh Museum,** also recently renovated, devoted to a stellar collection of the works of Vincent van Gogh. Among the highlights, I'd single out the following:

 - *Self-Portrait with Hat,* which shows the painter, a domineering and totally fearful man, looking evilly out at you with one of the most disturbing glances ever depicted. Look at this and you'll have some inkling why van Gogh was so bothersome to many of his contemporaries. (See Figure 35 in the museum guide color insert.)

 - *Boats on the Beach at Saintes-Maries-de-la-Mer* (1888). The bright, almost garishly painted, sailboats lined up on the beach by their fishermen owners look like dollops of candy.

 - *Bedroom in Arles* (1888). The colors are all so impossible, but they work — the crimson bed blanket, the yellow sheets, the orange planks of the wood making up the bed. The wicker chair is the one on which the troubled painter sat for hours, head cradled in his hands, contemplating his sad life.

 - *In Vincent's House in Arles,* one sees the yellow house at night under an invigorating and mysterious deep cerulean blue sky glowing like some ancient dying star.

Stedelijk Museum of Modern Art

For those who dote upon modern art style, especially the hard-edge and line and blocks of vibrant color as manifest in the paintings of Piet Mondrian, the **Stedelijk Museum of Modern Art** is the place to go.

Kröller-Müller Museum, Otterlo (near Amsterdam)

For the **Kröller-Müller Museum,** I'd recommend hitting the postcard shop right off the bat and choosing the Vincent van Gogh's you might want to pore over at your leisure.

The Hague

The **Mauritshuis**, recently redone, is one of the prides of Europe and is world-famous for its Dutch pictures of the Golden Age of the 17th century. The Rembrandts excel, but what outstrips them all is a large and gorgeous Jan Vermeer, his *View of Delft* (c. 1658), which is at once a triumph of the effects in paint of real light and real atmosphere. It was intended to be a religious symbol as well, for the steeple of the church is supposed to persuade the viewer to Catholicism.

The paint is applied with Vermeer's characteristic small highlights or white, glowing dots; and through their bravura, the painting gains an inner life. If you care to analyze the shadows, you'll see that the source of light in this sunset is from many differing points.

Russia

Travel to Russia and the former Soviet Republics is hazardous, with crime and inefficiency and disease hampering the visitor. My time in Russia was spent mostly during the final days of the "Evil Empire," and since I had the most cordial relationships with the cultural nabobs, I never suffered a day of stress (culturally, that is). I had the pleasure of being given permission to roam almost at will through the grandest museums and art repositories and was perhaps the only foreigner granted access to the "secret" storerooms of the Hermitage and the normally-closed-off conservation studios. I was astounded by the wealth of the Hermitage's treasures, especially the Greek and Roman goodies made for the nomad Scythians, which weren't on view for the general public and probably never will be.

Moscow

Pushkin Museum

In the **Pushkin** (www.museum.ru/Pushkin/default.htm), on loan from the Hermitage, are some of the finest paintings by Cézanne and Henri Matisse ever created.

The Cézanne is the *Still Life with Drapery* (1899), showing a white pitcher painted with the most delicate and colorful floral pattern. The peaches in the bowls glow like embers, and the tablecloth looks like a vast snow-covered mountain range. The work was collected by the astute retailer I. Morozov, a capitalist who supported the revolution and who eventually gave his pictures to the state.

A host of world-class Matisses are here, but two are incomparable. *The Harmony in Red* (1908) shows a woman putting a bowl of fruit on a table covered with a crimson tablecloth decorated with dynamic blue shapes —which seems to merge in and become the wallpaper — thus making everything seem to move and change shape and perspective (see Figure 36 in the museum guide color insert). This was probably Matisse's answer to Cubism, which was born in the same year by Pablo Picasso and Georges Braque. In *The Dance* (1910), which is nearly life-sized, five amber-colored female dancers link hands and make a vibrant circle on a green and blue background. Few pictures in Western history express such peace and harmony (see Figure 37 in the museum guide color insert).

Tretyakov Museum

I prefer the Russian paintings museum in Moscow, the **Tretyakov,** to the Pushkin, if only for the astonishing, brutal, yet beautifully painted 19th century painting by Ilya Repin (1844-1930), showing a crazed *Ivan the Terrible* desperately cuddling the bloody dead body of his son whom he has just murdered, and also for the unforgettable image of Hitler and his drunken hangers-on cowering in the Berlin bunker in the last day of the siege.

St. Petersburg

The Hermitage

In the **Hermitage** (http://www.hermitage.ru/), the most triumphant series of works in the sprawling place (which takes up 12 acres and five palaces built over centuries) are the pieces associated with the tribes that lived in the Altai mountains, the Scythians and the Sarmatians, who traveled widely, even ending up in France. These indigenous tribes populated Russia from the 6th century B.C. until the 4th century B.C. and were made up of fierce warriors who invented stirrups and cavalry warfare. Scythian works of art were made by the most skilled craftsmen of ancient Greece and were small in scale and easily portable.

Among the most staggeringly beautiful works of any civilization are the wooden harnesses and saddles, the felt wall hangings, saddle covers, and clothing covered with lively representations of all kinds, including animals and riders and their horses, made by artisans from the tribes that populated the Altai mountains in the 4th century B.C. They are impeccably preserved owing to their interment in tombs beneath the permafrost. There are special galleries in the Hermitage for this material — which the average tourist invariably avoids, understandably leery of plunging into what looks on the surface to be a welter of tired and dried-out archaeological objects. My advice is to make a beeline for these pleasantly deserted halls (even if the smell of formaldehyde preserving the mummies and tattooed — and gorgeous — 5th century B.C. body parts may be a bit daunting).

The Hermitage is the home of the world-famous Gold Treasury, which is frightfully hard to get into and needs cajoling and tips for one's guide, if one is going the guide route (recommended, actually). There are some Fabergé baubles here, but they are second-rate, so don't bother with them. Spend your time ogling the world's most spectacular hoard of gold and silver objects gathered up by Czar

Peter the Great in the 17th century (and by archaeologists since the 19th century) belonging to the Scythians and Sarmatians. They are unbeatable for beauty, craftsmanship, and sheer grace. The best four are:

- ✔ The enormous solid gold stag — a shield emblem — over a foot wide and made by Greek jewelers in the 4th century B.C.

- ✔ The gold comb of the 5th-4th century B.C. showing a battle between a Greek horseman and two Scythians, one of whose horses has been felled and lays there on its back gasping its last breath. It's only four by four inches (10 x 10 cm) and is sculpted on both sides — but it seems life-size because of the utter magnificence of style.

- ✔ Gold bottle — 5 inches (12.7 cm) high — showing in startling low relief a crew of Scythians chatting amongst themselves, stringing a bow, treating a sore tooth, and bandaging a wounded leg. They are so vibrant they look as though they could speak. The date is 5th-4th century B.C.

- ✔ An enormous shield emblem in gold of a stylized panther whose tail and paws are made up of small felines (dating to the early 6th century B.C.) is one of the true wonders of world art.

The second richest department in the Hermitage is the one containing all sorts of works — from painting to furniture and other decorative arts — of Russian manufacture from the 16th to the 19th centuries (including a fascinating display of the boots and clothing of Peter the Great, who was over seven feet tall). The pieces are in excellent condition and are all authentic. This is offbeat but intriguing. Don't fail to see the wonderful series of embroidered and tapestried portraits of the lords and ladies of the 18th century. In old Russia, it was common to take oil paintings and translate them into embroideries and tapestries — and it's hard to tell the difference.

Don't waste time with the Greek and Roman antiquities (separate from the Scythian treasures made by Greeks). Most were purchased by Catherine the Great in the 18th century, and all too many are fakes or overly restored marbles cobbled up in Rome and Naples by the better forgers of the period. Yet, glance at some extraordinarily rare, slim and perfectly-preserved 3rd-century B.C. Greek ivory carvings showing women in flowing costumes — they are svelte and sinuous.

The European paintings of the Hermitage have, I think, been given a slightly exaggerated press over the years and possess a bit too lofty a reputation. The collection, although it contains some must-sees and is especially strong when it comes to Dutch and Flemish painting of the 17th century, is not quite as rich as the Kunsthistorisches in Vienna or the National Gallery in London or the Louvre. That is not to say that it's not extraordinary. It is.

For the paintings, here is my list of not-to-be-missed.

16th Century

- ✔ Leonardo da Vinci, the *Benois Madonna and Child,* begun in 1481 and finished in France in 1519, named for a collector who once owned the oil that has been transferred to canvas from a panel (and thereby blunting slightly the radiance of the picture). This is typical eccentric Leonardo — the Virgin looks like a teenager, and the Christ Child has a face which seems elderly. But the elegance of the picture and the bravado of the storm clouds of the

swirling draperies are moments of pure genius. The other "Leonardo," the *Madonna Litta,* is, in my opinion, by a close follower of Leonardo and is pretty but slick and a shade lifeless.

17th Century

✔ There's one Caravaggio worth a long look, a saucy picture of 1595 entitled the *Lute Player* in which an androgynous young boy plucks on a lute with an expression of almost maddening self-satisfaction. On the left side, there's a fantastic still-life apparent in the flowers, which are presented with singular clarity and perfection of painting.

✔ One of the greatest landscape painters in history is the 17th century Frenchman Claude Gellée, who was also called Claude Lorrain. No one captured the romantic, moody, lyrical setting as well, as the painting *The Italian Landscape* (1682) admirably shows.

✔ The Hermitage is famous for its sublime works by artists who are not household words (even to specialists). One is by the Roman 17th-century painter Domenico Feti and portrays the miracle of the *Healing of Tobit* (1624), in which can be found some of the most gorgeous painterly passages of the entire Baroque period. The angel touches the closed eye of the elderly Tobit, and suddenly there will be an awakening of his vision.

✔ Nicholas Poussin's *Tancred and Erminia* (c. 1630). Poussin, the unequalled classicist of the 17th century, painted a host of gripping masterworks, but few come close to this fascinating image of the woman who kills her lover by mistake and watches as the last embers in his eyes fade away. The two horses — the dark one symbolizing approaching death and the white one the shining hope of Erminia — are splendid. The silver tones of the shield and armor are worth the visit.

✔ Rembrandt's *Prodigal Son* (c. 1665). The large work, said to be unfinished, but I'm not sure, is a powerful rendering of the return of the grimy, lice-infested son who, on his knees, grasps his father and begs forgiveness — which he gets. The elder son who has stuck around all the years to care for the now-doddering father looks on with a marvelous expression, part relief and part regret. (See Chapter 10 for an illustration.)

✔ Peter Paul Rubens, *Stone Carters* (1620). One of his rare landscapes depicting a horse and carriage, laden with huge blocks, that the workers are working perilously down a steep path in a jumbled and mysterious wood. The setting sun illuminates the scene and the viewer will think, "Will they get to where they're going in time?"

✔ Rubens, *The Temple of Janus,* an oil of 1635 (which the Hermitage has in great numbers) shows the skillful application of fluttering paint and incandescent colors.

✔ Few 17th-century artists were as good at portraits as Anthony van Dyck, as the marvelous *Self-Portrait* of the late 1620s attests. The young artist lolls, arms akimbo, as he looks straight at us in surpassing confidence. Van Dyck all but invented the nonchalant portrait.

18th Century

✔ That master of the portrayal of love, the 18th-century Frenchman Jean-Honoré Fragonard, has outdone himself with the spicy *Stolen Kiss* (1780). A lovely young lady dressed in a silvery satin is suddenly seized by a handsome young man who appears through a door. He gives the surprised and delighted maiden a quick kiss as the ladies in the back room continue playing cards.

✔ Joshua Reynolds, *Cupid Undoing Venus' Belt* (1792), which is one of the most seductive and appealing paintings ever of a young woman. The torrid glance from this goddess of love, half-concealed by her left arm draped provocatively over her face, is dynamite.

✔ Giambattista Tiepolo's *Maecenas Presenting the Liberal Arts to Augustus* (1745). A glowing example of the Venetian's amazing bright color and dash of execution. The emperor is shown sitting in his military regalia on a throne, and at his feet kneel or stand in waiting three comely lasses who symbolize the fine arts. A disgruntled page holding Augustus' sword looks like he's just been laid off, which he has been, if temporarily. There's a soaring view through an arch across a lagoon to a perfect, round, classical temple, which may be a fantasy view of the emperor's tomb, which was round.

✔ Jean-Antoine Watteau is well known for the feathery quality of his brushstrokes and the indelible personalities of his subjects. He could be offbeat, as the small and scintillating oil representing an itinerant entertainer, *The Savoyard with a Marmot* (1716), shows. It looks like a Monet, loose and impressionistic. The frazzled kid stands there smiling slyly, holding his flute, and the little furry creature looks out just as slyly

✔ The English painter of the late 18th century, Joseph Wright of Derby, is often overlooked in the understandable desire to venerate Turner. In the Hermitage, there's one that should not be passed by, the *Illumination of the Castel Sant' Angelo* (1778). It is one of most breathtaking early night scenes ever painted of Rome. The exploding fireworks and spray of a thousand candles embellishing the Castel are wondrous to behold.

19th Century

✔ The most accomplished painter of the Romantic era in the early 19th century was the German artist Caspar David Friedrich. The Hermitage has an unusually large collection of his works, and *On a Sailing Ship* (1818-1820) is one of his finest. The work, showing a man and girl seated on the prow of a sailing vessel, is a realistic image and more. It is a religious symbol, as the lofty church spires in the far-off city seen in the evening indicate. Friedrich always seeded a bountiful religious import into his works.

✔ Claude Monet painted this sunny and atmospheric stunner in the summer of 1867 at the vacation spot on the Seine River at Sainte-Adresse. It was the same ebullient moment he created the Metropolitan's landscape at the same place. This *Woman in a Garden* has light so intense that you'll think you need sunglasses. It's a painterly dream with white used as vivid marks — the glowing white dress of the woman and her parasol, which shimmers like some halo, all energized by the bed of poppies, which have a punch like Chinese red lacquer.

Spain

Barcelona

Barcelona is one of the most charming cities in Spain and may be the best one just to walk around in. Try Las Ramblas, the spine of the town in a way, a street with broad, tree-lined center strips populated by a series of kiosks and shops selling flowers, books, newspapers, and loads more. The best view over the city is from Mt. Tibidabo the Latin for "to thee I shall give . . ." which is how the devil tempted Christ, offering him worldly treasures which were, of course, turned down. There's a cable car to the top, and at night the view is sparkling.

The symbol of the city is the unfinished religious sanctuary called **El Templo Expiatorio de la Sagrada Familia,** designed by Antonio Gaudí (1852-1926.) The style is so individual and quirky that is defies description. To me, its soaring openwork tower (one of a planned four), its complex oddly curving vaults, and its walls opened up by irregular windows is Gothic in feeling yet intensely personal. Gaudí also designed a couple of impressive tall buildings — Casa Batlló and Casa Milá — and a small park, the Parca Qüell — which are fascinating for their individuality. Gaudí was the leading light of a movement that explains much of Barcelona's 20th century history. Around 1900-1920, there was an attempt to secede the province of Catalonia from the domination of Madrid (Castille), and la Sagrada Familia is part of the attempt to be different and therefore look differently. Everyone who supported the movement — the Catalonian renaissance, it was called — had to own something symbolic of when Catalonia was independent in the Middle Ages. Altar frontals, paintings, even frescoes on walls and ceilings from the large number of small medieval churches in Catalonia were removed to be collected as a mark of the secessionist faith.

That's partly the reason for the incredibly large number of wall paintings of the 12th and 13th centuries removed from their sanctuaries and now on display in the redone **Museu Nacional d'Arte de Catalunya** (National Museum of Catalan Art). The structure built originally as part of an international fair has been spruced up in a decent way by the architect Gae Aulenti (who toyed around with the Musée d'Orsay in Paris). Catalonian art of the Middle Ages is, face it, lesser in quality than French or English art of the same period, being heavy and often somewhat overly silhouetted by thick black lines. Yet, you'll find some imposing images there, especially a fresco representing Christ, formerly in the church of Sant Climent de Taüll.

Amusingly, once the authorities put a stop to the widespread taking of art from churches as a political symbol, the fervor to collect Catalonian altar frontals and other painted church furniture didn't subside. Guess what? Yes, the forgers stepped in. As a young curator at The Cloisters in New York, I saw, to my distress, fakes in the National Museum in Barcelona that three supposed "medieval" Catalonian objects we'd just bought were from around 1910. Luckily, we learned this just before putting them on exhibition.

Other museums of note in Barcelona are the **Barcelona Museum of Contemporary Art** (Museu d'Art Contemporani de Barcelona) or MACBA, designed by the doctrinaire American stylist Richard Meier (see the Americas

museum guide for his massive Getty Museum), and the **Museu Picasso** (Picasso Museum). The collection here is small, and the best works are from his youth, showing what a gifted child prodigy he was.

Finally, for sheer enjoyment of the highly amusing, yet deceptively serious paintings of the Spanish surrealist Joan Miró (see the Pompidou section for his *Blue I, II, III*) spend some time in the **Fundació Miró** (Miró Foundation). There is a host of exceptional Miró pieces here.

For the art of today, be sure to check out what's scheduled at the Miró Foundation.

Bilbao

Museo Guggenheim Bilbao

The museum hit of the past two years — and likely to be the prime hit right through Y3K — is the branch of New York's Guggenheim Museum in this fading port famous in the 1920s for its smuggling and sin. The flamboyant and utterly breathtaking museum, the principal architectural motif being a shining shaft of titanium reaching to the sky and an explosively soaring vault, contains changing exhibitions taken primarily from the Guggenheim's permanent collection. You may see some old New York friends, but so what; the architectural environment created by the contemporary genius, Frank Gehry, is a world-class knockout.

Madrid

El Museo del Prado (The Prado Museum)

You'll never see the full **Prado** (museoprado.mcu.es) because it owns over 20,000 works of sculpture, decorative arts, drawing and painting. Today, 1,200 paintings out of 4,500 are on view as are a handful of the sculptures (including one fabulous forgery that the Prado officials can't get around to admitting — the "5th century B.C." *Dama de Elche,* which seems to be 19th century instead).

Here are my picks:

- ✔ Rogier van der Weyden's *Descent from the Cross* (c. 1435) may be second best to Jan van Eyck's *Ghent Altar*. The players in this deeply moving chapter of the Passion are almost beyond belief they act so poignantly.

- ✔ Hieronymous Bosch's breathtaking *Garden of Earthy Delights* (c. 1505-1515), a visual primer on the perils of living too high, wide, and handsome. (See Chapter 8 for Bosch in Northern Renaissance and Figure 38 in the museum guide color insert.)

- ✔ Titian's *Danae* (1553). This large canvas by the Venetian Renaissance genius depicts the Greek myth of Zeus making love successfully to yet another beauteous mortal woman — this time disguised as a shower of gold coins.

✔ Pieter Brueghel the Elder's *The Triumph of Death.* This magnificent painting, which may also be a plague, has to be one of the most gripping depictions of a grim subject ever created. It's a dark, horrible, yet breathtaking clutter of death, torture, and murder. The action starts with the table of elegant diners off the lower right; gals and their dandies are having a ball when the skeletal army of death stalks in. All those lovely, lascivious naked ladies, the well-dressed lute players, and the gang of bon vivants are consumed. One bravo reaches futilely for his sword to slay death — it doesn't work. All are consumed.

✔ Veronese's *Judgment of Paris.* The great painter Diego Velázquez was sent in the mid-16th century by King Philip IV to Italy to buy pictures for the royal collection, and he acquired some of the finest examples of Venetian art of the 16th century to survive. This array of the three most beautiful female goddesses on Olympus to be judged by Paris is incomparable.

✔ Peter Paul Rubens was the ambassador to Spain from Flanders for many years and was commissioned by the Spanish crown to do a number of block-busters. One is his *St. George and the Dragon* (c. 1606-10), an imposing canvas some 9 by 6 feet (2.7 m by 1.8 m). The colors and the drawing of the horse's mane, armor, sword, and dragon in this battle royal are so vivid that the picture seems to be on fire.

Diego Velázquez and Rembrandt van Rijn stand as the two most exciting portrayors of humanity and the human spirit in Western civilization. The Prado is the shrine for Velázquez — except for his great *Innocent X* in Rome and the stunning *Juan de Pareja* in New York's Metropolitan Museum (see the New York section of the Americas museum guide). Most, if not all, of the fabulous works are here.

I remember once being allowed to enter the Prado late at night for several hours alone, and I spent all the time in the galleries of Velázquez and Goya.

The pick of the Velázquez picks are:

✔ *The Surrender of Breda* (1634-35), in which every element — from the landscape with the defeated and burning Flemish city of Breda dominating the scene to the faces of the participants to the angle of the weapons and spears — emphasizes defeat and victory. Its portrayal of the Catholic Spinola gently comforting the defeated Calvinist Dutch commander emphasizes the dwindling pleasure of victory, even over religious antagonists.

✔ *Las Meninas* or *The Handmaidens* (1656) — this is an enchanting picture that combines effortlessly the real and the totally imagined. The large painting — 12 by 9 feet (3.6 m x 2.7 m) — shows the young Infanta Margarita surrounded by her ladies-in-waiting and her favorite mastiff as Velázquez himself puts the last touches onto the canvas we have entered. King Philip IV and his wife are reflected in a mirror at the long end of the chamber, and a well-dressed courtier stands on the stairs in a bright doorway, giving a startling perspective depth to the amazing environment. (See Figure 39 in the museum guide color insert.)

This picture, which captures an instant and makes it infinite, has been painted in a breathtaking technique that makes it ethereal, atmospheric, and full of natural light. This has it all: the dignity of officialdom, the tenderness of humanity, the laughter of a child, and a sense of joy unmatched in all of art.

✔ The 18th century is very well represented here, and the tops, to me, is the Venetian master Gianbattista Tiepolo's *Immaculate Conception* (1767-69), a sumptuous religious work with colors that seem to be those of melted-down precious gems.

For Goya, the absolutely-must-sees are:

✔ *The Third of May, 1808* (1814-1815), which is a must, despite its horrible subject matter — the massacre by French soldiers of the citizens of Madrid who rebelled against the Napoleonic conquerors on that grim day in 1803 (see the main color insert for a full-page look). The night is black and brooding, and the foreground (where the poor souls are being gunned down by soldiers who wear packs for a quick getaway) is brilliantly lighted as if rays from heaven shine on the martyrs.

✔ Goya was said to be in love with the Duchess of Alba, one of the most gorgeous women of history, and painted her many times. None of his exceptional efforts are more delicious than the two images of his beloved called the *Clothed Maja* and *Naked Maja* (1797-98).

✔ In his late years, ill and deaf, Goya, having retreated into a sullen and wicked shell, painted for his dining room a series of huge dark and beautifully painted canvases popularly called "The Black Paintings." Among the most renowned is the disgusting episode of the Greek mythic giant, *Saturn Devouring His Children* (1820-1823).

Museo Nacional Centro de Arte Reina Sofía (National Museum Art Center of Queen Sofia)

There's a museum dedicated to modern art that's known popularly as the **Reina Sofía** and specializes in a collection and exhibitions exemplifying avant-garde movements of the past and present.

The most spectacular painting is Pablo Picasso's frightening *Guernica* of 1937, which, in symbolic ways, depicts the horrors that befell the little northern Spanish town of Guernica when the German Luftwaffe joined the repressive forces of General Franco and bombed it. The weeping woman and the screaming, wounded horse are among the most powerful of Picasso's images of the destruction of war (see Figure 40 in the museum guide color insert).

The Reina Sofía (this is the way it is popularly referred to in Spain and the art world) is also justifiably famous for the many paintings by the puckishly humorous Surrealist, Joan Miró.

Museo Thyssen-Bornemisza (Thyssen-Bornemisza Museum)

One of the not-to-be-missed collections in Madrid is in the remodeled Villahermosa Palace — the fabulous one of the German-Swiss Baron Thyssen-Bornemisza — with exceptional old masters. A highlight is *St. Catherine,* by Michelangelo Merisi da Caravaggio, the great Italian innovator of the early-17th century.

Museo Nacional de Arqueología (National Archaeological Museum)

The **Museo Nacional de Arqueología** (National Archaeological Museum) contains two glorious works worthy of a visit. One is a unique, large, ivory cross of the 10th century made for King Sanchez and his Queen Isabella with an abstract but amazingly vigorous Christ. The second is a trove of matchless Visigothic golden crowns of the 7th century, which were probably made to hang above a church altar.

Switzerland

Basel (Switzerland)

The **Kunstmuseum** (www.kunstmuseumbasel.ch) is often overlooked. Here are sensational paintings by various members of the Holbein family, including the exceptional round portrait of the 16th-century philosopher Erasmus by Hans Holbein the Younger. The museum possesses a number of top-notch modern paintings, too, especially by Picasso. Plus a sublime portrait of Émile Zola by Édouard Manet, entitled *Guest of Honor: Portrait of a Modern Man of Letters*. Finally, one of the most stunning, small, late-Gothic wood carvings (in hard box-wood) is *Adam and Eve* by Hans Wydyz.

Zurich

The **Landesmuseum** (which means the Museum of the Province) has an abundant amount of decorative arts, furniture, and a few period rooms, which range in date from the 4th century A.D. to the late 19th century. One of the treasures is a trove of Late-Antique and Early Christian silver.

The **Kunsthaus** (www.kunsthaus.ch/) presents some fine temporary exhibitions, so you should be aware of the schedule before going, and there are some large and fascinating paintings by Ferdinand Hodler, the Zurich painter of the late 19th and early 20th century. There are also several works by the 20th-century master Paul Klee, another renowned Swiss painter and the creator of magical, near-surreal scenes, some of which make you burst out in laughter. This museum also displays a fine bronze of Rodin's *Gates of Hell* on the summit of which is the justifiably famous *Thinker*.

The **Oskar Reinhart Collection** is near Zurich and easy to get to. It's justly renowned for its Impressionists and Post-Impressionists.

United Kingdom

London

Because of common language and the exceptional politeness of the British, American tourists feel more comfortable in Great Britain and seldom experience tourist anxieties as they do in places where language can be a frightening barrier.

It's easy to find one's way around London by underground or bus, and the museums and galleries offer superior guides and maps, so I won't attempt to cover the entire art territory of this unique art town. Instead, I shall steer the reader to those works in the famous places that may inadvertently be given short shrift.

The British Museum

I have always looked upon this bursting warehouse called **The British Museum** (www.british-museum.ac.uk) — truly one of the most disorganized, badly designed, and overcrowded museums on the globe — as a fusty old Colonialist who roamed the world and picked up everything the natives had and in some cases, especially African works, seized the idols and ceremonial statues to prevent the natives from slipping back into heathenism after their conversion to Christianity.

- Do pay homage to the *Rosetta Stone* in the Egyptian galleries and the *Elgin Marbles* in the Duveen Gallery, but don't miss what is, after the Parthenon marbles, the single most stunning and beautiful classical antiquity in the place. This is a small glass cup, the *Portland Vase,* a triumph of glass-making, with the most skilled human figures floating on a breathtaking blue ground. The faces are sweet, idealized, and perfect. The vase, made at the height of the Augustan age of the 1st century A.D., was smashed by a crazed visitor in the last century but was restored with only a few tiny pieces missing.

- The Late Antique and Early Medieval galleries are hard to find, so ask a guard for the *Sutton Hoo Treasure* (a gold and silver hoard with amazing enamels dating to A.D. 615-25) and the *Lycurgus Cup,* a gorgeous glass cup of the 4th century A.D., which was cast in glass like bronze and cut like stone to reveal a lusty, somewhat raggedy-looking Hercules on a milky-green exterior that would change colors when wine was poured into the receptacle.

- In the medieval galleries named the Prince Edward Galleries, there is one blockbuster of the most refined period of the Middle Ages, a gold and enameled cup with scenes from the life of Saint Agnes, made in the late 14th century for history's greatest art collector, the Duke of Berry. Of all the precious pieces to have survived from Late Gothic times, this glowing solid gold cup (with red, azure, and emerald green enamels shining like gems) is definitely the high point.

- The British Museum used to be the great library of the land and housed a collection of illuminated manuscripts rivaling any on earth. Many of these are being moved to the new British Library, but there is a selection still visible. Of these, do not miss either the stocky and forceful Linsdisfarne Gospels, painted during the so-called Dark Ages (c. A.D. 700) — not so dark after all (see Chapter 6) — and the striking 10th-century Benedictional of Aethelwold with its expressionistic, electrically-charged, and agile depictions of the life of Christ.

The National Gallery

The **National Gallery** (www.nationalgallery.org.uk/) has one of the foremost collections of paintings in the world and ranks, I'd say, just behind the Prado (although well behind the Kunsthistorisches in Vienna). There was a scandal a few years back about the overcleaning and "skinning" of certain oil paintings, that is, the removal by mistake of a very thin surface of the paint, but this practice has, thankfully, stopped.

You will be directed by a handy computer terminal orientation room to the prime treasures like Piero della Francesca's *Baptism* (1448-50) and the *Adoration of the Shepherds* and Uccello's *Battle of San Romano* (c. 1455) (the other two pieces being in Florence and the Louvre). But here's a quick list of those paintings that might get passed by and shouldn't:

✔ Don't miss a two-paneled oil painting on wood called the *Wilton Diptych* after the Lord who once owned it. It's a glorious example of the elegant International Style (see Chapter 6). On the right panel, King Richard II (1377-1399), crowned and garbed in a luxurious red-and-gold damask robe, kneels and looks at the Virgin and Child, on the right panel, who are surrounded by 11 of the most gorgeous angels dressed in the same lapis lazuli blue as the Madonna. We have no idea who created this fine Late Gothic masterpiece, but the sentimental vote goes to an unknown English painter.

✔ Although Jan van Eyck's *Ghent Altarpiece* (1425-32) is arguably the top Western painting, his small portrait of "Mr. and Mrs." Arnolfini (often called, erroneously, the *Anolfini Wedding*) is very close in quality and excitement. The work shows Giovanni Arnolfini, a member of a wealthy Lucca family, who was the Medici monetary representative in Belgium, and his young wife, standing with a pet dog in their bedroom about to greet a visitor or two (which happens to be us, the onlookers). The bedroom was where honored guests were allowed to come. The incredibly finely finished work in oil, a medium van Eyck invented, dates to 1434. The inscription, which looks like an ornate curlicue decoration, says in Latin "Jan van Eyck was here." The microscopic details are amazing, and if you are allowed close enough to look at them, see if you can find van Eyck's tiny image reflected in the bull's-eye mirror in the center. (See Chapter 8, Figure 8-10.)

✔ Before Sandro Botticelli became a follower of the religious fundamentalist Savonarola, he created some splendidly provocative works, bursting with humanism and paganism. The best is his *Venus and Mars* (1483), which is sexy, frivolous, and painted with exceptional skill.

✔ A masterful example of the drawing talent of the incomparable Leonardo da Vinci is hidden away in a room, which has lights of exceptionally low foot-candles to preserve the delicate paper and drawing. The subject is *The Virgin and Saint Ann with the Christ Child and the Young John the Baptist* (c. 1500-1501). In this tight and powerful composition, in which the figures are glued to one another, there's genuine affection in the way Christ blesses his cousin and lightly touches him under his chin.

✔ Hans Holbein, the 16th-century Swiss master from Basel, worked for many years in England at the court of Henry VIII and painted him and his courtiers. One of his triumphs, dating to 1533, is a large oil-on-wood portrait of two young and wealthy Frenchmen, Jean de Dinteville and Georges de Selves, called *The Ambassadors*. (See Chapter 8 for an illustration). The work is rich in visual symbolism, which was much revered at the time — sight puns if you wish. De Dinteville's chateau is located on the finely painted globe in the foreground, and one of the books in front of de Selves tells us that he's 25 years of age. The objects on the upper shelf are reserved for astronomical accouterments, and those on the lower shelf epitomize earthly pursuits. The presence of a Lutheran hymnal tells you their religious frame of mind. That odd-looking gray, white, and blackish streak at the bottom of

the painting (which looks like some weird weapon) is a human skull depicted in anamorphosis focus, which can be seen in its proper perspective if you position yourself way to the right side of the picture — or if you happen to have in your possession the kind of glass cylinder that will allow you to see the grisly object, a symbol of vanity and the remembrance of coming death to all, in its full glory.

✔ The British have always been obsessed by the Venetian Titian, and one of his most attractive and athletic works is the *Bacchus and Ariadne* (1522). The god of wine is shown in a frenzy of love-stricken passion, leaping out of his chariot to embrace the gorgeous Ariadne. The full Titian as secular painter is here — classical subject matter, flowering nudes, and a poetic landscape.

✔ There's a great Rembrandt here, his *Woman Bathing,* a portrait of his confident, mature period around 1654. She is his wife, Hendrickje Stoffels, shown lifting her skirt up as she wades in a shallow stream. It's earthy and highly satisfying, executed with huge dollops of thick paint that merge somehow into a vision of utter reality.

✔ The British also loved Peter Paul Rubens' works, and there are two world-beaters in the National Gallery. One is the gracious and scintillating *Portrait of Susann Lunden* (1622-5). This work is commonly called *Woman in a Straw Hat,* despite the fact that the hat is felt and decorated with feathers. No one knows why.

Rubens excelled as a landscape painter, but his works in this subject are rare. One of the finest is the early-morning piece called *Autumn Valley,* with his lavish country place, the Château de Steen (or Het Steen) near Vilvorde, Belgium. The woods, workers, and farmers are sublimely painted, as is what is perhaps the most breathtakingly beautiful sunrise in all of art.

✔ Diego Velázquez, as I have seen from my delight in the *Las Meninas* in the Prado, is one of the top-ranked artists in history. His flamboyant and magnetic nude (his only one), called *The Rokeby Venus* (1647), is a splendid exercise in painting the female figure and in tricks of perspective. Venus' face reflected in the cloudy mirror held up by a bold, winged cupid, is both full of radiance and a few doubts, too. We have the spooky feeling that she's just caught us — voyeurs all — watching her.

✔ Not to be missed is Thomas Gainsborough's suave and witty portrait of the young and beautiful couple *Mr. and Mrs. Andrews* (c. 1748-1750). This is a charming confection (see Figure 11-8 in Chapter 11).

There are some worthy modern paintings, too, although the National Gallery has had to play catch-up ball acquiring Impressionists and Post-Impressionists.

✔ Joseph Mallord William Turner is better represented in the fullness of his unequalled talent at the Tate Gallery, but there's one gripping and movingly Romantic work in the National Gallery. It's *Rain, Steam, and Speed — the Great Western Railway* (1844). What's portrayed is a locomotive and train thundering over the Maidenhead railway bridge over the Thames. See if you can find the rabbit, the fastest animal, desperately trying to outrun the train.

✔ Georges-Pierre Seurat (commonly just known by Georges Seurat) is wonderfully represented by his monumental *Bathers at Asnières* (1884). The figures lolling on the shore or bathing look like characters in some classical Greek frieze — they are both timeless and very 19th-century creatures at the same time.

The Tate Gallery

The **Tate Gallery** is undergoing renovations and expansions, so be sure to find out what is open. The greatest Turners and Constables are there as well as some very fine examples of the works of the late Francis Bacon, whose semiabstract images of twisted and bloated figures are horrifying yet mesmerizing. Frequently overlooked are the vibrant and poetic canvasses by Joseph Wright of Derby, and I highly recommend his works, especially *Iron Forge* (1772).

The Victoria and Albert Museum

The **Victoria and Albert Museum** (www.vam.ac.uk/) is being reorganized, remodeled, and expanded and is famous for its decorative arts, furniture, period rooms, Renaissance bronzes, and miniature paintings. Here is my list of the greats.

✔ The high point of the Carolingian renaissance of the 9th century, when emperor Charlemagne and his ministers tried to evoke the glory of the age of Constantine and set out to capture the essence of the art of the Roman 4th century, is superbly exemplified by a glistening large ivory bookcover that once decorated the gospels illuminated for the emperor himself. It's in the medieval treasury. The splendid figures are both early Christian in their stocky down-to-earth feeling and Carolingian, as their flamboyant curling and whipping draperies so beautifully express. An exceptionally rare work of art.

✔ The Romanesque period of the 11th and 12th centuries was marked by a wild inventiveness of decorative elements — especially in the margins of illuminated manuscripts. Creatures of all kinds, real and dreamlike, appear, bustling and fighting and dashing here and there. A very unusual and spectacularly rich three-dimensional example of this fertile style is the bronze Gloucester Candlestick (11th-12th century) in the medieval treasury gallery. The casting with the deeply undercut figures and foliage is uncommonly daring — even an accomplished Renaissance sculptor wouldn't have dared this.

✔ In Germany, in the Late Gothic period of the 15th-16th century, sculptors who worked in wood, lavishly painted or left in natural wood, were praised throughout the civilized world. None more than the Nuremberg master Veit Stoss, who carved the breathtaking, huge altarpiece in Saint Mary's church in Krakow (see also Chapter 8). In the Victoria and Albert Museum, there's a diminutive sculpture in hard, brown boxwood of the standing Virgin and Child, which is one of the finest monuments of its entire time. Crisp, flawless, and full of emotion, this little work is unforgettable.

✔ Speaking of small scale, miniaturists who painted on vellum or ivory with all the vibrant colors of the High Renaissance were looked upon in the period of Elizabeth I as distinguished artists. The most acclaimed was Nicholas Hilliard, and the museum possesses a host of his exceptional works. The

most alluring is an oval watercolor on parchment no bigger than five by three inches, a stunning portrait of a dashing dandy. (Maybe he's the errant and crooked Robert Devereux who, in his 20s, was a "favorite" of the queen and later was beheaded after attempting a truly mismanaged rebellion.) He is fair, supercilious, and tall, with legs longer than a spider's (and a heart, one feels, of about the same weight as a spider's), dressed in snow white tights and an embroidered shirt that probably cost as much as the national debt, standing very come-hither in a thorn bush, surrounded by prickly eglantines. The complicated trek to the V. & A. is worth it just for this treasure.

Apsley House

Apsley House is the townhouse given by a grateful nation to the Duke of Wellington after the Battle of Trafalgar and possesses some fine pieces, notable among them being an early, devastatingly realistic painting by Diego Velázquez, *The Water Carrier of Seville* (c. 1623), in which the real star of this subject taken from everyday life is the enormous terra-cotta jug held by the water seller, which oozes moisture in an utterly entrancing manner. There is also an overlifesize, glistening white marble statue of Napoleon by the brilliant 19th century Neoclassic sculptor Antonio Canova, in which the war-maker and plunderer is depicted as a Greek god. It is an amusing and fitting item of war-booty for the man who felled the dread Napoleon.

Courtauld Institute Gallery

Finally, the **Courtauld Gallery** is one of the major repositories in the Western world of old masters and Post-Impressionists, and every art lover from novice to postgraduate will want to spend some time there. One of the key works is Éduoard Manet's powerful and lyrical *Bar at the Folies Bergeres* (1881-1882), which combines a sharp realism with the mystery of mirrored images and which may be the single most accomplished Impressionist work.

Queen's Gallery

The **Queen's Gallery,** near Buckingham Palace, presents varying works from the royal collection, and whatever the show happens to be is a must-see. The Queen of England has what is indisputably the single finest art collection in the world — how else to describe the largest gathering on earth of Michelangelo and Leonardo drawings? The works are in phenomenally good condition, primarily because the pieces have never been for sale and thus have never been subjected to damaging overcleaning.

Royal Academy of Art

Be sure to check the newspaper listings for what shows are current at the **Royal Academy,** where the exhibitions range from power-packed blockbusters of traditional art to the most searing contemporaries.

Sir John Soane's Museum

Oddball and quirky is **Sir John Soane's Museum,** devoted to the collections and memorabilia of the very famous architect (1753-1837). The place is noted for the highly entertaining series of William Hogarth's paintings of the *Rake's Progress,* which, as you may suspect, was all downhill. (See Chapter 11.)

Wallace Collection

One of the artistic joys of London, which, for some reason, too often gets lopped off the tourist circuit, is the **Wallace Collection.** The pride of the massive collection is old master paintings, especially French ones of the 18th century, decorative arts, and fine furniture. The collection was started by the fourth Marquess of Herford, a witty recluse and a fantastic "eye" between 1830 and 1870. The holdings were completed by his bastard son, Sir Richard Wallace or Richard Jackson, who lived from 1818 until 1890, and who, after inheriting his father's unparalleled collection, added munificently to it. The visual knockouts are:

- Franz Hals' uproarious *Laughing Cavalier* (1624), one of the most amusing pictures of the entire 17th century, bursting with the energy of lavish paint, decoration, and jollity.

- Jean-Honoré Fragonard's *The Swing* (1767), which is a very sexy painting without any pornographic overtones. There's a spectacular-looking young French girl on the highest altitude of a swing dressed in such a way that many of her charms are visible to her handsome lover who's positioned just so in the rose bushes beneath her. The husband, perceiving nothing of this, is there tugging on the cord that lifts his wife ever higher, oblivious to the lover and presumably thinking of his moneybags. It's painted with all the verve Fragonard could impart to a scene so beloved during the ancien régime.

- There's such an Ali Baba's treasure of decorative arts in the Wallace Collection that it's hard to single out one piece. Yet to me, the best-of-the-best is an astronomical clock made around 1750 for Jean Paris de Monmartel, who was godfather to King Louis XV's mistress, Madame de Pompadour. The extraordinary movement is by the world-famous clockmaker Louis Fortier, the incredible casework crafted by Stollewerk, with the vivacious bronzes on top probably by the decorative arts sculptor of the period, J. Caffieri. The wood glows so richly that the whole work looks like a giant hunk of polished amber. This one is worth a detour, as they say.

Fitzwilliam Museum

If time permits for a longer sojourn in Great Britain and environs, I'd suggest the **Fitzwilliam Museum** in Cambridge, the **Ashmolean Museum** in Oxford, the museum in **Manchester** and **Birmingham Museum and Art Gallery,** and the **National Gallery of Scotland,** Edinburgh.

Non-Western Destinations

I could not include a large variety of non-Western museums and destinations in this book simply because of lack of space. If you're interested in some destinations not discussed here — such as China, Japan, and so on — be sure to check out Chapter 17.

Egypt

You can never see the unparalleled country in one visit or even several. But if you can go only once, here's my list of what to see in descending order of importance.

Stepped Pyramid at Saqqara

The Stepped Pyramid and funerary complex at Saqqara is the first example of architecture in history designed by Imhotep, who translated reed and mud forms into stone, nearly half a millennium before the Great Pyramid. If you have an adventurous spirit, take the special tour in desert-capable SUVs. It goes to every one of the 19 pyramids, including the fascinating Bent Pyramid at Dashur. (See Figure 41 in the museum guide color insert.)

The Great Pyramids of Giza, the Sphinx, and the Giza Plateau

Must-sees are the Sphinx (see Figure 42 in the museum guide color insert) and the Giza Plateau for the grand trio of Cheops (Khufu), Chephren (Khafre), and Mykerinos (Menkaure) pyramids.

One startling thing about the great one is that it's entirely in human scale. At the base is a horrid-looking modern structure containing a breathtaking solar boat some 70 feet long with a high cabin made out of cedar planks roped together. The Pharaoh sailed to the sacred West every evening and returned in it. The magnificent vessel was found a couple of decades ago carefully laid out in all its pieces in a pit covered by a host of beautifully-dressed blocks, each weighing several tons. Two more pits are there at Giza, waiting to be opened — containing what? I asked a friend who had been the first man who had slipped into the black pit (and who had been overwhelmed to smell what seemed like fresh cedar, though it was five thousand years old) how he could hold himself back from looking into the others, and he answered, "In Egypt, we have a tendency to wait."

By the way, the Sound and Light at Giza is tremendous, although I recommend going the night they put on the Arabic version, for even if you have no idea what's being said, the language is beautiful and the lights and colors are the reasons for attending anyway.

News for pyramid-watchers

There's good news for pyramid-watchers, for the great Pyramid, the Sphinx, and the 4,500-year-old temple in front of the creature are now open again after extensive reconstruction. The Sphinx's 66 foot by 66 foot (20 m by 20 m) temple has 24 pillars representing the day's hours plus two carved niches symbolizing sunrise and sunset. The stones, some of which weighed eight tons, had collapsed and are once again standing in position. The Egyptian government will allow tourists into the great Pyramid, but only 300 a day instead of the pre-restoration 5,000 — so, plan your visit accordingly.

Cairo

The **Egyptian Museum, Cairo,** cannot be digested in the single day most tours dictate, so plan on at least two days and never hire a local guide. Naturally, the Tutankhamun material comprise the most celebrated holdings — they rank as the finest archaeological survivals in the world — but visit the galleries on the first floor before going to Tut on the second floor. The earliest, and possibly the finest, stone carving of Egyptian art is in the gallery just opposite the entrance, the Stela of Narmer, which shows this first Pharaoh crushing his enemies.

The Old Kingdom materials (see Chapter 5) are found in the series of galleries going clockwise West and North from the entrance. The finest are the wooden panels from the tomb of Hesy-Ra, the gray-stone image of the Pharaoh Khafre as the god Horus with the deity in the form of a falcon protecting his head, the statue of Rahotep and his beautiful wife, Nofret (shown in Chapter 5), and the wooden sculpture, almost 3,000 years old, of an Old Kingdom official today called the Sheik el-Beled after the Arabic foreman of the digging crew who found him.

In the West galleries, you can find some fine portraits of Queen Hatshepsut, who built the mammoth funerary temple in Luxor. One small low relief shows the obese Queen of Punt arriving before Hatshepsut — a different form of feminine beauty.

On the first floor, you'll find several imposing, enormous statues of the Pharaoh Akhenaten, who introduced a kind of monotheism to the land and, very likely, lost his life for his crusade. These sculptures make the man look like a deformed, slobbering fool, but they were not intended to be caricatures — that was the official style. (See Figure 43 in the museum guide color insert.)

His queen was the famed beauty, Nefertiti, and there are several sculptures of her and their daughters, perhaps not anywhere as striking as the bust of the queen in Berlin's Egyptian Museum, but they are gripping nonetheless.

Then I'd go straight for King Tut on the second floor. The pieces are laid out in no sensible order and, sadly, there are no adequate illustrations showing what the four tiny chambers in the modest tomb looked like jammed with the thousands of amazing items.

TIP

Cairo mosques

Cairo is an Arabic city, founded in 969 by the Fatimids who moved to Egypt from Tunisia and Sicily. Cairo in Arabic is "al-Qahirah," meaning, "the Victorious." Visiting the two most imposing mosques is all but mandatory — that of Cairo— al-Azhar (started in 970) and al-Hakim (c. 1002-03). Both are simple, pure, and profoundly moving. Be sure to be dressed in a very sedate manner before the tour. The Islamic Museum is very fine, but can be overlooked on that single visit.

Here's what to spend more time looking at:

- ✔ The pitch-covered wooden statue of the jackal-god Anubis, god of the dead, who guarded over the so-called Antechamber.
- ✔ The miraculously-painted box showing the child-king slaughtering all his enemies from a grand war chariot. Leonardo da Vinci would have loved this.
- ✔ King and his adoring Queen Ankhesanamun.
- ✔ The alabaster lamps and the small statue of the reclining lion.
- ✔ Tut's wooden parasol.
- ✔ The huge wooden, gilded shrine surrounded by the lovely goddesses who protected the king's vital organs, which were placed in alabaster urns — called the Canopic Shrine.
- ✔ The chariots (which were actually sawed in pieces to get them into the tomb originally).
- ✔ Everything in the Treasury is unique and in superb condition, and be sure not to miss the small, solid gold seated statue of the boy king.
- ✔ The second floor also shows several intriguing paintings and drawings on papyrus. One shows some *Cats Serving Lady Mouse* — a mouse attired in elaborate court dress sits on a wicker stool, quaffing some wine, while a servant cat dresses her ladyship's coiffure. You'll smile.
- ✔ The second floor also has a fine collection of wooden, painted sculptures of the Old Kingdom, including a large number of wooden models of various daily activities and a platoon of stalwart soldiers compromising half of the contents of the tomb of the Old Kingdom Vizier Meket-Ra (3,000 B.C.) that was the Egyptian share of the tomb's full contents, the other half being in the Metropolitan Museum in New York (see more details in the Awesome Americas museum guide).

Luxor

Luxor, the Valley of the Kings, Hatshepsut's funerary temple, the Temple of Karnak, and the Luxor Museum are prime spots.

Impressionists in Egypt

If you get gorged with Pharoanic or Islamic art, why not try some Impressionists to cool off? Cairo boasts a quite acceptable collection of them, the Mr. & Mrs. Mohammed Mahmoud Khalil Museum, which is far, far better than the Museum of Decadence in Teheran, which offers some pathetic fake Impressionists and post-Impressionists bought unwisely by the empress of Iran in the 1970s. The Kahlilis, an Egyptian married to a French connoisseur, collected at the turn of the century, some prime pictures, such as Gauguin's *La Vie et la Mort (Tahitian Bathers)*. There are mint Corots, Renoirs, and van Goghs, and one startlingly fine Claude Monet, *Sous-Bois, Intérieur de Forêt (Forest Interior)* which, with its black lines and areas of white, may remind you of a Jackson Pollock. The collection housed in a Rococo-revival villa overlooking the Nile has the perfect "Egyptian" Monet, too, London, Westminster Abbey, and Cleopatra's Obelisk.

The museum at Luxor, built, incidentally, by my friend who once ran the Giza Sound and Light described earlier in this chapter, is one of the few modern museums in Egypt. Opened in 1975, it displays objects with fetchingly dramatic lighting effects — and has informative labels in French, English, German, and Arabic. The design is one long room lined with knockout sculptures, each housed in its own niche. The finest work is a sculpture in majestic red sandstone of the Pharaoh Amenhotep III. What distinguishes the Luxor Museum from most others is that the works on view come from nearby excavations: The massive Temple of Luxor is virtually down the street, and Karnak is not too far away.

The Valley of the Kings, where the New Kingdom Pharaohs were buried in rock-cut tombs (and were, except for Tut, all plundered) is a hot, barren, yet thoroughly gripping place. Even though Tut's tomb will probably be closed (his mummified body, his sarcophagus, one of three gold coffins, and some wall paintings remain), and access is increasingly being denied to the painted tombs, the Valley is worth a visit just for the mystery and poetry of it.

Aswan

At Aswan, there are the enormous stone, seated portraits of Rameses III, lofty sculptures carved out from the rock of the high cliffs and, in modern times, moved and reassembled after being cut into pieces to avoid being inundated by President Nasser's famous Aswan High Dam.

A museum for Nubian art — the last great phase of Egyptian traditional styles — has recently opened at Aswan, and being clean, crisp, and attractive is a marked innovation (compared to the stodgy Egyptian Museum, Cairo). It combines art and ethnology and is surrounded by terraced gardens with lots of water from fountains and pools. The displays include a re-creation of a traditional Nubian house plus a whole rock-cut chapel rescued from Lake Nasser. This museum is constructed in lovely light-hued granite, and the walls are pierced with triangular

The challenge of Egypt

I fell in love with Egypt the moment I entered the shabby galleries in the Cairo Museum devoted to the 5,000 or so objects found by Howard Carter in King Tutankhamun's tomb. On my first of dozens of visits to organize the Tut exhibition and personally choose the 55 objects for it, I learned that the country was, well, challenging. To get anything done, you had to invent the wheel to get moving and then write your own rules. When I arrived, the Cairo Museum's much-promised electricity that I needed for the photography didn't work. I persuaded the man who ran the Sound and Light show at the Pyramids to bring some coaxial cable to the back of the disheveled museum the same night, momentarily shut down the electricity all over town, splice the cable into the city power, snake it up the wall, then through the broken skylight and into the gallery where our studio was located. It worked. So, never be discouraged by the erratic, slow pace of things in Egypt and how nothing seems to happen as advertised. Things will eventually always work. One way to keep your sanity is to mutter to yourself occasionally, "I'll be back again."

motifs to enhance the feeling of lightness. The artworks that come up to the level of the Nubian pieces in the Museum of Fine Arts in Boston are accompanied by explanatory time lines and well-written wall texts in English and Arabic.

Note: Alexandria is probably not worth the trouble of going there, for the museums, which do have some excellent Roman pieces, are experiencing extended renovations, and the recent harbor excavations revealing fine remnants of Cleopatra's Palace have yet to be put into museum order.

Israel

My general rule on visiting museums outside of the great European centers is to leave for the end of a trip what you can see in better examples in Europe and concentrate on the local strengths. In Israel, there are excellent museums filled with fine European and American art, thanks to a host of dedicated donors — and when in Tel Aviv or Jerusalem, don't neglect them.

Jerusalem

Israel Museum and the Shrine of the Book

Of the myriad museum and archaeological experiences in this incredible country, my favorite has always been the stunning Shrine of the Book at the **Israel Museum** in Jerusalem. Few buildings in the world can equal the domical structure housing the Dead Sea Scrolls and explain other rare, ancient manuscripts and artifacts. The contrast of the white dome and the gleaming black basalt wall is a work of art in itself.[11]

The Shrine of the Book houses some of the most intriguing archaeological discoveries in Israel and are of four kinds: the Dead Sea Scrolls themselves, the pieces in the library of the Dead Sea Sect, archaeological material from Khirbet Qumran, which was the headquarters of the Yahad community, the biblical Aleppo Codex, and finds from the "Cave of the Letters" from the time of Bar-Kokhba (first half of the second century).[11]

I've always been impressed by the poetic feeling of the cave-like atmosphere of the vestibule to the permanent exhibition entitled *A Day at Qumran*. The exhibition follows the daily routine of the Yahad from morning to night and gives you profound insight into what was going on in ancient times. Noteworthy among the artifacts is what is presumed to be a sundial that helped the Jews of Qumran to keep time and to mark the dates of their festivals.[11]

Here are a selection of the biblical manuscripts, apocrypha, and sectarian writings that have both added to — and confounded — our understanding of history and the nature of religion in the period. The prize of the group, to me, is the 2,000-year-old Isaiah Scroll A. Of the sectarian documents, you'll find most fascinating the one entitled *The War of the Sons of Light and the Sons of Darkness,* which offers insights into fervent messianism of the people who created them.[11]

Finally, highly significant is the so-called Aleppo Codex, which is the earliest known Hebrew manuscript comprising the full text of the Bible. It may have been the manuscript used by Maimonides when he defined the way the Torah scrolls should be written.[11]

On the lower level are discoveries from the time of the failed Bar Kokhba revolt against the Romans (A.D. 132-135) found in the cave where the inhabitants of Ein Gedi fled. The Romans entrapped the survivors, and they died in the cave, having left behind their belongings. Among the finds were clothes, kitchen utensils, knives, keys, and mirrors.[11]

Bible Lands Museum

A newly-founded museum in Jerusalem of considerable interest for fans of the Ancient Near East is the collection of the **Bible Lands Museum.** It was formed by a retired art dealer of note, Elie Borowski, who had galleries in Basel, Switzerland, and Toronto, Canada. The museum houses an outstanding collection of antiquities, covering all the principal cultures and civilizations of the Near East.

Rockefeller Archaeological Museum

You'll also find rewarding a visit to the **Rockefeller Archaeological Museum** on Sultan Suleiman Street, with its notable collection of antiquities unearthed in digs during the British Mandate period.

TIP

Other Mideast possibilities

Gone, perhaps forever, are the museums in Kuwait and Beirut. Saddam Hussein's henchmen looted many of the fine decorative arts housed in the Royal Kuwait Museum — luckily, some excellent works were in America on tour when the invaders struck. Beirut (before the chaos) was the home of a spectacular small archaeological museum, but the building was shattered in the civil war.

I would recommend one and only one site in Iran, if you have the courage to travel there. It would be Persepolis, the vast palace built by the Achemenian King Darius I (ruled 522-486 B.C.) It was plundered by Alexander the Great, who also totally destroyed the old palace of Xerxes, an act of revenge against the invasions of Greece in the 5th century.[5] Despite the despoliation, an amazing number of grandiose sculptures remain — and there's no better time to see it than when the moon is full.

Turkey

Istanbul

Istanbul is by far the most intriguing city for art and architecture in the near-Middle East or outer-Europe, whatever that means, wherever you wish to place it. For me, it beats most of Europe for mystery, splendor, and diversity. Emperor Constantine, in A.D. 330, took an unprepossessing Roman town and transformed it into his dazzling eponymous capital of Christianity — calling it at first New Rome, then Constantinople. It was taken over by the Ottomans in A.D. 1300 and has always flourished.

A proper cultural tour of Istanbul cannot be done in less than a week. Other than the unmatched riches of architecture and art, there are spectacular walking tours, the grand and spooky bazaar, marvelous places to dine, and day trips to places like the fishing village of Tarabia, which is charming.

Istanbul is a quintessential Islamic city, and what Christian monuments there are survive decently enough, yet they are nestled within the protective embrace of Islam. The gorgeous mosques and the Topkap Saray or Topkapi Palace are the prime attractions.

For the Roman and Byzantine Christian sights, here's my list of the essentials.

✔ The **Basilican Cistern,** a closed, deep-underground construction comprised of 336 columns soaring from the black, still waters to the impressively-vaulted roof. It was begun by Emperor Valens and completed in early Byzantine times.[5]

✔ The **Hippodrome** started by Septimus Severus and completed by Constantine and the severely smashed base of the long-gone column erected to honor emperor Theodosius (who is known in history as the man who destroyed more ancient Greek treasures in history for the sake of the new faith, of course).

✔ The church of **Hagia Sophia** (Holy Wisdom), now a museum, was built by Constantine (along with the nearby church of St. Irene — Divine Peace — also a definite stop) on the foundations of a pagan temple. Hagia Sophia was burned to the ground in A.D. 532 and totally rebuilt by Emperor Justinian. Then an earthquake in A.D. 559 destroyed the dome, and it was rebuilt in a "secret" way to withstand all future quakes.[5] How? This impressive dome, which is over a hundred feet in diameter and is upheld by the four massive buttresses, is not made of masonry. It is constructed out of hundreds of custom-made, hollow vases so that it won't ever collapse under its own weight. It's worked perfectly.

✔ The remains of **Justinian's Palace** near Hagia Sophia with extensive mosaics representing the attractions of the imperial Circus.

✔ The **Church of the Chora** (Kahrie Djami). This lovely church, situated near a peaceful plaza, possesses what are probably the finest 14th-century Byzantine mosaics extant. These profoundly delicate, golden stunners were discovered beneath walls whitewashed in the 15th century by Muslims, who graciously refrained from gutting them. The mosaic technique is the finest imaginable. The craftsmen used minute pieces of glass, the majority of which are silvered and gilded. The style is ethereal and sinuous, and the wraithlike figures acting out the entire Old and New Testaments seem to be alive. See Figures 44 and 45 in the museum guide color insert.

✔ The Justinian church of **Sts. Sergius and Bacchus** (A.D. 527-536) with its fascinating domed octagon within a rectangle and its richly columned interior. Justinian had been condemned to death for conspiring to overthrow the then-emperor Anastasius I; and Sergius and Bacchus, two soldier-saints, interceded on Justinian's behalf and he was freed (only to take over in yet another of his unending conspiracies).[5]

For the Islamic and Turkish monuments, the following are demand bids:

✔ The **Mosque of Sulieman I,** the Magnificent (1550-1557). The architect is Mimar Koca Sinan, who ranks amongst the top five architects of history. Sinan based his concept of a vast complex, which includes a hospital, a medical school, four madrasahs, baths, shops, and stables, on Hagia Sophia. Yet the central dome is utterly different from that of the Byzantine church and includes 32 openings that light up the interior as if the sun itself were housed within.[5]

✔ The **Blue Mosque** or the Mosque of Sultan Ahmed (1609-1616) designed by Mehmed Aga. The interior, which is feathery and gracious, is decorated with thousands of shining blue tiles. By the way, in the Topkap Saray is a magnificent throne designed by the architect for the sultan. When I worked one August in Istanbul and a heat wave descended upon the city, I'd come to the Blue Mosque at midday; and while dozens of citizens talked business in the side aisles, I'd sit in the middle of the mosque, cool as a cucumber. Under that radiant dome on carpets piled four layers deep, making sure that I always had one leg tucked beneath me — for a guard with a scimitar was making sure that I, and everyone, did so — I read the long history of the fabulous city.

✔ Istanbul is a city of fountains, too, and perhaps the most glorious is the one built by Sultan Ahmed II in 1728 located behind the apse of Hagia Sophia.

Topkap Saray (Topkapi Palace)

This grandiose *seraglio* (or palace) is part residence and part fortress. It was begun in 1462 by Mehmed II and served as the residence of the sultans until the 19th century. It was famous in the Western world as the place where ambassadors went to be accredited, passing through the renowned Imperial Gate, called the Sublime Porte. Topkapi consists basically of a bunch of relatively small buildings grouped around three grand courts. The most important buildings are the Pavilion of Tiles (1472), the Audience Chamber, the delicate Baghdad Kiosk, which commemorates the capture of that city in 1638, and what is called in Arabic, the Hirkaiserif, the sanctuary containing relics of the prophet Muhammad.[12]

Some of the highlights of the Topkapi Saray are:

- The shrine of the Prophet — the relics were brought by Sultan Selim I, after the conquest of Egypt in 1517.
- What is reputed to be the oldest existing Koran written on deerskin.
- The personal effects of the Prophet Mohammed, including a letter, soil from his grave, several hairs from his beard, his footprint, and some of his teeth.
- The sterling silver chest that contains his Holy Mantle.[12]

The Palace possesses an enormous collection of Chinese and Japanese porcelains, which in size, variety, and quality, beats all other collections, even the legendary holdings of the Palace Museum, Taipei, Taiwan. The Chinese pieces number 10,700, ranging from the late Song of the 13th century through the Ch'ing Qing period (1644-1912). There are up to 730 Japanese porcelains dating from 17th to the 19th centuries. One of my favorites is a plain white ewer of the Ming dynasty dating to the early 15th century whose pearl-shaped body is decorated in gold with rubies. Another is a fabulous blue and white Chinese plate with the Ch'i-lin motif dating to the Yuan dynasty of the 14th century.[12]

The Treasury of Topkap Saray is world renowned and contains a hoard of bejew-eled treasures (one of which is, of course, the famous 17th century dagger featured in the popular movie of the 1960s *Topkapi*). The collection includes gifts from ambassadors, enthronement gifts, and purchases of the Sultans themselves, plus spoils of war. Here is my choice of the four most dazzling treasures in this rambling and romantic section of the palace, which could be seen only by the Sultan alone or by a group of 40 hand-picked men, each one, presumably, fixing an eagle eye on another.[12]

- The armor of Sultan Mustafa III, made of iron mail but decorated in gold and precious stones.
- The pendant of Sultan Abdulhamid I, framed in gold, which has three huge emeralds set into a triangular mount with 48 strings of pearls making up the tassel.
- The Topkapi dagger, made for Mehmet IV in the 17th century. The handle is a huge solid, flawless emerald.
- The throne of Mahmut I, a gift of the Persian King Nadir Shah, with intricate Indian and Turkish designs made of emeralds and pearls set on a green and red background. Dazzling.[12]

Archaeological Museum

The **Archaeological Museum** is old and shabby-looking, but the displays are being worked on steadily. The one reason to go is one of the wonders of the world — the 3rd century B.C. sarcophagus in marble with traces of paint — called, incorrectly, the *Alexander Sarcophagus*. It had nothing to do with the world conqueror but was made for an unknown prince who wanted to be him. Everything about it is superior, from the crisp architectural details — it looks like a miniature Parthenon — to the dramatic sweep of the struggles between Alexander and his troops against the Persians, to the marvelous details of faces, the exquisitely-carved hair, delicately painted eyes, and even fingernails. See Figure 46 of the museum guide color insert.

Ankara, Ephesus, Aphrodisias

I'd strongly recommend visits to three other places in Turkey — Ankara for the great museum of Hittite objects, Ephesus for the wonderful Greek city and especially the Greek library with its lofty columned facade, and the archaeological site of the Hellenistic city of Aphrodisias.

The latter is situated in the high logging country above the city of Izmir and has been excavated brilliantly for several decades by specialists from New York University. There are copious remains of imposing, monumental marble sculptures of the Hellenistic period and a unique amphitheater, virtually intact, which one comes across quite suddenly when walking over the site, since it was completely hollowed out of the ground.

Bibliography

Online Material:

1. Allen Memorial Art Museum, Oberlin College, Oberlin, Ohio: www.oberlin.edu/allenart (last reviewed 8/99)

2. "The Altamira Cave": www.ozemail.com.au/~spain/heritage.htm (last reviewed 8/99)

3. Astudillo, Francisco, "Altamira": www.spaintour.com/heritage.htm#altmira (last reviewed 8/99)

4. Crylen, Katie and Meghan Stedt, "Cave of Lascaux": www.ecnet.net/users/gemedia3/Las/Las.html (last reviewed 8/99)

5. Encyclopedia Britannica Online: www.eb.com (last reviewed 8/99)

6. The Grove Dictionary of Art Online: www.grovereference.com (last reviewed 8/99)

7. Kyoto National Museum, Kyoto, Japan: www.kyohaku.go.jp (last reviewed 8/99)

8. The Montreal Museum of Fine Art, Montreal, Quebec: www.mmfa.qc.ca/collections/a-coll02f.html (last reviewed 8/99)

9. The National Palace Museum, Taipei, Taiwan, Republic of China: www.npm.gov.tw (last reviewed 8/99)

10. Raynal, Florence, "The Chauvet Prehistoric Cave": www.france.diplomatie.fr/label_france/ENGLISH/SCIENCES/CHAUVET/cha.html (last reviewed 8/99)

11. "The Shrine of the Book," Israel Museum, Jerusalem, Israel: www.imj.org.il/shrine (last reviewed 8/99)

12. The Topkapi Palace Museum, Turkey: www.ee.bilkent.edu.tr/~history/topkapi.html (last reviewed 8/99)

Print Material:

13. *The Dictionary of Art*, Grove's Dictionaries, Inc., 1996.

14. Dobrzynski, Judith H., "Representing America in a Language of Her Own," *The New York Times*, May 30, 1999.

15. Haskell, Barbara, *The American Century: Art and Culture 1900-1950*, W.W. Norton and Company, 1999, pp. 104-107.

16. Hoving, Thomas, *Greatest Works of Art of Western Civilization*, Artisan Press, 1997.

17. Richler, Gisela, *The Sculpture and Sculptors of the Greeks,* Museum of Modern Art, ca. 1950.

18. Touring Club Italiano, *Florence: A Complete Guide to the Renaissance City, the Surrounding Countryside, and the Chianti Region (The Heritage Guides)*, Abbeville Press, 1999.

19. Touring Club Italiano, *Rome: The Eternal City and the Vatican, Their Churches, Museums, Monuments and Archaeological Sites (The Heritage Guides)*, Abbeville Press, 1999.

Index

• *F* •

• *G* •

• H •

• N •

• O •

• P •